ART INC
AMERICAN PAINTINGS
FROM CORPORATE COLLECTIONS

ART INC

AMERICAN PAINTINGS
FROM CORPORATE COLLECTIONS

Introduction by Mitchell Douglas Kahan

Published by Montgomery Museum of Fine Arts in association with Brandywine Press
Distributed by Elsevier-Dutton Distribution Services

This book was prepared in conjunction with an exhibition organized by
Art Inc., a division of the Montgomery Museum of Fine Arts. Henry Flood Robert, Jr.,
Director of the Montgomery Museum, served as director of the exhibition.
Walter Hopps served as curatorial advisor. Mitchell Kahan, Curator
of the Montgomery Museum, was editor of this publication.

Art Inc: American Paintings from Corporate Collections
was made possible by a generous grant from The Blount Foundation, Inc.
with supporting contributions from the following Montgomery businesses:
Alabama Farm Bureau Mutual Insurance Service, Inc., Alabama National Bank,
Mrs. W.R. Britton, Central Bank of Montgomery, Coca-Cola Bottling Company of Montgomery,
Collier Cobb & Associates of Alabama, Inc., Exchange National Bank of Montgomery, First Alabama
Bancshares, Inc., First Alabama Bank of Montgomery, Mr. and Mrs. W.J. Gordy, Jim Wilson &
Associates, Kershaw Manufacturing Company, Turner Insurance & Bonding Co., Inc.,
Union Bank & Trust Company, and Weil Brothers-Cotton, Inc.

EXHIBITION SCHEDULE

Montgomery Museum of Fine Arts, Montgomery, Alabama
March 7, 1979 through May 6, 1979

Corcoran Gallery of Art, Washington, D.C.
June 12, 1979 through July 14, 1979

Indianapolis Museum of Art, Indianapolis, Indiana
August 8, 1979 through September 23, 1979

San Diego Museum of Art, San Diego, California
November 17, 1979 through December 30, 1979

Library of Congress Catalog Card Number: 78-65838
ISBN: 0-89616-008-4 (casebound); 0-89616-009-2 (softcover)
Distributed by Elsevier-Dutton Distribution Services

Cover illustration: Thomas Cole, *Falls of Kaaterskill*, 1826
The Warner Collection of Gulf States Paper Corporation

CONTENTS

SPONSOR'S FOREWORD

Art Inc: American Paintings from Corporate Collections is ample and impressive proof that the art and corporate worlds share a community of interest. Both flourish best in a free society. Both are concerned with brightening and strengthening the quality of life. Their shared "market" is the human environment; their mutual aim, refining and enriching it.

In recognition of this, particularly in recent decades, American corporations have played a significant role in the support of the arts, commissioning and acquiring works in growing numbers and creating collections containing the very finest in American art. This exhibition of the work of ninety artists — from collections of representative corporations throughout the United States — is the most ambitious exhibition of American corporate art ever undertaken.

Art Inc. also acknowledges the responsibility of corporations to provide public access to their art collections. Corporate art acquisitions supplement and support the efforts of public museums in carrying out a basic function of any strong and influential free society: verifying those things which are of value to that society by making art available to its citizens.

Sincere thanks are due to the *Art Inc.* staff for its comprehensive work in organizing the exhibition; to the members of the National Business Advisory Committee for their cooperation and support; and to those corporations who have generously lent their works to the exhibition.

Winton M. Blount
Chairman of the Board and President
Blount, Inc.

DIRECTOR'S FOREWORD

The acquisition of paintings by American corporations began around the turn of the century. This activity has become especially widespread within the last decade, with growing numbers of companies acquiring increasing numbers of artworks. It is our intention through this exhibition to document the evolution of corporate collecting and to celebrate its maturity.

This is the first exhibition to present the full scope and variety of paintings owned by American corporations. Represented are collections from the East, Midwest, Far West, and South. From over three hundred corporations contacted and surveyed, members of the *Art Inc.* staff selected and visited approximately one hundred. We were fascinated by the depth and range of the collections. After careful review, we chose thirty corporations to participate in the exhibition. Three works from each are included. Private collections placed on loan to corporate facilities were not eligible for inclusion.

We have purposely not chosen only master works from corporations, although some paintings fit this designation. Our aim is to point out the interesting range of work that has been collected and the adventurous collecting patterns of certain corporations. We selected some companies because of their pioneering role, others because of the current vigor of their collecting. We did not attempt to present a historical survey; however, it happens that the patterns of corporate collecting touch upon most of the major periods of American art from the early nineteenth century to the present.

The concept for the exhibition was proposed by the Montgomery Museum of Fine Arts Business Advisory Committee through the leadership of Philip T. Murkett, Jr. The Museum staff welcomed the idea and, as a logical extension, initiated a corporate research archive for our recently established Art Inc. division. These archival resources will be maintained and expanded for future programs at the Montgomery Museum.

All of those involved in assembling this project are pleased to thank our sponsors and lenders. It is our hope that *Art Inc.* will play a significant role in encouraging the continued growth and quality of the interaction between business and the visual arts.

Henry Flood Robert, Jr.
Director
Montgomery Museum of Fine Arts

CORPORATE COLLECTING AND AMERICAN ART

Corporate collecting in this country has been characterized by three important tendencies: the widespread use of commissioned art for advertising purposes, after which the works become the property of the company; the purchase of contemporary works by living artists; and the acquisition of predominantly American art. As attitudes have changed, the use of fine artists to illustrate specific corporate interests has diminished in favor of outright purchases of existing art. Today, corporate collecting remains oriented primarily to contemporary artists working in this country. The vigor of this activity has provided artists with a new source of patronage and augmented their sales to museums and private collectors.

To appreciate the significance of corporate collections it is necessary to begin with their initiation in the early part of this century and follow their growth in the ensuing decades. The history of corporate collecting is intimately bound with a number of related historical phenomena. It must also be discussed in conjunction with corporate support of art exhibitions, competitions, and museums; individual commissions to visual artists; and support of the arts in general.

PART I
A HISTORY OF CORPORATE COLLECTING FROM 1900 TO 1970

PRIOR TO 1940, there were only a few corporate collections. One of the earliest was begun at the turn of the century by the Atchison, Topeka and Santa Fe Railway and now numbers over five hundred works. Depicting the land, people, and history of the American West, the collection focuses on the early twentieth century Taos school painters. The first work was acquired in 1903. Many paintings were bought within a year or two of their completion, such as the genre scenes of the Taos Indians by Walter Ufer, E.I. Couse, and Oscar E. Berninghaus. Among the most dramatic paintings in the collection is a series painted by William Robinson Leigh, depicting the Grand Canyon of the Yellowstone River at different times of the year. Many of the works acquired before 1913 were received on an exchange basis from the artists. The Santa Fe Railway provided free transportation to the Southwest in return for paintings, which were reproduced in magazine advertisements and on the menus used in dining cars. In this novel manner, the company not only acquired a fascinating collective portrait of the Southwest but also stimulated the art colony in New Mexico. In recent years, the Atchison, Topeka and Santa Fe Railway Company of Santa Fe Industries, Inc. has sponsored numerous exhibitions culled from its collection featuring special themes on the Grand Canyon or Indians of the Southwest.¹

Toward the end of the second decade of this century, Steinway & Sons became the first American company to commission paintings from artists and illustrators specifically for advertising. Artist-designed posters had been seen both in Europe and this country since the 1890s, when designs by Toulouse-Lautrec and Will Bradley became well known. Steinway, however, commissioned actual canvases. Reproduced in color, free of letters or dates, these discrete images accompanied advertisements. Although some of the artists were also illustrators, their painted commissions represented a conscious attempt to introduce fine art into the realm of advertising. Period pieces by such illustrators as Harvey Dunn and N.C. Wyeth depicted various composers or scenes from musical scores. In addition, works were commissioned from painters Rockwell Kent, Ernest L. Blumenschein, and the contemporary portraitist John C. Johansen. These paintings, like those in the Santa Fe Collection, simultaneously reflected the sponsor's interests and allowed the artist to pursue his own aesthetic. It was appropriate that Steinway & Sons, a business involved in the creative arts by supplying musical instruments for performing artists, should stress in its commissioned images the art form itself. Their advertisements promoted musical interests in general rather than specific Steinway products.

In 1939, International Business Machines became the first corporation to assemble a group of artworks solely for the purpose of forming a collection and not for the illustration of advertisements. Two years earlier, Thomas J. Watson, then president of the company, conceived of forming a collection of contemporary art representing those countries in which IBM conducted business. Two separate collections were then assembled, based on recommendations of art authorities in seventy-nine countries. One was shown at the 1939 New York World's Fair in the IBM Gallery of the Business Systems and Insurance Building. The other was exhibited in the Palace of Electricity and Communication at the Golden Gate International Exposition, San Francisco. The next year, IBM brought together a collection of contemporary American art with two artists chosen from each of the forty-eight states, the District of Columbia, and the four territories. Again, local experts provided advice. They selected paintings which IBM then purchased outright. Like the previous exhibitions, the American art collection was also shown simultaneously at the still open New York World's Fair and the Golden Gate International Exposition. After receiving enthusiastic response, selected works from both exhibitions were shown in Washington, D.C., at the Corcoran Gallery of Art. Thus, in the short period of 1939-1940, IBM pioneered two significant trends for modern support of the visual arts: the purchase of existing works by contemporary American artists for permanent collection and the sponsorship of art exhibitions.

Another important effort in the collection and general support of visual art was begun in the late 1930s. In Chicago, beginning in 1937 under the direction of the N.W. Ayer advertising agency, the Container Corporation of America initiated a plan to revitalize the use of original artwork for advertising purposes? At the time, photographs were replacing hand-executed images. Container Corporation hired internationally known graphic designers, like A.M. Cassandre, Herbert Bayer, and Georgy Kepes, to bolster the quality of advertising artwork. Gradually, with the encouragement of the company's founder Walter P. Paepcke, non-commercial artists such as Henry Moore and Ben Shahn were also solicited. They provided images which accompanied, but did not precisely "illustrate," a written text.

The Encyclopaedia Britannica, Inc., another Chicago institution, also provided a major stimulus to visual art in the 1940s. Like IBM, it assembled a collection of contemporary American art unrelated to advertising and circulated the works as an exhibition. Not surprisingly, with the company's educational focus, an extensively researched and illustrated catalogue was published in 1945 to accompany the collection. With essays on techniques of painting and the history of modern American art, as well as statements by the artists, the book provided insight into the problems, motivations, and styles of recent American painting. Donald Bear, of the Santa Barbara Museum of Art, wrote in the introduction, "The greatest emphasis is placed upon American painting of still living artists, many of whom have reached their full maturity quite recently."[3] Now dispersed, the collection was composed almost entirely of figurative works, including paintings by the most prominent artists of the day: Grant Wood, Thomas Hart Benton, Stuart Davis, Max Weber, Reginald Marsh, Isabel Bishop and Yasuo Kuniyoshi. To help select the paintings, the Encyclopaedia Britannica formed an advisory board. Composed of noted artists and museum professionals, the roster included Dorothy Miller of the Museum of Modern Art, Juliana Force of the Whitney Museum of American Art, and Adelyn D. Breeskin, director of the Baltimore Museum of Art. Many of the artists whose works were in the collection were also invited to serve on the advisory board.

A retrospective analysis of the collection shows it to have been oriented toward traditional figurative painting, with an absence of nonrepresentational art. This emphasis was noted by Daniel Catton Rich, director of the Art Institute of Chicago, in his preface to the catalogue:

> *The collection has serious lacks and just as serious inclusions. I find it somewhat too heavily weighted on the regionalism of the last decade and with too little emphasis on recent experiment.*

Despite these criticisms, Rich concluded, "It is one of the most complete and lively surveys yet made."[4] From both the general public and a good number of critics, no adverse criticism would have been voiced. The collection was assembled at a time in American history when the artistic giants of the postwar years — Willem de Kooning, Robert Motherwell, Jackson Pollock, Adolph Gottlieb — were already producing brilliant abstract art, but their work remained largely unrecognized.

In 1944, Pepsi-Cola Company initiated a competition from which twelve paintings were selected for reproduction on calendars. The images, like those used by the Container Corporation, bore no relation to the company's product. Pepsi-Cola's new artistic approach was heralded over its rival Coca-Cola's calendars, which usually bore young ladies sipping Cokes. Pepsi also offered prize money to an outstanding group of artists selected by judges. A number of works were chosen from those submitted for circulation in the exhibition, *Portrait of America*. Walter S. Mack, Jr., Pepsi's president, wrote that by sponsoring the exhibition his company hoped to set an example for industry — to support artistic freedom of choice and not the employment of art solely to illustrate products. Mack encouraged others to advance art "not by asking artists to paint a particular theme submitted to them, but by allowing outstanding artists and critics to pick good works of art...."[5] In requesting the entrants to paint with regard to the broad theme, "Portrait of America," the sponsors of the competition intended to foster artistic creativity by initiating what they felt was an open-minded approach. In fact, the one requirement was restrictive; it eliminated nonrepresentational art and reinforced a conservative trend in early corporate collecting.

In light of the cautious nature of most early collections, it is surprising to discover that the Miller Company, in Meriden, Connecticut, was collecting works by such figures as Piet Mondrian and Ilya Bolotowsky before 1950. The impetus for the collection came in late 1943 from Miller Company's art director, Emily Hall Tremaine, and its president, Burton G. Tremaine, Jr. In accord with the spirit of the Bauhaus, they hoped that company advertisers, engineers and graphic designers could learn new design principles from nonrepresentational art. They formed a collection of the best contemporary abstract art, with works by Europeans Theo Van Doesburg, Juan Gris and Georges Braque placed in offices alongside those by younger Americans Irene Rice Pereira, Stuart Davis, José de Rivera and Alexander Calder. The works were then mined for design ideas to be applied to printed matter, light fixtures, and fuel devices. The collection's emphasis on European artists reflected the Tremaines' preferences as well as the fact that European abstraction was more developed than American. In an exhibition at Hartford's Wadsworth Atheneum in 1948, the Miller Collection was made public. Its premier announced not only the emerging importance of Burton and Emily Tremaine as modern art collectors of discriminating taste, but also a significant application in this country of the Bauhaus philosophy of the interrelation between fine and applied art.

The 1940s witnessed a dramatic growth in corporate commissions for specific works from

artists. This practice, as already noted, was begun in 1918 by Steinway & Sons. Among other early sponsors in this area were *Fortune* and *Life* magazines. In the new age of photographic reproduction, they continued the tradition of the artist-illustrator with one significant variation; they employed painters rather than trained commercial illustrators. The Texas artist, Alexander Hogue, was among several who contributed to *Life's* "Historical American Scenes." The works were consciously regarded as "fine art at the service of communication" and not simply as illustration. *Fortune* commissioned Charles Sheeler to paint a series on the theme of "Power." Sheeler traveled around the country beginning in 1939 and completed the works in 1940, when they were published in full-page color reproductions.[6] In 1943, Charles Burchfield and Philip Guston were among those whose works were reproduced in *Fortune*. Over the decades, the magazine has retained its interest in allying art with communications.

During the war years, Dole Pineapple Company, De Beers Consolidated Mines, Ford Motor Company, and Abbott Laboratories commissioned paintings relating to their interests. Dole, for example, flew artists to Hawaii in 1939 to give them firsthand knowledge of the company and its products. The result was a series of interesting and often amusing paintings of pineapples, pineapple juice, and Hawaiian vegetation by Georgia O'Keeffe, Yasuo Kuniyoshi, Isamu Noguchi, and Millard Sheets.[7] De Beers Consolidated Mines adopted painting for advertising use in 1940, first employing Salvador Dali, André Derain, and Aristide Maillol, then turning to American painters. The Ford Motor Company began, in 1946, to purchase and commission paintings by Americans, mostly watercolors, for use in its publications. By 1953, the company had amassed two thousand watercolors.

With the Second World War came a surge in patriotism and a conscious effort to employ those at home to their fullest capacity — preferably in some war-related activity. This trend affected artists. Abbott Laboratories commissioned numerous works from artists depicting wartime activities here and abroad. The works were exhibited and then donated to organizations around the country. It was in this way that the Missouri Historical Society came to own an unusual and powerful series of paintings by Thomas Hart Benton, *The Year of Peril*. Although uncharacteristic of Benton's work by virtue of their war-related themes and violent imagery, they are nonetheless among his most moving paintings. Standard Oil Company of New Jersey, in 1944, commissioned works depicting the role of oil in the war effort. Among the many contributing artists were Frederic Taubes, Ernest Fiene, Adolf Dehn, and Benton. The drawings and paintings were later exhibited at the Carnegie Institute, Pittsburgh.[8] Perhaps the decade's most publicized series of commissions, these works were documentary in nature. Quality works did appear among the commissions, such as Reginald Marsh's depiction of ships at dock in Bayonne, New Jersey, but the overall quality was uneven.

"Pennsylvania as the Artists See It" was another well-publicized project involving commissions. It was sponsored in 1947 by the Pennsylvania department store, Gimbel Brothers. Fourteen artists, painters in the tradition of the American Scene, were commissioned to "create a dramatic record of Pennsylvania and its contemporary people." Among the popular artists of the late thirties and early forties who participated were Adolf Dehn, Paul Sample, Fletcher Martin, Franklin Watkins, and Doris Lee. The collection was presented to Pennsylvania and then toured the state.

The end of the 1940s brought the first international competition sponsored by a corporation. In an effort to "contribute to international good will," Hallmark Cards Incorporated

invited artists from France and the United States to submit paintings based on the theme of Christmas. Company chairman Joyce C. Hall set three goals for the competition and for subsequent exhibitions: "to encourage fine art...to bring contemporary recognition to artists of today...to broaden public appreciation of fine art."[9] From over ten thousand entries, an exhibition was selected, works were purchased, and cash prizes were awarded for outstanding works. The exhibition toured the country to major art institutions in Kansas City, the District of Columbia, Boston, New York, and Los Angeles. Hallmark continued sponsoring the competitions through the 1950s, expanding the roster to include a multi-national group of artists, both famous and obscure. In the process, the company amassed an extensive art collection.

The various competitions sponsored by Pepsi-Cola and Hallmark, as well as those by companies like Metro-Goldwyn Mayer and Abbott Laboratories, were perhaps the most visible aspects of corporate art support in the 1940s. Before the end of World War II, IBM was the only corporation to collect art in the same manner as a museum or private individual. In 1946, a company spokesman was quoted as saying that IBM intended never to "resell a work of art once it has been acquired and included in the permanent collection, and never to use the art so acquired in advertising the company's products."[10] Earlier, IBM's Thomas J. Watson had noted that since the Renaissance, private acquisition of art had increased more than purchases by church or state. In 1940, he asked, since corporations had become the largest repositories of private wealth, "Why not business itself?" as a collector of art. Watson spoke of art in relation to its abstract worth, and not as an implement of business.

It is our opinion that mutual benefit would result if the interest of business in art and of artists in business should be increased....When we see what painters reveal, it increases our hope for better understanding among the peoples of the earth. We believe that all who view these paintings will recognize, through the many forms of expression, traits common to all men which bind humanity together in universal kinship.[11]

It is appropriate that a leader in the field of communications and information should — at a time of unprecedented world crisis — offer a plea for the value of art in helping a strife-ridden world to communicate more effectively.

THE EMERGENCE OF BUSINESS AS A PATRON of the visual arts had begun by the late thirties. By the end of the war, the new role was only beginning to be recognized; nonetheless, it was already firmly entrenched. In *Culture and Company*, Alvin Reiss explains, "The modern era of corporate giving dates only to 1935," when Congress passed a law allowing up to five percent of net income before taxes to be deducted for charitable gifts. This was "the magic spur which motivated business" to become a key source of philanthropy. With this economic incentive, corporations slowly began to support education, social welfare and finally, the arts. Reiss notes, however, that only in the 1960s did corporate contributions to charity continually pass above one percent of pre-tax income each year.[12]

Since art collecting and commissions usually come under the general heading of business expenses rather than charity, the actual cause for the surge in patronage in the late thirties and early forties must be sought elsewhere. The Federal government itself may have been the inducement. By 1940, the various Federal Art Projects had become a well-known part of the American cultural scene. Although they had recently been fighting for their survival

and were, in fact, soon to be dismantled, the value of the projects seems to have infiltrated the business world. Corporate executives, like artists themselves and the American public, began to think of art as somehow valuable to their own efforts, whether directly, in the form of illustration, or indirectly, by its stimulating presence.

In one important case, this mode of thought in the business community preceded the government's New Deal efforts. The effect of the construction in New York City of Rockefeller Center (1931-1937) should not be underestimated. Like many subsequent developments in the interaction between business and art, this effort reflected the Rockefeller family's dual commitment to art and commerce. With its array of murals, reliefs, and sculpture by such artists as Paul Manship, Isamu Noguchi, and Gaston Lachaise, the complex of office buildings in midtown Manhattan became the preeminent example of art incorporated into the working environment. It presaged the growth in recent years of large-scale sculptural commissions for office buildings.

The nascent corporate patronage of the thirties and forties was also the result of hard economic changes in our society. Due to the inauguration of income taxes after World War I, the ranks of the fabulously rich dwindled. The Great Depression, following the introduction of the new tax structure, also eliminated many large private fortunes. Alvin Toffler explains in *The Culture Consumers* that the magnanimous "philanthropoids" of fifty years ago have almost entirely disappeared. Only the Rockefellers and Mellons continue giving on the scale of the late nineteenth and early twentieth century magnates, and even the art institutions which they helped to found—the Museum of Modern Art and the National Gallery of Art— are now supported by large amounts of outside money, government as well as private.[13] Today, government, private foundations, and corporations are the primary dispensers of large monetary gifts. Importantly, they are joined by tens of thousands of individuals who make small or moderate contributions.

In light of this development, it is not surprising that corporations, and increasingly the art world itself, saw the business sector as the successor to the earlier philanthropoids. The corporation as an entity began to assume functions which had been the privilege of the tycoons—Morgan, Frick, Carnegie, Hearst—all of whom were art collectors. These men had based their roles on the royalty of Europe, amassing and supporting such things as they perceived to characterize foreign nobility. As corporate structure became more democratized, as the number of stockholders increased, and as control of wealth spread from one hand to many, individuals came less and less to direct all the power and finances of a company. Gradually, the responsibilities and tastes of the earlier all-powerful individuals spread to top-level management as a whole. By 1960, an art collection was likely to be formed by the corporation and enjoyed by a large spectrum of employees. The turn of the century business attitude of "the public be damned" was superseded by economic and social changes which gave rise to the new attitude that "the public be accommodated." Art was gradually being made available to many, not to just a select few.

Corporations which collect, however, do not regard themselves as the imitators of Hearst, Morgan, and Carnegie. This generation of industrialists almost consistently acquired European art of the old masters. In areas which were sanctioned by connoisseurs, they sought that which old money and titled families sought. Although the corporations are historically the successors to individual industrialists, corporate patterns of taste and support are quite

different. Eloise Spaeth was one of the first to point out the new corporate taste in collecting, geared toward art of its own time. "It is my personal opinion," she wrote in 1956, "that the corporate good citizen is closer, in fact, in his art effort, to the real footsteps of the Medici."[14] This parallel holds true for the early collections resulting from direct commissions, such as those of Steinway and Santa Fe, as well as recent vanguard collections like those of Owens-Corning Fiberglas or Ponderosa System, Inc. One of the many reasons for this change in patronage is that by 1940, if not earlier, sources for older art in Europe had begun to be depleted. Moreover, newly produced art was less expensive than that of the old masters, a significant factor when corporate, rather than personal, funds were used, and the expenditures had to be justified. Perhaps most important were two non-economic factors: American art was flourishing in the 1930s and 1940s, and corporations, taking their cue from the populist efforts of the New Deal, sought to become involved in their own society's cultural growth. It was realized that a healthy economy depended on many things, among them creative cultural attainment.

Today's corporate executives are acutely aware of this interdependency. Frank Stanton, a CBS president and former Chairman of the Business Committee for the Arts, has eagerly embraced the notion that corporations are the successors to the patrons of the past:

> In the ages considered great by history, society's primary managers of wealth—kings, bishops, aristocrats and industrial leaders—have accepted this obligation [of supporting the arts]. In America today the comparable source of wealth is the corporation![15]

Winton M. Blount, of Blount, Inc., has expressed the relationship even more directly. "The old patrons and the church were not just dabblers in art; they were institutions which shaped and guided their societies. And so are we today."[16] These statements imply a broad conception of the role of art support. Not content merely to accumulate paintings, corporations today aim for direct exchange between the worlds of art and industry, spheres which have too often remained estranged in the past.

It was characteristic of corporate collections and visual arts support in these early decades to view art in terms of commissions to be used by business, whether for illustration, publicity, packaging or advertising. Most of the collections formed before 1950 comprised works which were remainders of corporate efforts to advertise or raise their quality of design. Even the art in the Miller Collection and that chosen for Pepsi-Cola's calendars served some practical purpose. For many of today's art conscious generation—raised on abstract expressionism and in awe of the individualistic approach to art—this pragmatism seems inappropriate. At the time, however, public opinion was not so critical. Large groups in both the art and business worlds found the use of art for business purposes encouraging. A major goal of the various New Deal art projects, especially those under the WPA, had been to break down the barriers between artists and the world in which they lived. To many in the 1940s, the artist working for business was a fruit of this effort and signaled the assimilation of art into the world at large. As early as 1943, a critic wrote that the "encouraging business-art partnership road has not been traveled far, but already the ground covered opens up a vista of great promise."[17]

During the 1940s, business sought to reassert itself and compete with government after a decade of increasing government control in the economic realm. The surge of art patronage at that time may also be seen as a competitive effort by business. In a sense, it was assuming the New Deal's former role as art patron. Exceeding the growth of business commissions for

artists was a corporate commitment to the betterment of education and social welfare, two areas into which government incursion during the New Deal had been strong. In fact, comparable growth in business support of cultural endeavors, particularly the visual arts, would have to wait until the 1960s. It was then that President Kennedy appointed, for the first time, a White House consultant on the arts. It was no coincidence that the formation of the Business Committee for the Arts followed closely upon the passage of a bill in 1964 to form a National Council on the Arts and the subsequent formation in 1965 of the National Foundation on the Arts and Humanities. The Business Committee for the Arts was conceived in 1966 and by early 1968 was a reality. The successive emergence of these two bodies reflects the delicate balance in a democratic society between government and private support of educational, social and cultural endeavors. This balance has certainly been an issue in the past decade; it was as well in the late thirties and early forties.

In addition to competition with government, there was also the growth of genuine corporate concern for a healthy society. The Great Depression had been seen by many as the result of a capitalist economic structure divorced from serving its public. Acknowledgment of this shortcoming was also expressed in board rooms around the nation. In 1944, Pepsi-Cola's Walter S. Mack, Jr. voiced an unusual viewpoint:

> Industry recognizes that today it must assume the same responsibility as any private good citizen. It must take an active part in the community life of the country...by participating actively and beneficially for the public good...which is an activity entirely separate and apart from its ordinary business role![18]

Twenty years earlier, such a statement would have been unheard of.

THE OPINIONS OF THE ART WORLD concerning the relationship between artists and businessmen were varied. The earliest known opinion by an artist—although an obscure one—was published in 1934 in *Art Digest*. Howard Patterson wrote that industry in America was in a position comparable to that of the church during the Renaissance. Like the church, business should take the initiative and use artists to interpret its needs. This was important, he explained, because while the present looked to the accomplishment of business and science for its self-evaluation, the future would look at art to discover what kind of society existed. "Also," he added, "I know that artists of today have a burning urge to paint Industry...."[19] Patterson made some valid points that have continually been sounded by corporate and art world spokesmen. But he did not seem to realize that, at the time, artists were usually either opposed to big business or simply not interested in its activities and needs. These two attitudes are obvious in the savage depictions of industrial exploitation painted by social realists like William Gropper and Philip Evergood and in the avoidance of modern industry and return to agrarian imagery which marked the works of the regionalists. Many artists of varying political persuasion regarded business as the cause of the Depression; they were not likely to portray it kindly.

The political polarization in this country during the 1930s created a large group with Marxist leanings, critical of capitalism. In their view, art should serve a large group of people and not a ruling class determined by inheritance, political control, or economic power. These beliefs were hardly conducive to the development of a relationship between art and business. However, Marxist principles were subject to a great array of interpretation, especially after

the disillusionment in liberal circles caused by the 1939 German-Russian non-aggression pact. In an interesting variation on "art for the people," artist Dale Nichols wrote in 1940, "I think that the American artist's work should be available to the majority of the people and there is no better medium than American industry to accomplish this end." He found that art serves "a more useful purpose when it illustrates the benefits of an Edison invention" than "when it decorates the wall of a wealthy man's home." To Nichols, a painter of rural landscapes and Western scenery, American industry appeared "the greatest patron of art in modern times," commissioning huge amounts of art each year for packaging, advertising and illustration.[20]

In 1945, Peyton Boswell, Jr., the editor of *Art Digest*, gave voice to the growing optimism of the 1940s:

> In this transitional period of art patronage, the sponsorship of industry is a needed substitute for the tax-bereaved wealthy collector; through industry, art can be brought to the masses of intelligent Americans and thus widen the base of the narrow pyramid of patronage—that is, provided the artist never forgets he is an artist, and the patron accepts him as such.[21]

The war effort, which had united Americans in a common goal, had also done much to repair the severed ties between different political and cultural groups. After 1942, the climate became more hospitable for collaboration between art and business. However, Boswell did issue a conditional statement along with his sanguine prophecy. He reminded his reader that artists must remain artists, with aesthetic goals foremost in their efforts; they must not be considered illustrators, either by themselves or by their patrons. The articulate and loquacious Thomas Hart Benton also addressed himself in the 1940s to the question of art and business. In 1946, he noted three ways in which business was becoming more and more involved in fine art: by buying works of art and putting them on exhibit; by commissioning artists "to paint the going concerns of Business" (which he likened to portraiture and the attendant problems of the "sitter" requesting the artist to make a "pretty picture"); by employing fine artists to create advertising for products. In this last category, Benton explained, the usual result was that "the very distinctiveness for which the artists were hired was lost." His conclusion was that only the first and second approaches "are good for art, artists, business and society; the third is good for nothing beyond the cash usage that comes to the artist."[22]

The question of specific commissions related to corporate interests was a vexing one for many artists during the 1940s. In a special issue of *Magazine of Art* devoted to the art-business nexus, Walter Abell wrote, "Only a small proportion of its [business'] support has gone to experimental painting of the kind which may be regarded as visual research, although this type of work is highly significant and highly distinctive to our time." Abell felt that the WPA's Federal Art Projects were more successful propagators of art than business because they not only commissioned artists but also distributed art to a broad sector of society—to schools, government agencies, post offices, and community centers. He concluded that the Federal Art Projects had asked:

> "In what ways can art and artists contribute most to society?" Under industrial patronage, the basic question at its worst is, "In what ways can art be made to subserve commercial aims?"; at its best, "To what degree do the interests of art and industry coincide?", or, "In what ways can industry provide art with philanthropic support?"[23]

18

Abell's conclusion was one that has been echoed repeatedly in recent years by business executives and artists alike—that financial support alone is not sufficient. There must also be direct interaction between the two worlds, each observing and learning from the other.

The Pepsi-Cola competitions of the later forties provide insight into the somewhat critical art world attitude which arose by 1949. An innovative effort, the Pepsi campaign hoped to bring the best contemporary art to the homes of Americans in the form of reproductions on calendars. Cultural historian and art critic Russell Lynes ascribed the demise of Pepsi's competition sponsorship to the "uneasy sense of conflict between the artists and the patron." The artists felt "that they were being used merely for publicity purposes and not from motives that they could respect, and their disaffection became evident as the quality of their contributions to the exhibition fell off sharply."[24] Disenchantment also arose from another problem. In 1945, a professional panel of judges was asked to select twenty artists for awards; from them, the company officials picked twelve to appear on the calendar. In a sense, this second screening process undermined the company's impartiality, for it edited the judges' selections. This may not have been much cause for alarm except that company officials did not choose for reproduction the first prize winner, thus arousing much debate.

Daniel Catton Rich, Director of Fine Art at the Art Institute of Chicago, wrote in 1945 of the new optimism generated by the possible role industry might play in supporting art. "On the whole, I have been skeptical of the happy vision" of newspaper critics and gallery dealers, he commented. Singling out specific efforts for analysis, he applauded the Container Corporation of America, which he felt commissioned extremely high quality work. Although he found other companies' efforts partly satisfying, he expressed a conclusion which would become obvious later:

Set in the straight-jacket of a page our artists have found it hard to breathe naturally. To date the best advertising art has been done by men trained specially for that field.

Rich also held reservations concerning competitions, feeling that too often "glittering prizes and cumbersome juries have not only failed to bring out the best contemporary designs but have resulted in second-rate exhibitions." He ascribed the disappointing results to industry's patronage of art, not for art's sake, but for publicity. Nonetheless, like many in the art world who criticized the standard of quality in competitions and commissions, Rich found the corporate efforts worthwhile because, "millions of Americans are looking at pictures who never had the opportunity before." In his view, the assembling of an impressive collection such as Encyclopaedia Britannica's did much to compensate for other less successful efforts.[25]

Doubts held by the art world about associating with business were often shared by corporations themselves. Hesitant to venture into an area in which they questioned the legitimacy of their involvement, many company officials asked themselves if they could rightfully support art in any way other than through commissioned advertisements. They questioned whether an art exhibition or collection could be justified to stockholders interested in dividends. Despite reservations of this sort, the art-business alliance had been born. The end of World War II has been cited as "the detonation of the cultural explosion." For culture in general—the visual and performing arts—and for education as well, the mid-forties was an important period of growth, the beginning of "complex, multi-level relationships between commerce and culture in America."[26] When the U.S. State Department sent abroad in 1946 an exhibition entitled *Sixty Americans Since 1800*, the works were chosen from the IBM

collection. After its initial showing in Cairo, other works were added to the exhibition and it toured Europe as *American Industry Sponsors Art*. The first group exhibition of corporately owned art, it might well be viewed as a symbolic official imprimatur upon corporate collecting.

THE DECADE OF THE 1950s saw a continuing, but not startling, growth in corporate collecting and support of the visual arts. The corporate view of itself as having a social role expanded as well, and the concept of corporate involvement in nonprofit-bearing enterprises slowly gathered support. Several major collections were inaugurated in the fifties. In 1955, The Atlanta Paper Company (which has since become a part of The Mead Corporation) sponsored a "Painting of the Year" competition and exhibition from which it chose one work to reproduce and distribute to its customers as a gift. By 1965, the idea had evolved to become a national exhibition of fifty works selected by jurors throughout the country. As *Art Across America*, the exhibition toured the United States until 1967.

A particularly vital effort came from the Meta-Mold Aluminum Company in the small town of Cedarburg, Wisconsin. An ardent art patron, Otto Spaeth, became its board chairman in the early 1950s and immediately involved the company in both art and the surrounding community. Art became the vehicle to attract and stimulate interest in the company from the local populace. Works were commissioned from Alexander Calder and Charles Sheeler for a newly constructed building. Its opening was highlighted with an exhibition, assembled by Otto and Eloise Spaeth, of art owned by business and businessmen.

At the beginning of the decade, Container Corporation of America instituted the widely published series of advertisements, *Great Ideas of Western Man*, the successor to their artist-designed ads of the 1940s. The premise of *Great Ideas* was related to chairman Walter Paepcke's own humanistic orientation. The founder of the Aspen Institute of Humanistic Studies, Paepcke was also a board member of Encyclopaedia Britannica, Inc. and the University of Chicago. Formulated in response to his desire to stimulate critical and interpretive thinking, the "ads" in fact advertised no product. Mortimer Adler, the philosopher and editor, made an initial selection of provocative texts from wide-ranging sources: ancient writings from The Dead Sea Scrolls and Marcus Aurelius, statements by Thomas Jefferson and Edmund Burke reflecting the thought of the Enlightenment, and modern-day writings by William Faulkner and Albert Einstein. Artists were then chosen, given texts, and asked to offer their visual interpretations. Over the years, artists as varied as surrealist René Magritte, abstract expressionist William Baziotes, and pop artist James Rosenquist contributed to the series. Major illustrators, designers, and photographers were also selected, including Milton Glaser, Herbert Bayer, and Jerry Uelsman. This continuing series was the culmination of Walter Paepcke's efforts, begun in the late thirties, to unite artistic and philosophical perceptions with society's ongoing practical concerns. "It should be easy, remunerative and agreeable," he said, "for the artist to function in society, not as a decorator but as a vital participant."[27] Put into practice, Paepcke's ideas have resulted not only in the *Great Ideas* series but also in a significant art collection and exhibitions culled from it.

As corporations expanded their support of the visual arts during the 1950s, the art world became more specific in voicing its needs. The decade saw increased demands for sincere interest from corporations, interest motivated by concerns for art itself and not for its uses in publicity. Referring to advertisements and competitions, a 1953 editorial in the *Art Digest*

complained, "We think the time has come for publicity stunts to end and for a more serious collaboration to begin." It became an acknowledged fact to the art world that competitions were not attracting enough quality work. In the words of the editor: "Most of our best artists refuse to participate in them." He cited many possible reasons for this: artists wished to avoid the chance of rejection; they were unwilling to produce art with a specific theme; they were disappointed by the commercialism surrounding competitions; or they thought perhaps that competing itself was unseemly.[28]

Corporations themselves slowly came to examine the same critical questions. Hallmark decided to offer its 1957 competition without thematic restriction; the result, as the jury noted, was that the quality of the exhibition reached "an unusually high level." Paintings by Andrew Wyeth, Charles Sheeler, Edward Hopper, and Loren MacIver were entered. In 1960, an impressive work by Pierre Alechinsky won first prize in the Fifth International Art Award. This last competition specifically sought the challenge of the new. Its subheading bore the forward-looking words, *Fifty Painters of Promise*, and it contained figurative and abstract works by Fairfield Porter, Jane Freilicher, and Jack Youngerman. The significant transition in Hallmark's approach bears witness to the sophisticated attitudes about art that often develop over a period of time. The original premise of the exhibition was geared to serve the company's own needs; it assembled images appropriate for Christmas cards. By the late fifties, the program had changed into one dedicated to art itself, one which encouraged the continuing development of artists both here and abroad.

The tenor of the 1950s was not surprising. The idealism and spirit of cooperation which had marked the war years in the United States had dissipated, at least from the point of view of many intellectuals and creative personalities. The postwar American boom in material consumption meant little to artists, who turned away from social and political involvement and relationships with commerce and industry. Abstract expressionism, the greatest artistic achievement of these years, extolled this alienation from the social mainstream. Beginning after the war and continuing until 1960, it gave visual form to the *individual's* private feelings and observations; the appreciation, understanding, or even interest, of an audience beyond one's immediate friends was hardly considered. In 1944, essays had appeared in art journals praising the efforts of respected artists depicting "oil at war." In 1954, this could not have happened. By then, attitudes about painting objects and events had changed. The vast majority of exceptional artists had turned to abstraction. One can see in the pictorial change far more than a simple shift in taste, for a change in style implies a change of intention. Figurative depictions of the individual in relation to his environment or of people reacting to one another—the mainstay of the art world in 1935—were of little interest in 1955. The artist stood alone, sought his goals alone, and gave pictorial form to metaphysical concerns, creating abstract images of death and rebirth, agony and alienation, chaos and the infinite.

THE TUMULTUOUS DECADE OF THE SIXTIES witnessed a boom in corporate art collecting and, to a degree, a slackening of artistic isolation.[29] Pop art, a product of the 1960s, is an indication of the artist's new interest in the commercial artifacts and imagery of his environment. Tom Wesselmann, James Rosenquist, Andy Warhol, Roy Lichtenstein and others took a fresh look at the appearance and objects of their world. Often utilizing techniques from advertising and commercial art, they created an ebullient—though sometimes

critical—art. Business, in turn, began to look more closely at art. Although the vanguard figurative art of the 1960s was ambivalent in its look at society, even this hesitant regard seemed valid cause for excitement at the time. In 1964, Alvin Toffler went so far as to claim, "The artist is now going to be integrated into American society to a degree unprecedented in the past century." He felt, "Today, a rapprochement is underway which threatens to undo the cherished alienation of the artists as it changes the position of art in the American context."[30]

Accompanying this optimism was increased artist interest in the technologies developed by the industrial world. Numerous experiments in this vein occurred throughout the sixties, including projects at MIT's Institute for Advanced Visual Research and artist Robert Rauschenberg's Experiments in Art and Technology. This interest culminated in the Art and Technology Program at the Los Angeles County Museum of Art. Beginning in 1968, under curator Maurice Tuchman's guidance, artists were introduced to industrial plants to use commercial techniques in the production of art. Participants included artists as varied as Robert Irwin, Newton Harrison, and Andy Warhol; corporations included Cummins Engine Company, Container Corporation of America, Walt Disney Productions, and Kaiser Steel Corporation. Such intimacy between the arts and business is always a temporary phenomenon subject to quick revision depending upon political, social, and economic changes. In retrospect, Tuchman felt that his innovative program could not have occurred four years later.[31] By that time, the escalation of the Vietnam War had renewed a polarization in American society. A climate of hostility developed, severing the fragile ties between the art world and business and government.

Before the hiatus of cooperation in the early 1970s and the concomitant depression of the art market in 1973, the visual arts had seen a boom in collecting and financial support by corporate interests. Several important factors contributed to this growth. There had been a continuing increase in art prices. Franz Schulze observed that "corporate enterprise began to assume a patron's role, at first out of the mixture of *noblesse oblige* and national pride that had moved many wealthy individuals to support the new American ascendancy, later because art became big business in its own right and hence a profitable partner to corporate enterprise."[32]

In the early 1960s, two important exhibitions drew attention to and encouraged responsible corporate collecting. The first large scale exhibition spotlighting the phenomenon occurred at the Whitney Museum of American Art in 1960. *Business Buys Art* was organized not by the curatorial staff of the museum but by the Friends of the Whitney Museum, a support group with many members prominent in both the business and art worlds. The appearance of the corporation in the museum was thus prompted by business oriented patrons who galvanized the interest of the professional art world. In 1961, the San Francisco Museum of Modern Art organized *American Business and the Arts*. Like the Whitney's exhibition, it included a national spread of corporations. The artworks were from many different countries and showed that "American firms with international interests" had brought "into their collections the work of artists from countries to which these interests extend."[33] After subsiding in the late sixties, the exhibition of corporate collections has flourished in the 1970s. In recent years, museums in Indiana, Pennsylvania, New York, Florida, Alabama, and California have drawn attention to corporate collecting by staging

group exhibitions of corporately owned art.[34]

John F. Kennedy's appointment of August Hecksher as the White House special consultant on the arts also provided impetus to public awareness of the arts. The appointment legitimized interest in the arts as a vital aspect of society along with education, science, and technology, areas which both industry and government had heavily supported during the 1950s. In 1966, Hecksher addressed himself directly to the issue of growing corporate collecting. He concluded that there were "hopeful signs of an appreciation of the arts more real than a search for status or an enjoyment of rare and expensive commodities."[35] By the end of the 1960s, regarding art as a status commodity pervaded American society at many levels. Hecksher's concern for a real appreciation of art was well warranted; it reflected the fact that, during the sixties, seeking social prestige was regarded as a valid cause for corporate collecting of art. While this motive perhaps now seems crass, it was precisely this new status which caused art to become so widely desirable and so broadly distributed. Art's new status and appeal, in fact, prompted Sears, Roebuck and Company to hire actor and art connoisseur Vincent Price to select original paintings and prints for the company to sell in its stores. This effort to attract a higher income group resulted in exposing more Americans to original artworks.

Those sensitive to corporate interests were becoming more aware of the questions surrounding art collecting. Richard J. Whalen, newspaper and magazine editor, warned that it was a large step from hanging art in an executive office to winning "an enduring place for art within the corporate structure." To achieve the status of a true patron, Whalen insisted that top-level management must be determined to see its "personal commitment to art transferred to the organization," and ensure "that support for art wins staff, budget and, most important, *internal* prestige as a permanent corporate interest."[36] In *The Corporation and the Arts*, Richard Eells concluded that the development of collections was a highly constructive force. Eells admonished corporations to shun poor or tasteless art and avoid thinking of art investment in purely financial terms. In its most sophisticated form, he explained, art investment brings rewards that are not monetary, but intellectual, emotional, and aesthetic.[37]

Many important collections were assembled in the 1960s; among the most notable were those of The Chase Manhattan Bank and S.C. Johnson & Son. Chase actually began purchasing in 1959, in conjunction with the opening of its new sixty story headquarters in lower Manhattan. With the advice of a committee of art professionals, the bank selected a wide range of art from many countries and historical periods and executed in various media. In 1960, the existing holdings were first publicized and announced to be the nucleus of a continually expanding collection. Writing in *Art in America*, curator and critic Katharine Kuh found the new building and its art "not just another handsome building with luxurious offices and interesting modern art. It is an imaginative, daring concept, a model for further public-spirited businessmen to follow."[38] Her hope was to become a reality, for the unveiling of the collection at the turn of the decade heralded the increasing momentum and sophistication of corporate collecting which was to occur in the sixties. The evolution of Chase's collection underlines a trend in recent corporate collecting; though an international collection, it has concentrated its efforts on contemporary art by younger Americans.

Also in the early sixties, Herbert F. Johnson of S.C. Johnson & Son, Racine, Wisconsin, joined forces with New York art dealer Lee Nordness to assemble a collection of American

paintings. Johnson observed, "Our American painters, who have reached a position of world leadership, should be exhibited as widely as possible both here and abroad." Although the collection received some criticism as to its quality and method of assembly, it represented a wide variety of art and included first-rate paintings by Ellsworth Kelly, Jack Youngerman, Joan Mitchell, Richard Diebenkorn, Robert Rauschenberg, and Franz Kline.[39] Johnson purchased the artworks not for his private appreciation but specifically for public enjoyment. In having the collection tour the country and the world, he set an example for making accessible original artworks owned by a corporation. The eventual disposition of the collection, as a gift to the National Collection of Fine Arts, Smithsonian Institution, served as a generous precedent for other corporations to follow.

By the end of the 1960s, dozens of new collections had been formed. Many companies which owned only a few works when included in the early exhibitions at the Whitney and San Francisco Museum possessed substantial collections by 1970. Corporate support was being extended to all aspects of art—dance, theatre, music, and the visual arts. By the late 1960s, scholarly investment banker Armand G. Erpf could accurately declare:

> The pseudo-highbrow notion that the businessman is uninterested in the artifacts of life and unmoved by beauty is unhistorical and increasingly baseless. It is being recognized as a stale caricature that has enjoyed quite excessive longevity.[40]

Erpf warned, however, that corporate support must not be extended in an effort to organize the artist, for one cannot effectively organize creativity. This line of thought suggests that purchasing the work of contemporary artists provides needed financial support and professional encouragement while leaving the artist free to pursue individual goals.

Throughout the 1960s, the art world continued to demand sincere and informed support by corporations. In 1968, the publisher of *Arts* railed against the business establishment for not committing enough money to its purchase funds. He also deplored the purchase or commission of painting and sculpture for public relations purposes. Reiterating the familiar demand for true dialogue between artists and their galleries, on one side, and industry and architects on the other, editorials in *Arts* reasoned that this was the only way to award commissions which would produce good work.[41] Nicolas Calas, writer, critic, and longtime observer of the art scene, decried the use of art as decoration by corporations. He explained that if art "becomes part of a 'total design' its artistic value is minimized, for then it is meant to decorate, not to impress by its originality or its aesthetic personality." Raising a sensitive point, he questioned the reliance on outside advice—whether from museums, galleries, or art consultants—for the purchase of art which was then assigned to specific offices instead of leaving the employees to select works themselves.[42] A number of corporations have encouraged free choice in art selection by having employees choose their favorites from among a large group of works bought by the company.

Thomas B. Hess, the noted critic and editor of *Art News*, reproached "the Safe and Sane look—which is disastrous to art." He also clearly expressed the opinion that the most successful form of business support had been in outright purchases of existing pictures. Hess urged businessmen not only to exercise taste and discernment but also to "check their precautions at the door."[43] Art collecting, like art itself, should take chances. Today, companies like Avco Financial Services, Edward Duffy & Co., and Ponderosa System, Inc. have done exactly that.

PART II
CONTEMPORARY COLLECTING AND SUPPORT OF THE ARTS

CONTEMPORARY ATTITUDES HELD BY BUSINESS LEADERS on arts support are often quite penetrating. During the 1960s, several reasons for art collecting were advanced equally by corporate spokesmen; art collections could bring prestige, financial remuneration, and a quality environment. Recently, the issue has become more a philosophical one based on concerns for stimulating a healthy society. An analysis of contemporary statements by corporate heads indicates three basic lines of thought: freedom in art contributes to any well-balanced free society; art is the spiritual sustenance of a humanistically oriented culture; and art makes a qualitative improvement in the working environment. During the 1960s and increasingly since, an attitude that corporations are not simply profit-bearing institutions gained greater acceptance. The idea was advanced that corporations are social organisms interested in their own survival and continuity. As such, they are concerned inevitably about the environment within which they operate. "To maintain a favorable atmosphere in the broader social sense is a legitimate purpose for the expenditure of funds," explained White House consultant August Hecksher.[44] Application of this premise has resulted in corporate contributions to ballets, symphonies, and museums, and to the proliferation of corporate collecting as something more enriching than financial investment.

Otto Sturzenegger, chairman and president of CIBA-GEIGY Corporation, remarked in 1972: *I believe enlightened self-interest dictates that a strong and profitable company should lend its support to those activities which assure the strength and vitality of the community. A sick and colorless society will eventually paralyze creativity and productive enterprise.*[45]

J. Irwin Miller, long-time chairman of Cummins Engine Company, has reiterated this view: *Support for the arts is part of our responsibility to the society which gives us our franchise. It ought not to fall under the category of non-controversial public relations: business support of the arts is even in a sense shameful if it is prompted only by a desire to enhance the corporate image...business itself has been enormously enriched by the work and the free inheritance of past generations;...the only way to discharge this honest debt is to hand over to the future a country and society truly responsive to the deepest needs of its people.*[46]

What actually gives a good image to business is reliable service and fine products. Arts support affords something quite different, for it is an action undertaken with the hope that it makes this country a better place for self-fulfillment. Such a place, Miller explains, is one where business can prosper.[47] Cummins Engine has applied Miller's enlightened and ideal-

25

istic attitude to actual practice by underwriting the highest quality environmental design for Columbus, Indiana, the location of the company's home office. As a result, Columbus has become a point of architectural pilgrimage for those who value the best contemporary urban design.

The corporate world is increasingly responding to the idea that cultural needs are as important for business to consider as the educational and scientific development they now support. William Ruder, president of the public relations firm Ruder & Finn, explains that one hundred years ago education, good health facilities, and a decent standard of living were regarded as a privilege. Today, they are seen as a right for all citizens. "The arts and the quality of life are now in their emergent state as the next area" to move from the status of privilege to prerogative.[48]

Another important reason for corporate support of the visual arts, and of the arts in general, is that a healthy society and one's own humanity depend upon creative activities, not only new and better technology. This view, voiced by John D. Harper, Alcoa's chief executive officer, suggests that creativity in any form is necessary, no matter where it may lead: "We cannot have human progress without the inspiration—intellectual, imaginative, disturbing—of the arts."[49] Today, there is a positive attitude toward support in general, whether or not one approves of or even understands the particular effort of the artist. Whether in science or in the arts, "creative individual expression wherever it may be found" must be supported.[50] George H. Pringle, president of The Mead Corporation, has written of today's artists:

This is not to say we completely understand or enjoy, or even approve, all they say and do. Nor is there any reason we should. What we have learned is that their works—those we enjoy and those we do not—can tell us much about the society in which we live and work.[51]

Individual reasons for collecting are many, but the foremost is that the presence of art creates a better environment in which to work. A great range of sophistication surrounds this idea. The decorative approach interprets "a better environment through art" to mean filling empty spaces with something colorful and unassuming. The status-conscious attitude sees "a better environment" as one that is more impressive to clients and competitors. Today, genuine artistic appreciation recognizes the potential of art in providing an exciting new dimension to the business world. Many executives now feel that to attract the best talent, it is necessary to create an environment that combines business with other cultural concerns. Lois Dickson, art coordinator and a member of the professional art staff at Prudential Insurance, stresses that "a creative environment stimulates creative thinking."[52]

Artists wholeheartedly support the presence of art throughout the different areas of society. Henry Moore (along with Alexander Calder) has been one of the most frequent recipients of large-scale corporate commissions; he has commented that a "head of a household thinks of the environment in which he wants to raise his children. He wouldn't want to have a house without pictures, without ornaments, without carpets, without a garden if he can have one." Corporations, as well, Moore feels, should make working environments as "though they are creating a house for the inhabitants to enjoy and live in."[53] Many in the art world think that the recent surge of contemporary art into museum galleries needs to be balanced by the presence of art in the public environment. Corporate collections serve this function. Museums will surely remain the preservers and displayers of art, but they should not become the sole place where quality works can be seen.

A survey of the *Fortune 500* companies indicated the most common reason for collecting to be the creation of an interesting and stimulating environment. Other reasons mentioned were "satisfying a responsibility to the community, making an investment, improving public relations and enhancing their image among customers and clients."[54] The company responses to the survey overwhelmingly indicate a common belief in the power of art to make one's activities more pleasant and meaningful. Art is not thought of as a luxury but as a valuable and necessary stimulus to worthwhile creative effort in many fields. There are also, of course, pragmatic reasons cited by corporate spokesmen. One theme recurs: industry and commerce now demand a highly educated corps of executives and this is precisely the group with an interest in the arts. In addition, as business becomes more service-oriented and less dependent on proximity to commodities or natural resources, executives wish to locate themselves in communities which can attract and culturally sustain their professional staff. "The presence of cultural activities is a potent force in helping to make a city attractive to the new breed of college graduates," explained Dr. Charles F. Jones, president of Humble Oil and Refining Company in 1968.[55]

Corporations, then, are responsive to their employees' desire for art and arts support as well as to the similar desire of the community at large. This corresponds with Alvin Toffler's observation of 1964 that modern corporate management sees itself as responsible to three distinct groups—to stockholders, consumers, and company workers. This shift in focus is partly the result of a change in corporate management. With a "growing divorce of ownership from control of industry," a highly educated class with a variety of experiences has been put in control; the tastes and attitudes of this class have done much to stimulate corporate involvement in the arts."[56] The political and social tensions of the late 1960s were also a major factor in arousing corporate concern for the social good. The social activism of young people stimulated already developing corporate efforts in this realm. In order to attract this youthful group into the business world, explained Dayton Corporation's Kenneth N. Dayton, in 1967, "We in business must not be ashamed to say that our primary purpose is to serve society—our customers, our employees, our community—as well as our stockholders."[57] Supporting art, it has come to be felt, falls within the purview of serving society's needs.

Business has maintained a view of itself as the free enterprise counterpart to government support. If art is not to fall under the sway of government, corporate leaders feel they must support art and help it to maintain multiple funding sources. Government, it is believed, "by definition seeks to control, and art requires freedom and rejects any control beyond the artist's own self-discipline."[58] The purchase of art by corporations is seen as a small contribution to the continuation of free enterprise and the support of a capitalist economy. It seems likely that government support of art production and the arts in general will increase in future years. As the rising costs of inflation have diminished the buying power of the stable endowments of non-profit organizations, corporate contributions have begun to play an increasingly important role.

WHAT MIGHT BE THE RESULT of corporate collecting for the artist, for the corporation, and for society? For the artist, the immediate result is increased sales. In addition, there is often contact between artist and businessman—and each can learn from the other.

After a recent exhibition of his work at Security Pacific Bank's innovative public plaza gallery, Billy Al Bengston voiced eager praise for the bank's professionalism and its encouragement of his work. Direct interaction of this sort between different sectors of society can lead to a culturally integrated country. The Art and Technology Program at Los Angeles County Museum encouraged another kind of integration. It did not result in the assembly of an actual collection; however, corporations funded the production of art, and twenty-four companies actually had artists in residence, including Cummins Engine Company, Container Corporation of America, and Kaiser Steel. The exchange between the two worlds humanized the business world for the artists and introduced them to new technical procedures and methods of planning and organization. Likewise, the introduction of artists in corporations offered businessmen a vital new perspective on creativity, critical thought, and production. In a less dramatic way, the appearance of fine art in the corporate environment can do the same.

Newspaper and magazine editor Richard Whalen foresees an idealistic future when corporate patronage will have matured beyond the acquisition and display of art. At that time, "businessmen and artists will be drawn into a continuing, mutually rewarding involvement."[59] Concrete efforts have already been made to effect this interaction. Tamara Thomas, an art consultant for Security Pacific Bank and other corporate clients, has prepared information sheets for employees discussing the bank's artworks. In a similar vein, many other corporations are instituting a variety of educational programs to stimulate artistic appreciation and to achieve educational goals.[60] CIBA-GEIGY Corporation has provided its employees free admission to the Whitney Museum and has offered them concerts and lectures. Prudential Insurance has shown films on art and invited artists to speak. Cummins Engine funds a performing artists-in-residence program.

For employees, the benefits are many. In recent years, workers have demanded greater personal rewards from their work as well as more pleasant working conditions. The corporate art collection helps fill both these needs. The appearance of art in the working arena is a symbol of new values brought into the corporate realm. Economic security is no longer the sole objective for employees at many income levels; both corporations and employees are increasingly concerned with providing outlets for individuality. The emphasis today is on personal, rather than impersonal, communication in the working world. Art serves these needs; in our society it is the most tangible product—and perhaps the only product—which is usually the result of one individual's thought and action. Allowing a wide latitude of interpretation, art is the quintessential personal expression. It serves an indispensable psychological need in both the corporate world and the world at large.

An analysis of the changing terminology used at different times aids the discussion of art's relationship to the world of commerce. During the 1940s, support was sought from "industry"; in the fifties, "company" support became more prevalent. In the sixties, "business" was the new patron, and today we most often speak of seeking "corporate" support. These changes in nomenclature reveal Americans' changing notions of their institutions of productivity and service. "Industry" connotes production of material goods, especially heavy items—cars, steel, weapons, construction materials. Active and forceful, it is the favored term of the forties and reflects the needs of the war years to build and supply. The "company man," who identified closely with the company, was a product of the 1950s, a time when idealistic fervor veiled a latent malaise. Material comforts were sought, the

country was moving forward in technological progress, and employees were still trying to identify with their organizations and view them as family. The "company" sometimes carried a paternalistic connotation, suggesting that what was good for the company was also good for the employee.

By the late fifties the term "business" came into usage; it characterized the sixties as well, suggesting the switch to an efficient white-collar world. "Business" connotes a non-specific but all-encompassing enterprise, involving paperwork and decision-making. Businesses are far removed from the actual manufacturing of items and signal the change to a service-oriented society. Today, "corporation" is the most commonly used term. It implies that the business world is composed of operations encompassing innumerable activities under one controlling body and that a legal entity has taken the place of individual or small group control. In such a world, art is often the last hand-made item conceived and constructed by a single person. It is rightly seen as a humanizing element, the repository of challenging and rewarding ideas. The word "corporation" also has a positive connotation: united effort on the part of many for the benefit of the overall institution. It is to this aspect of the corporation that art makes a valid and needed contribution.

THE IMPETUS TO FORM A COLLECTION almost always comes from the personal commitment of a top-level executive. This figure has appropriately been designated the "advocate" in *Artist and Advocate*, by Nina Kaiden Wright and Bartlett Hayes. While the advocate may be an outside agent, such as a consultant or advertising agency, usually it has been the chairman or president of a company; sometimes it may be the art director or public relations head who initiates the commitment. In a corporation, a top-ranking individual can make an enormous contribution by acting quickly and decisively. The continuing interest of executives seems essential for the long term survival of any effort to introduce art to the working environment. Judith Selkowitz, the head of a corporate art advising firm, has said that her best clients are definitely corporations "with strong chief executives who take an active interest in their art program."[61]

Many corporate collections have been formed by business executives who are knowledgeable collectors. Chase Manhattan's David Rockefeller, American Republic Insurance's Watson Powell, and Paine Webber's Donald Marron are but a few. Committed men and women in business often form both personal and corporate collections. In Los Angeles, The Frederick R. Weisman Company Collection was formed by Mr. and Mrs. Frederick R. Weisman in addition to their exceptional personal collection of postwar art. Sidney and Frances Lewis' extensive private collection in Richmond, Virginia, includes contemporary paintings and sculpture by nationally known artists. It complements their Best Products corporate collection which is dispersed around the country and often focuses on regional artists. It is common for such corporate collectors to sit on museum boards and acquisition committees. Howard Ahmanson of Home Savings and Loan, J. Irwin Miller of Cummins Engine Company, and the Lewises and Weismans are typical of this group. That so many private collectors have also formed corporate collections indicates their commitment to making art widely available. A genuine willingness to learn more about art also characterizes many corporate collectors.

The wide-ranging contemporary art collection held by Owens-Corning Fiberglas Cor-

poration in Toledo, Ohio, is the result of keen interest and acquired knowledge. The company sends top executives on buying trips to galleries. One New York dealer recalls the incident of offering a rather tame selection of prints to the representatives from Owens-Corning. They looked appreciatively, then asked what she would buy for herself. After intensive scrutiny and discussion, they left the gallery with a selection of exciting and challenging works by younger artists. Such attitudes and collecting patterns are no longer rare. The expectations of the gallery owner in this incident point to the possibility that galleries, art consultants, and museums may have preconceptions about what should be offered to corporations, preconceptions that may be quite unwarranted.

The actual expenditures for art by corporations may have declined in the past six years, but the incidence of collecting itself has increased. A Business Committee for the Arts pamphlet compared data from 1973 and 1976 and found that although more companies were collecting in 1976, the money they spent was not much over half of that spent in 1973. A three-year estimate on money spent for art from 1975 through 1977 places the figure at a minimum of fifteen million dollars.[62] The almost four and a half million dollars spent on art in 1976 alone is, in fact, a rather small amount, especially when one considers that the cost of a single painting can exceed two hundred and fifty thousand dollars.

Only those expenditures which are considered business expenses or philanthropy are included in the above figures. A good deal of purchasing, however, is also considered capital investment, especially if the art is historically established and bought at high prices. This type of buying, not reported in the above calculations, makes purchases far greater than the published figures indicate. A 1968 National Industrial Conference Board survey showed that only one half of the corporations purchasing art regarded it as a business expense. Some corporations retain confidentiality on the subject of money spent in areas such as art collecting that are not directly related to business activities. However, the feared resistance of stockholders to art purchases and cultural support seems not to have materialized. It appears that stockholders themselves tend to support the same activities privately.

The focus of corporate collecting is now on contemporary artists in the one to five thousand dollar price range, as well as to graphics under one thousand dollars. This commitment to contemporary art does not indicate merely an unwillingness to spend large sums of money. Purchasing new art suggests the desire of corporations to collect art for its intrinsic value and not for investment, for despite opinions to the contrary, contemporary art is the least sure market in which to invest. One corporation executive explained that his company's investment hopes have not materialized but that other benefits—prestige within and without the company and the making of new contacts—have greatly satisfied their expectations.[63]

Art collecting has become an important fact in the financial structure of the business world. Numerous art consultants and fine arts advising firms have sprung up in the past ten years. The Ruder & Finn public relations agency, almost twenty years ago, formed a special department to handle art collecting, sponsorship, and related activities. Art galleries depend heavily upon corporate sales, some counting them as well over half their income. Dependable customers such as corporations and major individual collectors allow galleries themselves to support worthwhile experimental and unfamiliar work which finds few buyers. At present, there are well over five hundred art galleries in New York City, compared to about one hundred fifty in 1950. Their continued survival would seem to depend on

corporate purchases.[64]

Corporate support of museums is closely allied to corporate collecting. In recent years, corporations have emerged as major sponsors of important temporary and traveling museum exhibitions. IBM, Hallmark, Encyclopaedia Britannica, and Abbott Laboratories were among the first to sponsor museum exhibitions. While they sponsored shows drawn from their own collections, corporations today often fund a wide range of historically important exhibitions organized by museums and borrowed from many different sources. In retrospect, the year 1970 seems to have been an important watershed: Olivetti sponsored *The Great Age of Fresco*, Xerox supported *New York Painting and Sculpture* (both at the Metropolitan Museum, New York), and the Alcoa Foundation underwrote *Four Americans in Paris: The Collections of Gertrude Stein and Her Family* (Museum of Modern Art, New York). Gideon Chagy, of the Business Committee for the Arts, has pointed out that corporations do not support only conservative projects. The common museum attitude held five years ago was that corporate support would be extended only to traditional art, large theme shows, or group exhibitions. However, corporate funding of exhibitions, like corporate collecting, is now extended to contemporary artists. Underwritten by corporations, large retrospectives of Saul Steinberg and Jasper Johns circulated in 1978. SCM Corporation, Exxon, IBM, and Philip Morris have been the leaders in funding important exhibitions. Support has gone to a wide range of art, from *Two Centuries of Black American Art* to *Cézanne: The Late Years*. With works by artists such as Laddie John Dill, Robert Ryman, and Gordon Newton presently hanging in corporate offices and affecting corporate taste, predictions are moot as to what may be considered too daring for corporate support.

Recently, criticism of corporate funding for exhibitions has arisen in art circles.[65] It is feared that museums may choose projects on the basis of whether or not they will receive support and that innovative plans may be shelved in favor of those with mass appeal. Certainly, corporate supporters do take into account whether or not the exhibitions they fund will be well attended. And certainly, an exhibition of King Tut's treasures will attract more people than one of Brice Marden's paintings. Yet, outside funding of the former frees vital museum funds for more esoteric goals. Commercial galleries have followed analogous reasoning for years. Many a Chagall and Toulouse-Lautrec have been offered in front rooms to support the unfamiliar art in the back. Various constraints usually accompany all types of financial support. Museum directors have for a long time accommodated the personal wishes of their private benefactors who may be board members as well. New pressures will be brought by corporate and government support. Yet, these pressures are no cause for museums to recoil from such support; they are well prepared to strike effective solutions beneficial to all parties.

Corporate offices, hallways and dining rooms are not the only places where art is displayed. In recent years, companies have initiated art galleries on their premises. A pioneer in this area is The Underwood Corporation in Bridgeport, Connecticut. As early as 1955, it hosted exhibitions of contemporary American paintings in its Bridgeport facilities.[66] Another early effort, now discontinued, was the gallery operated in New York by IBM. Companies which operate galleries today include: Prudential Insurance Company, Newark, New Jersey; Wm. Underwood Company, Westwood, Massachusetts; General Mills, Inc., Minneapolis, Minnesota; Atlantic Richfield Corporation, Los Angeles, California; and Security Pacific National

Bank, also in Los Angeles. These galleries not only exhibit the companies' own collections but host temporary exhibitions as well. Security Pacific's program includes films, performing arts, and lectures; assembled by their own excellent staff or by outside consultants, exhibitions on wide-ranging topics have been offered to their employees.

Related activities include corporate sponsorship of actual museums, such as the Corning Museum of Glass in Corning, New York, and Dearborn Village in Dearborn, Michigan, operated by Ford Motor Company. Another recent phenomenon is the appearance of branch museums in the downtown business areas of American cities. Usually located in office buildings and operated by local art museums, these efforts are supported by the business community they serve. The pioneering effort in this realm was made by the Whitney Museum of American Art. Its Downtown Branch Museum serves New York's financial community in the Wall Street area and is supported by the Helena Rubinstein Foundation and area businesses. In addition to the usual New York art crowd, the museum attracts a wide range of visitors, from maintenance workers to presidents of corporations. The Branch Museum also serves as a training ground for young curators, critics, and scholars. Other museums have organized downtown branches in Baltimore, Maryland; Richmond, Virginia; and San Francisco, California. Across the country, plazas surrounding corporate headquarters have come to function as outdoor museums, displaying sculpture commissioned from important contemporary artists. In New York City especially, a walk through midtown provides exposure to a wide variety of recent monumental sculpture. These varied activities are ample indication that art is becoming an integral part of today's lifestyle, both on and off the job.

Corporate collecting and exhibiting of art gives rise to the accompanying responsibility of providing public access to art. Although art exists as a privately owned commodity in today's society, it is often regarded by the public as a cultural trust. As such, this art must be cared for and made available. Many corporations have come to realize this obligation. They respond by placing important works in areas of public access, by offering guided tours of their collections, or by donating particularly significant works to museums. When a collection approaches the size and significance of museum holdings, it then requires full time attention. Today, many corporations employ art consultants or an in-house curatorial staff experienced in the special considerations which must accompany the ownership and care of artworks. As companies collect more, art world advocates are beginning to urge corporations to employ art professionals. If artists are to give their best work to business, critic William Wilson explained in the Los Angeles *Times*, then that art must be treated with respect by qualified individuals charged with its maintenance.[67]

An acknowledgment of and response to these problems has been made in several of the largest corporate collections. In addition to the recent proliferation of art consultants, the number of corporate curators, and those who act in the capacity without the title, has multiplied. They range from perhaps one part-time employee to a full-fledged curatorial staff. Chase Manhattan, First National Bank of Chicago, *Forbes* magazine, and General Mills are among the corporations employing curatorial staff. Atlantic Richfield has both a curator of its permanent collection and a curator of its Center for Visual Arts. The Gilman Paper Company in New York has as its curator a knowledgeable critic and former museum curator. It is likely that the future will see more companies following these examples. Corporations with small or moderate collections may not be able to justify curators on their staffs. But all

collections can benefit from informed assistance, whether from art world professionals or from specially trained in-house staff. Mary Lanier, the former curator of the Chase Manhattan Bank Collection, has emphasized, "The key to excellence in any art collection is the knowledgeable person."[68]

The history of the Prudential Insurance Company art program serves as an illuminating example of how responsible corporate collections can develop. The initial purpose in acquiring art was to decorate the board room and several high-level offices. What began as a way of beautifying working spaces, however, profited from the efforts of a highly knowledgeable interior designer and a board chairman who wanted quality art. From this typical beginning, an exemplary program has developed which provides art for all Prudential facilities, rotates pieces to provide exposure to new work, and employs a full time staff including an art historian and registrar. The company also operates educational and cultural programs, including films and lectures, for its employees.

CIBA-GEIGY, Owens-Corning Fiberglas, Avco, and IBM among others, are in the forefront of making their collections accessible. Through informed and generous loan policies, their collections are circulated around the world. The removal of a work of art from an office or corridor is often viewed as a reason to rotate artworks or perhaps even to purchase a new work. A new placement for a work of art can often reveal an undiscovered facet of its "personality." CIBA-GEIGY has sponsored a number of impressive exhibitions drawn from its collections: *Visual R & D: A Corporation Collects; Works on Paper From the CIBA-GEIGY Collection;* and the recent exhibition, *Works by Women,* which included notable established figures like Louise Bourgeois, Joan Mitchell, and Elaine de Kooning as well as younger artists such as Pat Steir. Many corporate collections composed of objects other than paintings have also been widely disseminated, prominent examples being the collection of antique and modern soup tureens belonging to the Campbell Museum (funded by the Campbell Soup Company) and the crystal objects of Steuben Glass.

Museums have begun to recognize the art needs of corporations. The Museum of Modern Art formed an Art Advisory Service which counsels corporations and collects fees for planning and supervision of installations. At present, museum directors across the country are relied upon for advice by local collectors, both individual and corporate. Following the long-time example of privately owned collections, corporate collections are now often catalogued when shown at museums. Critics, museum curators, graduate students, and independent curators have all been contributors to the ever growing number of catalogues on corporate collections. Those of the American Republic Insurance Company, the First National Bank of Chicago, and Blount, Inc. are particularly impressive. With access to computer facilities, corporate inventories of art holdings are becoming models of efficiency, sometimes surpassing museum inventories which have only recently been introduced to computerization. Chase Manhattan's inclusive computerized catalogue is in several sections and is arranged by location, medium, inventory number, and alphabetically by artist; it includes date of acquisition, price paid, source, current market evaluation, and location as well as an accession number.

THE GREAT VARIETY of present-day corporate art collections allows for only a few generalizations. Collections in the United States overwhelmingly comprise works by American artists. There are several notable collections of European or Eastern art, such as *Forbes* magazine's extensive holdings of British art and the *Reader's Digest* collection of French painting. Several companies that collect American art have even stronger holdings in European art, such as Deere & Company and the First National Bank of Chicago. Not surprisingly, corporations of international stature tend to have multinational collecting habits. There are also a few collections of primitive art.

Another major characteristic, previously mentioned, is that corporate collections are most often geared to contemporary art. Of the thirty companies represented in *Art Inc.*, only seven hold collections of predominantly non-living artists. IBM, First National Bank of Chicago, Cleveland Trust, and United States Steel own historical art, but each has also acquired contemporary art. Many of the collections of non-contemporary art, such as those of Steinway & Sons and the Atchison, Topeka and Santa Fe Railway, were actually formed of contemporary works from the American art world of fifty years ago. It seems that closely held or privately owned corporations are likely to buy higher priced works of art as well as older art of historical significance. Publicly held corporations, those which are service oriented, and those which involve interaction with the public, seem especially to favor contemporary art. Dealing frequently with the community, these corporations wish to stress their active involvement in the world of today. Ponderosa System, Inc., the owner of a chain of restaurants, collects art executed only since its founding ten years ago. A conscious effort is made to compare its dynamic and progressive business with equally new and dynamic art. Art is thought by many companies to express their own values as well as those of contemporary culture in general.

It is interesting to consider what does not appear in corporate collections. They do not usually favor politicized or highly expressionistic contemporary art. In general, American artists, private collectors and museums also seem less attuned to such art than their counterparts in Europe. Notable exceptions do exist and they point to the variety of the corporate collections. In the 1940s, the Encyclopaedia Britannica collection included Joseph Hirsch's *Guerillas*, William Gropper's *The Opposition*, and Anton Refregier's *Let My People Go*. The Gilman Paper Company, New York, owns a controversial piece by the highly politicized contemporary artist, Hans Haacke. Entitled *On Social Grease*, the work enshrines quotations by corporate leaders on the value of art for business. It is deadpan, seemingly impartial, but actually critical of corporate motives for supporting art. Its presence in a corporate collection does not negate its critical questioning but makes the issues more immediate and important to ponder.

Particular historical gaps in corporate collections are easily explained. Late eighteenth century and nineteenth century history painting is seldom found. These works were intended as museum pieces or for public places and have long since entered those realms. Portraiture by distinguished early artists is also not often collected, partly due to the value of the works. The United Missouri Bank Collection is the most important exception in this regard; it offers paintings by Thomas Sully, Benjamin West, Raphael Peale and Gilbert Stuart. Early twentieth century modernism and works by the major figures of abstract expressionism also rarely appear. The early modernists, such as Arthur Dove, Marsden

Hartley, and Max Weber, were already established figures when corporations began collecting in earnest. The important works from the decade 1910-1920 were no longer contemporary, but a rather neglected part of history, and thus not avidly sought.

Figures like Willem de Kooning, Hans Hofmann, Barnett Newman and Jackson Pollock seldom appear in corporate collections. By the time these men were recognized as masters, the prices of their works were out of range. There are, of course, exceptions; paintings by Mark Rothko and Franz Kline do sporadically appear in corporate collections. The younger and affordable abstract expressionists have been widely collected, however, especially Theodoros Stamos and James Brooks. For reasons of scarcity and value, oils by Jasper Johns and Robert Rauschenberg are rarely represented in corporations, although their prints are widely collected. It is interesting to note that works by famous artists are sometimes sold by companies when they become extraordinarily valuable, not primarily for their cash value, but because they pose security problems.

Much collecting, both private and corporate, has been and will continue to be motivated for purposes of decoration. The corporate urge to decorate has been more severely criticized than the corresponding desire in private homes. When a painting is chosen to match the color of a wall or sofa in a residence, those knowledgeable ascribe such reasoning to a lack of awareness. When the same thing is done in a board room or corporate lobby, it is viewed in a different context and is perhaps unconsciously compared to a museum standard. Perhaps unfairly, one expects better judgment from corporations, assuming their expertise in *all areas* of operation. Yet, corporate collecting generally follows private patterns. Examining this parallel relationship, one finds that nineteenth century genre painting appears seldom in corporate collections, whereas landscape predominates. Until recently, the same held true of private acquisitions. With the recent increase in private collecting of nineteenth century genre and academic painting, there should soon be similar works in corporate collections. The recent surge in photography collecting is already evidenced in corporate offices. Joseph E. Seagram & Sons, Gilman Paper Company, and Exchange National Bank of Chicago have impressive holdings in photography.[69]

Corporations appear to favor certain artists; they may also now favor abstract over representational art, a reversal of previous taste. Paul Jenkins, Jack Youngerman, and Richard Anuskiewicz were among the popular abstract artists collected in the late sixties and early seventies. Works by Richard Diebenkorn, Frank Stella, and Helen Frankenthaler have been widely collected, presumably less so today due to the present high prices their works command. This proliferation of nonrepresentational art mirrors contemporary taste. It may also be argued that, because it lacks specific imagery, abstract art can be non-controversial. It is probably not coincidental that the rapid surge of private and corporate collecting in the 1960s accompanied the production of a large body of art concerned with formal issues — shape, color, line, edge, and structure. In a decade ripe with social change, this art provided a restful interlude from the stringent demands of the real world. Those objecting to abstract art in general would not, of course, be pacified by the hard-edge or color-field paintings of the sixties. Yet, these works are less inflammatory than those of artists like Hans Haacke or Ed Kienholz.

Among the most popular artists commissioned by corporations have been Charles Sheeler and Herbert Bayer. Sheeler's accomplishments in commercial photography, art photography,

and painting joined with his preference for industrial subjects to make him an attractive, appropriate choice for business. Commissioned photographs by Sheeler often became the basis for later paintings, as in his famous depictions of the Ford Motor Company's River Rouge plant. Corporations which either bought or commissioned his paintings include General Motors, Meta-Mold Aluminum Company, Pabst Brewing Company, Hallmark, Citibank and Commerce Bank. Herbert Bayer has served as art consultant and designer for several companies in addition to having provided them with his own paintings and sculpture. His design of the Atlantic Richfield headquarters in Los Angeles reveals the source of his appeal to corporations: grounded in the ideology of the Bauhaus, he combines art, design, and a concern for function to create a stimulating—some have said almost spiritual—environment.

During the 1960s if not earlier, commissioned sculpture became a particular growth area in corporate buying. Banks had been in the forefront of this development, but in 1964, Henry J. Seldis explained of the new interest in sculpture:

Perhaps even more encouraging than the growing attention that bankers pay to art in Los Angeles, is the suddenly awakened concern of builders and architects. Once indifferent to a happy balance of art and architecture, they are now eager to incorporate contemporary works of art into the rapidly increasing number of highrise buildings which are radically altering the city's face.[70]

Notable among sculpture collections is PepsiCo's collection on the grounds of its headquarters in Purchase, New York. Even more than with painting, sculpture collected by corporations is almost exclusively contemporary. Commissions form a large part of the effort; in recent years, Henry Moore and the late Alexander Calder have been prominent in the list of recipients. José de Rivera, Seymour Lipton, George Rickey and Richard Lippold are also among those having received significant commissions. Some of the most imaginative efforts have come from Isamu Noguchi, whose totemic stone figures stand before Connecticut General Life Insurance in Hartford, Connecticut. In New York City, Noguchi's pierced red cube forms the period to the exclamation mark of the ascending black mass of the Chase Manhattan Bank behind it; on the other side of the bank is a Noguchi-designed sunken stone garden.

Banks make up the largest and most visible group of collectors in the corporate sector.[71] In the *Art Inc.* exhibition, banks number seven of the thirty companies included; finance and investment companies are also well represented. The reasons are several. Banks have more usable space visible to the public than other kinds of businesses. Their spaces are designed for public reception and are unencumbered by merchandise; they virtually demand art. At the same time that the display of artworks has become common in offices and areas of public access, art has also begun to appear in places previously unimagined. Whether in warehouses, restaurants, or showrooms for merchandise, painting and sculpture are now being found in new environments.

It has become fairly common for corporations to concentrate part or all of their collecting efforts on artists from the regions in which they are located. In Minneapolis, General Mills offers notable examples of Peter Busa, Charles Biederman, and Cameron Booth, artists who have made outstanding contributions there. In Chicago, Playboy Enterprises and Illinois Bell both own numerous works by Chicago artists, many of whom are now known nationally —Ed Paschke, Karl Wirsum, Roger Brown. CIBA-GEIGY and Chase Manhattan have col-

lected primarily New York artists such as Adolph Gottlieb, James Brooks, and Elaine de Kooning. California corporations have been leaders in collecting "their own." Great Western Financial Corporation, United California Bank, and Avco Financial Services are prominent in this respect. Several splendid collections of Western art are held by corporations west of the Mississippi: Valley National Bank, Phoenix, Arizona; The Anschutz Corporation, Denver, Colorado; and United Missouri Bank, Kansas City, Missouri. The enormous collection of Santa Fe Industries (now located in Chicago) includes ninety-five paintings of the Grand Canyon alone.

THE INCEPTION, DEVELOPMENT, AND GROWTH of corporate collecting have been responsive to changing historical and cultural forces. Over the years, the goals of corporate collecting have also changed. However, one factor has remained consistent. There has been a common belief held by each business involved in purchasing art that the very presence of painting and sculpture—whether by reproduction or in the display of original artworks—is a potent force in the enrichment of modern civilization. Although often un-articulated, this idea has continually motivated corporate collecting just as it has stimulated business involvement in all the arts.

In *The New Patrons of the Arts*, Gideon Chagy concluded, "Where corporate responsi-bilities extend to support of the arts, the kind of business activities a corporation engages in is rarely predictive of the kind of arts program it will support."[72] A company's business interests do not necessarily relate to its art preferences. Likewise, the art it collects often reflects a wide range of taste. Notwithstanding this diversity, there are several excellent examples of collections which mirror the interests of the company. In New York, the Sea-men's Bank for Savings has a collection of art and artifacts which reflects its original charter as a bank to serve the needs of sailors. Included are several hundred predominantly nine-teenth century paintings which depict ships and maritime activities. In California, Golden State Mutual Life Insurance Co., which serves the black community, owns a large number of works created by black artists. Blount, Inc., primarily a construction company, comple-ments its collection of major works with small drawings and studies of industrial and construction scenes by artists such as Charles Burchfield, Thomas Hart Benton, and Reginald Marsh. Several of the Pittsburgh steel companies own works by Aaron Harry Gorson, a turn of the century artist who painted views of the steel mills in a style inspired by impressionism.

It is strikingly appropriate that Deere & Company owns Grant Wood's *Fall Plowing*, that Weil Brothers-Cotton, Inc. owns Winslow Homer's *Upland Cotton*, and that Paul Staiger's *Five Trucks at the Big Rig Restaurant* greets visitors to Cummins Engine Company. In these examples, art addresses itself to daily life and offers an alternate and invaluable view of the activities in which business people are engaged. Contemporary art has a special contribution to make, for it is the focus of the intellectual concerns, creative ideas, and aesthetic tastes of today. As such, it is an index of the society in which business operates. All art, in fact, serves as a key to social or historical understanding, whether directly or indirectly. In corporations across the country there is an increasing acknowledgment of this function. Today, art is continually at work, adding fresh insight, penetrating observations, and a measure of beauty to our daily lives.

NOTES

[1]"Artists of the Santa Fe," *American Heritage: The Magazine of History*, 27 (February, 1976), pp. 57–72. Two exhibitions of paintings of the Grand Canyon were shown at the Visitors Center, Grand Canyon National Park, in winter, 1975–1976 and July–October, 1976. *Indians of the American West*, which included selections from other collections, was shown at the National Archives, Washington, D.C., October 26, 1973 through January 21, 1974.

[2]The N.W. Ayer and Son agency, in Philadelphia, provided a significant incentive to the collaboration between artists and businessmen. The agency had been involved in obtaining commissions for Steinway & Sons in the late 1920s. During the 1940s, they directed the artist illustrated advertising campaigns for Dole Pineapple Company and De Beers Consolidated Mines.

[3]Donald Bear, in *Contemporary American Painting: The Encyclopaedia Britannica*, ed. by Grace Pagano (New York: Duell, Sloan, and Pearce, 1945), p. viii. The early involvement in art of both Container Corporation of America and the Encyclopaedia Britannica points to the fact that midwestern companies, along with those based in New York City, were among the earliest corporate collectors. These two locales have continued to furnish much of the corporate collecting activity of the present.

[4]Daniel Catton Rich, in Pagano, ed. *Contemporary American Painting*, p. xxvii.

[5]Walter S. Mack, Jr., "Viewpoints: A New Step in Art Patronage," *Magazine of Art*, 37 (October, 1944), p. 228. See also Walter Abell, "Industry and Painting," *Magazine of Art*, 39 (March, 1946), p. 86.

[6]"Power: A Portfolio by Charles Sheeler," *Fortune*, 22 (December, 1940), pp. 73–83.

[7]See Abell, *Magazine of Art*, p. 84.

[8]See "Oil: 1940–45," *Carnegie Magazine*, 20 (June, 1946), pp. 38–41.

[9]Joyce C. Hall, in *The Hallmark Art Award* (Hallmark, Inc., 1949), n.p.

[10]Quoted in Abell, *Magazine of Art*, p. 84.

[11]Thomas J. Watson in *Contemporary Art From 79 Countries* (International Business Machines Corporation, 1939), n.p.

[12]Alvin H. Reiss, *Culture and Company* (New York: Twayne Publishers, Inc., 1972), pp. 12–14.

[13]Alvin Toffler, *The Culture Consumers: A Study of Art and Affluence in America* (New York: St. Martin's Press, 1964), p. 170.

[14]"Art and Industry," *Art in America*, special issue on art and industry, 44 (Spring, 1956), p. 170.

[15]Frank Stanton, address delivered at the dedication of the Brown Pavilion, Museum of Fine Arts, Houston, Jan. 15, 1974 (New York: Business Committee for the Arts, Inc.), n.p.

[16]Winton M. Blount, "Art and Business…Natural Allies," address delivered at the "Business in the Arts" Awards Luncheon, Dorothy Chandler Pavilion, Music Center, Los Angeles, California, June 15, 1978 (New York: Business Committee for the Arts, Inc., 1978), n.p. Past art patrons to which contemporary writers and corporate spokesmen allude were, as well, the rulers of their respective societies. Corporations today do not consider themselves to have assumed that function. Instead, they view their support of social institutions as an antidote to that of those now ruling. Regarding themselves as holders of independent wealth, corporations are eager to maintain multifaceted support of the arts so that they do not fall increasingly and totally under government control. This is analyzed later in the essay.

[17]Frank Caspers, "Patrons at a Profit — Business Discovers Art as a Selling Force," *Art Digest*, 17 (May 1, 1943), p. 17.

[18]Mack, *Magazine of Art*, p. 228.

[19]Quoted in "Through Industry, A Forward Movement Towards an American Art," *Art Digest*, 8 (February 15, 1934), p. 31.

[20]"Their Own Fault," *Art Digest*, 14 (September 1, 1940), p. 22.

[21]Peyton Boswell, "Comments: Common Sense," *Art Digest*, 20 (December 15, 1945), p. 3.

[22] Thomas Hart Benton, "Business and Art from the Artist's Angle," *Art Digest*, 20 (January 15, 1946), pp. 8; 31.

[23] Abell, *Magazine of Art*, pp. 115–116.

[24] Russell Lynes, "Whose Business is Art?," *Art in America*, special issue on art and industry, 44 (Spring, 1956), p. 12. See also Ralph M. Pearson, "A Modern Viewpoint: The Pepsi-Cola Prize Contest," *Art Digest*, 20 (December 15, 1945), p. 28.

[25] Rich, in Pagano, ed. *Contemporary American Painting*, p. xxvi.

[26] Toffler, *The Culture Consumers*, p. 93.

[27] *Great Ideas of Western Man* (Container Corporation of America, 1974), n.p.

[28] "Great Day Coming — Maybe," *Art Digest*, 27 (January 15, 1953), p. 5.

[29] For attitudes on corporate collecting, see Henry J. Seldis, "Business Buys Art," *Art in America*, 52 (February, 1964), especially pp. 132–134; Hal Morris, "Art Enhances the Image of Finance — Pays Other Returns," *Burroughs Clearing House*, 50 (June, 1966), pp. 38 ff. For attitudes on general cultural support, see George Alan Smith, "Business Investment in the Arts," *Conference Board Record*, 3 (July, 1966), pp. 23–26; Arnold Gingrich, "The Arts and the Corporation," *Conference Board Record*, 6 (March, 1969), pp. 29–32.

[30] Toffler, *The Culture Consumers*, p. 108.

[31] Maurice Tuchman, *A Report on the Art and Technology Program of the Los Angeles County Museum of Art: 1967–1971* (Los Angeles: Los Angeles County Museum of Art, 1971), p. 17.

[32] Franz Schulze, "The Collection of the First National Bank of Chicago," *Apollo*, 96 (August, 1972), p. 96.

[33] George D. Culler, in *American Business and the Arts* (San Francisco: San Francisco Museum of Art, catalogue of an exhibition held September 14–October 15, 1961), n.p.

[34] See Bibliography: Group Exhibitions of Corporate Collections.

[35] August Hecksher, "Business and the Arts in the United States: A Hopeful Partnership," in *Industry Supports the Arts*, ed. by Alan Osborne (London: The Connoisseur, 1966), p. 16.

[36] Richard J. Whalen, "Artist and Advocate," in *Artist and Advocate: An Essay on Corporate Patronage*, ed. by Nina Kaiden and Bartlett Hayes (New York: Renaissance Editions, 1967), p. 33.

[37] Richard Eells, *The Corporation and the Arts* (New York: The Macmillan Company, 1967), p. 289.

[38] Katharine Kuh, "First Look at The Chase Manhattan Bank Collection," *Art in America*, 48 (Winter, 1960), p. 74.

[39] Quoted in Thomas B. Hess, "Big Business Taste: The Johnson Collection," *Art News*, 61 (October, 1962), p. 32.

[40] "Interface: Business and Beauty; An Interview With Armand G. Erpf," *Columbia Journal of World Business*, 2 (May–June, 1967), p. 86.

[41] Joseph James Akston, "Editorial," *Arts*, 43 (December, 1968–January, 1969), p. 5.

[42] Nicolas Calas, "ABC or LSD?," *Arts*, 40 (September–October, 1966), p. 15.

[43] Hess, "Johnson Collection," *Art News*, p. 55 for the quote, also pp. 32; 56.

[44] Hecksher, *Industry Supports the Arts*, p. 13.

[45] Quoted in George Gent, "The Growing Corporate Involvement in the Arts," *Art News*, 72 (January, 1973), p. 24.

[46] Quoted in Gent, *Art News*, p. 23.

[47] J. Irwin Miller, address to the "Business in the Arts" Awards Luncheon, Indianapolis Museum of Art, June 21, 1977 (New York: Business Committee for the Arts, Inc., 1977), n.p.

[48] Quoted in Gideon Chagy, ed., *The State of the Arts and Corporate Support* (New York: Paul S. Eriksson, Inc., 1971), p. 160.

[49] Quoted in Gent, *Art News*, p. 24.

[50] Robert O. Anderson, Chairman of the Board, Atlantic Richfield Company, quoted in Gideon Chagy, *The New Patrons of the Arts* (New York: Harry N. Abrams, Inc., 1973), p. 38.

[51] George H. Pringle in *Art Across America: An Exhibition of 50 Contemporary American Paintings and Wall-hung Constructions Sponsored by The Mead Corporation*, catalogue of an exhibition held at M. Knoedler & Co., Inc., New York, 1965 and at museums and galleries across the country, 1965–1967 (The Mead Corporation, 1965), n.p. Also quoted in Kaiden and Hayes, eds., *Artist and Advocate*, p. 45.

[52] Quoted in Michael Norman, "Office Art: Buyer, Beware," *The New York Times*, February 19, 1978, Section III, pp. 1, ff.

[53] Quoted in David Finn, "Art for Business's Sake, Art for Art's Sake," *Across the Board*, 13 (December, 1976), p. 36.

[54] Referred to in Diane Cochran, "Looking Back — Three Corporations Evaluate Their Art Collections," *Interiors*, 136 (November, 1976), p. 114.

[55] Address to Houston Chamber of Commerce, March 7, 1968. Quoted in Arnold Gingrich, *Business & the Arts: An Answer to Tomorrow* (New York: Paul S. Eriksson, Inc., 1969), p. 55. The same point was reiterated by Dr. Frank Stanton, former Business Committee chairman and president of Columbia Broadcasting System, Inc., in an address to the Arts Council, Columbus, Ohio, February 23, 1967. This idea has been stressed repeatedly in Business Committee for the Arts' nationally distributed advertisements in recent years.

[56] Toffler, *The Culture Consumers*, p. 100.

[57] Quoted in Gingrich, *Business & the Arts*, p. 43.

[58] Blount, "Art and Business...Natural Allies," address.

[59] Whalen, *Artist and Advocate*, p. 31.

[60] Lesley Wenger, "Art Like Religion, Only Works if You Believe in It: Three Corporate Collections," *Currânt*, 1 (February–March–April, 1976), p. 50.

[61] Quoted in Norman, *The New York Times*, p. 1.

[62] "Business Support of the Arts 1976," (New York: Business Committee for the Arts, Inc.); also, Norman, *The New York Times*. It should be noted, however, that in both 1963 and 1976 the greatest amount of money to general cultural support went to museums.

[63] Quoted in Cochran, *Interiors*, p. 116.

[64] Another form of support, direct funding of individual artists by corporations, remains small. It is estimated that only 3% of the companies surveyed in 1976 by the Business Committee for the Arts practices this kind of support; the figure includes performing as well as visual artists.

[65] See Lee Rosenbaum, "The Scramble for Museum Sponsors: Is Curatorial Independence for Sale?," *Art in America*, 65 (January–February, 1977), pp. 10–14.

[66] See Hans van Weeren-Griek, "The Underwood Experiment," *Art in America*, special issue on art and industry, pp. 40–41; 66–68.

[67] William Wilson, "Patronage and the Corporate Patriarchy," *Los Angeles Times* "Calendar," March 20, 1977, p. 70.

[68] Quoted in Cochran, *Interiors*. This article discusses the collection of Prudential Insurance Company, Chase Manhattan Bank, and Mitchell-Hutchins (now a part of Paine Webber Incorporated).

[69] Margaret R. Weiss, "Big Business: Photography's Newest Patron," *Saturday Review*, 4 (July 23, 1977), pp. 44–45; 54.

[70] Henry J. Seldis, "Business Buys Art," *Art in America*, 52 (February, 1964), p. 132.

[71] This has been noted also in Schulze, *Apollo*, p. 96 and in Hecksher, *Industry Supports the Arts*, p. 14.

[72] Chagy, *The New Patrons of the Arts*, p. 97. An interesting form of support related to a company's products is that of Union Carbide Corporation. One of its divisions has given money to the Art Institute of Chicago for a prize "for the best sculpture produced by oxy-acetylene welding." From Toffler, *The Culture Consumers*, p. 179.

LENDERS TO THE EXHIBITION

American Republic Insurance Company, Des Moines, Iowa
The Anschutz Collection, Denver, Colorado
Atlantic Richfield Company Corporate Art Collection, Los Angeles, California
Avco Financial Services, Newport Beach, California
Blount, Inc. Collection, Montgomery, Alabama
The Collection of The Chase Manhattan Bank, New York, New York
Collection of CIBA-GEIGY Corporation, Ardsley, New York
Citibank, N.A., New York, New York
Cleveland Trust Company, Cleveland, Ohio
Commerce Bank of Kansas City, N.A., Kansas City, Missouri
Container Corporation of America, Chicago, Illinois
Cummins Engine Company, Inc., Columbus, Indiana
Deere & Company, Moline, Illinois
Edward W. Duffy & Co., Detroit, Michigan
First City National Bank of Houston, Houston, Texas
The First National Bank of Chicago, Chicago, Illinois
Great Western Savings and Loan Association, Beverly Hills, California
The Warner Collection of Gulf States Paper Corp., Tuscaloosa, Alabama
Hallmark Cards, Inc., Kansas City, Missouri
IBM Corporation, Armonk, New York
Paine Webber/Mitchell, Hutchins Collection, New York, New York
PepsiCo, Inc., Purchase, New York
Playboy Enterprises, Inc., Chicago, Illinois
Collection of Ponderosa System, Inc., Dayton, Ohio
The Prudential Insurance Company of America, Newark, New Jersey
Seattle-First National Bank, Seattle, Washington
Steinway & Sons, Long Island, New York
United States Steel Corporation, Pittsburgh, Pennsylvania
Weil Brothers-Cotton, Inc., Montgomery, Alabama
Westinghouse Electric Corporation, Pittsburgh, Pennsylvania

CATALOGUE

INCLUDING CORPORATE HISTORIES
AND ARTIST BIOGRAPHIES

Corporations are presented according to the chronology
of their selected paintings

GULF STATES PAPER CORPORATION

Gulf States Paper is a privately owned corporation with plants and facilities in Alabama, Texas, Illinois, Kentucky, Ohio, North Carolina, New York, and Georgia. Through its different divisions, it has become a major figure in a wide range of markets, from paperboard and packaging to various forest products and services.

Founded in the 1880s when Herbert Westervelt began operating several small mills, the company at first made wrapping paper from wheat straw. At the turn of the century, Westervelt's invention of the E-Z Opener bag machine signaled the company's first great period of growth. The paper bags made on the newly invented machines opened "with a flick of the wrist" and soon became the standard grocery bag in America. In 1912, the company began producing the paper bags.

In 1929, widely dispersed operations in New York, Texas, Louisiana, and the Midwest were consolidated in Tuscaloosa, and the multi-division, modern paper industry was introduced to Alabama. As plants and divisions grew, the company strengthened the quality and quantity of its woodland holdings. Gulf States Paper was the first in the southern pulp and paper industry to hire a full time game specialist. Through the years, the company has earned national recognition for its pioneering work in water, wildlife, and forest conservation. Under Jack W. Warner, grandson of the founder, Gulf States Paper perfected new techniques that became standards in pulp and paper operations across the globe.

Gulf States' present national headquarters, completed in 1970, is a striking complex of buildings distinctly Oriental in flavor. Regular tours of the headquarters complex in Tuscaloosa are available. Each year, thousands visit the buildings, not only to see the Oriental gardens but also to view the extensive collection of fine art and primitive artifacts displayed throughout the headquarters. Specializing in the art of historic America, The Warner Collection of Gulf States Paper Corporation includes paintings, bronzes, porcelains, prints, and American Indian artifacts. European and Asian paintings as well as artworks from Africa, the South Pacific, and the Far East are included. One theme shared by many works in the collection relates to man's constant challenge of coping with nature and his natural environment.

The quality so important to the company's production is upheld also in its art collection. Among the artists included are Albert Bierstadt, Thomas Cole, Thomas Moran, Asher B. Durand, Alfred Jacob Miller, Frederic Remington, George Catlin, John Mix Stanley, Seth Eastman, N.C. Wyeth, and Leonard Baskin. One of the most historically important groups of paintings in the collection is a series of Charles Bird King portraits of American Indians who visited Washington, D.C., in the early nineteenth century.

THOMAS COLE
1801–1848

FALLS OF KAATERSKILL
OIL ON CANVAS, 1826
43 x 36 INCHES

Thomas Cole was America's first major landscape artist and the founder of the first American school of painting. His belief that divine power was manifest in the spectacle of nature led him to choose two major themes for most of his career. One was pure landscape, emphasizing the eternal drama of nature and depicting the romantic scenery of the eastern United States. This approach led to the formation of a group of painters called the Hudson River School. Cole's other major concern derived from the eighteenth century concept of an allegorical landscape. In painting these landscapes, often in series, he directly expressed lofty moral truths.

Cole was born in Bolton-le-Moors, an industrial town in Lancashire, England. It was there, partly in reaction to his environment, that he acquired a deep love of nature. Immigrating to the United States with his family in 1818, Cole spent five arduous years in Ohio and Pennsylvania, making a living while learning artistic skills by sketching from nature. Although he studied for a short time in Philadelphia at the Pennsylvania Academy of Fine Arts, he was essentially self-taught. Cole moved with his family to New York in 1825, determined to be a landscape painter. He soon received recognition. John Trumbull, the most eminent contemporary American artist, Asher B. Durand, and William Dunlap became his supporters. In 1826, Cole became a founder of the National Academy of Design, the organization soon to be at the center of the nineteenth century American art world.

In the same year, Cole was invited to the home of George Featherstonaugh in Duanesburg, near the Catskill Mountains. It may have been during this visit that he made sketches which resulted in *Falls of Kaaterskill*. Early in his career, Cole had established the practice of making numerous oil and pencil sketches from nature and then, in the studio, developing them into finished compositions. Cole's favorite formula for landscape came to employ a darkened foreground with a twisted, broken tree; a highlighted middle ground; and a high background, often a vista of distant mountains. This pattern stresses the power and immensity of nature and suggests the limitations of human might.

A trip to England and the continent from 1829 to 1832 stimulated Cole's interest in allegorical paintings. His celebrated series, including *The Voyage of Life* (Munson-Williams-Proctor Institute; also National Gallery of Art) and *The Course of Empire* (New York Historical Society), were the result. Cole's patrons favored his dramatic, topographical compositions of American landscapes, while the artist himself preferred allegorical themes, often from Biblical or classical sources. After moving to the Catskill area in 1836, Cole continued painting in the two different veins. Although he had only one pupil before his early death in 1848, Cole's depiction of landscape began a revolution in the artistic taste of America.

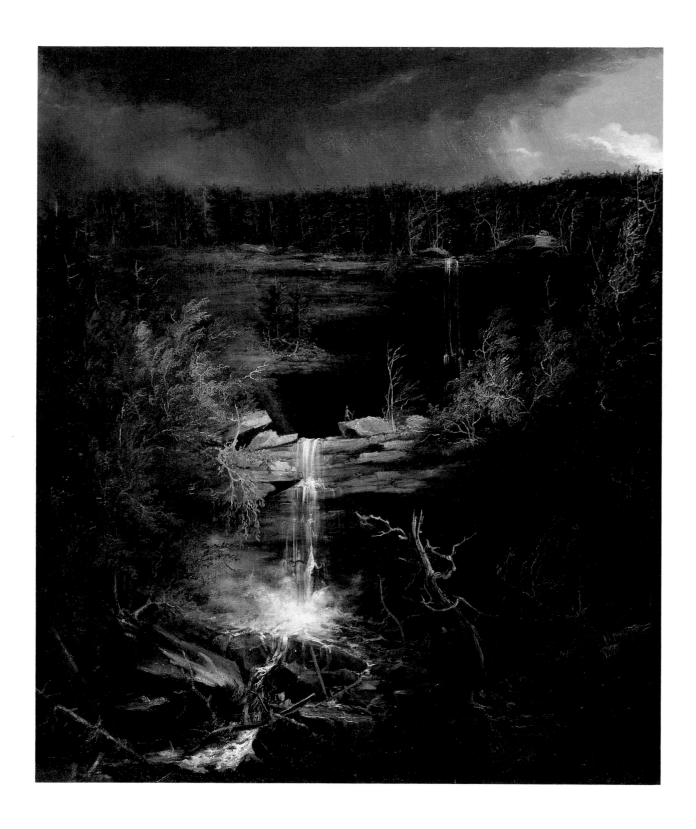

CHARLES BIRD KING

1785–1862

MAKATAIMESHIKIAKIAH (BLACK HAWK)

OIL ON PANEL, CIRCA 1833

24 x 19⅞ INCHES

The foremost portraitist of Washington, D.C., during the four decades preceding the Civil War, Charles Bird King is best remembered for his portraits of Indians who visited the capital between 1821 and 1842. Born in Newport, Rhode Island, King was the son of a revolutionary war officer who was killed by Indians in Ohio while tilling land granted to him for his military services. Encouraged in his artistic interests by his maternal grandfather, a Newport merchant and amateur artist, King spent two years learning the rudiments of his profession from Edward Savage, the New York painter and engraver.

King's acquaintance with Washington Allston and Edward G. Malbone, schoolmates from Newport, probably led him to follow their example of seeking further artistic training abroad, and in 1806 he left for Europe. In London for six years, he received instruction at the Royal Academy from some of the most respected artists of the day—Benjamin West, Henry Fuseli, and David Wilkie. At the Academy, King's circle of friends included many of the future leaders of American art—John Trumbull, Thomas Sully, and Samuel F. B. Morse.

On returning to Newport, King expressed his never fulfilled hope of becoming a history painter as well as a portraitist. After working in various cities, he settled in Washington, D.C., in 1819. Over the years, as a semi-official portraitist, he painted members of presidential families and many other notables.

Because of the continually expanding western border, there had been a constant stream of Indians—ambassadors, captives, or the merely curious—passing through Washington since its founding. At the behest of the War Department, King began a series of portraits in 1821 that eventually numbered some one hundred forty-three paintings. Usually bust-length, the Indian portraits are straightforward studies, faithful in representing Indian physiognomy, colorful in depicting native costume, and successful in suggesting particular personality traits. *Makataimeshikiakiah* depicts one of the most infamous Indians of the period. Leader of a band of Sauk braves who refused to accept the cession of their lands east of the Mississippi, Makataimeshikiakiah terrorized the Illinois frontier for a time. Peace was ultimately arranged, and the portrait was presumably painted when he was a member of an Indian delegation to Washington in 1833.

Unfortunately, most of King's original portraits were destroyed in the 1865 Smithsonian fire. However, Henry Inman had made copies in the 1830s, so many facsimiles have survived. A complex individual, King was reluctant to pursue a role of leadership in the American arts. Yet, as a portraitist, he produced an important series of remarkable images of native Americans.

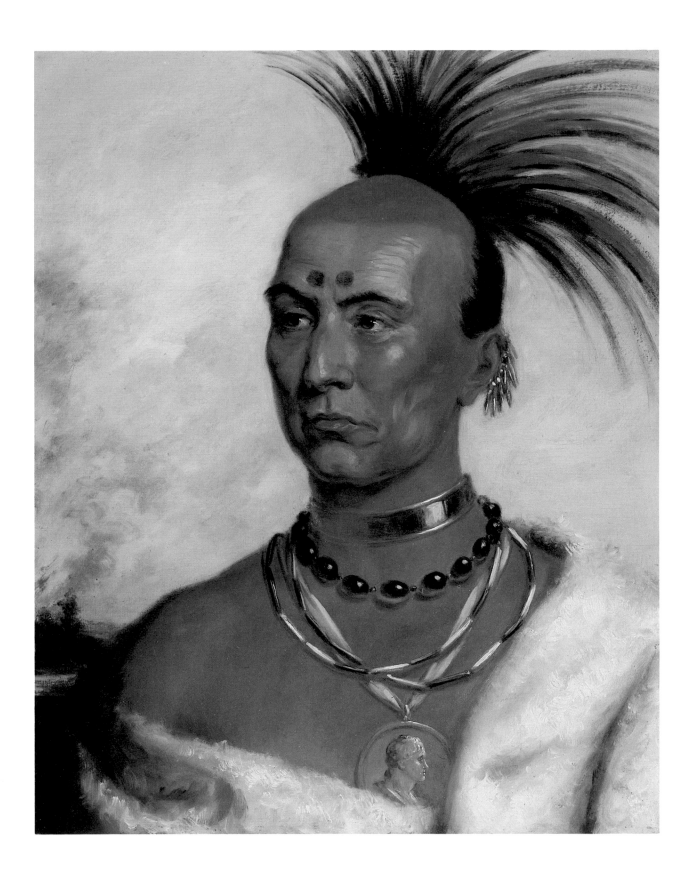

WILLIAM BRADFORD

1823–1892

MUIR GLACIER

OIL ON CANVAS, CIRCA 1880–1890

35⅛ x 69⅛ INCHES

An eminent nineteenth century landscape and marine painter, William Bradford is noted for his studies of the Arctic. His work reflects both the artistic proclivities and the scientific hypotheses of his period. One of the first to recognize the value of the photograph for the artist, Bradford used photography extensively to make his precise, detailed studies of natural phenomena.

Born in Fairhaven, a small town across the harbor from New Bedford, Massachusetts, Bradford grew up in the midst of the whaling industry. While working for his father, a ship outfitter and dry goods merchant, he began drawing on his own. About 1855, the desire to paint overcame Bradford's business inclinations, and he opened a studio in New Bedford. Influenced by the work of the marine painter Fitzhugh Lane and a Dutchman named Van Beest, with whom he shared a studio for a few years, Bradford specialized in ship portraits.

A long-time fascination with the Arctic led Bradford to undertake a series of expeditions to the North; the first was in 1854. Particularly captivated by the northern light, Bradford painted many beautiful depictions of the Arctic sun, both rising and setting. Another favorite theme was unusual ice formations and icebergs. Bradford often composed his paintings with a low horizon to emphasize the loneliness and isolation of the region; he contrasted the smallness of his human figures with the immense scale of their natural surroundings. A tightly drawn style and thin application of paint intensifies the naturalism of his work.

In the late 1860s or early 1870s, Bradford moved from New Bedford to the center of the American art world, the Tenth Street Studio Building in New York City. There, he kept company with such artists as Albert Bierstadt, Sanford Gifford, and Worthington Whittredge. From July to October, 1869, Bradford made his most ambitious Arctic trip. During the journey, he drew many sketches and, with the aid of professional photographers, made a number of photographs to be used in completing oil paintings once he returned home. In 1872, an internationally known figure, Bradford visited England, where he was well received. He obtained not only many commissions, including one from Queen Victoria, but also the necessary patronage for his book, *The Arctic Regions*, published in 1873. Bradford became a popular lecturer, illustrating his talks with lantern slides of his paintings and photographs.

In its concentration on the sublime imagery of the Arctic, Bradford's art is the northern counterpart to the dramatic Western scenes of Albert Bierstadt and the awe-inspiring South American landscapes of Frederic Church. In their attention to natural phenomena and the spectacle of light and sky, Bradford and these artists paralleled the contemporary scientific efforts of Alexander Humboldt and Charles Darwin.

Muir Glacier, now a part of Glacier Bay National Park, was discovered on the Alaskan coast in 1879 by explorer and naturalist John Muir. Bradford's painting depicts an ice floe which had separated from the glacier and drifted into the bay.

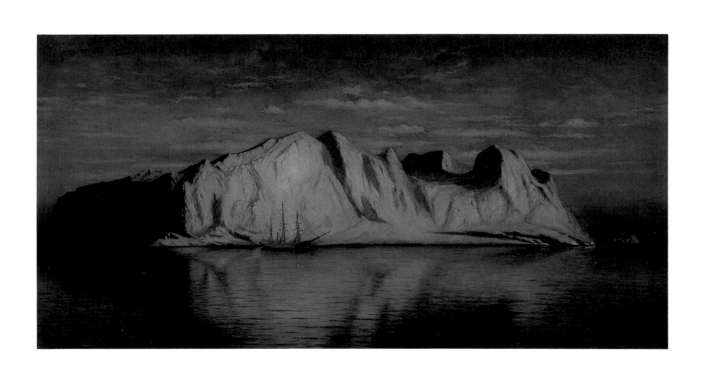

CLEVELAND TRUST COMPANY

Cleveland Trust, an acknowledged leader in banking among American financial institutions, was established in November, 1894. The bank has eighty offices in Cuyahoga County, serving the businesses and residents of Cleveland and its suburbs. Because of a change in Ohio banking laws effective January, 1979, Cleveland Trust has expanded banking services to other communities in the state.

The bank's art program began in late 1971 when the company moved into its new downtown headquarters designed by Marcel Breuer. The bank's former office building, the Rotunda, was restored by Cleveland Trust and, due to its historic significance, was entered in the National Register of Historic Places in November, 1973. The art collection comprises mostly paintings and was assembled for installation in the handsome new building. Included are a number of nineteenth century works by David Johnson, Worthington Whittredge, Homer D. Martin, and Albert Bierstadt, among others. The collection also contains several contemporary pieces by such artists as Alvin Loving, Frank Stella, and Victor Vasarely. In addition, there are lithographs and a number of Japanese screens. The works in the collection were assembled by a committee that included Hawley E. Stark, former Vice Chairman of Cleveland Trust; Sherman Lee, Director, Cleveland Museum of Art; and Severance Milliken, Advisory Director, Cleve-Trust Corporation. L. Louis Amoroso, Senior Vice President, is responsible for cataloguing and maintaining the artworks installed throughout the bank's main office. To insure their preservation, works are inspected annually by staff from the Cleveland Museum of Art, headed by William Talbot, Associate Curator of Painting.

In recent years, the bank has commissioned regional artists to create works for special locations in its branch offices. Among these are enamels by Silvia Miller, murals by Kathy Cap and modular abstract art by Bruce Bilek. Having encouraged "the long and important relationship between art and business," M. Brock Weir, Chairman of the Board and Chief Executive Officer, has recently stated, "We at Cleveland Trust Company are honored and pleased to be able to participate in this unique project of American painting from corporate collections. The support of the arts by American free enterprise has been one of the key factors in the public's ability to enjoy fine and rich culture over the years throughout our land."

DAVID JOHNSON
1827–1908

ON THE ESOPUS CREEK, ULSTER COUNTY, NEW YORK
OIL ON CANVAS, 1859
26¾ x 44¼ INCHES

David Johnson first achieved recognition as a landscape painter in the tradition of the Hudson River School. In addition, he painted many portraits and a few fine still lifes. Concentrating on a peaceful, bucolic view of nature, he painted small-scale canvases that were extremely popular during the latter half of the nineteenth century.

Born in New York City in 1827, Johnson remained there and in its environs throughout his life. He was a self-taught artist and followed the tradition established by Thomas Cole of sketching directly from nature. Johnson never went abroad, preferring to depict the landscapes of upstate New York and New England. By 1849, he was exhibiting his work at the National Academy of Design and the American Art Union. For a brief period in 1852 he studied with Jasper Cropsey who probably influenced his precise and realistic style of drawing. Johnson was an active member of the New York art world of the 1860s and 1870s. In 1859, he aided in founding the Artists' Fund Society and in 1861 was elected to the National Academy. He received a medal at the 1876 Centennial Ex-

hibition in Philadelphia and exhibited at the Paris Salon the following year.

Johnson's painting *On the Esopus Creek, Ulster County, New York*, a scene near his country home, shows his affinity with the Hudson River School. Below an expansive, cloud-filled sky, a middle ground is painted in darker tones and shows a careful study of nature. The Esopus, a picturesque stream which flows into the Hudson River, was popular with landscape painters in the mid-nineteenth century.

In the mid-1870s, Johnson began to change his style, adopting a looser brushstroke in admiration of the French Barbizon painters. The results were more personalized, less topographical interpretations of the landscape. Johnson particularly admired the work of Théodore Rousseau. The evidence was visible in his paintings, even to the point of earning him the sobriquet, "the American Rousseau." In later life, Johnson became something of a recluse, and both his interest and his ability in painting are generally considered to have declined.

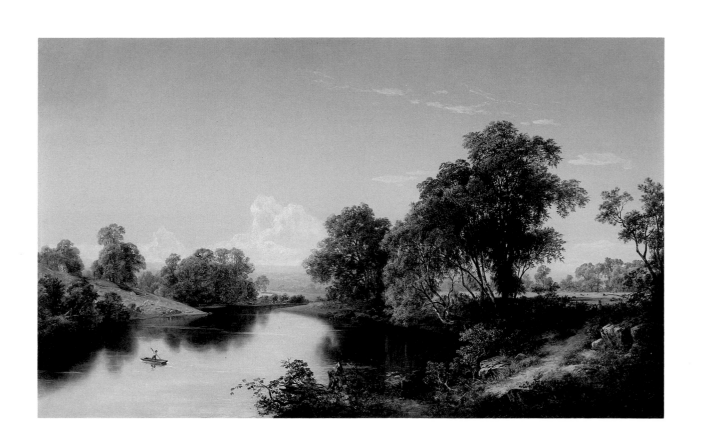

WORTHINGTON WHITTREDGE

1820–1910

MORNING ON LAGO MAGGIORE

OIL ON CANVAS, 1860

30 x 50 INCHES

A landscape painter particularly celebrated for his intimate views of woodland scenes, Worthington Whittredge was a leading member of the Hudson River School. Born on a farm near Springfield, Ohio, he was the youngest child of a retired sea captain from New England. Averse to leaving his aged parents and fearful of mentioning his interest in art, Whittredge spent his early youth at home. He eventually moved to Cincinnati in 1837 to work with his brother-in-law as a housepainter. After a short period in sign painting and then in an unsuccessful daguerreotype business, Whittredge turned to portraiture in 1840. In 1843, dissatisfied with his ability to capture an accurate likeness, he returned to the environs of Cincinnati and decided to devote himself to landscape painting. Though self-trained, he soon established a local reputation, but to expand his knowledge and skill he decided to seek professional training. Whittredge traveled to Düsseldorf in 1849, where he studied first with Andreas Achenbach. He soon attached himself to the studio of the German-American painter Emanuel Leutze, then working on his monumental *Washington Crossing the Delaware*. Whittredge remained in Düsseldorf for five years.

In 1854, Whittredge joined fellow student Albert Bierstadt on a sketching tour through Switzerland to Italy. Settling in Rome, a meeting ground for American artists, he remained in Europe another five years, painting many views of the Italian countryside.

Whittredge returned to the United States in 1859, opening a studio in New York's Tenth Street Studio Building. He was soon established as a major figure in the city's art world. It was during the year after his return that he painted *Morning on Lago Maggiore*, probably from sketches made during his stay in Italy. Whittredge's peaceful, beautiful images of nature share none of the tumultuous drama of Thomas Cole's painting—even though he admired Cole—nor the grandiose sublimity of Bierstadt's. In 1861, Whittredge was elected to the National Academy of Design, later serving briefly as president.

Whittredge devoted most of his mature work to landscapes of the Hudson River area, the White Mountains, and the New England coastline. He made three extended trips west in 1865, 1870, and 1877, but his favorite area remained the Catskills. His other subjects included interior scenes and still lifes; however, these were never very numerous. In 1880, Whittredge moved to Summit, New Jersey. Throughout his career, despite changing styles, Whittredge remained faithful to his naturalistic view of the landscape.

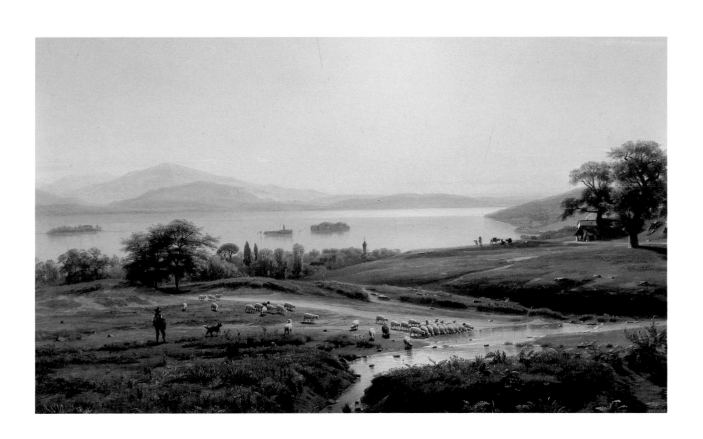

ALBERT BIERSTADT

1830–1902

LIBERTY CAP, YOSEMITE VALLEY

OIL ON CANVAS, 1873

29⅝ x 21⅞ INCHES

Albert Bierstadt was one of the most successful and admired American artists during the 1860s and 1870s. Concentrating on the landscape of the American West, he produced large, panoramic canvases filled with minute foreground detail, dramatic lighting, and spectacular mountainous backgrounds. Bierstadt would make visual records of a scene with both a sketchbook and a camera. He later composed his paintings in the studio, following the procedure of Thomas Cole and the Hudson River painters. Bierstadt's style also reflected the balanced composition and precise brushwork of his training in Düsseldorf, Germany.

The son of immigrants from Westphalia, Bierstadt was raised in New Bedford, Massachusetts. In 1853, he went to Germany to study under his cousin Johan Hasenclever, an instructor at the Düsseldorf Academy. The latter's untimely death led Bierstadt to the studio of fellow German-American, Emanuel Leutze. Spending the winters in Düsseldorf, Bierstadt was most productive during the summer, when he set off alone to sketch the German countryside. During his final year abroad, he traveled to Rome with a colleague from Leutze's studio, Worthington Whittredge.

Bierstadt returned to the United States in 1857, settling in New York City's Tenth Street Studio Build-

ing a few years later. His first of four trips to the American West, the 1858 expedition led by Colonel Lander, resulted in his famous painting, *Thunderstorm in the Rockies* (1859, Museum of Fine Arts, Boston). Election to the National Academy of Design soon followed, and his artistic course was charted.

Bierstadt's impressive canvases, some immense in scale, were conceived as a progressive planar development from detailed foreground through lightened middle ground to dramatic background. They became extremely popular in both the United States and Europe. The large finished works were composed in Bierstadt's New York studio and later in his home on the Hudson River from sketches and photographs made during summer travels. *Liberty Cap, Yosemite Valley*, a finished oil sketch made while he had a studio in San Francisco, is characteristic of the kind of detailed study from which he would compose his paintings.

Despite waning popularity in the 1880s, Bierstadt continued to paint panoramic landscapes until the end of his life. He is now considered one of the major figures in nineteenth century American landscape painting. Particular admiration is accorded his small sketches, painted directly from nature and often capturing the dramatic light and color of the outdoors.

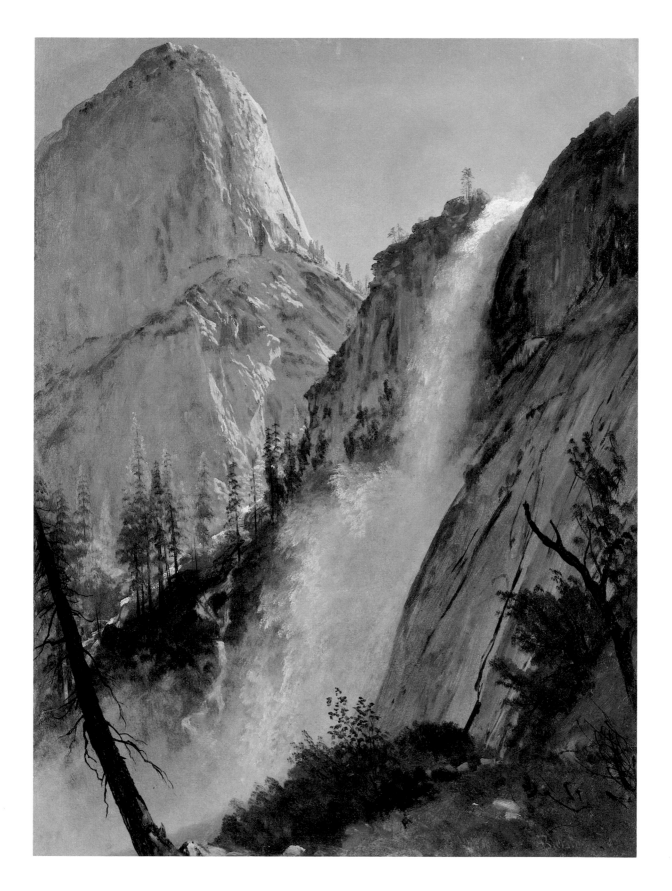

INTERNATIONAL BUSINESS MACHINES CORPORATION

International Business Machines Corporation was founded in 1914. The company's business spans the entire range of activities and products in the information processing industry. Nearly all the company's products — from computers to copiers — are designed to record, process, communicate, store, or retrieve information. The IBM Corporation operates in the United States and one hundred twenty-five countries in Europe, the Middle East, Africa, the Americas, and the Far East.

IBM gives financial support to numerous art programs and has been recognized for its efforts by recently becoming a six-time recipient of the "Business in the Arts" award presented by the Business Committee for the Arts, Inc. Contributions are made to the fine arts and performing arts, as well as to a number of art galleries, cultural exchanges, and museums in the United States and abroad. IBM has made major contributions to Kennedy Center for the Performing Arts in Washington, D.C., and to Lincoln Center for the Performing Arts in New York City. The company supports performing arts programs such as the New York Philharmonic's 1975 European tour; it also sponsors cultural programs on commercial television and provides grants for programs on public television.

The company has helped underwrite many significant exhibitions, among them the National Gallery of Art's *Exhibition of Archaeological Finds of the People's Republic of China* and the Museum of Modern Art's 1977 Cézanne exhibition. Most recently, *The Splendor of Dresden: Five Centuries of Art Collecting* was made possible by grants from the IBM Corporation and others. Corporate funding not only made possible the exhibition's assembly but also will allow it to travel across the United States. In addition, IBM France, IBM Europe, and IBM Japan, Limited have provided support to traveling exhibitions.

The corporation began its collection in 1939 under the leadership of Thomas J. Watson, Sr., the first president of the company. At that time, works of art were chosen from the seventy-nine countries in which the company conducted business. These paintings were displayed in the IBM pavilions at the New York World's Fair and the Golden Gate International Exposition in San Francisco. Partly due to the enthusiastic reception of *Contemporary Art of 79 Countries*, additional paintings were acquired the following year from each of the forty-eight states. Since then, the collection has focused primarily on American art.

The artworks consist of several hundred oils, watercolors, drawings, and prints. Artists represented range from colonial portraitists John Singleton Copley and Charles Willson Peale to nineteenth century landscape painters Albert Bierstadt and Thomas Cole. The collection continues into the twentieth century with works by Robert Henri, William Glackens, Grandma Moses, and Marsden Hartley. Contemporary artists include Peter Hurd, Jacob Lawrence, and Andrew Wyeth. Some Mexican works, including a small collection of pre-Columbian sculpture, are also part of the collection. The art is installed at IBM facilities in the United States for the enjoyment of both employees and visitors. Individual pieces are loaned to galleries and museums for special exhibitions and are also made available to the State Department's *Art in the Embassies* program.

JASPER FRANCIS CROPSEY
1823–1900

LAKE GEORGE
OIL ON CANVAS, 1868
24 x 44 INCHES

A member of the Hudson River School of landscape painters, Jasper Cropsey is particularly celebrated for his depiction of the brilliant, autumnal colors in the northeastern United States. Born on a Staten Island farm, Cropsey was apprenticed to New York architect Joseph Trench in 1836. He probably developed his remarkable drawing ability in Trench's office, where he was also encouraged to pursue his interest in painting. With election as an associate to the National Academy of Design in 1845, Cropsey seems to have committed himself to a career as an artist, although he continued to practice architecture from time to time.

Traveling to Europe in 1847 to augment his artistic training, Cropsey spent most of his time in Italy. There, he enjoyed the companionship of Transcendentalist poet and amateur artist Christopher Cranch, artist Thomas Hicks, and sculptor William Wetmore Story. It was probably the influence of John Constable that heightened Cropsey's awareness of cloud formations and lightened his palette. Despite his residence in Europe, Cropsey was determined to maintain his American characteristics. The predominant influence on his work remained the allegories and dramatic landscapes of Thomas Cole.

Upon his return from Europe in 1849, Cropsey settled in New York and shared a studio with Hicks. He soon achieved recognition for his landscapes and was elected an academician in 1852. Neither an innovator nor a revolutionary, Cropsey followed the Hudson River School tradition, painting landscapes composed from his sketches of upper New York state and New England. In the manner of Cole, a spotlighted middle distance was usually framed by a tree or trees in the foreground.

Returning to Europe in 1865, Cropsey settled in England. He was influenced there by both Constable's expansive landscapes and the detailed naturalism of John Ruskin and the Pre-Raphaelite Brotherhood. He completed his masterpiece *Autumn on the Hudson River* in 1860, establishing both his reputation and the compositional formula followed throughout the remainder of his career. Cropsey returned to New York in 1864 and settled at Hastings-on-Hudson. Becoming almost exclusively a painter of the autumn scene, he achieved particularly bright hues by applying his colors on top of a white ground.

Lake George is a fine example of Cropsey's mature style. A panoramic view looking out over the lake in the middle distance, the painting has the traditional repoussoir of dead and gnarled trees, symbols of the last stage in the life cycle. Cropsey also includes details of exposed roots, eroded soil, and small plant life. The few human figures in the painting are dwarfed by the lake and distant mountains.

During his later career, Cropsey turned to watercolor and was a founding member of the American Water Color Society. His detailed topographical approach to the landscape, however, waned in popularity as the nineteenth century progressed and public interest turned to more imaginative scenes.

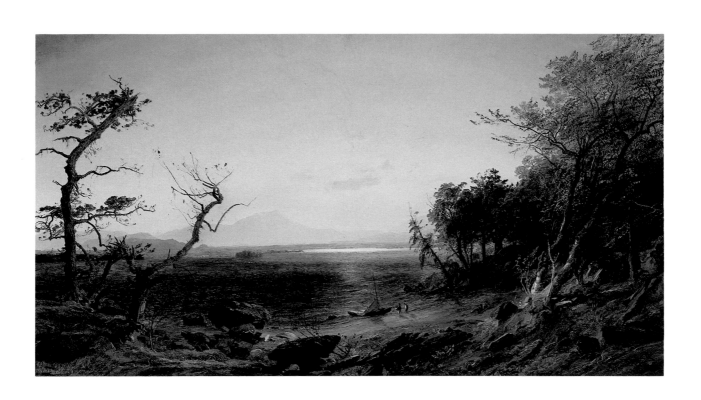

JOHN FREDERICK KENSETT

1816–1872

STUDY FOR TREES ON THE BEVERLY COAST

OIL ON CANVAS, CIRCA 1869

14⅛ x 24⅛ INCHES

His simple, quiet outdoor scenes made John Kensett a leader of the American landscape school in the 1850s and 1860s. Painted in careful gradations of gray, brown, and green, much of his work is characterized by large forms silhouetted against the sky. Following in the luminist tradition, Kensett painted meticulous studies of nature which aimed to capture the effect of direct or reflected sunlight on the land. His subjects were the forested landscapes and seaside views of New York and New England.

Kensett was born in Cheshire, Connecticut, the son of an English engraver and publisher. After learning the rudiments of engraving and drawing in the family firm, he moved to New York to work at the lithography shop of Peter Maverick. The death of his father in 1829 brought Kensett back to the family business in Cheshire, but he later returned to New York as an engraver for the American Bank Note Company. Through his work, he met the artists Thomas P. Rossiter, John Casilear, and Asher B. Durand. They were turning from engraving to oil painting and advised him to do likewise.

In 1840, in company with Rossiter, Casilear, and Durand, Kensett sailed for Europe. After their tour of the English museums and galleries, Kensett went to Paris and remained there for several years, sharing a studio with Benjamin Champney. The two became acquainted with the elderly American painter John Vanderlyn, then working in Paris. Kensett stayed in Europe seven years, spending two in England awaiting the outcome of legal proceedings concerning a legacy. Before returning to the United States, he gave up his engraving work and joined Champney in a walking and sketching tour along the Rhine. Kennsett's early style in Europe was influenced by Thomas Cole's romantic dramas of Nature as well as by John Constable and other European artists.

In 1847, Kensett settled in New York, already recognized as an outstanding landscape painter through the works he had sent home from Europe. He gained election to the National Academy of Design in 1849. Influenced by Durand's advocacy of a realistic, topographical approach to painting, Kensett developed his mature style using carefully modulated colors, smooth brushstrokes, and a meticulous naturalism. He further followed Durand's advice in making detailed drawings and sketches from nature before composing the final painting in the studio. Kensett spent summers at favorite sketching sites and passed winters in his New York studio working up completed paintings. *Study for Trees on the Beverly Coast*, made near the Massachusetts shoreline, is the kind of detailed sketch that Kensett used in creating his finished oil paintings. The subtle, poetic beauty of such work brought Kensett great popularity and prestige in his day.

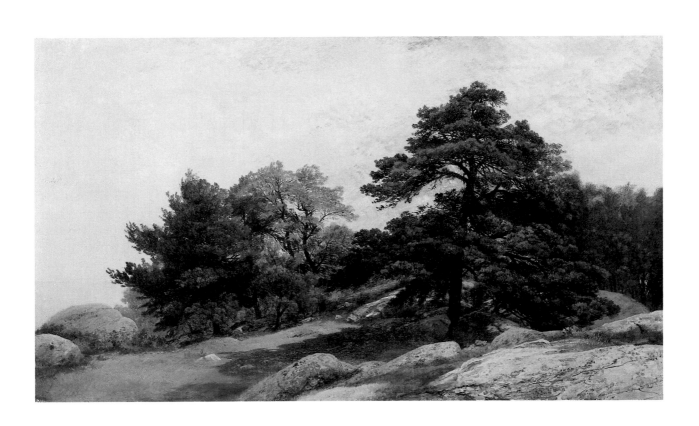

ALEXANDER HELWIG WYANT

1836–1892

POOL IN THE WOODS

OIL ON CANVAS, CIRCA 1880

22⅞ x 18⅞ INCHES

Alexander Helwig Wyant painted in two distinct styles. The first followed in the tradition of the Hudson River School; it resulted in objective, painstaking representations of natural vistas. The second style grew out of the tradition of French Barbizon painters; it was characterized by muted tones and a fluid handling of paint applied to small studies of rural areas.

The son of an itinerant farmer, Wyant spent his boyhood in Defiance, Ohio. First apprenticed to a harness-maker, he turned to sign painting in the 1850s. During a trip to Cincinnati, Wyant saw paintings by George Inness and was so impressed that he visited New York to seek Inness' advice on how to begin an artistic career. In 1860, with the support of the well-known Cincinnati patron Nicholas Longworth, Wyant returned to New York to study. He began exhibiting at the National Academy of Design in 1864.

In his early style, Wyant painted meticulous panoramic landscapes. This tendency toward precision and detail was reinforced during his first trip to Europe when he studied briefly with Hans Friedrich Gude, a Norwegian painter of the Düsseldorf School working in Karlsruhe, Germany. Wyant also spent some time in England and Ireland before returning to New York in 1867. He was elected to the National Academy in 1869. Interested in watercolor as well as oil, Wyant exhibited yearly and became a founder of the American Water Color Society in 1878.

Intrigued by the artistic possibilities of western American landscape, particularly after seeing Albert Bierstadt's spectacular paintings, Wyant joined a government expedition to the New Mexico territory. The hardships of this journey proved too severe for Wyant's constitution, and he suffered a partial stroke that paralyzed his right arm.

Learning to paint with his left hand, Wyant perfected the loosely painted style which he had begun to experiment with even before the expedition. *Pool in the Woods* is characteristic of this later work. Influenced by the work of the French Barbizon painters Jean-Baptiste Corot and Theodore Rousseau, the painting gives a glimpse of woodland scenery and is depicted in earth tones. It also demonstrates Wyant's growing interest in subtle atmospheric effects rather than the grand spectacle of nature. Many of Wyant's later scenes derive from the areas around his summer homes, one near Lake Champlain and another in Arkville, New York.

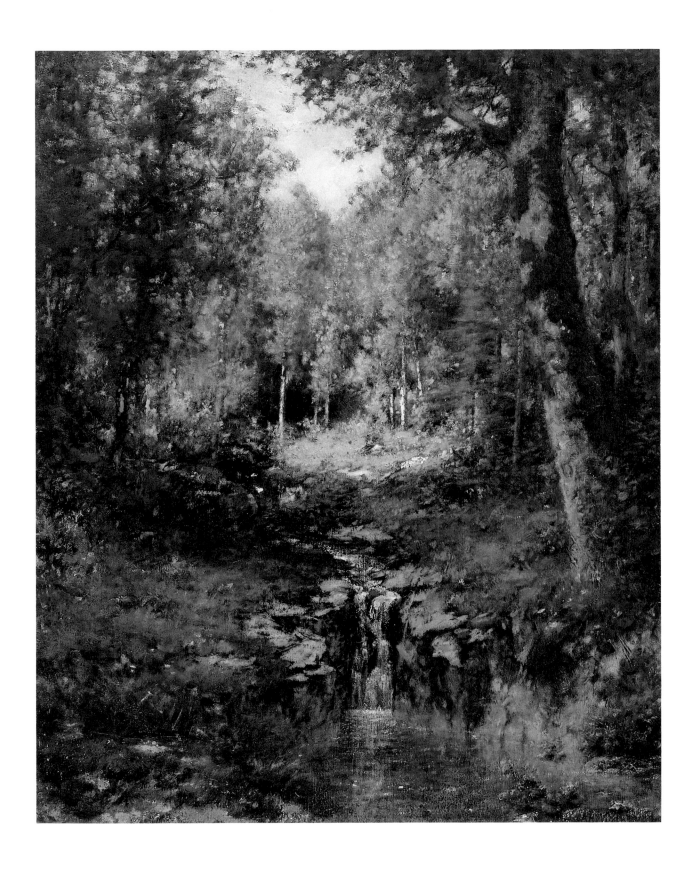

THE FIRST NATIONAL BANK
OF CHICAGO

The First National Bank of Chicago, tenth on *Fortune* magazine's list of the fifty largest commercial banking companies, has ten offices in the United States outside of Chicago and fifty-six offices in other countries. Long one of the most prominent institutions in Chicago, the bank has made several policy decisions in recent years which have had as much impact on the arts as on its own fiscal well-being. In 1964, it hired two important Chicago architectural firms, the Perkins and Will Partnership and C.F. Murphy Associates, to design an immense new building. When the building was being planned, the question of how to complement the impressive architectural spaces became important.

The bank's Board Chairman, Gaylord Freeman, conceived the idea of building "a distinguished collection of art. We even aspired to acquire representative works from a wide range of periods and places covering the centuries of man's development." The earliest piece in the collection dates from the sixth century B.C.; the most recent is from 1977. The collection includes art from Asia, the Near East, Africa, Latin America, the South Seas, Australia, the Caribbean, Europe, and America.

The person Freeman designated to select the bank's art was Katharine Kuh, for sixteen years Curator of Modern Painting and Sculpture at the Art Institute of Chicago. Mrs. Kuh stated in the foreword to the catalogue of the collection, "Our aim was to accumulate objects of high quality before their prices became unduly inflated. In a word, we have tried to buy fine works that were not necessarily in fashion. As a rule, we have avoided thinking in corporate terms and have been suspicious of offers proposing just the right thing for a bank. Whether in a bank, home, or museum, art has the same mission — to enrich life and widen horizons. Works at First National have not been bought as investments, as decorations merely to humanize stark modern walls, nor as a thesis for any single movement or period. The main body of the collection is intended as a personal extension of daily life."

Mrs. Kuh not only selected the twenty-six hundred pieces in the collection; she also designed their installation in the building. The extensive and varied collection encompasses paintings by Gilbert Stuart, James B. Sullivan, Richard La Barre Goodwin, Michelangelo Pistoletto, and Romare Bearden; sculpture by Hans Arp, Emile Antoine Bourdelle, Alexander Calder, William King, Louise Nevelson, Frederic Remington, and Auguste Rodin; numerous drawings, prints, and wall hangings; and an enormous commissioned work of plastic multiples by Richard Anuskiewicz for one of the walls in the building. Works have been acquired not only for the Chicago headquarters but also for the bank's other offices. About half of the art in the offices abroad is of local origin and often includes archaeological pieces that cannot lawfully be exported. This important collection fulfills Freeman's hope: "If our art is interesting to our customers and both pleasing and stimulating to our employees, we will feel that our commitment has been worthwhile."

69

ANDREW JOHN HENRY WAY

1826–1888

GRAPES

OIL ON CANVAS, 1881

18⅛ x 12⅛ INCHES

Andrew John Henry Way was one of several successful still life painters in the second half of the nineteenth century. The genre became extremely popular at that time, with representations of foodstuffs a particularly favored subject for the Victorian dining room. The art of painting still lifes attracted some remarkable talent, the Peale family of Philadelphia providing the first successful specialists in the field. Most appreciated today is the work of William M. Harnett, John F. Peto, and Martin J. Heade.

Way was born in Washington, D.C. He studied in Cincinnati with John P. Frankenstein, a respected portraitist of the period. Way subsequently moved to Baltimore and worked under Alfred Jacob Miller, an American trained in Paris and made famous by his trip to the West with the Drummond-Stewart expedition. In 1850, Way traveled to Paris to study. Dissatisfied with the training there, he enrolled at the Academy of Fine Arts in Florence in 1851. Three years later, he returned to the United States and settled in Balti-

more. There, he began his career as a portraitist and miniaturist. Way was one of four artists who organized the Maryland Academy of Fine Arts.

In 1859, Way painted a still life of fruit that was seen by Emanuel Leutze, then at the height of his fame. Leutze encouraged him to continue his work and Way soon became a successful still life painter. He achieved national recognition by winning a medal at the Centennial Exhibition in Philadelphia in 1876.

Way's paintings depicted various fruits and delicacies for the table, but his specialty was grapes. An adept colorist, he created sensuous, luscious representations, often placing a single cluster of grapes against a contrasting color or depicting them hanging from a sun-bathed vine. Way was particularly known for his skill in differentiating between varieties, an ability much admired by Victorian taste. *Grapes* is one of several paintings of similar size and composition but with differently colored backgrounds and fruit.

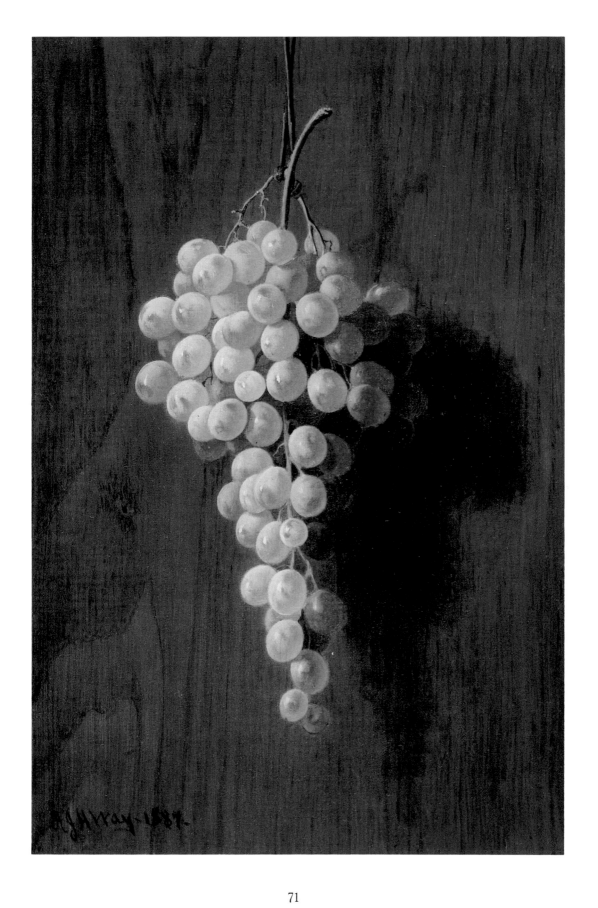

ALFRED THOMPSON BRICHER

1837–1909

COAST OFF GRAND MANAN

OIL ON CANVAS, 1885

16 x 33 INCHES

Alfred Thompson Bricher is one of a number of talented nineteenth-century American painters who never achieved fame but produced work which adequately supported them throughout their lives. Painting for over half a century, Bricher remained faithful to his objective naturalism long after it was outmoded in contemporary artistic circles by the new styles of those trained in Munich and Paris.

Born in Portsmouth, New Hampshire, the son of an immigrant Englishman, Bricher was raised in Newburyport, Massachusetts. After attending local schools, he sought employment as a clerk in Boston in 1851 and may have studied art at the Lowell Institute. When he decided on an artistic career and opened a studio in Newburyport in 1858, he was in all probability self-taught. He began as a landscape painter concentrating on New England scenery. In 1859, he moved his studio to Boston and perhaps received some instruction from William H. Titcomb. His sketches of the Catskills, the White Mountains, and Long Island followed the tradition of Thomas Cole, Asher B. Durand, and other Hudson River School painters. By 1864, Bricher was exhibiting at the Boston Athenaeum and continued to do so while he lived in Boston.

Bricher also began to produce work for Louis Prang and Company of Boston. When the first chromolithographs of his work were published in 1866, they were credited with helping to establish the popularity of the Prang firm. During the same year, Bricher made a sketching trip of the upper Mississippi valley, traveling to Iowa, Wisconsin, and Minnesota. Two years later, he moved to New York and began exhibiting at the National Academy of Design and with the American Society of Painters in Water Color, to which he was elected a member in 1873. In 1879, he was elected an associate of the National Academy.

Bricher first turned his attention to the seacoast in 1871, spending the summer sketching along the New Jersey, Long Island, and Rhode Island shores. With the completion of *Time and Tide* in 1873, he established the compositional form and chosen subject for most of the rest of his career. *Coast Off Grand Manan* follows this format and has much in common with the luminist marines of Martin J. Heade. Depicted with precision, a light-filled atmosphere centers on waves breaking off a coast, set on a low horizon. Bricher traveled the entire New England coast in search of subjects, and he was particularly delighted by the dramatic cliffs of Grand Manan, an island at the entrance to the Bay of Fundy.

Although Bricher's coastal scenes may seem repetitive from painting to painting, minute variations in waves and clouds show his intimate knowledge and appreciation of the nuances of seacoast weather. His fascination with the sea, similar to the Hudson River School's interest in the landscape as an expression of divine immanence, led Bricher to paint a number of works of lasting value.

72

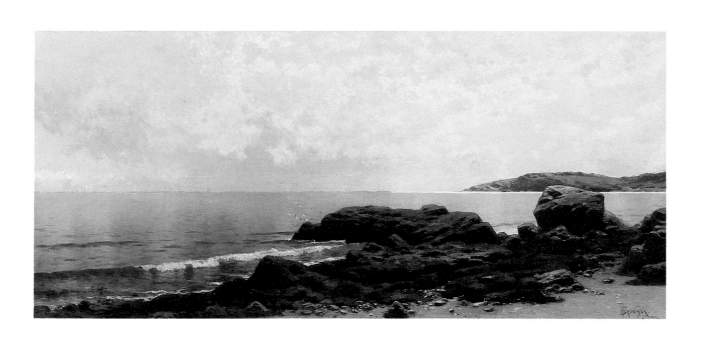

C.H. CHAPIN
DATES UNKNOWN

LOWER FALLS, GRAND CANYON OF THE YELLOWSTONE RIVER
WATERCOLOR AND TEMPERA ON PAPER, 1886
40 x 60 INCHES

Very little biographical information is available on C.H. Chapin. A few signed landscapes have been located, and illustrations of Civil War troops—probably by Chapin — appear in the October and November 1864 issues of *Harper's Weekly*. While Chapin remains an elusive figure in American art, the subject he depicted was widely heralded in the late nineteenth century. In 1871, a government expedition explored the area around the Yellowstone River to verify the reports of its many natural wonders. The artist Thomas Moran accompanied the party and on his return, painted *The Grand Canyon of the Yellowstone*. It presented a magnificent panorama of the canyon. Congress purchased it for $10,000 after having decided to create a national park around the canyon.

Although his painting is realistic in detail and differs in perspective from Moran's work, it is not known whether Chapin actually saw the Yellowstone area. Scenes of the western landscape were particularly popular in the 1880s, largely because of the work of Albert Bierstadt and Moran. Chapin continued their tradition of large-scale depictions but was unusual in using watercolor. The medium was becoming popular among professional artists; Jasper Cropsey and Alexander Wyant, along with Moran, regularly exhibited landscapes in watercolor. Seldom, however, were works of the magnificence and scale of this one by Chapin done in watercolor.

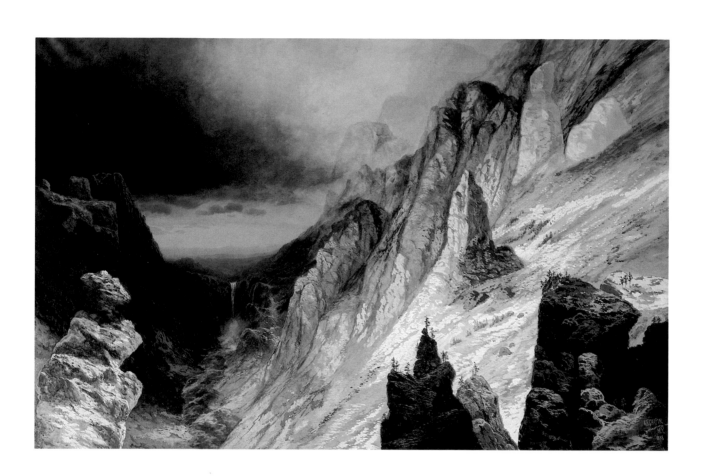

THE ANSCHUTZ CORPORATION

The Anschutz Corporation is a privately owned firm operating in the areas of petroleum, mining, and real estate. The corporation maintains its principal offices in Denver with other offices in New York, Houston, Calgary, London, and La Paz.

The art collection, begun ten years ago, reflects the personal interest of Philip Anschutz in the rich history and heritage of the American West. The more than six hundred works in the Anschutz Collection cover the period of Western painting from 1830 through 1940 and treat the history of this period from the wilderness and exploration of the frontier to the urbanization and development of its vast potential. The collection has been described by Clement E. Conger, Curator of the White House and State Department, as "one of the foremost private collections of Western American art in the United States." Part of the collection has been viewed by an enthusiastic public in the United States and abroad during an extensive ongoing tour. An illustrated catalogue, with many reproductions in color, accompanies the traveling exhibitions.

The collection is unique in chronicling the development of Western art from the early painters such as George Catlin and Alfred Jacob Miller, who accompanied the explorers across the new territory of the American West, to the romantic late nineteenth century artists such as Frederic Remington and Charles Russell, who dealt with the already disappearing Western frontier. The collection continues through the important Taos and Santa Fe school of painting, which emerged in the American Southwest around the turn of the century. This school included artists of international reputation, such as Georgia O'Keeffe, tired of the conventions of academic painting and drawn to New Mexico where the subject matter was new and the light quality unsurpassed.

Anschutz has focused on an important area of American art and history in this ever-growing collection of Western art. The numerous artists represented in the collection either lived in the West or painted works there which have had an influence on many aspects of American art.

GEORGE CATLIN
1796–1872

MANDAN DANCE
OIL ON CANVAS, 1832
23½ x 28⅝ INCHES

With a sensitivity, historical awareness, and anthropological curiosity rare among Americans in the early nineteenth century, George Catlin dedicated his career to preserving images of American Indians and their unique heritage. Idealizing the Indian character in the tradition of Jean-Jacques Rousseau's "noble savage," and realizing their imminent demise as a cultural entity because of western settlement, Catlin created over five hundred paintings based on visits to forty-eight different tribes from New York to Wyoming. In his quest, he became one of the first artists to work west of the Mississippi River. The paintings and published accounts of his travels not only established the pattern by which other artists would portray the Indian, but also became vital records of Indian tribal life.

Born in Wilkes-Barre, Pennsylvania, Catlin studied law at his father's insistence and even practiced for a few years. His abiding desire to become an artist, however, led him to close his office and move to Philadelphia where he became a portraitist and miniature painter. He was largely self-taught, studying the few works of European painters that were available as well as those of local artists such as Thomas Sully. After achieving a certain proficiency, he was elected to the Pennsylvania Academy of Fine Arts in 1824 and two years later to the National Academy of Design in New York.

Catlin's interest in the Indian is thought to have been inspired by the Indian delegations passing through Philadelphia to or from Washington, D.C. He painted his first Indian subject in 1826, and in 1830 he headed west, traveling to Prairie du Chien with the well known explorer, William Clark, then Superintendent of Indian Affairs in the West. In subsequent years, Catlin roamed up the Missouri River, extending his endeavors from portraiture to studies of landscape and details of Indian life. His record of a torturous ritual in *Mandan Dance* is one of his many invaluable chronicles of Indian life, for the Mandan tribe became extinct shortly after Catlin's visit.

In 1837, Catlin prepared an exhibition of paintings and artifacts for a tour of major American cities. Traveling to London two years later, he opened his exhibition to much popular acclaim and published accounts of his sojourns in the West. In 1845, he moved to Paris. For much of the remainder of his life, Catlin continued to travel, exhibit, and publish, undertaking expeditions to South America between 1853 and 1860. Although he was never successful in convincing the government to purchase his works, most of them are now in the Smithsonian Institution. Despite Catlin's arguable technical limitations, his rapidly executed paintings illustrate his sincerity, dedication, and enthusiasm. At times they capture not only a sense of the spirit of Indian life but also the rapturous wonder of the white man's first glimpse of the American West.

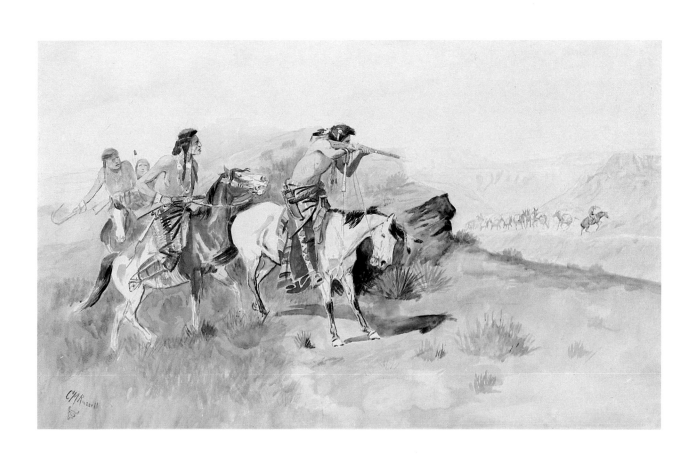

GEORGIA O'KEEFFE
BORN 1887

ANOTHER CHURCH, HERNANDEZ, NEW MEXICO
OIL ON CANVAS, CIRCA 1939
10 x 24 INCHES

One of the major figures of early twentieth century modernism in this country, Georgia O'Keeffe has continued to be a vital force in American art. Her paintings contain both beautiful visual patterns and an emotional expression informed by controlled intensity. While O'Keeffe steadfastly maintains that her approach to painting is purely aesthetic, critics and admirers often impose emotional and psychological interpretations on her work.

Born in Sun Prairie, Wisconsin, O'Keeffe was one of seven children in a successful farming family. In 1905-1906, she briefly studied drawing at the Chicago Art Institute before a serious bout of typhoid necessitated her withdrawal. Upon recovering, she enrolled at the Art Students League in New York and was taught there by William Merritt Chase, F. Luis Mora, and Kenyon Cox. Soon, dispirited with her studies and accomplishment, O'Keeffe moved to Chicago to work as a commercial designer.

In 1912, while visiting her family in Charlottesville, Virginia, she attended the summer classes of Alon Bement, a disciple of Arthur Wesley Dow. An influential teacher at Columbia University, Dow rejected European realism for Eastern principles of design involving flat patterning, simplified forms, and harmonious color. O'Keeffe recognized in this approach a means of expression that would free her from her academic training, and in 1914 she entered courses at Columbia under Dow.

Later that year, O'Keeffe moved to Texas to teach in the public schools. There, she made some landscape sketches and sent them to a friend in New York. The free form drawings in charcoal and watercolor were shown to Alfred Stieglitz, who mounted them in an exhibition at his "291" gallery. At first displeased at the idea of showing her work, O'Keeffe eventually acquiesced to the exhibition. She held her first one-woman show at "291" in 1917. In 1918, Stieglitz offered O'Keeffe a stipend for one year so that she could devote herself to painting. She moved to New York and became a member of the Stieglitz circle along with Arthur Dove, John Marin, Marsden Hartley, Charles Demuth, and Paul Strand. Although she developed her own unique imagery, O'Keeffe's style adopted the linearity, geometrizing and broad flattening of the precisionist movement. Her famous series of flower paintings was begun in 1926. She also created some outstanding visions of American architecture, both in New York and the Southwest.

In 1929, O'Keeffe visited Taos and discovered the arid, brilliantly lighted landscape and sky of New Mexico. She was particularly fascinated by the hills of the desert and the Rio Grande Valley. The simple forms of the region's adobe buildings were for many years to provide subjects for paintings like *Another Church, Hernandez, New Mexico*. O'Keeffe returned to New Mexico every summer until 1949, when she settled permanently at the Ghost Ranch. She also kept an adobe house in the nearby village of Abiquiu, north of Santa Fe.

The holder of several honorary doctorates, the recipient of retrospectives in major museums across the country, and recently the subject of a widely acclaimed film, O'Keeffe is now involved in ceramics as well as in paintings often more abstract than her earlier works.

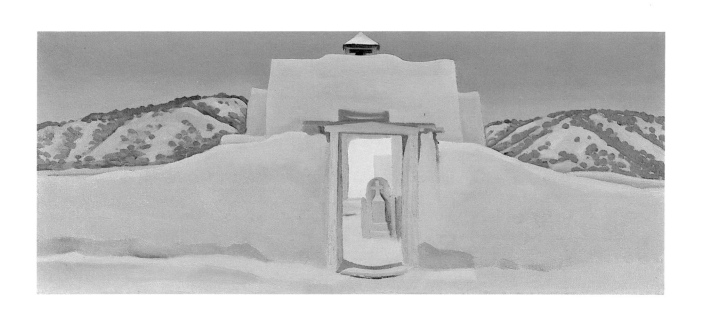

WEIL BROTHERS-COTTON, INC.

Weil Brothers-Cotton, Inc., a cotton marketing firm, was founded in Opelika, Alabama, in 1878 by the brothers Isidor and Herman Weil. In its early years, the firm purchased cotton in Mississippi, Alabama, and Georgia and shipped it through the ports of Mobile, New Orleans, and Savannah to New England mills and to customers in Europe. About 1898, Weil Brothers acquired the business of New York's John C. Graham and Company and became members of the New York Cotton Exchange.

In 1903, the business was moved from Opelika to Montgomery, Alabama. Cotton-growing areas were expanding westward, and the textile industry in the United States was beginning to move from New England to the South. After World War I, second generation brothers Adolph and Leonel Weil began operations in Tennessee and Texas, and later in California. Due to export restrictions on United States cotton, the business expanded into Mexico about 1930. Since then, it has grown to include companies in Central and South America, the Middle East, and Africa. The corporation is also established in the Orient, now an active center for the textile industry. Today, Weil Brothers and its affiliated companies are managed by Adolph Weil, Jr. and Robert S. Weil, grandsons of Isidor Weil. A fourth generation is also represented in the family business.

Weil Brothers-Cotton, Inc. began a program of purchasing art just prior to 1970. Reflecting the preferences of the two principals of the business, the collection comprises art in various media and from many countries. The works range from those by such European masters as Auguste Renoir, Edgar Degas, and Claude Monet to those by American artists including Winslow Homer, Edward Hopper, Maurice Prendergast, and Willem de Kooning. The collection includes paintings, watercolors, Chinese scrolls, woodcuts, etchings, and engravings. The Weil brothers believe that having the art in the firm's offices makes what would otherwise be unimaginative surroundings an inspiring environment in which to work.

In addition to maintaining and expanding the collection, the company contributes to the Montgomery Museum of Fine Arts and to local art councils and competitions. It has a liberal loan policy, and works owned by Weil Brothers have been included in exhibitions in Alabama, South Carolina, and Florida. Recently, the company promised the National Galleries of Scotland one of its paintings for an upcoming Degas exhibition.

Adolph and Robert Weil feel that "participation in art collecting enriches not only the collector but also the community in which the collector lives, in that it provides cultural advantages otherwise found only in the great cities of the world."

WINSLOW HOMER

1836–1910

UPLAND COTTON

OIL ON CANVAS, 1875

49¼ x 30¼ INCHES

Winslow Homer is considered one of the foremost American painters of the nineteenth century and one of the few American masters of watercolor. A self-taught artist, he developed steadily, passing through a series of stylistic changes to his final studies of the elemental contest between land and sea. Homer's compositions are highly structured and superbly colored. Their strong outlines and solid masses offer a powerful aesthetic and emotional effect.

Born in Boston and raised in Cambridge, Homer showed an early interest in drawing. In 1855, he was apprenticed to John H. Bufford, a well-known Boston lithographer. He disliked the mechanical aspect of lithographic work, however, and became an illustrator, working for *Ballou's Pictorial* and *Harper's Weekly*. In 1859, Homer moved to New York, where he continued to work for *Harper's* and studied briefly at the National Academy of Design and with landscapist Frederic Rondel. As part of his job, he was sent to Civil War battlefields in Virginia as a field illustrator, but he preferred drawing views of camp life to scenes of battle. Influenced by photography, Homer began composing sketches of large, simplified forms with solid blocks of black and white; this style facilitated the wood-engraving process of commercial reproduction. He also began his first experiments with oil painting.

At the end of the war, Homer made his first trip to France, returning with a new interest in color and a lightened palette. He began painting in earnest, choosing themes from rural life in upstate New York, the White Mountains of New Hampshire, and the North Shore area of Boston. His technical interests widened to include watercolor. In 1875, he traveled back to Petersburg, Virginia. He presumably composed *Upland Cotton* from impressions of this trip. The painting was first exhibited in 1879 at the National Academy of Design. *Upland Cotton* gives an indication of Homer's growing preference for large figural forms and strong primary colors.

The major turning point in Homer's career occurred in 1881-1882 when he returned to Europe and journeyed to a bleak fishing village in northern England. His work of this period grew increasingly somber in color and monumental in form. Even more notable was the disappearance of anecdote from his painting; the theme of survival took precedence over narrative detail.

Upon returning to America, Homer settled on Prout's Neck, a rocky peninsula on the Maine coast. He continued to work in both watercolor and oil, creating powerful seaside studies of man and nature as well as scenes of outdoor life in the Adirondacks and the Caribbean. As his studies progressed, however, he eliminated the human figure altogether and devoted his energy to depicting nature. Despite his reticence and solitary existence, Homer gained ever greater acclaim and popularity.

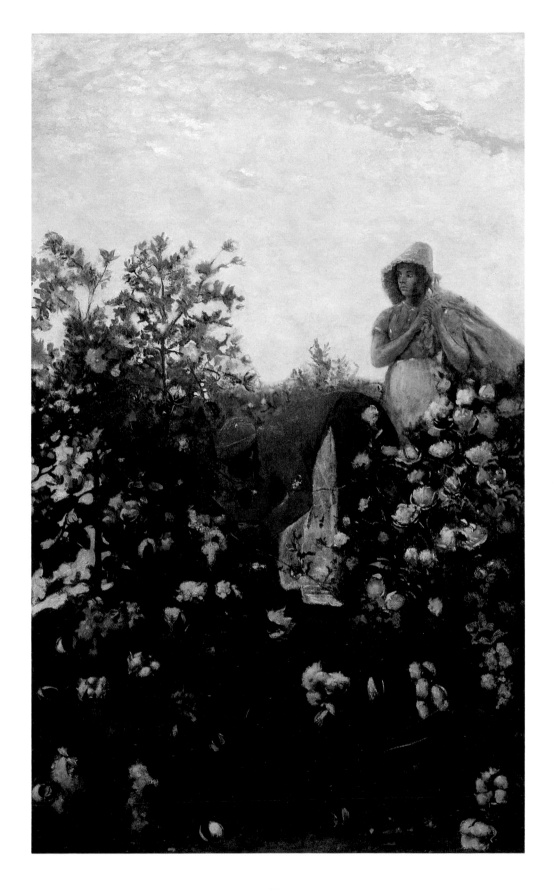

THOMAS HART BENTON

1889–1975

ACROSS THE CURVE OF THE ROAD

OIL ON PANEL, LATE 1930s

24¼ x 30⅜ INCHES

Thomas Hart Benton was perhaps the most popular and best known of the American scene painters during the 1930s. Articulate, argumentative, and prolific as an artist and writer, Benton was born in Neosha, Missouri, the son of a United States Congressman. He was the namesake and grandnephew of Missouri's illustrious United States Senator. Understandably, his boyhood was filled with discussions of the political and social issues shaping the Midwest, and his youth was divided between Neosha and Washington, D.C.

From the outset, Benton was interested in drawing. In 1905, he gained his first professional experience as a cartoonist for the Joplin (Missouri) *American*. He decided to abandon newspaper work to concentrate on painting, and in 1906 he enrolled at the Art Institute of Chicago. Two years later, he went to Paris to continue his training at the Académie Julian. Introduced to the impressionists and post-impressionists by his friends, Benton began experimenting with a variety of avant-garde styles. He returned to America in 1912, initially settling in Missouri but ultimately moving to New York City. Here, he renewed his acquaintance with Stanton Macdonald-Wright, whom he had known in Paris, and became involved in synchromism. Benton sought in its color theories a way to combine the new focus on pure color with the art of the Renaissance and Baroque. He began to construct abstracted figures in a rhythmical manner related to early sixteenth century compositions— Michelangelo and El Greco were especially influential. In 1916, Benton participated in the Forum Exhibition, his first public exposure.

During World War I, Benton served as a draftsman for the Navy, and his interest in figurative art was reinforced. He subsequently abandoned abstract painting in favor of American historical subjects. From 1920 to 1924, Benton explored the back country of America via foot, bus, and train. Captivated by the raw energy of its people, he wanted to probe the frantic pulse of America and the various environments it sustained. To convey a sense of activity within energetically charged landscapes, the musculature of Benton's figures became exaggerated, their poses distorted, and their settings fragmented. By 1926, Benton's mature style had emerged, and with it, his ideological commitment to the development of a purely American art.

Benton was best able to project his image of America through large-scale historical murals. In these readily identifiable scenes, the local citizens could often see themselves and their ancestors as participants in their region's development. In the 1940s, Benton became less concerned with recording the usable past and more concerned with creating an idealized past.

Across the Curve of the Road, painted in the 1930s after Benton had moved back to Missouri, reveals a move away from angular figures engaged in frenetic activity. The painting reflects Benton's compassion for the land and its people and his understanding of local geography. Typical midwestern cloud formations and the character of the state's softly rolling hills are easily recognizable. The painting strikes an elegiac note of intimacy not often found in Benton's earlier works.

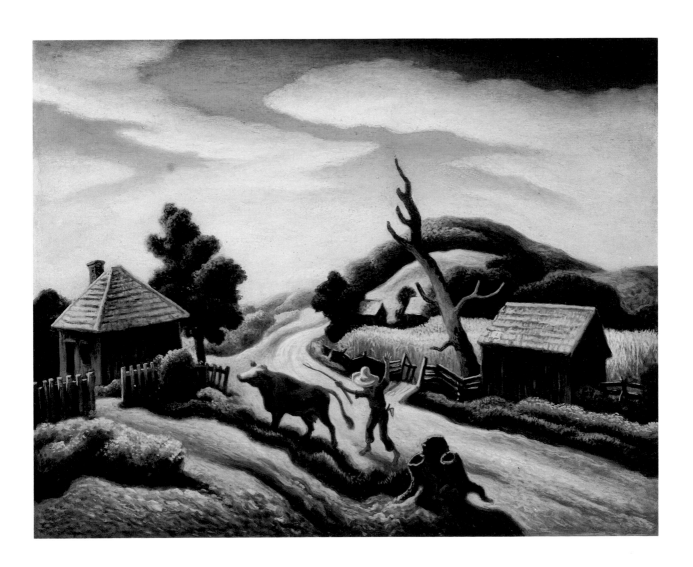

ANDREW WYETH
BORN 1917

ALEXANDER CHANDLER
WATERCOLOR ON PAPER, 1955
20¾ x 14¼ INCHES

Andrew Wyeth is perhaps more admired by the general public than any other living artist. His art is celebrated for its poignant clarity and realistic evocation of a simple rural life lost to and romanticized by most Americans. An underlying foundation of Wyeth's popularity is his sure draftsmanship, superb sense of design, and subtle coloring. This renowned style is complemented by an engaging contemplative mood; Wyeth's art conveys a subjective sense of tragedy and mortality, a hint of man's finer as well as baser instincts.

Wyeth was born in Chadds Ford, Pennsylvania, son of the well-known illustrator Newell Convers Wyeth. He received some early training from his father but is essentially self-taught. In 1937, he was given his first one-man show in New York, exhibiting a series of Maine watercolors. By the end of the second day, every work had been sold. Perhaps in reaction to this instant success, Wyeth subdued his colors. Two years later, he turned to the use of tempera and the dry brush technique.

Wyeth's choice of subjects lies within his immediate life: his neighbors in Chadds Ford, the environs of his summer home in Maine, and his family and friends. All his paintings have a carefully structured design and a single focus. Wyeth's representational style goes beyond the relatively straightforward pictorial depiction of realistic form, for often he suggests ominous, even morbid, sentiments.

The portraits usually depict strong individualists. *Alexander Chandler* is a study of a blind man whom Wyeth glimpsed while driving through a neighboring village. It is a sensitive portrayal of the infirmities of old age, but the blind stare off to the perimeter of the painting, the determined mouth, and the focus on the hands directly below, suggest an inner strength, adjusted to accepting the vicissitudes of life. These details amplify the meaning of the portrait.

Wyeth's immense popular success depends somewhat upon his chosen themes, seemingly simple, traditional, and honest, even romantic in today's culture. They are presented in a style easier to comprehend than that of much contemporary painting. Also a factor is the conception that his finely detailed paintings are produced through long and laborious work. Whatever the full explanation, Wyeth has touched a responsive chord in Americans today. His infrequent exhibitions have continually attracted many viewers, and his works are among those most sought after by collectors. In 1976, the Metropolitan Museum of Art, New York, celebrated the Bicentennial with an extensive one-man exhibition of Wyeth's paintings and drawings.

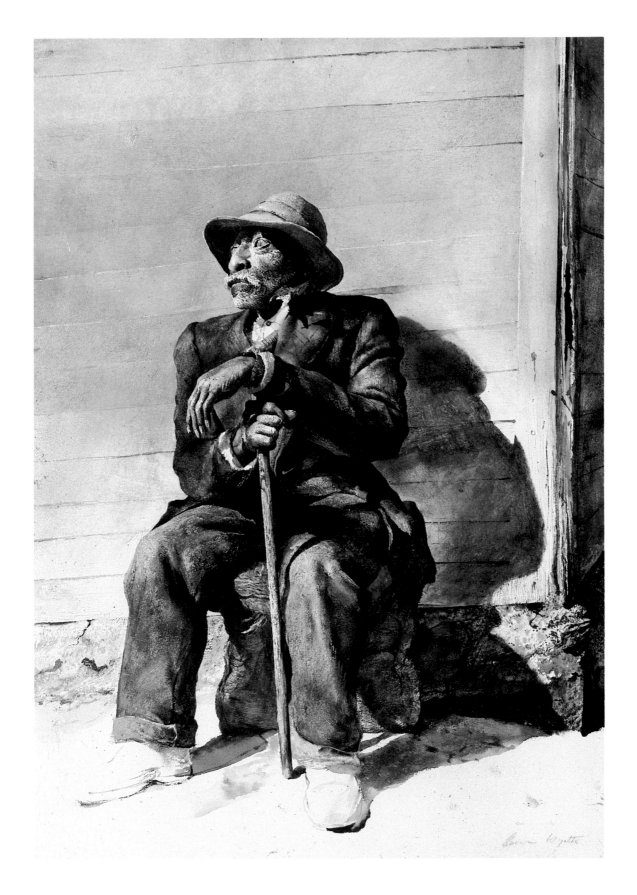

91

UNITED STATES STEEL CORPORATION

United States Steel Corporation was incorporated February 25, 1901, and began business in April of that year. Organized as one of the world's largest manufacturing operations, it has continued since that time as America's leading steel producer. A number of the nation's legendary businessmen of the period were involved in the formation of the company, among them Andrew Carnegie, J.P. Morgan, and Charles M. Schwab. Since its formation, U.S. Steel has undergone great change. As America's economy has continued to grow, the company has adapted its operations to the increasing and varying demands for steel. From time to time, new production units have been added better to serve these demands and to round out operations. In 1964, a major reorganization was carried out when seven divisions were consolidated with other steel operations, bringing all domestic mining, lake shipping, and steel manufacturing under the Production Department of U.S. Steel Corporation. Administration of the steel processing plants is currently grouped under two branches of the Production Department, Eastern Steel Operations and Western Steel Operations.

United States Steel's art collection was assembled in 1970 at the time of the opening of the new headquarters building in Pittsburgh. An attempt was made to include works by artists of international reputation as well as by artists from the Pennsylvania region where the headquarters are located. According to Edgar B. Speer, Chairman of the Board, the idea of including the works of many local artists in the collection "is particularly appropriate to U.S. Steel and its Pittsburgh headquarters. The corporation, although worldwide in its scope of operations, has many of its roots in Pittsburgh and western Pennsylvania."

Historically important European artists, such as Eugene Delacroix, Edouard Vuillard and Fernand Léger, are represented in the collection. Many well-known American artists also have works in the collection, including Morris Louis, Joan Mitchell, Leon Polk Smith, Mark Tobey and Louise Nevelson. The works were selected by a distinguished panel of experts that included Leon Arkus, Director of Carnegie Institute's Museum of Art, Pittsburgh; Max Abramovitz, Harrison & Abramovitz & Abbe, architects of the building; Maria Bergson, President, Maria Bergson Associates, interior design firm; James M. Walton, President, Carnegie Institute; Sylvester Damianos, President, Pittsburgh Plan for Art; and Edgar B. Speer, Chairman of U.S. Steel.

CHILDE HASSAM

1859—1935

OLD HOUSE, DORCHESTER

OIL ON CANVAS, 1884

16 x 20⅛ INCHES

Although he began his career as an illustrator and was educated in the French Academic tradition, Childe Hassam became one of America's leading exponents of impressionism. His brilliantly colored, sunlit studies of American landscape, architecture, and interiors have made him a well recognized figure in American art.

Born in the Boston suburb of Dorchester, Hassam spent his youth apprenticed to an engraver. In his spare time, he studied at the Boston Art School, then at the Lowell Institute, and finally with the young German painter Ignaz Gaugengigl. He also began working as an illustrator. In 1883, Hassam made the first of many trips to Europe but was back within a year to be married in Boston. It was during his stay in Boston that he painted Old House, Dorchester in the darker tonalities of his pre-impressionist period. Returning to Paris in 1886, he began studies at the Académie Julian under Gustave Boulanger and Jules Lefebvre. The following year, one of Hassam's paintings was accepted at the Salon, and in the Paris Exposition of 1889 he won a bronze medal, the first of many prizes and awards he was to receive throughout his lifetime.

Having completed three years of study at the Académie, Hassam returned to the United States in 1890. He brought with him not the official academic style but the impressionist technique of broken brushwork and a high-keyed palette. Settling in New York, he soon became friends with other American advocates of impressionism—Willard Metcalf, J. Alden Weir, Robert Reid, and John Twachtman. This group formed the nucleus for the first collective exhibition of American impressionists, The Ten American Painters, which opened at New York's Durand-Ruel Gallery in 1898.

Despite his espousal of impressionist technique, Hassam maintained a certain amount of description in his work. He balanced his interest in the effects of light and color against his concern for describing particular subjects. Perhaps because of his colonial ancestry, Hassam especially favored colonial artifacts. The eighteenth century home in Old House, Dorchester is characteristic of his architectural subjects. He also painted many interior scenes, often centered on a single figure silhouetted against a sunlit window.

About 1915, Hassam became interested in printmaking; he produced over three hundred etchings and lithographs, a number of which depict colonial architecture in New England and New York. Intensely patriotic, he was moved during World War I to paint a series of studies of colorful New York streets draped with the flags and bunting of wartime celebrations. Hassam's inherent artistic conservatism was reflected in his aversion to the new trends in painting which developed after the turn of the century. Although his late work lacks his characteristic vitality, the uncomplicated joy in Hassam's artistic vision gives a delightful quality to much of his painting.

94

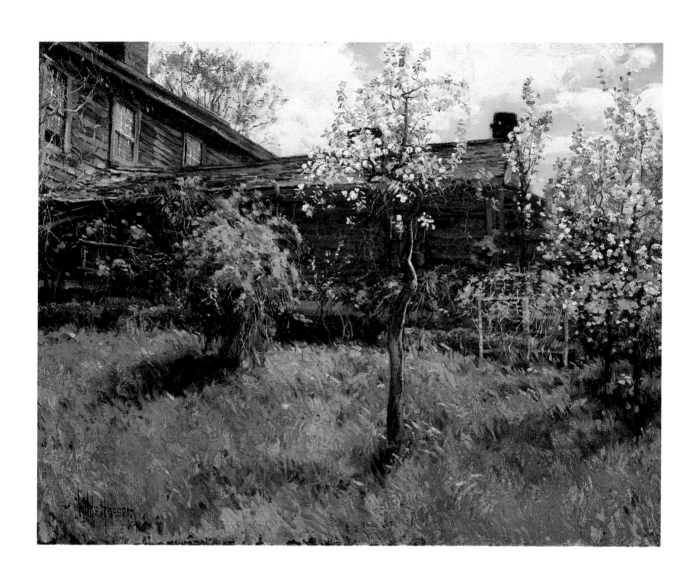

JOHN HENRY TWACHTMAN

1853–1902

LANDSCAPE STUDY

OIL ON CANVAS, CIRCA 1890

31¾ x 53¼ INCHES

John Henry Twachtman was one of the most important and original of the large group of American impressionists. His style evolved continuously from the time of his training in Munich to his adoption of impressionist technique. Just before his death, he developed yet another style, perfecting a delicate tonality that approached abstraction.

Twachtman was born in Cincinnati, Ohio. His father was a German immigrant who decorated window shades. While still young, Twachtman joined his father in attending drawing classes at the Ohio Mechanics Institute. He later entered the Cincinnati School of Design to work under Frank Duveneck. In 1875, he journeyed with Duveneck to Munich; there, he studied under Ludwig Loefftz for two years. He then joined Duveneck and William Merritt Chase in Venice. Twachtman's early paintings had the dark, warm tonalities and free brushwork of Duveneck and the Munich School. However, Twachtman eschewed their typical romanticized figure paintings and genre scenes. Instead, he chose straightforward landscape views.

In 1883, Twachtman journeyed to Paris and took classes at the Académie Julian under Gustave Boulanger and Jules Lefebvre. While in Paris, he was profoundly affected by the work of the French impressionists and the delicate tones and balanced forms of James A. McNeill Whistler. As a result, Twachtman's paintings changed dramatically in color, and he acquired a richly brushed technique. He was also inspired to turn to etching and produced prints in the manner of Whistler's Venetian period.

After returning to the United States, Twachtman spent a short time in Cincinnati and Chicago before settling on a farm near Greenwich, Connecticut. His theme was landscape, and he depicted simple subjects with exquisite design and subtle hues. He was particularly attracted to winter scenes. Twachtman taught in New York City at the Cooper Union and the Art Students League. In 1898, he was one of the founders of "The Ten," a group of American impressionists who first exhibited together in that year. Twachtman's last summers were spent in the picturesque fishing port of Gloucester, Massachusetts.

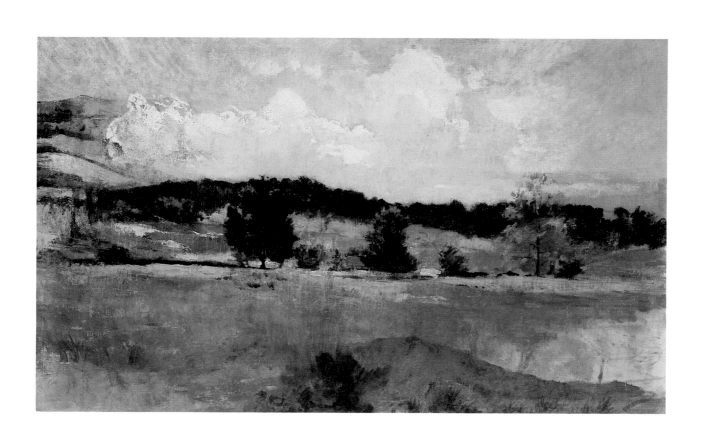

RALSTON CRAWFORD
1906–1978

NACELLES UNDER CONSTRUCTION
OIL ON CANVAS, 1946
28¼ x 40 INCHES

Ralston Crawford, painter, photographer, and lithographer, is best known for his abstract depictions of the industrial landscape and urban life. The pursuits of his youth left him with a deep admiration for the world of steel and concrete. Born in St. Catharines, Ontario, and raised in Buffalo, New York, Crawford spent much time sailing on the Great Lakes, and developed a fascination for the industrial architecture of harbor cities. In 1926-1927, he sailed on tramp steamers through the Caribbean and Central America, ending up in California. There, Crawford decided to become an artist and enrolled in the Otis Art Institute (now the Los Angeles Art Institute). He also worked for a time in Walt Disney's studio in Hollywood.

Crawford returned East to attend the Pennsylvania Academy of Fine Arts, Philadelphia, where he studied with the progressive teachers Hugh Breckinridge and Henry McCarter. It was the Barnes Foundation in nearby Marion, however, with its collection of modern masterpieces, that really opened the young artist's eyes to contemporary ideas. Crawford continually alluded to the impact of the art of Matisse with its taut delicacy of line and clarity of color, the art of Cézanne with its structural discipline, and the art of Picasso with its abstract forms. Crawford also studied in Europe for a year. His first one-man show, held at the Maryland Institute of Art in 1934, signaled his arrival as an original and distinctive artist. Crawford was dedicated to teaching and served as a visiting instructor at many institutions, including the Art Academy of Cincinnati, the Honolulu School of Art, and the Brooklyn Museum Art School.

World War II interrupted Crawford's painting career, and he served as Chief of Visual Presentation for the Unit of Weather Division, Army Air Force. In 1946, Crawford was the only artist to cover, for *Fortune* magazine, the detonation of the atomic bomb at Bikini. After the war, Crawford returned to painting, teaching, and traveling. His travels provided constant visual stimulation, whether the colors of Ajanta and Ellora in India, the bullfights in Spain, or the jazz in New Orleans. In his late years, Crawford devoted much energy to lithography and especially to photography, through which he left a remarkable record of his travels and his sensitive vision. Crawford's devotion to jazz was such that, although he lived in New York and died in Houston, he was buried in New Orleans with a traditional jazz funeral.

Nacelles Under Construction is based on Crawford's observation of unassembled aircraft parts at a Curtiss-Wright factory where he was working on a commissioned painting. In contrast to his previous more representational imagery of the late 1930s, this painting has a nonobjective quality; the engine cover parts are not readily recognizable. The artist is making a picture out of refined experience; it is not *of* something but *about* something. As Crawford himself noted, "I don't feel obligated to reveal the forms. They may be totally absent to the viewer of the work, or even to myself, but what is there, however abstract, grows out of something I have seen." Within a near abstract design, he achieves clarity through the use of lucid color. Crawford's precisely constructed vision metaphorically suggests the world of modern technology where space and speed are controlled and measured by the mind of man.

98

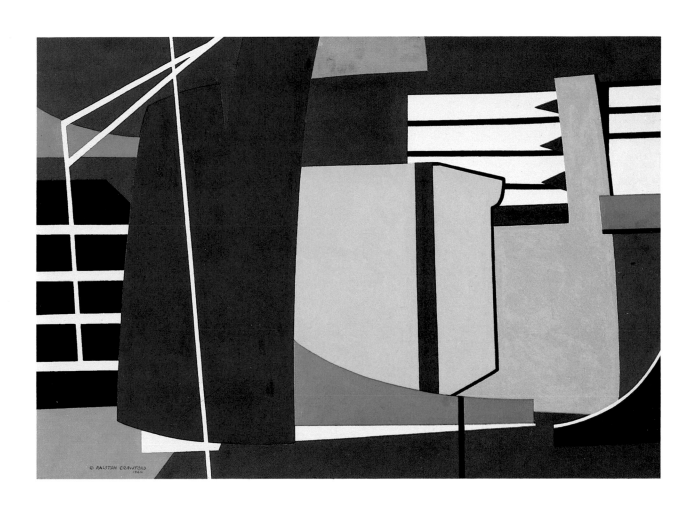

STEINWAY & SONS

Steinway & Sons, Inc., a leading manufacturer of pianos, was founded in 1853 in New York by the Steinway family, three years after they had immigrated to this country. Today, the company is still headquartered in New York. It has a second factory in Hamburg, Germany, and sales offices in London and Berlin. Three Steinway brothers, great-grandsons of the founder, are presently in charge of the corporation. It is now a subsidiary of Columbia Broadcasting System.

The paintings included in this exhibition are normally on view with the other works in the Steinway Collection. They can be seen at Steinway Hall in New York, which is open to the public five days a week. The collection began at the turn of the century as an advertising campaign. The company commissioned important painters and sculptors to create works that related to music or to great musicians or composers. In 1919, the company published *The Steinway Collection*, a sumptuous book containing early examples of tipped-in color plates. Twelve works were reproduced and accompanied by critic James Huneker's texts describing the musicians and their scores. Included were N.C. Wyeth's *Beethoven and Nature* and John C. Johansen's *Liszt*.

The collection now consists of over two hundred works of art—drawings and watercolors as well as paintings and sculpture. Especially prominent are works by such artists as Randall Davey, Charles E. Chambers, Ignacio Zuloaga, and Rockwell Kent, and sculpture by Malvina Hoffmann and the Polish sculptor Podanovich. On occasion, the paintings, such as a Somoff portrait of Rachmaninoff, have been reproduced on album covers of the composer's music.

In addition to its art endeavors, Steinway & Sons, Inc. operates a Concert Service program which supplies approximately three hundred fifty concert pianos to cities throughout the world. These pianos are made available at no cost to concert pianists performing in various locations, thereby enabling many artists and institutions who cannot afford the rental of a fine piano to present concerts and recitals. Steinway is also a patron of the New York Philharmonic Orchestra.

N.C. WYETH
1882–1945

BEETHOVEN AND NATURE
OIL ON CANVAS, 1918
48⅝ x 42½ INCHES

Newell Convers Wyeth was an acclaimed and popular illustrator. Perhaps most noted for his work in books for children, he also made many illustrations for other books and for magazines. In addition, he painted murals, undertook commercial work of all types, and later in life, developed a strong interest in easel painting. His work is recognized for its fine draftsmanship, its expressive and heroic figures, and its dramatic use of light and color. Particularly noteworthy is Wyeth's ability to capture and emphasize specific emotional moods; this adds immeasurably to the expressive content of his illustrations.

Born on a farm in Needham, Massachusetts, Wyeth attended the Massachusetts Normal School of Art where he was encouraged to pursue his natural ability in drawing. After a few years' study in Boston under Charles W. Reed and at the Eric Pape School of Art, he transferred to a school run by the illustrator Howard Pyle in Wilmington, Delaware. Under Pyle's tutelage, Wyeth learned his distinctive style and acquired his ambition to become an illustrator.

Inspired by the work of Frederic Remington, Wyeth looked to the American West for his first area of specialization. His interests soon expanded and he produced memorable illustrations for editions of such authors as Robert Louis Stevenson and James Fenimore Cooper. Wyeth also created calendars and various scenes for advertisements. Extending his abilities, he painted a number of murals, completing commissions for the Utica Hotel in Utica, New York, and the Missouri State Capitol. Late in life, he began a series of fine easel paintings, some in tempera. Settled in Chadds Ford, Pennsylvania, the site of Pyle's summer studio, Wyeth raised a family of talented artists, including his son Andrew.

Beethoven and Nature is one of four works commissioned from Wyeth by Steinway and Sons to enter the company collection and to be used in advertisements for their pianos. The painting typifies Wyeth's evocative, realistic style. His physiognomy readily recognizable, the figure of Beethoven stands with a pensive look before a small brook. Beethoven's love of nature is well documented. He spent many of his summers in the picturesque countryside around Vienna, wandering with his musical notebook, ready to record his inspirations. One passage of the famous *Pastoral Symphony* was inspired by the sounds of a small brook and perhaps it is this moment that Wyeth chose to represent.

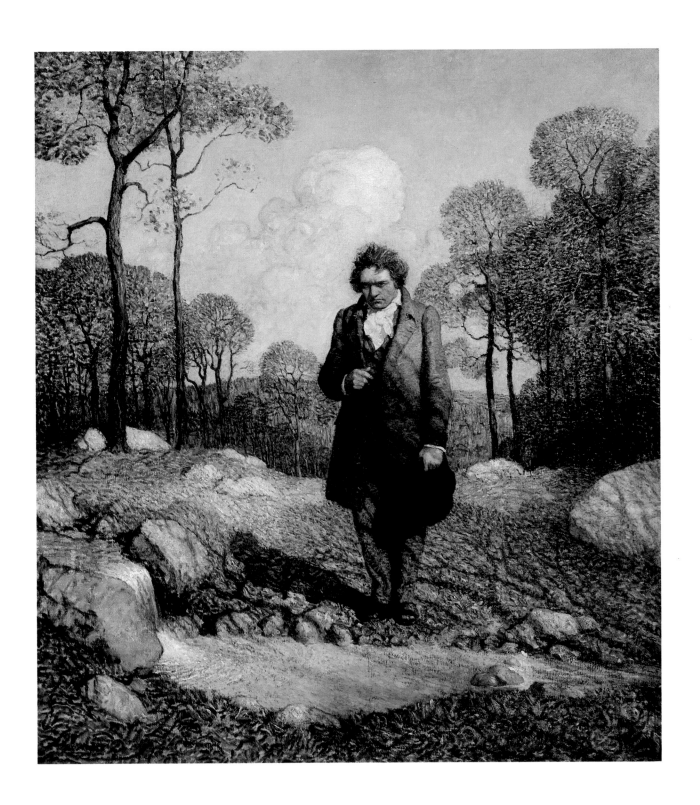

ROCKWELL KENT

1882–1971

RICHARD WAGNER, "DAS RHEINGOLD," THE ENTRANCE OF THE GODS INTO VALHALLA

OIL ON CANVAS, 1929

33 ¼ x 43 ⅜ INCHES

A versatile and energetic man, Rockwell Kent was an accomplished painter, printmaker, illustrator, draftsman, and architect. As an artist, his style derived in part from the avant-garde developments following the Armory Show of 1913 and also showed certain similarities to that of the precisionists. Kent's landscape studies were composed of large, geometric forms, simplified and organized into a rhythmic design. His figural work was greatly influenced by the English artist William Blake.

Kent was born in Tarrytown, New York. While an architecture student at Columbia University, he also attended William Merritt Chase's summer classes in Shinnecock, Long Island. In 1903, Kent entered the New York School of Art, continuing to study under Chase as well as under Robert Henri and Kenneth Hayes Miller. His paintings exhibited the dark tonalities and fluid brushwork of the Henri circle. During the following summer, he worked as a studio assistant to Abbott Thayer in Dublin, New Hampshire.

While employed as a draftsman in New York for the next nine years, Kent began the first of his travels to hostile climates, where he pitted himself against the extremes of nature. At Henri's suggestion, he visited Monhegan Island, off the Maine coast, later building a house and establishing summer art classes there with Julian Jolz. Kent spent winters in the Berkshires or the White Mountains. In 1911, he organized the *Independent Exhibition of Eleven Artists* including Maurice Prendergast, George Luks, and Arthur B. Davies as well as Marsden Hartley, Alfred Maurer, and others. Three years later, his first book illustrations appeared in a small satirical novel, *Architectonics: The Tales of Tom Thumtack, Architect.*

Kent experimented with living in Newfoundland and later on Fox Island, Alaska, where he spent 1918 with his nine year old son. In 1920, he published his first book, *Wilderness: A Journal of Quiet Adventure,* an account of his Alaskan experience. It marked Kent's coming of age as an artist and the beginning of his work as one of the most important graphic artists of the 1920s and 1930s.

Kent's stylized and powerfully designed illustrations and vignettes made him extremely successful. As proficient in printmaking as he was in painting, Kent could produce commercial advertisements as easily as illustrations, individual prints, or oil paintings. He was one of several American artists who received commissions from Steinway and Sons during the second two decades of this century. *The Entrance of the Gods into Valhalla* represents a scene from Wagner's *Das Rheingold.* It is a fine example of Kent's balanced composition, stylized forms, and smooth painting technique.

A strong individualist and humanitarian of liberal beliefs, Kent came under investigation during the McCarthy era. He is unique among American artists in being the recipient of the Lenin Peace Prize in 1967.

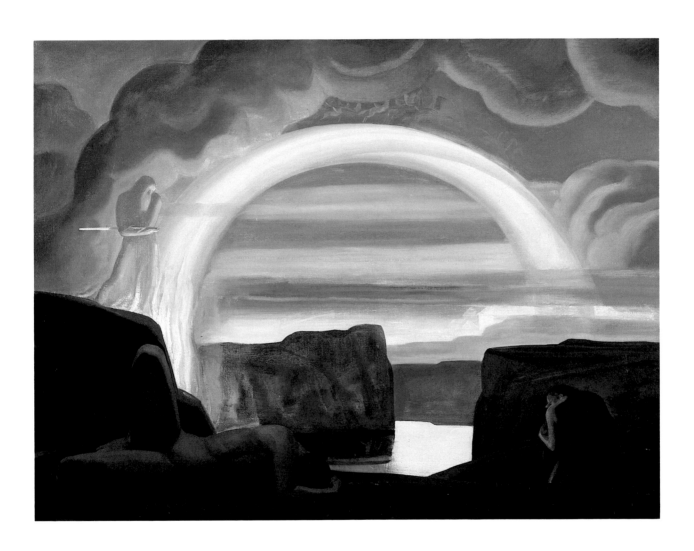

CHARLES E. CHAMBERS
1883–1941

HENRY ENGELHARD STEINWAY AT HIS WORKBENCH
OIL ON CANVAS, 1920
30⅛ x 30⅛ INCHES

Born in Ottumwa, Iowa, Charles Chambers studied at the Art Institute in Chicago and in New York at the the Art Students League. He became a successful New York illustrator and joined the Society of Illustrators in 1912. Painting both in black and white and in color, he was employed by *Cosmopolitan* to illustrate "Get Rich Quick Wallingford" and stories by Pearl Buck. He also supplied *Harper's Magazine* with many frontispieces. Chambers designed a number of advertisements including a series for Chesterfield cigarettes. He was one of several artists commissioned by Steinway and Sons to paint portraits of famous composers and musicians, scenes from operas, and other musical compositions.

Chambers' portrait of Henry Englehard Steinway commemorates the founder of the Steinway firm. One of twelve children of a German forester in the Hartz mountains, Steinway was the sole member of his family to survive the Napoleonic wars. Always interested in music, he began as a cabinetmaker and wood carver, soon moving to a shop that made organs. At home, he experimented with pianos and produced the first Steinway Grand in 1839. In 1850, Steinway and most of his family immigrated to New York. There, they joined Henry Steinway's son Charles, who had been forced to leave Germany after the Revolution of 1848. Steinway and Sons soon became a musical success itself, owing to the high quality of craftsmanship in its pianos and the many innovative improvements brought to their sound.

By the time of the elder Steinway's death in 1871, the company had built a large factory with power-driven machinery. Chambers depicts Steinway at an earlier period, working by hand in his small workshop. Painting in a realistic manner, the artist enlarges the usual concept of a portrait to recreate an imagined moment long past. Chambers highlights Steinway's face, intent upon a job about to be completed, a piano about to make music.

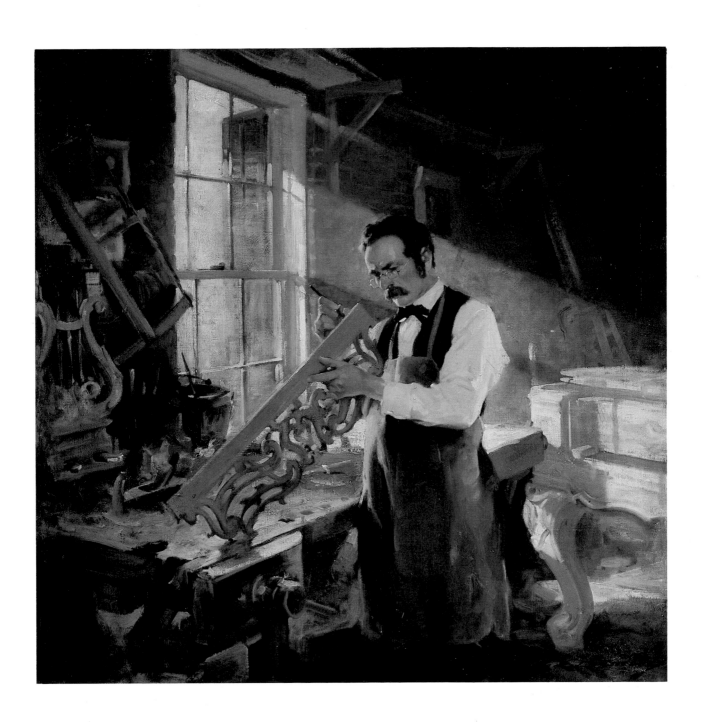

BLOUNT, INC.

Founded in 1946, Blount, Inc. is an international company whose principal lines of business are construction and agribusiness products and services. The corporation is headquartered in Montgomery, Alabama, and operates internationally. Specializing in unusual and complex construction projects, Blount, Inc. built the Superdome in New Orleans and the launch facilities for the moon shot at Kennedy Space Center, which it is presently adapting for the new space shuttle.

The Blount Collection was begun in 1973 after the Chairman of the Board, President, and Chief Executive Officer, Winton M. Blount, returned to Montgomery following his tenure as Postmaster General in the first Nixon Administration. At that time, construction was completed on the firm's award-winning headquarters. Blount, extending a long-standing personal interest in the arts, decided to form a corporate collection of American art to complement the superb design of the new building, an appropriate project to undertake for the upcoming Bicentennial. The extensive collection comprises American art from the time of the Revolutionary War to the present. Included are eighteenth and nineteenth century masters such as John Singleton Copley, Charles Wilson Peale, and Mary Cassatt. Among the many twentieth century artists represented are Charles Burchfield, Ben Shahn, and Edward Hopper. The collection is documented in an illustrated catalogue; individual works are made available for loan to qualified institutions.

In an address to the Business Committee on the Arts in Los Angeles, 1978, Blount described his belief that art and business are "natural allies" when he said, "I feel that the business role is two-fold. It is in commissioning works and in making significant works available to our various publics. Some of us do one, some the other, some both. In the former respect, we are like the old patrons, but better. Today, wealth is not concentrated in so few hands. It is spread broadly, and the opportunity to use it well and the obligation to use it well has spread proportionately." In addition to contributing generously to the support of the Montgomery Museum of Fine Arts and sponsoring the *Art Inc.* exhibition organized by that institution, Blount served twice as Chairman of the Committee of Religion and Art in America at the Vatican in 1976 and 1978.

STUART DAVIS
1894 – 1964

SUMMER TWILIGHT
OIL ON CANVAS, 1932
36¼ x 24 INCHES

Stuart Davis eagerly embraced the avant-garde temperament which developed in the United States after 1913. In the 1920s, he created a personal style of abstract art utilizing the experiments of that revolutionary era. Born in Philadelphia to artist parents, Davis grew up in East Orange, New Jersey. His father was a newspaper art editor, who counted many artists among his friends. Davis left high school to study under Robert Henri in New York. His early paintings and drawings manifested the influence of the Henri circle in their socially concerned themes.

The Armory Show of 1913 marked a major turning point for Davis' art. Perceiving the lack of importance given to subject matter by many avant-garde foreign artists and fascinated by the possibilities of a subjective rather than realistic use of color, Davis began to experiment with abstract art. He did not, however, abandon representational painting. In the seacoast towns of New England, which he visited most summers between 1913 and 1934, he discovered the brilliant light that persuaded him to simplify his work. It bleached out color and clarified topographical features. Davis also employed collage and began combining objects seen from different angles into one composition.

In 1917, he was given his first one-man exhibition at the Sheridan Square Gallery in Greenwich Village.

Yet, it was not until 1927-1928 that Davis hit his artistic stride. During that time, he made a series of abstract paintings based largely on the form of an egg-beater. These works were close in style to synthetic cubism. Basing his paintings on pictorial concerns rather than realistic arrangement, Davis greatly simplified the forms and employed an arbitrary but complementary choice of colors. He became particularly interested in achieving a strident, eye-catching effect; his brash use of color derived in part from the dissonant vitality of jazz, one of his obsessions.

Davis' paintings of the 1930s depicted superimposed, strongly colored objects on different planes seen from different perspectives. This pattern of composing is evident in *Summer Twilight*. One aspect of Davis' art is his consistently witty juxtapositions seen here in the bird, business charts, city grid plans, and varying weather conditions. Davis was among the few American artists who continued to champion an abstract style throughout the 1930s when various forms of realism dominated the American art world. Although he began gaining recognition in the 1950s, he had few followers of note. The subject of much recent writing and several major retrospectives, Davis is today considered one of the outstanding American artists of the early twentieth century.

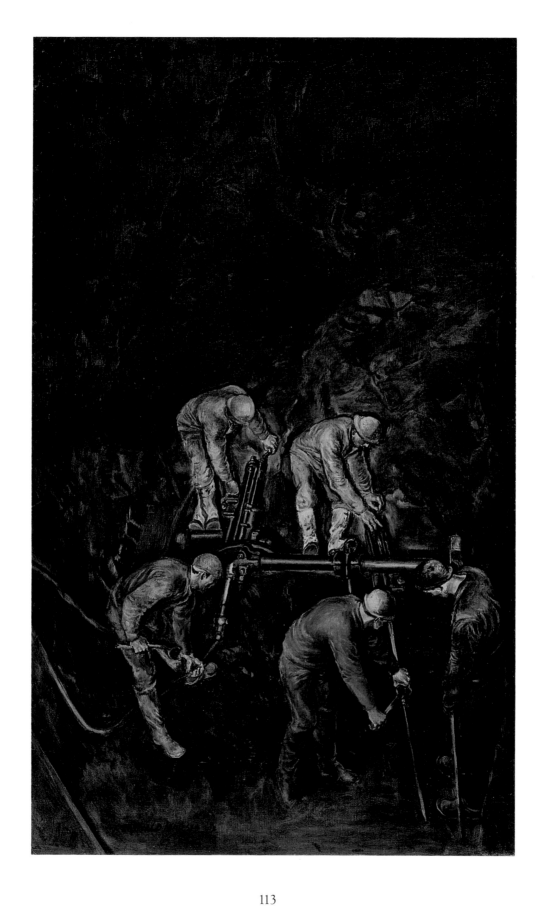

113

EDWARD HOPPER
1882–1967

NEW YORK OFFICE
OIL ON CANVAS, 1962
40 x 55 INCHES

Edward Hopper is one of the most popular and respected American realists of this century. Sombre and solitary images, composed with a spare yet powerful geometric solidity, convey a monumental presence in his urban and rural scenes. Hopper favored particular themes, set either in New York where he maintained his studio, or in the countryside, usually New England, where he spent many summers. His subjects include buildings, often old and usually anonymous; urban interiors with lone or unconnected figures; night scenes; and marines. Often deliberately ambiguous, his works seem to stress the harsher aspects of American culture.

Hopper was born in Nyack, New York in 1882. At the New York School of Art, he studied illustration under Arthur Keller and Frank Vincent DuMond. There, he also took painting courses from Robert Henri and Kenneth Hayes Miller, from whom he acquired an interest in depicting contemporary life. Traveling to Europe in 1906, Hopper stayed in Paris for a year and made visits to England, the Netherlands, and Germany. Patrick Henry Bruce, a friend and fellow Henri student from New York, introduced Hopper to French impressionism. After two more trips abroad in 1909 and 1919, Hopper disavowed any further interest in Europe or its avant-garde art.

Settling in New York, Hopper participated in several important exhibitions: Arnold Friedman's *Paintings and Drawings of Contemporary Americans* in 1908, the *Exhibition of Independent Artists* in 1910, and the 1913 Armory Show, at which he sold his first oil painting. Finding little subsequent support for his art, Hopper turned to illustration and commercial work for a livelihood. His first sustained artistic recognition came from his etchings begun in 1915. In 1920, he held his first one-man show at the Whitney Studio Club, later to become the Whitney Museum. The success of an exhibition of watercolors in 1924 at the Frank Rehn Gallery gave Hopper the confidence to leave commercial work and devote himself wholly to easel painting. A retrospective of his work, the first of many, was held in 1933 at the Museum of Modern Art, New York. In the following decades, Hopper was the recipient of many prizes, awards, and honors.

New York Office is an excellent example of Hopper's urban themes. Framed in an architectonic composition and flooded with the strong, clear light that so fascinated Hopper, the painting focuses on a large window through which one sees a woman strangely immobilized in the sunlight. She is an anonymous figure isolated from, yet inextricably bound to, the business world. Simple and evocative, the painting offers a view that is simultaneously beautiful and disquieting.

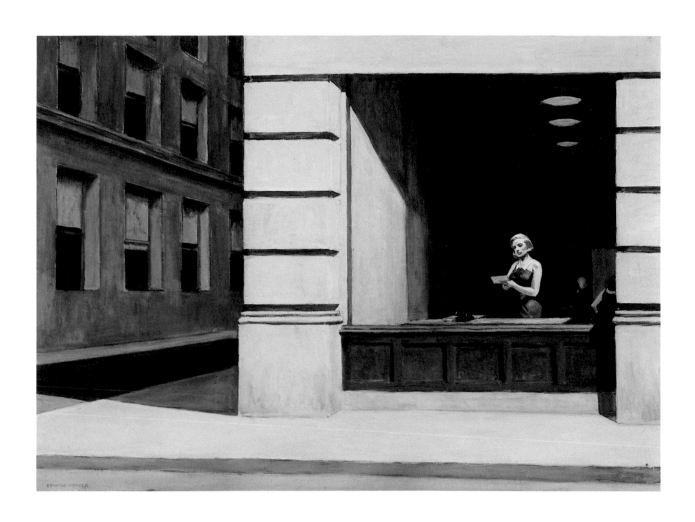

COMMERCE BANK OF KANSAS CITY, N.A.

Commerce Bank was founded in 1865 by Francis Long as the Kansas City Savings Association. It was renamed the National Bank of Commerce when Dr. W.S. Woods became president in 1881. Under his leadership, the bank grew rapidly. It continued Long's policy of supporting and advising young businesses and acting as a refuge for smaller banks seeking funds for their depositors. In 1906, Woods organized the Commerce Trust Company, with William Kemper as president. The two banks merged in 1921 under the name of Commerce Trust Company, and Kemper's son James was elected president the following year. He initiated the bank's policy of conscientiously aiding the community. In 1940, he chaired what was later to become the Downtown Redevelopment Corporation, a highly successful urban development project that, by 1970, had changed the face of downtown Kansas City.

In 1955, James Kemper, Jr. became president of Commerce Bank; under his leadership, banking practice in the entire state was changed. Because branch banking is illegal in Missouri, Kemper organized a holding company named Commerce Bancshares which began acquiring Missouri banks as affiliates. By 1975, Commerce Bank was affiliated with thirty-one banks and five non-banking subsidiaries. Kemper, a third generation banker, has remarked that it is a family tradition never to be content with simply preserving what one's father has done, but to expand upon it.

The bank's policy of community involvement has caused it to contribute generously to cultural institutions including the William Rockhill Nelson Gallery and Atkins Museum of Fine Arts, the Lyric Opera, the Kansas City Ballet, the city Philharmonic, local public television, the Chamber Music Society, and Young Audiences. This commitment to the arts was expanded fifteen years ago when Commerce Bank, with the assistance of a committee of art professionals, began assembling a collection of contemporary American art. The original Fine Arts Collection Committee included such knowledgeable figures as Lloyd Goodrich, Director, the Whitney Museum of American Art; William T. Kemper, President, Kemper Investment Company; Laurence Sickman, Director, the William Rockhill Nelson Gallery and Atkins Museum of Fine Arts; and the late Willard W. Cummings, President, Skowhegan School of Painting and Sculpture.

Today, there are over two hundred pieces in the collection. Painting, sculpture, prints, drawings, and photography are represented, with works by such artists as Arthur Dove, Barbara Hepworth, Charles Sheeler, Alex Katz, and Alan Shields. Many works are displayed in the Commerce Gallery on the second floor of Commerce Tower; they are rotated regularly with other pieces of art in the bank's dining rooms, offices, and lobbies.

The works are presently selected and cared for by Laura Kemper, daughter of James Kemper, Jr. She feels that acquiring works by living American artists both provides support for artists and offers visual recreation for bank customers, employees, and visitors to the Kansas City area. Ms. Kemper and members of the bank's senior management uphold the philosophy that civic and financial leaders have a responsibility to support the arts and make art available for public enjoyment.

EDWIN DICKINSON
1891–1978

SHILOH
OIL ON CANVAS, 1940
36¾ x 32¾ INCHES

Primarily a realist, Edwin Dickinson developed a highly personal style of painting that included aspects of cubism and symbolism, sometimes presented with a precisionist clarity, at other times with a soft, blurred effect. Little understood or appreciated for many years, Dickinson gained increasing recognition after the late 1940s, about the time he turned to teaching. He is now acknowledged as both an important artist and teacher.

Born in Seneca Falls, New York, the son of a Presbyterian minister, Dickinson was raised in Buffalo, a city with which he continued to identify throughout his career. Beginning in 1910, he studied in New York, attending the Pratt Institute for one year. The following two years were spent at the Art Students League working under William Merritt Chase and Frank Vincent DuMond. Dickinson began spending summers in Provincetown in 1912 when he attended the Cape Cod School of Art operated by Charles W. Hawthorne. Cape Cod, with its varied artistic and fishing community, its bleak winters and crowded, festive summers, and its proximity to the ocean, appealed to Dickinson so strongly that he settled there year-round until 1944, when he began teaching in New York.

After serving in the Navy during World War I, Dickinson spent 1919-1920 in Paris, working on his own and taking occasional courses at the Académie de la Grande Chaumière. After returning to Cape Cod, he evolved his own style, painting subjects realistically, but often fragmented or strangely juxtaposed. Between 1920 and 1937, Dickinson worked on various large, complex compositions, each taking several years to complete. The best known of these is *Fossil Hunters* (1926-1928), based on his interest in fossil-bearing rocks near Buffalo. The painting won him his first award, the Altman Prize at the National Academy of Design in 1929.

An inveterate Civil War buff, Dickinson depicted a famous and bloody battle in *Shiloh*. The painting focuses to the left on a seemingly disembodied head — actually a self-portrait — that floats above a crumpled uniform. Painted in somber tones, the image is mysterious and dream-like as well as suggestive of death. *Shiloh* was originally part of a larger painting Dickinson cut down, much to his later regret.

In addition to his large compositions, Dickinson painted portraits, mostly on direct commission, and small-scale landscapes, simplified almost to the point of abstraction. Recognition of Dickinson's personal style of painting and appreciation for his sustained study of perspective paralleled his rising success as a teacher. Elected to the National Academy in 1950, he was the recipient of many awards and the subject of several retrospectives.

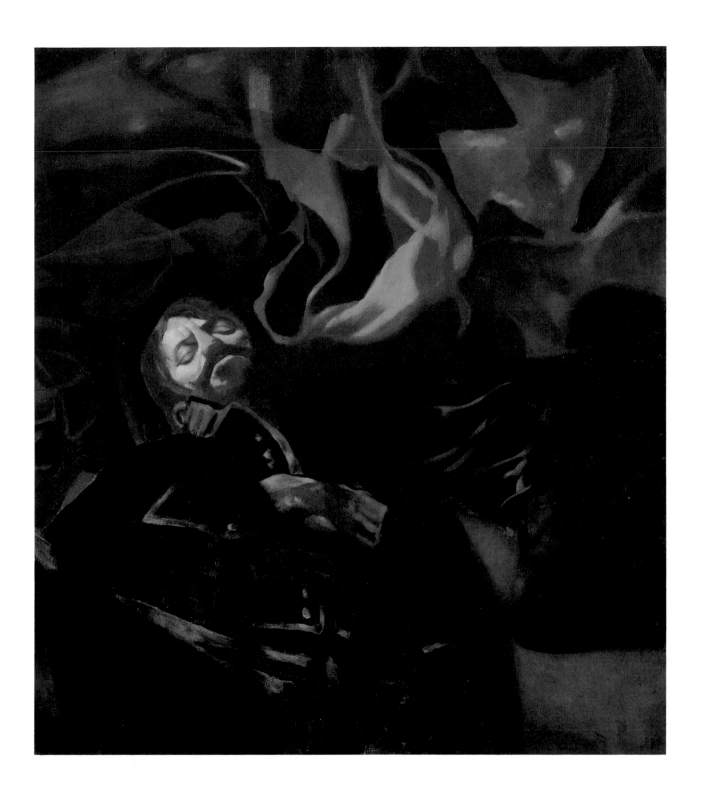

ARTHUR DOVE

1880–1946

TREE

OIL ON CANVAS, 1934
18⅓ x 24⅓ INCHES

Arthur Dove's life spanned the critical fifty year period that witnessed the development of the major modernist ideas in the visual arts. Dove's absorption of a nonrepresentational aesthetic, however, was intuitive and private. His art unites a pastoral mysticism with an ongoing quest to create abstract forms suggesting the intangible forces in nature.

Born in Canandaigua, New York, Dove grew up in nearby Geneva. A neighbor, Newton Weatherby, shaped the young boy's self-reliance and love for nature by including him on many expeditions into the countryside. Dove spent two years at Hobart College before transferring to Cornell to study with the illustrator Charles Furlong. After graduating in 1903, he went to New York City where he worked as a free-lance illustrator and developed an interest in painting.

Dove went to Europe to study in 1907. In Paris, he met Alfred Maurer, who introduced him to contemporary French art. Dove was particularly impressed by the exaggerated palette of the fauves. A painting he exhibited in the *Salon d'Automne* of 1909, entitled *The Lobster*, showed an awareness of the art of Cézanne and Matisse in its structure, its linear composition, and its bold color. Returning to New York in 1909, Dove met Alfred Stieglitz. A close friendship developed between the two, and Stieglitz became unwavering in his support and encouragement. He exhibited Dove's work at "291" and gave him his first one-man exhibition in 1912.

Dove began experimenting with abstract painting around 1910. The resulting works are among the earliest known totally nonrepresentational art. While participating in many of the progressive exhibitions of the decade, such as the Forum Exhibition in 1916 and the Society of Independent Artists exhibition in 1917, Dove was also trying to make a living as a farmer. He gave up that endeavor around 1920 and moved into a 42 foot yawl, cruising in the summers and spending winters in Huntington Harbor, Long Island. At this time, he started making small collaged constructions. He continued to paint, and understandably, there was a marked increase in the use of symbols suggesting the sun, moon, and sea in his work. In the late twenties, Dove moved into the upper floor of the Yacht Club in Halesite, Long Island; his new spacious quarters were reflected in the increased size of his paintings. Dove's arrival at this strong, mature phase in his work was disrupted by attempts to save family properties in upstate New York. He continued to paint, but after a series of lawsuits and foreclosures his health was undermined. He spent his last seven years living in a former Post Office in Centreport, Long Island, painting when his health permitted.

Tree exemplifies Dove's use of nature imagery. Through color, form, and line, he depicts the force or tensions alive within nature. In his works there are two elements: the inner—the emotion or idea in the mind of the artist; and the outer—the material world which the artist experiences. In fusing these, the artist tries to create a new image which combines the subjective with the objective. But as Dove himself admitted, "We certainly seem to set down a self-portrait of our own inner feelings with everything we do."

120

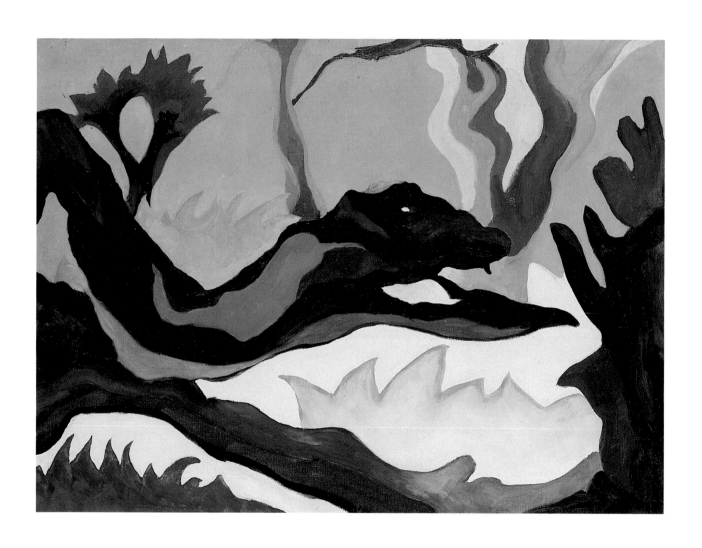

FAIRFIELD PORTER

1907–1975

GIRL READING OUTDOORS

OIL ON CANVAS, 1959

44⅞ x 40 INCHES

Born in Winnetka, Illinois, in 1907, Fairfield Porter spent most of his life in New England and New York. While studying at Harvard College, he attended Arthur Pope's influential course, *Drawing and Painting and Principles of Design*. After receiving his Bachelor of Science degree from Harvard in 1928, Porter studied at the Art Students League in New York with Thomas Hart Benton and Boardman Robinson. Thereafter, he worked steadily in New York City and in Maine. In 1949, Porter and his family settled in Southampton, Long Island.

Initially slow in achieving recognition, Porter exhibited regularly at Tibor de Nagy Gallery in New York from 1951 to 1970 and in the Whitney Museum's annuals from 1959 to 1968. In 1959, he became art critic for *The Nation* and published a monograph on Thomas Eakins. Many institutions actively sought Porter as a teacher and visiting artist, most notably Yale University and the Skowhegan School of Painting and Sculpture. The Cleveland Museum of Art organized his first retrospective in 1966. Several months prior to his death in 1975, the Hecksher, Queens, and Montclair museums presented a major survey of his paintings, drawings, and lithographs.

Porter readily acknowledged the major influences on his work, such as his appreciation of the paintings of Bonnard and Vuillard. He disavowed, however, his often noted affinity with earlier American representational painters like Edward Hopper. Porter's resolve to pursue representational painting was strengthened by several factors. One was the desire to contradict a remark made by Clement Greenberg to Willem de Kooning in the late 1940s: "You can't paint figuratively today."

The many still lifes, portraits, light-filled interiors and landscapes reflect Porter's commitment to painting as "a way of expressing the connections between the infinity of the diverse elements that constitute the world." The paintings evolved slowly, often without a predetermined plan. Porter's consistent selection of subjects from his environment infused his works with a quiet familiarity.

Although Porter's chosen path ran counter to the prevailing abstract expressionist mode, he was not insensitive to contemporary artistic developments. Due mainly to his exchanges with de Kooning, Porter began to employ some elements of abstraction. *Girl Reading Outdoors* shows planes and patches of form, light, and color broadly rendered to suggest abstraction but still permit identification of the subject. Porter's accomplished, critical approach to representational painting has provided an exemplary alternative for younger painters like Rackstraw Downes and Alex Katz.

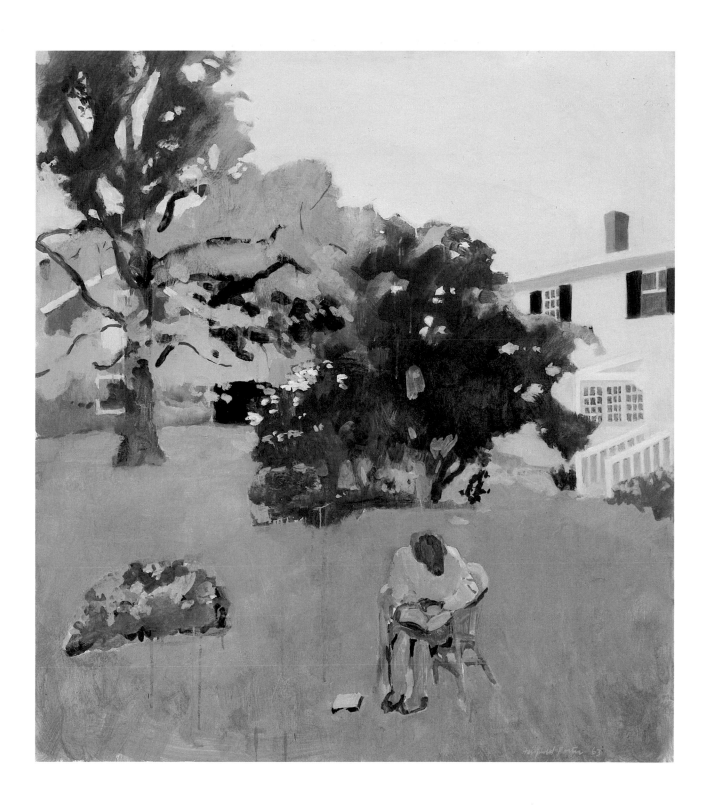

HALLMARK CARDS, INC.

In January, 1910, eighteen year old Joyce Clyde Hall arrived in Kansas City, Missouri, from Norfolk, Nebraska, where he and his brothers owned a small gift store specializing in postcards. Hoping to expand their market, Hall called on merchants in parts of Kansas, Oklahoma, Missouri, and Nebraska that could be reached by train. Such was the beginning of Hallmark Cards, Inc., a company whose three hundred fifty artists today create about twelve thousand new designs each year, and whose four production plants in Kansas and Missouri produce ten million greeting cards and three million non-greeting card items each day. Distribution centers in Liberty, Missouri, and Enfield, Connecticut, ship the firm's products to retail merchants across the nation and in one hundred countries abroad. The company now employs more than ten thousand people.

At the beginning of the 1960s, Hallmark was primarily a two-product company, manufacturing greeting cards and gift wrap. Since then, it has added such items as party goods, stationery, playing cards, home decorations, photo albums, calendars, gift books, and puzzles. In addition, it has developed Crown Center, an eighty-seven acre area in Kansas City that is regarded as among the finest designed urban developments in the country. Stepping aside as president in 1966, Joyce Hall passed to his son, Donald J. Hall, a company acknowledged to be a leader of the industry and an important contributor to public appreciation of the arts.

Committed to specific social and civic responsibilities, Hallmark Cards has discharged these duties in a variety of ways, from awarding educational grants and scholarships to funding hospitals and social agencies. Since 1951, Hallmark has spent more than fifty million dollars to produce the critically acclaimed television series, the Hallmark Hall of Fame. Hallmark has also awarded fifty purchase prizes annually since 1957 to winners of the Scholastic Art Awards program, the largest art competition in the world. Between 1949 and 1960, the company sponsored five international art competitions and continues to make annual purchases at major American exhibitions. The more than two thousand works in Hallmark's extensive collection have come to the corporation in various ways: purchase prizes at art shows or at the International Hallmark Art Awards, purchases from talented employees, or acquisitions from artists whose designs have been used on company products.

Through the five International Hallmark Art Awards, the company has acquired works by such painters as Andrew Wyeth, Edward Hopper, Maurice Vlaminck, Philip Evergood, and Charles Sheeler. In addition, the work of such important artists as Pablo Picasso, Salvador Dali, Grandma Moses, Norman Rockwell, and Saul Steinberg has been acquired for use on greeting cards and other products and then accessioned into the collection.

Hallmark has remained private about many of its philanthropic endeavors — social and cultural. In the visual arts, the company has tried to make commitments with discriminating taste. "Good taste is good business," Joyce Hall has said on more than one occasion. *The Wall Street Journal* reports, "What the Halls consider good taste seems to go well beyond the promotion of a public image of quality — to the point that its 'tasteful' practice of what might be called good corporate citizenship is considered by many publicly owned companies to be daring in the extreme."

NORMAN ROCKWELL
1894–1978

THE KANSAS CITY SPIRIT
ASSISTED BY JOHN ATHERTON
GOUACHE ON BOARD, 1951
44¼ x 32 INCHES

Norman Rockwell was born in New York City on February 13, 1894. He began drawing seriously as a child and quit high school to attend classes at the National Academy of Design. In 1910, he studied drawing and illustration at the Art Students League. By 1912, Rockwell was a professional illustrator, and during the 1920s he became highly successful, contributing to magazines like *Collier's* and *Literary Digest.* His long association with *The Saturday Evening Post,* begun in 1919, ended when he started working for *Life* in 1963.

Despite a major setback in 1943, when fire destroyed his studio, Rockwell began to enjoy critical acclaim during the 1940s. A one-man exhibition at the Milwaukee Art Institute and Arthur Guptill's 1946 monograph combined to stimulate interest in Rockwell's work. Sought as an illustrator for advertisements, calendars, and children's books, Rockwell designed his first Christmas card for Hallmark in the late 1940s. In 1960, he published his autobiography, and in 1972, Bernard Danenberg Galleries, New York, organized his first retrospective. Today, his paintings are known to the public primarily in the form of reproductions. Rockwell lived in Stockbridge, Massachusetts, where he died in November, 1978.

Inspired by Howard Pyle, Norman Rockwell became one of America's foremost illustrators. Rendered with meticulous accuracy and sensitivity, his images are often tinged with gentle humor. Rockwell achieved remarkable authenticity and familiarity in his characterizations. Whether rendered as portraits or caricatures, people provide the focus of his works; centered in the foreground and surrounded by glimpses of their environment, they tell their simple stories. Integral to Rockwell's working process is the careful selection of props and models. The paintings are preceded by a series of increasingly detailed drawings in black and white and then in color.

Starting in the 1920s, Rockwell assembled a large repertoire of trademark subjects and themes which can be divided into three major categories: nostalgic portrayals of American customs and activities, humorous views of human nature, and records of contemporary events. His interest in the latter escalated during the 1940s in response to the war. GI Joes and the freedoms and strengths of America were frequently featured in his chronicles of the decade.

The Kansas City Spirit was painted under unique circumstances. In 1951, Kansas City experienced a devastating flood. Rockwell phoned his friend Joyce Hall and inquired how he could help the ruined city. Hall asked him to paint a picture of "The Kansas City Spirit" which "would forever symbolize that something in good men's hearts that makes them put service above self and accomplish the impossible." This painting, inspired by the camaraderie that developed in the face of a crisis, exemplifies Rockwell's patriotic and positive approach to his work.

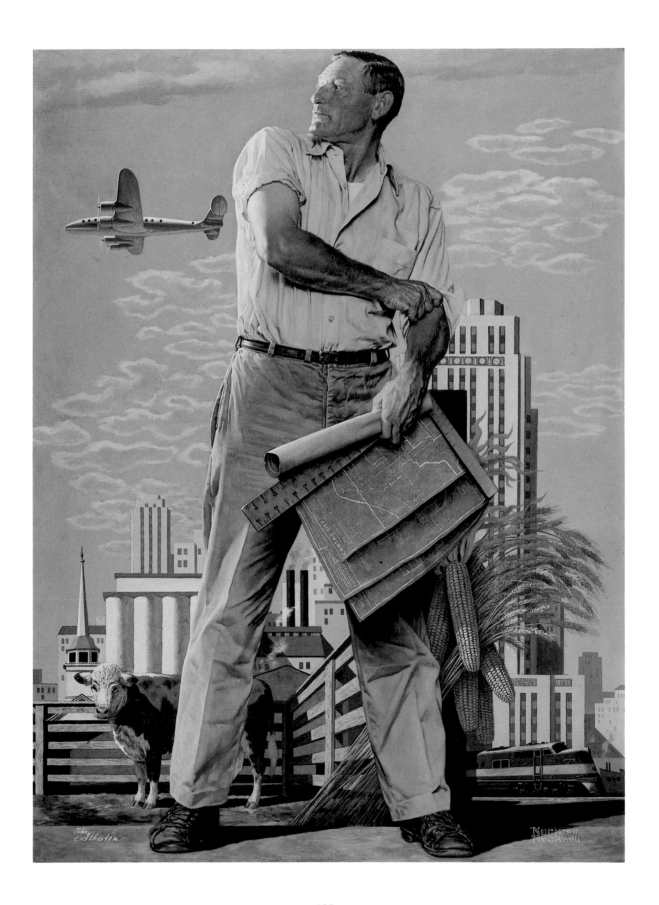

PHILIP EVERGOOD
1901—1973

EVERYBODY'S CHRISTMAS
OIL ON CANVAS, 1949
30 x 24⅛ INCHES

Philip Evergood, a painter who perplexed much of the art world throughout his career, was born in New York City in 1901. He was educated in England, first at Cambridge University, then at the Slade School of Art. In 1923, Evergood left London and studied at the Art Students League in New York under several instructors, including George Luks. Evergood's father, Meyer, was an artist who painted impressionist inspired landscapes which Philip fervently disliked. Evergood later wondered if his father's passionate concern with nature did not spark some kind of revolt in directing him toward the harder facts of life.

During the Depression, Evergood worked on the Public Works of Art Project and later the WPA Federal Art Project. He executed several important murals, notably *Cotton from Field to Mill* for the U.S. Post Office in Jackson, Georgia, and *The Bridge of Life* for Kalamazoo College, Michigan. In 1946, Evergood had a one-man exhibition in London at the Tate Gallery. Three years later, his painting, *Everybody's Christmas*, was one of fifty to receive the first International Hallmark Award. Evergood had a retrospective exhibition at the Whitney Museum of American Art in 1960, and in 1978 the Hirshhorn Museum and Sculpture Garden displayed forty-two of his works.

Evergood considered himself a social realist; his concern was with the individual. He depicted personal encounters and relationships rather than the grand scheme of urban life which many of his fellow artists treated. Priding himself on the artistic risks he took, Evergood was influenced in his painting by El Greco, Brueghel, Toulouse-Lautrec, Grünewald, and even cave painting and the antics of Charlie Chaplin. The resulting works shared a highly emotional and acidic color scheme with a complicated handling of space, often utilizing dramatic distortion and at times sacrificing logical balance for greater emotional intensity. The images were a synthesis of fantasy and realism, in part based upon the dreams and aspirations of the subjects. Evergood believed that if an artist could first achieve the technical skill of an artist like Dürer and then release himself in a free and spontaneous manner, the result would be not unlike the work of El Greco, whose swiftly moving paint seems to have flowed onto the canvas. Evergood set this fluid paint quality as one of his goals.

Commenting on *Everybody's Christmas*, Evergood explained that the "children embracing amidst their toys today should serve to point out man's higher instincts and potentialities in our present world of fears, suspicions, and aggressions." Of the background view of Manhattan through the window, he wrote, "I spent many a happy Christmas playing in Central Park, so this location brings back my most vivid memories of childhood and Christmas."

Evergood frequently magnified everyday experience to heroic or fantastic proportions in an attempt to imbue it with some sort of universality. The emotional and often grim intensity of his work finds a strange but not inappropriate complement in Evergood's own humanism and hope for the future.

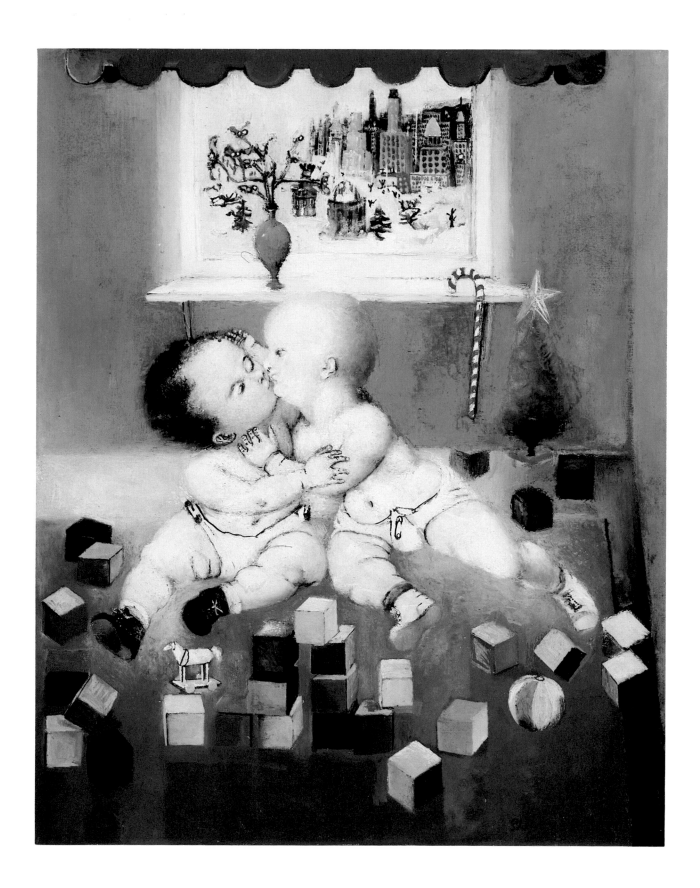

ROBERT VICKREY
BORN 1926

NUN
TEMPERA ON BOARD, CIRCA 1957
15⅛ x 19⅛ INCHES

Robert Vickrey was born in New York on August 20, 1926. He graduated from Yale University in 1947 and later studied at Wesleyan University and the Yale School of Fine Arts. At the Art Students League, he took courses with Kenneth Hayes Miller and Reginald Marsh. Since 1953, he has exhibited regularly at Midtown Galleries, New York. The University of Arizona Museum of Art organized and circulated a retrospective of his paintings, drawings, and watercolors in 1973. The same year, Vickrey co-authored *New Techniques in Egg Tempera* with Diane Cochrane. He lives and works in Orleans, Massachusetts.

Robert Vickrey's egg tempera paintings are generally somber compositions rendered in precise realistic detail. Among his favorite subjects are children, nuns, and clowns. Although he works from models and photographs, the paintings are often imaginative composites of things seen and things invented. In paintings like *Nun*, a solitary figure is centrally silhouetted against a patterned background. The face, averted and partially concealed, is typical. Also characteristic of Vickrey is an interest in the effect of raking light and shadow, evident here in the treatment of the nun's habit. Behind her, a calligraphic abstract composition of circles and intersecting lines seems to coalesce in veil-like fashion with the pitted surface of the wall. The contrast between the static withdrawn figure and its vaguely shifting background deliberately undermines the initial credibility of the scene. *Nun* was one of the fifty paintings selected in 1957 for the *Fourth International Hallmark Art Award* exhibition.

Loneliness suffuses much of Vickrey's work. In some paintings, a human presence is implied rather than shown—an object left behind, the effects of an action set in motion and abandoned. Still other works are curious reversals of normal perception—a brick wall incorporates the images which it would ordinarily reflect as shadows. A suggestion of the implausible haunts these paintings, despite Vickery's fidelity to traditional realistic depiction. Ultimately, the images he creates seem both familiar and bizarre.

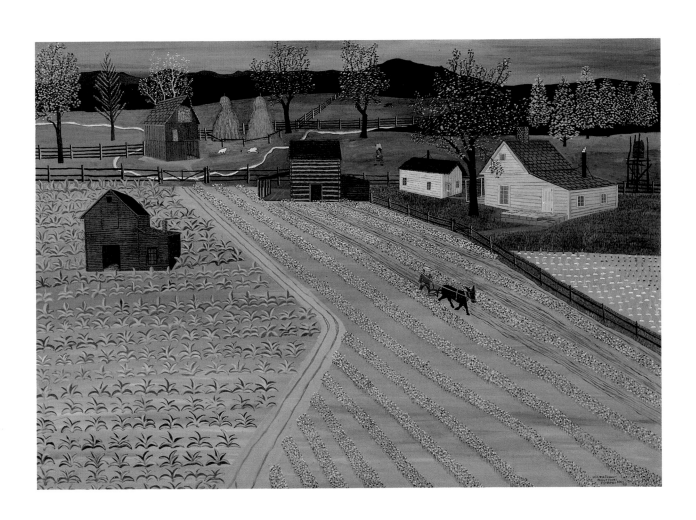

135

HEDDA STERNE

BORN 1916

SIX CYLINDER ENGINE

OIL ON CANVAS, 1961

33 x 25¼ INCHES

Hedda Sterne, an integral figure in the New York art scene of the forties and fifties, was born in Rumania in 1916. She studied at the University of Bucharest and also in Paris and Vienna before coming to the United States in 1941. In 1943, Betty Parsons gave her a one-woman exhibition at the Wakefield Gallery. At the time, Parsons was also showing works by Mark Rothko, Theodoros Stamos, and Adolph Gottlieb as well as some by Sterne's future husband, Saul Steinberg.

Sterne had been influenced by surrealism while still in Europe. Upon arrival in New York, she began painting her reactions to the city, impelled by its vast proportions and its terrifying, mechanized noise and pace. Soon, Sterne was expressing herself in almost abstract forms, no doubt inspired by the paintings of the other artists with whom she exhibited at Betty Parsons' gallery. The resulting works, of the late forties and early fifties, were often dynamic investigations of the various rhythms and moods of urban life expressed in faceted compositions at times reminiscent of stained glass or scaffolding.

Sterne has never clung to one style, and her inspirations have been as varied as her techniques. In many paintings, she deals with her own memories and experiences of life in Europe and New York City; abstract images of power and energy inform other works. Sterne is also an excellent draftsman. Her drawings, whether of people, machines, or even vegetables, are sensitive and powerful. She is able to combine a thin, delicate pencil line suggestive of Ingres with a wild, impassioned stroke directly out of abstract expressionism. The complexity and diversity of her work reflect a stunning personal range—private as well as professional.

Six Cylinder Engine was one of seven airbrushed paintings executed by Sterne for a commission from *Fortune* magazine in 1961. She was flown to Illinois and asked to paint her impressions of the Deere & Company factories. The resulting works combine the energy and force of industrial machinery with moody, almost mysterious, surroundings.

FRITZ SCHOLDER
BORN 1937

SNOW NIGHT RIDER
ACRYLIC ON CANVAS, 1972
30⅛ x 40⅛ INCHES

Fritz Scholder is the acknowledged leader of the "New Indian Art" movement of the 1960s which broke with the idealized and stylized art established in Indian schools during the 1920s. The new movement focused on the disrupting clash of Indians and Indian traditions with American culture.

Scholder was born in Breckenridge, Minnesota. His father—of German, French, and California Mission Indian (Luiseno) descent—worked for the Bureau of Indian Affairs as an administrator of the local school. Interested in becoming an artist from early childhood, Scholder was introduced to the work of Cézanne and the cubists by Oscar Howe, a Sioux artist. Between 1957 and 1958, Scholder became familiar with vibrant color and painterly technique when he studied under Wayne Thiebaud at Sacramento State College. At the same time, he had his first one-man show at the college gallery.

In 1961, Scholder moved to Tucson to obtain a Master of Fine Arts degree from the University of Arizona. There, he participated in a Rockefeller Foundation project that sought to determine whether Indian art could be allied to contemporary art and culture. Scholder won first prize at the West Virginia Centennial Painting Exhibition in 1963. In 1964, he began teaching painting and art history at the Institute of American Indian Arts in Santa Fe, New Mexico, an institution founded as a result of the Rockefeller project.

It was not until 1967 that Scholder began portraying Indians. Up to that time, he had been simply a contemporary artist, determined not to be classed as Indian. The focus of the Institute, however, was to combine Indian traditions with popular American culture, and Scholder's resolve to avoid ethnic identification gave way to a natural interest in his heritage. He began visiting pueblos, collecting Indian artifacts, and committing his impressions to canvas.

In 1969, Scholder left the Institute and toured Europe. He was especially impressed by the works of Francis Bacon at the Tate Gallery, London. Bacon's psychological probing, rich colors and spirited brushwork appealed to Scholder. Something of this influence—as well as Bacon's use of emotionally powerful, distorted images—can be seen in *Snow Night Rider*. The dashing horse and rider suggest the turmoil in modern Indian life. Particularly powerful are the unity of horse and rider and the brilliantly red, bullet-shaped outline around the horse's head. At the invitation of Tamarind, the foremost lithographic workshop in the West, Scholder settled in Albuquerque in 1970 and has devoted his recent efforts to painting and lithography.

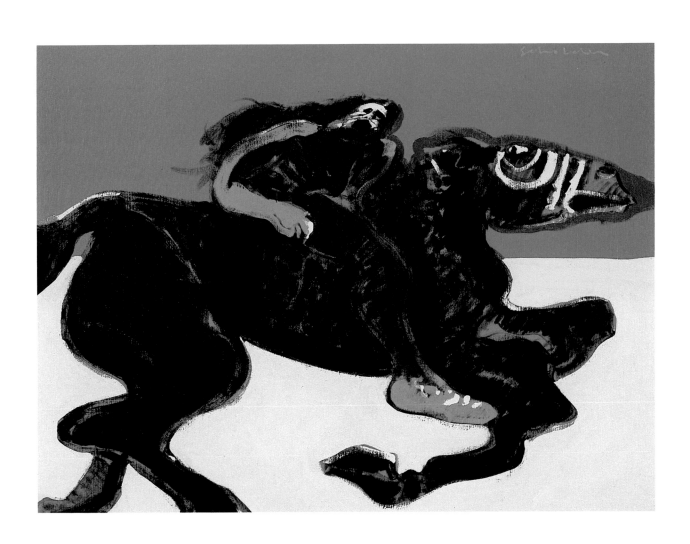

CITIBANK, N.A.

Founded as the City Bank of New York in 1812, Citibank has grown to become the largest bank in New York City and the second largest bank in the world. Its operations have expanded to include approximately one hundred countries around the globe, and through its parent company, Citicorp, it has diversified to provide a wide range of financial services.

Over the years, the bank has acquired a number of works of art. These works have not been consciously sought or assembled; the collection is a result more of evolution and accumulation than of an intentional acquisition policy. Some works date from the bank's earliest years, some from its middle years at the early part of this century, and a large number from its period of greatest growth, the years since World War II. Early in the postwar period, for instance, the bank commissioned a series of paintings for an advertising program. Such distinguished American artists as Charles Sheeler, Rockwell Kent, Thomas Hart Benton, and Walter Murch participated. Their works were later installed at the bank.

In tribute to its home city, works on themes related to New York grace the senior executive offices of the bank. They include paintings, drawings, and prints and span the greater part of this century. The artists range from contemporaries Colleen Browning, John Button, Richard Estes, Yvonne Jacquette, and Jacob Lawrence to American masters John Marin, Stuart Davis, Mark Tobey, and Abraham Walkowitz.

Citibank has acquired some artworks that reflect the working environment of its various groups, divisions, and departments. The Treasury Department, for example, has recently installed a series of Norman Laliberte banners and drawings commissioned to depict the history of currency. The World Corporation and International Banking groups have collected art representative of the countries around the world in which they conduct business. The entire collection is catalogued for internal purposes and is maintained by Laura Lynn Miner, Curator. The art is acquired as it is needed, in order to make the working environment in the bank's various facilities as enjoyable as possible and to provide cultural enrichment for its employees.

The major thrust of the bank's support of the arts, however, is represented not in the works it has purchased or commissioned, but in its generous contributions to a wide range of cultural institutions. Citibank views this support as part of its overall program of good corporate citizenship, for it believes in being an active participant in the communities where it has operations.

CHARLES SHEELER
1883–1965

PANAMA CANAL
OIL ON CANVAS, 1946
24¼ x 32⅛ INCHES

Captivated by the abstract forms of early twentieth century avant-garde movements, Charles Sheeler worked for over a decade to graft them to realistic images. In doing so, he developed a personal style similar to that of certain other American artists in the 1920s often called precisionists. Choosing native themes such as Pennsylvania Dutch barns, Shaker architecture, western granaries, or vast industrial complexes, Sheeler became a successful and well recognized artist. He was the recipient of numerous commissions from business and industry.

Born in Philadelphia, Sheeler began professional training at the School of Industrial Art in 1900. Upon graduation in 1903, he entered the Pennsylvania Academy of the Fine Arts where he worked under William Merritt Chase. Sheeler visited Europe with Chase's classes in 1904 and 1905 and painted in the dark-toned, freely-brushed Munich style. Traveling to Italy with his parents in 1908, Sheeler was joined by Morton Schamberg, a classmate at the Pennsylvania Academy. Both were struck by the strong composition in Renaissance painting that seemed to place primary emphasis on structural design. In Paris, introduction to the work of Cézanne, Picasso, and Matisse crystallized Sheeler's growing interest in a structural basis for composition, and he embarked upon a long series of experiments.

In 1912, for additional income, Sheeler turned to commercial photography, an interest that soon expanded and paralleled his painting career. His photographs of buildings helped him to find the clarity and objectivity he was seeking in painting. The Armory Show of 1913, in which he exhibited six paintings, reinforced his new artistic tendencies. As his work became more abstract, his artistic interest began to center on New York and the avant-garde circle around Walter Arensberg that included Marcel Duchamp and William Carlos Williams. Sheeler exhibited at the Forum Exhibition in 1916 and with the Society of Independent Artists in 1917. Shortly after settling in New York in 1919, he was given his first one-man show at the De Zayas Gallery.

During the 1920s, Sheeler returned to a more representational mode, developing spare, structural images composed of strong geometric shapes, sharp outlines, little atmospheric depth, and a near absence of the human figure. He was attracted to any form determined by function, whether a colonial barn or an automated assembly plant.

Panama Canal celebrates a superbly organized and efficient engineering complex. Its structural arrangement is quite characteristic for Sheeler, although the aerial perspective is unusual, but not unique, in his oeuvre. Though more realistic than much of his later work, *Panama Canal* reveals Sheeler's growing interest in strong color. The painting was commissioned by the bank to illustrate one of the world-wide locations in which it had financial interests.

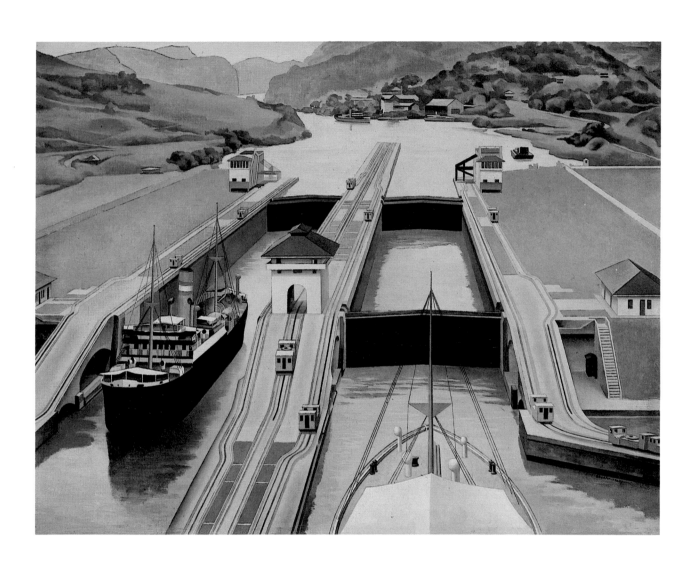

WALTER MURCH
1907–1967

CHEMICAL INDUSTRY
OIL ON CANVAS, 1957
15¾ x 21⅝ INCHES

Walter Murch grew up in Toronto, Canada, at that time a quiet town in predominantly rural Ontario. In 1925, he enrolled in the Ontario College of Art, prompted by his mother's suggestion rather than by any desire to become an artist. However, exposure to teachers such as Arthur Lismer, leader of Canada's avant-garde group "The Seven," and to works by American regionalists quickly shaped his commitment. While visiting New York in 1927, Murch decided to study at the Art Students League. A year later, disillusioned by its atmosphere and methods, Murch left the League to attend Arshile Gorky's drawing classes at the Grand Central School of Art. He also studied painting privately for two years with Gorky, who introduced him to modern European art.

From 1936 to 1950, Murch supported himself through freelance book and advertisement illustrations and commissions from department stores, decorators, and other commercial concerns. In his spare time, he painted and studied contemporary art developments. At Julien Levy's gallery, he became acquainted with surrealism, and in the 1940s, he followed the progress of abstract painters, particularly Mark Rothko, Barnett Newman, and Jackson Pollock. In 1941, Betty Parsons presented Murch's first major one-man exhibition at the Wakefield Gallery. After 1950, he began teaching, first at Pratt Institute and later at New York and Columbia Universities. The Rhode Island School of Design organized his first

retrospective in 1966. Murch died in New York on December 11, 1967.

Murch's style is not easily classified, although he was described as a "magic realist" during the 1940s. He consistently used machines, tools, and scientific equipment as subjects but did not subscribe to any of the machine-influenced aesthetics prevalent during the first half of the twentieth century. Instead, Murch's focus on such subjects can be traced to his childhood interest in gadgets and to memories of his father's watchmaking business.

Reminiscent of Chardin, Murch's still lifes are realistically rendered arrangements set upon ledges seen at close range. He often combined modern machines with traditional still life elements of bread or fruit to imply mysterious poetic associations. Hazy lighting and oddly marred or pitted textures contribute to create a bizarre impression. The eccentricity sensed is seldom jolting, however. Murch has commented, "Among objects, one thing is as good as another. I suppose the decision is based on looks at the moment, usually no great emotional reaction, it just looks right. A certain arrangement seems possible."

In the 1950s, Murch was commissioned by Citibank to paint a number of works. At the time, the bank was vigorously promoting the fact that it had recently financed innovative aspects of industrial growth. *Chemical Industry* suggests the bank's involvement in the field of chemical engineering.

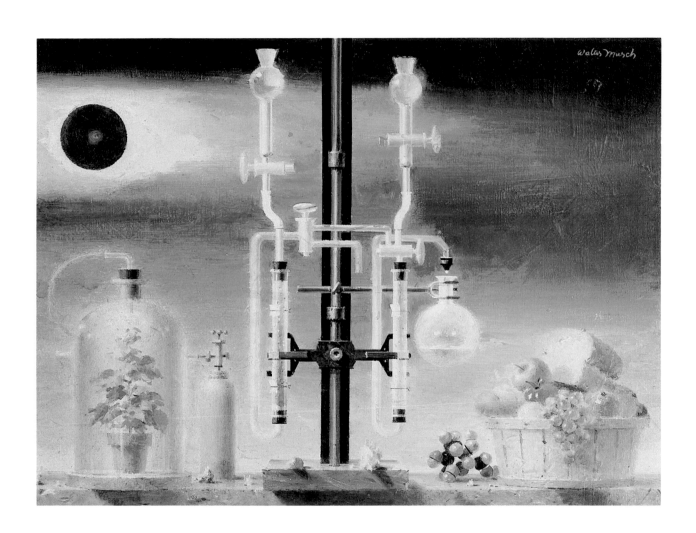

145

RICHARD ESTES

BORN 1936

SLOAN'S SUPERMARKET

OIL ON CANVAS, 1968

24 x 33¾ INCHES

As the basis for paintings, photographs allow Richard Estes to record for later study views of urban sites and buildings. Estes was born in 1936 in Keewanee, Illinois. At the School of the Art Institute of Chicago from 1952 to 1956, he studied traditional methods of painting and drawing but encountered opposition to the photographic sources and styles that interested him most. In 1968, he held his first one-man show at Allan Stone Gallery, New York, and began exhibiting in group shows which presented the emerging photorealist trend. Since then, he has become the preeminent figure of photorealism. In 1978, the Museum of Fine Arts, Boston, organized and circulated his first retrospective. Estes lives and works in Northeast Harbor, Maine.

Estes is sensitive to photography's impact on our perception of visual phenomena. His early figurative works suggest snapshots and imply that we have come to see the environment this way. Estes' concerns are predominantly formal ones. Precision, balance, structure, linearity, reflection, and transparency are the principal elements of his intricately detailed objective realism. The commanding interaction of form, line, and color and the notable lack of human presence thwart any impulse to read the paintings as narratives.

During the late 1960s, Estes began to concentrate on the city as his subject matter. Initially, he was in-trigued by the reflections and multiple images caught in its glass and metal surfaces. This attention to architecture's reflecting surfaces suggests his appreciation of Eugene Atget's photographs of Paris. Estes' early canvases were painted at extremely close range in harshly realistic and geometrically ordered planar compositions. His interest then shifted to the structures and settings themselves. In *Sloan's Supermarket*, the close range frontal view, the dead center focal point, and the parallel progression in space are characteristic of Estes' paintings from the late 1960s. The static geometric order is disrupted by touches like the fire escape intruding forward into space. Unlike reality, the scene is perceived with uniform clarity, thereby equalizing the importance of each pictorial element. Another unnatural device contributing to the supra-realism of the painting is the simplification and reduced number of elements.

Around 1970, Estes began painting from a less straightforward vantage point. After backing up at an angle to encompass several buildings, the street and the sky, he started producing works with the appearance of deep vistas rather than of parallel planes in space. Estes has tended to eliminate human figures and intrusive city litter; the result is a painted world that is visually beautiful, yet emotionally cold.

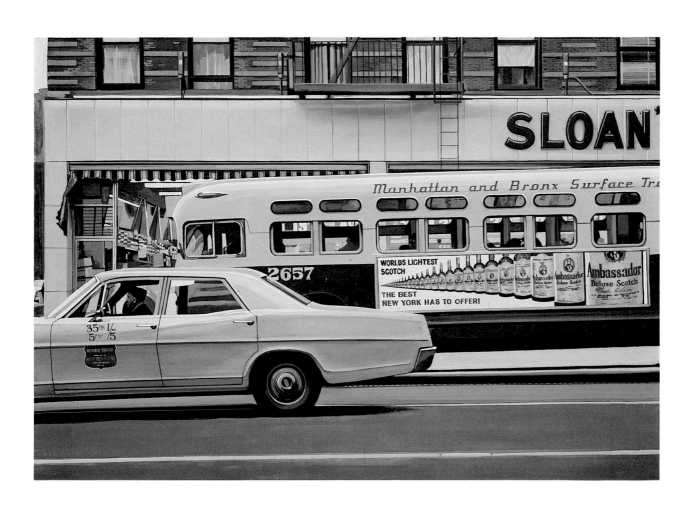

THE CHASE MANHATTAN BANK

In the 1790s, the citizens of New York City were confronted by a yellow fever epidemic. Because medical authorities advised that purified water would choke off the disease, New Yorkers petitioned their City Council to create a municipal water company. After some delay, a bill was proposed, entrusting a private corporation with the task of supplying water to the city. This proposal resulted in the formation of The Manhattan Company. Aaron Burr made it possible for the company to invest in different areas and after selling the water works to the city, The Manhattan Company began to devote all its energies to banking. A series of mergers, begun in 1918 and culminating in the 1955 merger with the nation's third largest bank, Chase National, produced The Chase Manhattan Bank. By 1974, Chase Manhattan had developed into a global organization with locations in almost one hundred countries and territories including the Soviet Union and The People's Republic of China.

When Chairman of the Board David Rockefeller initiated the bank's art program in 1959, its objectives were limited to the decoration of certain key offices. Today the more than four thousand seven hundred works in the collection are housed in the headquarters building in New York, in branches and offices throughout New York State, and in over seventy locations overseas. Although the focus of the collection has been on contemporary American art, works from many other countries and periods are included. A deliberate effort is made to search out the works of young, less well-known artists. Several major works are displayed at Chase Manhattan's New York headquarters as focal points of the collection: a thirty foot long commissioned painting by Sam Francis and monumental outdoor sculptures by Jean Dubuffet and Isamu Noguchi.

With the goal of finding works of museum quality, a committee of professional art experts has guided the program from its inception. In addition to Rockefeller and other executives of the bank, this committee has included such distinguished persons as Alfred H. Barr, Jr. and Dorothy Miller, formerly of the Museum of Modern Art; Robert Beverly Hale, formerly of the Metropolitan Museum of Art; Gordon Bunshaft and Michael McCarthy, of the architectural firm of Skidmore, Owings and Merrill; and Professor Robert Rosenblum, of New York University Institute of Fine Arts. The Chase Manhattan Collection also benefits from a curator, who selects many of the works that are presented to the committee and whose office is responsible for restoration and maintenance of the collection. Cataloguing also falls under the purview of the curator. Detailed information on the works in Chase's extensive collection is stored in a computerized format, a model example of present day cataloguing methods. In addition to its art collection, the bank has a philanthropic division which funds various local projects and institutions. Chase Manhattan underwrote, for example, the Whitney Museum's bicentennial exhibition *200 Years of American Sculpture*.

In 1969, when Chase's art program was ten years old, Rockefeller expressed his satisfaction with its progress, "in terms of good will,...staff morale and ...commitment to excellence in all fields." Today, after twenty years of collecting, he adds, "I am delighted that, though the bank's collection has tripled in size in the last decade, the level of quality has been maintained because our standard of reliance on expert advice has not changed." This insistence on quality and professional counsel has been the primary reason for the program's energetic spirit and success.

CHARLES BURCHFIELD

1893–1967

PINK LOCUSTS AND WINDY MOON

WATERCOLOR ON PAPER, 1959

38 x 45 INCHES

Born in Ashtabula, Ohio, and raised downstate in Salem, Charles Burchfield was encouraged to pursue pastimes of reading, painting, drawing, and listening to music. He also spent much of his boyhood roaming through the countryside, where he developed a deep interest in nature and a keen sense of observation.

Upon graduating from high school in 1911, Burchfield was offered a scholarship to attend the Cleveland School of Art, but he refused it and worked in a Salem metal fabricating plant for a year. He then enrolled in the illustration program at the school. There, stimulating teachers exchanged ideas with him on contemporary art, music, and dance. Burchfield loathed art school and Cleveland, however, and he longed to return to Salem and renew his rapport with nature. In 1916, he graduated and was offered a scholarship from the National Academy of Design in New York. He accepted but quit after only one day of classes. During his short stay in New York, Burchfield did attract some attention when a group of his watercolors was exhibited at the Sunwise Turn Bookshop. Soon after, he returned to Salem and the metal fabricating plant.

There is an obsessive, almost macabre quality in Burchfield's art; his profound fascination with nature results in either ecstatic or morbid fantasies. In Salem, Burchfield put together a notebook, "Conventions of Abstract Thoughts." It contained a system of graphic configurations representing states of mind such as Fear, Dangerous Brooding, Insanity, and Menace. He repeatedly used these symbols in his landscapes to signify an appropriate mood. The resulting art was an idiosyncratic, yet systematic, interpretation of nature.

Burchfield's dismissal from the metal fabricating plant in 1921, coupled with his imminent marriage, prompted him to move to Buffalo, New York. The adjustment to an urban environment produced a shift in his artistic outlook. Instead of symbolic representations of mood, Burchfield rendered the bleakness of the small-town scene, producing visual counterparts to the penetrating writings of Sherwood Anderson.

In 1929, confident that his watercolors could provide sufficient income to support him, Burchfield left a job designing wallpaper. He began to explore the countryside around Buffalo in the 1940s, resuming the intimacy with nature that had provoked the fantasies of his childhood. During this period, he also reconstructed many of his earlier watercolors, increasing their scale and using a loose, gestural painting technique.

Pink Locusts and Windy Moon exemplifies Burchfield's later style. The gothic house and full moon abound with romantic associations. The whistling of the wind is translated into a visual image. A vibrant calligraphy asserts itself; the line flickers with charged energy. In this, as in other of his late works, Burchfield gives monumental expression to the compelling forces of his childhood—the mysticism and lyricism of nature.

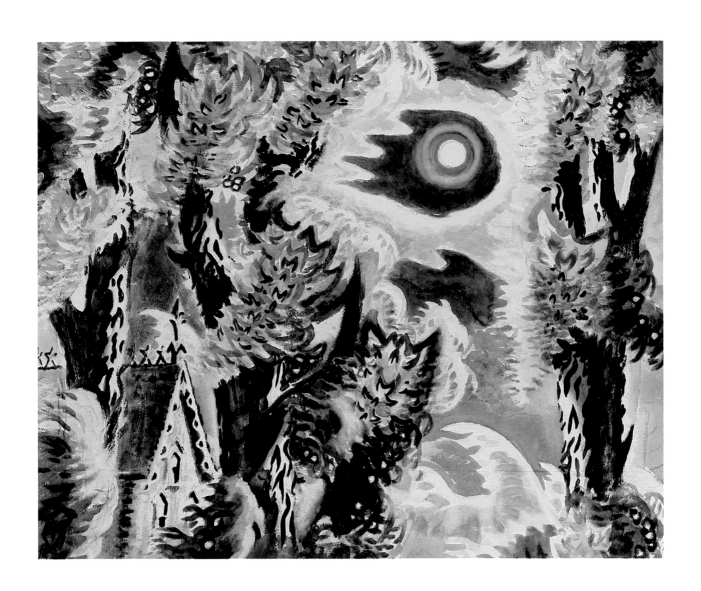

ROMARE BEARDEN

BORN 1914

BLUE INTERIOR, MORNING

COLLAGE ON BOARD, 1968

44 x 56 INCHES

Romare Bearden, one of the first artists to deal successfully with the contemporary black experience, was born in Charlotte, North Carolina. He graduated from New York University as a mathematics major in 1935. In the late thirties, Bearden studied at the Art Students League with the political satirist and former Berlin dadaist George Grosz. In 1945, Bearden had his first one-man show at Caresse Crosby's gallery in Washington, D.C. Bearden was a visiting lecturer at Williams College on African and Afro-American art in 1969. His first retrospective was held at the Museum of Modern Art in 1971.

During the 1940s, Bearden first began to explore black themes with a series of realistic paintings depicting aspects of everyday life. Like many other artists of the time, however, Bearden shifted to nonobjective painting in the fifties. After working in Paris in the early sixties, Bearden returned to America, where black activism was widespread. In response, he and several artist friends formed Spiral, a group devoted to the problems and concerns of the black artist in America. Their first group show in 1965 consisted of works executed entirely in black and white.

It was at this time that Bearden returned to his depictions of the black milieu, utilizing a collage technique of paint, cut paper, and scraps of fabric and magazine photographs. *Blue Interior, Morning* is representative of this mature phase. The colorful, pulsating visual effect of Bearden's collages has often been compared to jazz, while his images and references often relate to earlier American life and, in some cases, African culture. He is particularly fond of frontal and profile views, which often cause his figures to resemble those in ancient friezes and murals.

Bearden's use of collage for social themes was relatively unusual in the sixties and related perhaps to European dada of the early twentieth century. Painters in the United States had previously preferred a synthesis of expressionist and realist painting. Through collage, Bearden was able to combine decoration with expressive content. His figures are drawn from both the present and the past. He demonstrates that the myth and ritual of the black experience can be explored with the stylistic elements characteristic of other art. As Bearden himself puts it, "I paint the life of my people as I know it, passionately and dispassionately, as Brueghel painted the life of the Flemish people of his day."

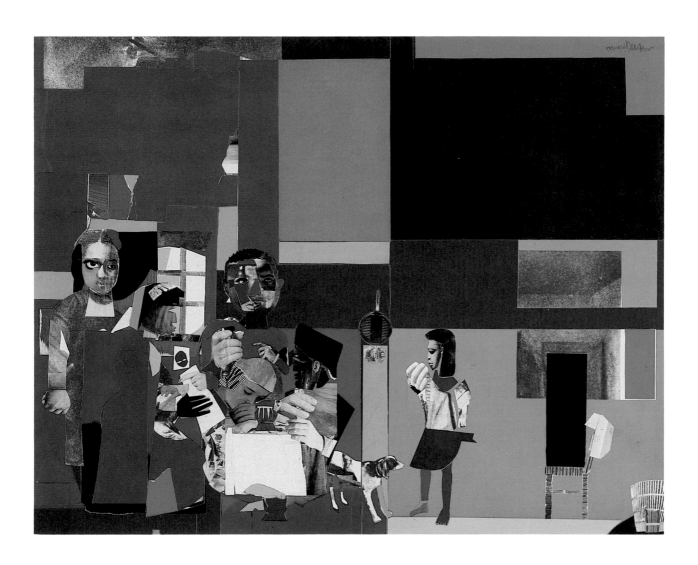

HELEN FRANKENTHALER
BORN 1928

YELLOW VAPOR
ACRYLIC ON CANVAS, 1965
69¼ x 77¾ INCHES

Helen Frankenthaler is an important figure in the transition from second generation abstract expressionism to the color field painting of the 1960s. In 1952, she pioneered a method of painting using thinned oil pigment poured onto a horizontal canvas. She was directly influenced in this by Jackson Pollock's method of drip painting; Frankenthaler differed in letting the paint soak down into the weave of the raw material rather than allowing it to build up on the surface. This soaking and staining technique eliminated brushwork and paint texture; areas saturated with color of varying intensity were unified with areas of unpainted canvas. After visiting Frankenthaler's studio in 1953, two young painters from Washington, D.C., Morris Louis and Kenneth Noland, also began to use stain techniques and developed a new kind of color painting.

Frankenthaler began to study art at an early age; in high school, she was a painting student of the renowned Mexican muralist Rufino Tamayo. At Bennington College, she continued her study of painting with Paul Feeley, who introduced her to cubism and gave her a thorough understanding of pictorial structure. Upon graduation, Frankenthaler moved to New York, where she took private painting lessons from Wallace Harrison and then from Hans Hofmann. Already interested in the works of Picasso, Gorky, and Kandinsky, Frankenthaler quickly became involved with abstract expressionism through her friendships with Clement Greenberg, Jackson Pollock, and Robert Motherwell (she and Motherwell were married from 1958 to 1971).

In 1951, Frankenthaler had her first one-woman show in New York. Since then, she has had numerous exhibitions throughout the world and retrospectives in New York at the Jewish Museum in 1960 and at the Whitney Museum in 1969. She won first prize at the Paris Biennial in 1959.

Although she was deeply indebted to abstract expressionism, especially for the practice of improvisational composing during the painting process, Frankenthaler's canvases were different from the dark, moody paintings of her abstract expressionist colleagues. She used color to express states of mind ranging from joyful to contemplative. It was this which appealed to Louis and Noland in her work, in addition to the technique. Hers were confident and optimistic paintings, combining intuition and inspiration with a highly refined formal structure; she addressed both the formal problems of painting and the task of expressing emotion.

During the 1960s, Frankenthaler simplified her images, and formal structure became the dominant element in her paintings. The ambiguous space and somewhat fragile color of her earlier work gave way to flat patterns in bold, sometimes opaque hues. In 1963, she began to use acrylic paint which eliminated the turpentine halo that had appeared around the edges of the painted forms in her oils. Acrylic also hardened the edges of forms in general. In Frankenthaler's recent work, shapes are often pushed to the edge of the canvas, opening up a central empty space. *Yellow Vapor*, in its gentle lyricism, suggests natural movement and process, always evident in Frankenthaler's painting.

SEATTLE-FIRST NATIONAL BANK

Founded in 1870, Seattle-First National Bank is the twenty-first largest bank in the United States. Headquartered in Seattle, it has branches throughout Washington state as well as in Tokyo, London, and Zurich. The bank's art collection was assembled in 1968 by Robert Arnold, Senior Vice President, to complement the handsome new fifty story headquarters designed by Donald Winkelmann of Naramore, Bain & Brady Associates, Seattle. Today, the collection contains more than two hundred items including works by American and European artists. Although most of the collection is in the main office building, there are works of art in all one hundred seventy branches and departments of Seattle-First.

The collection includes sculpture, painting, prints, and fiberworks. Its focus is primarily contemporary, including paintings by Morris Graves, Mark Tobey, and Jules Olitski. An impressive sculpture by Henry Moore stands in front of the new building. Like other corporations on the West coast and in the Northwest, Seattle-First has collected many artists of regional significance. Several, such as Graves and Tobey, have also gained international reputations.

Lawney Reyes, who is with the Bank Properties Division, is in charge of maintaining the collection and acquiring new works. He has recently formed a committee with Charles Cowles, Curator of Modern Art, Seattle Art Museum, and Mrs. C. Bagley Wright, a trustee of the Museum and an important collector of contemporary art, to develop a plan for the art collection. The bank encourages frequent guided tours and at present is considering rotating the art throughout the branch system so that as many people as possible can benefit from the works in the collection. In addition, First of Seattle is preparing to publish an extensive illustrated catalogue of its expanding collection.

MORRIS GRAVES

BORN 1910

HAN BRONZE WITH MOON

TEMPERA ON PAPER, CIRCA 1946

22½ x 13½ INCHES

Morris Graves, a native of the Pacific Northwest, sought to integrate Western painting with Eastern philosophy. Zen Buddhism, with its belief in the unity of the individual and the universe, became the source for the personal symbolism of his work.

Graves was introduced to the Orient while serving as a seaman for the American Mail Line in the late 1920s. It was then that he began his lifelong habit of traveling, with Seattle serving as a home base. In 1933, without formal art training, Graves produced his first paintings; only three years later, he was given a one-man show at the Seattle Art Museum. From 1936 to 1939, Graves was employed on the WPA Federal Art Project in Seattle. His *Inner Eye* series was seen there by Dorothy Miller of New York's Museum of Modern Art. When she included Graves in the 1942 exhibition *Eighteen Artists from Nine States*, his already sizable local reputation grew to national proportions.

In addition to Oriental philosophy and art, another important influence on Graves was fellow Northwest painter Mark Tobey. Graves studied with Tobey in 1939 and absorbed his technique of "white writing." Like Tobey, Graves was attracted to Oriental calligraphy; he used its natural forms and simplicity to create in his paintings an atmosphere of other-worldliness and spirituality. Graves tried to capture the spiritual essence of the world of nature rather than that of the man-made world which Tobey sought to render at the time.

The natural forms in Graves' paintings include snakes, trees, flowers, fish, and most importantly, birds. In the bird, he discovered the perfect metaphor to express his philosophical concerns about human existence. The birds tended to symbolize positive feelings of hope, freedom, or playfulness in the early paintings. In later works, as Graves came increasingly under the influence of Eastern philosophy, the bird symbol became more psychological and mystical, reflecting the restlessness of the human spirit which he saw as analogous to the migratory instinct of birds.

In 1946, Graves was awarded a Guggenheim Fellowship to study in Japan, but his military permit was denied, and he ended up staying in Honolulu. While there, he became interested in the collection of Chinese ritual bronzes from the Shang and Chou dynasties at the Honolulu Academy of Art. Their abstracted animal forms became the inspiration for a series of paintings. Graves has explained that the images are "for meditation, form-symbols to support the mind which is engaged with the abstractions attendant upon the apprehending of God and beyond God to Diety and on to Origin." *Han Bronze with Moon* is a vision of a two thousand year old Chinese urn glowing in the moonlight. Graves writes: "The moon...this gentle luminary of the night...that refreshes the worlds after their vital fluids have been extracted by the scorching sun of day — which forever man has used as a healing agent — seeking solace and recollection."

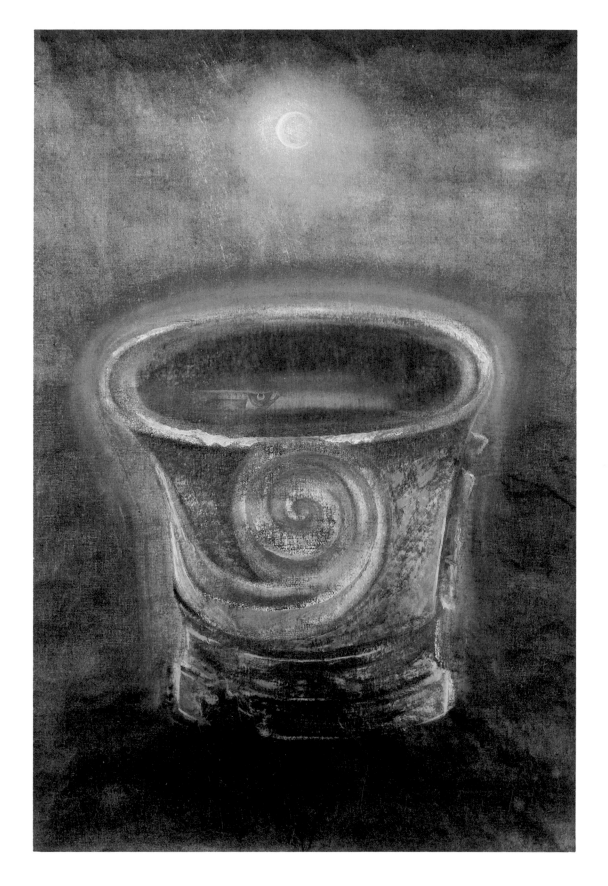

MARK TOBEY
1890–1976

OMNIA II/1962
TEMPERA ON PAPER MOUNTED ON BOARD, 1962
39⅝ x 29½ INCHES

Recognition as a painter came late to Mark Tobey. It was not until 1944, when he was fifty-six, that he began to gain a national reputation after a successful one-man show in New York. Tobey's paintings are imbued with the philosophy of the Bahai faith to which he converted in 1918. In his art, as in his religious concerns, he attempted to capture and express the ultimate spiritual unity of the world. This philosophy was usually presented indirectly in abstract works but sometimes in specifically religious themes and images.

Tobey's artistic career began in New York and Chicago in fashion illustration. In 1923, he moved to Seattle, there meeting Ten Kuei, a Chinese student at the University of Washington who introduced him to the art of Chinese calligraphy. In 1931, Tobey left the United States for England, where he spent most of the next seven years as resident artist at Dartington Hall, a progressive school. There, he met such literary figures as Aldous Huxley and Pearl Buck, among others, who furthered his interest in Oriental art, literature, and mysticism. During this time, Tobey also made trips to the continent, the Near East, and the Far East. Traveling to China in 1934, he renewed his friendship with Kuei, learning the "difference between volume and the living line." Back in England in 1935, he developed his "white writing" technique.

Tobey's white writing, a tangled web of interrelated lines that covered the picture surface, sometimes depicted specific objects and sometimes was superimposed over recognizable images. A number of small works done when Tobey was first exploring the style are nighttime views of New York City's Broadway, its lights flickering, its streets bustling with activity. Tobey has explained the meaning of white writing: "White lines in movement symbolize light as a unifying idea which flows through the compartmented units of life, bringing a dynamic to men's minds, ever expanding their energies toward a larger relativity.... Multiple space bounded by involved white lines symbolizes higher states of consciousness." Unlike the static, contemplative images of Morris Graves, a fellow Pacific Northwest painter with whom Tobey is often associated and with whom he shared an interest in Oriental calligraphy, Tobey's images are joyful and kinetic, full of the pulsing energy of urban existence.

Tobey was well acquainted with European developments in abstraction as well as with its American manifestations, such as abstract expressionism. But guided by his philosophical beliefs, he developed a style independent of both; pictorially, he may resemble abstract expressionism but in mood he is far removed from its raw emotionalism and tension.

During the 1950s, Tobey eliminated from his paintings all representational imagery, leaving behind highly abstract energized surfaces. He also developed a deep interest in printmaking. In 1958, Tobey won first prize at the XXIX Venice Biennale. Two years later, he moved to Basel, Switzerland, where he died in 1976.

MORRIS LOUIS
1912 – 1962

ITALIAN SPRING
ACRYLIC ON CANVAS, 1959
75¼ x 104¼ INCHES

Morris Louis' painting blossomed into its brilliantly colored maturity and national recognition only a few years before the artist's death. Louis was born on November 28, 1912, in Baltimore, Maryland. From 1929 to 1933, he studied at the Maryland Institute of Fine and Applied Arts. While living in New York in the late 1930s, he participated in David Alfaro Siqueiros' workshop on experimental painting technique. Louis also worked in the easel painting division of the Federal Art Project. After returning to the Baltimore-Washington area in 1940, he was active as a teacher and exhibited regularly. The Washington Workshop Center, where Louis taught, presented his first one-man exhibition of paintings, collages, and drawings in 1953. The following year, critic Clement Greenberg included Louis in *Emerging Talent*, presented at Kootz Gallery, New York; in 1957, Martha Jackson Gallery gave him his first New York one-man exhibition. Louis died in 1962 in Washington, D.C. The Solomon R. Guggenheim Museum organized a memorial exhibition, and the Stedelijk Museum, Amsterdam, prepared and circulated his first retrospective in 1965.

The direction of Louis' paintings changed significantly after he encountered Helen Frankenthaler's stained painting, *Mountains and Sea*, in 1953. Having already revealed his debt to Jackson Pollock in his *Charred Journal* series of 1951, Louis described Frankenthaler as being "a bridge between Pollock and what was possible."

In 1954, Louis created his first "veil" paintings. Using thinned acrylic paints, he stained the canvas with successive waves of different colors. At first, he used sized canvas; later, he stained untreated raw canvas. The overlay of color, usually more subdued than the brighter underlying hues, produces large continuous fields. In some veils, the transition between contiguous overlays is fairly well defined; even so, the impression of wholeness is conveyed by the color which sweeps across the surface and overwhelms the perception of the edges. The minimal amount of bare canvas left between the paint and the frame also contributes to the impression of a continuous field of color. The stained color usually emanates from one edge of the frame, reaching out toward another edge. After two years of experimenting with a more abstract expressionist mode, Louis resumed painting veils in 1958 and 1959.

In the last years of his life, Louis produced three other series. In 1960, he painted works generally termed "florals," in which overlapping opaque colors create distinct internal shapes flowing from the center rather than from the edges of the canvas. Louis worked on a series of paintings called "unfurleds" in 1961. From opposite edges of large blank canvases, intensely bright colors stream in irregular but roughly parallel sets. In Louis' last paintings, vertical stripes of vivid opaque colors are flanked by blank areas on narrow vertical canvases.

Although large in scale, *Italian Spring* is, in fact, smaller than other of Louis' veil paintings. Harvard University's Diane Headley explains that *Italian Spring* was one of several canvases prepared with the intention of being shown in 1960 in an Italian art gallery of limited size. Its ravishing green hues and destined place of exhibition thus gave rise to its title.

PEPSICO, INC.

From its beginnings as the producer of a single soft drink product, PepsiCo has developed into a manufacturer of a wide variety of products distributed around the world. The corporation was formed in 1965 by the merger of Pepsi-Cola Company and Frito-Lay Company. Pepsi-Cola was founded about eighty years ago by Caleb Bradham, who put the soft drink formula together in his pharmacy in New Bern, North Carolina. Frito-Lay Company produced the popular Fritos Corn Chips and Lay's Potato Chips. Today, PepsiCo is a multi-product international corporation that provides food services and manufactures soft drinks, snack foods, and recreational products. Among its subsidiaries are Pepsi-Cola, Frito-Lay, Wilson Sporting Goods, Pizza Hut, Taco Bell, and a transportation division. Divisional headquarters are dispersed throughout the United States with the world headquarters located in Purchase, New York.

The art collection was begun ten years ago by Donald M. Kendall, Chairman and Chief Executive Officer, for the opening of the new world headquarters in Purchase. In addition to paintings by such important artists as James Brooks, Echaurren Matta, and Jean Dubuffet, PepsiCo possesses a large corporate collection of twentieth century sculpture. The approximately twenty-five works are placed around the headquarters in a beautiful one hundred acre garden designed by landscape architect Edward Durrell Stone, Jr., whose father, architect Edward Durrell Stone, designed the building.

The sculpture garden is open to the public every day. It includes works by such important twentieth century sculptors as Henry Moore, David Smith, Alexander Calder, and Alberto Giacometti. In addition, the corporation has commissioned special works by Isamu Noguchi and David Wynne. Some small scale sculpture is located inside the headquarters building. The broad range of figurative and abstract styles represented in the collection is complemented by a wide variety of materials: marble, steel, granite, bronze, and wood. "I wanted work that would express a range from stability to adventure, the things I believe in," explains Kendall. A handsome illustrated catalogue of the corporation's collection has recently been published. The combination of outstanding architecture and gardens with paintings and sculpture by some of the most significant artists of this century makes PepsiCo's contribution to the visual arts unique.

ALEXANDER CALDER
1898—1976

THE POTATO
OIL ON CANVAS, 1949
59⅞ x 48 INCHES

Alexander Calder is universally known as the man who made sculpture move. He was born in 1898 in Lawton, Pennsylvania. His father and grandfather were recognized sculptors and his mother was a painter. In 1919, Calder received a degree in mechanical engineering from the Stevens School of Technology, Hoboken, New Jersey. He studied drawing with Clinton Balmer in New York in 1922 and with Boardman Robinson, George Luks, John Sloan, and Guy Pène du Bois at the Art Students League from 1923 to 1926. In 1926, he also attended the Académie de la Grande Chaumière, Paris. That same year, he published *Animal Sketching*, based on circus drawings of 1924, and began making toys and figures of wood and wire for his *Circus*. Calder's first one-man exhibition of wire sculpture was held at Weyhe Gallery, New York, in 1927, and his first mobiles were exhibited in Paris in 1932. During his lifetime, Calder was honored by numerous retrospectives at some of the world's best known museums, most recently at the Whitney Museum of American Art in 1976. He died in New York in November of that year.

Calder's concern with motion as an element of sculpture led him in 1932 to the development of non-mechanical movement. His mobiles can generally be described as internally balanced systems in which abstract planar and linear forms function as moving and supporting parts in a multi-directional design. At times humorous and toy-like, the mobiles are often brightly painted and suggest natural forms in their color and arrangement of parts.

During the 1940s, Calder introduced stabiles, large shapes resting on their legs, edges or points, as his solution to the problem of freeing static sculpture from its traditional supporting base. The architectural and environmental scale of Calder's stabiles has significantly enlarged the tradition of monumental public sculpture.

Calder's major contribution as a sculptor has often overshadowed his other works: paintings, prints, jewelry, and tapestries. It is significant that he began as a painter and illustrator. Important also is the influence of painters—most notably Mondrian, Arp, and Miró—on the evolution of Calder's formal vocabulary and his aims as a sculptor. His oil paintings, gouaches, and watercolors from the 1940s to the 1970s reflect an abiding concern with space and movement. Abstract forms, biomorphic or geometric, and figurative calligraphic images float in an indeterminate space, activated by the use of white, black, and primary colors. Calder became increasingly interested in gouache during the 1950s, producing many of the compositions that are so popular today.

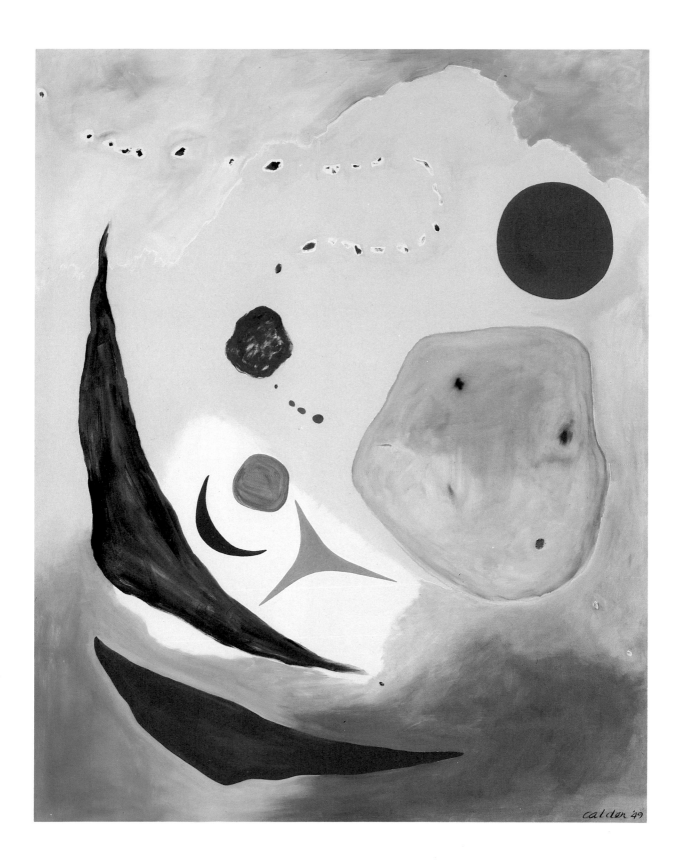

JAMES BROOKS
BORN 1906

MOOR
OIL ON CANVAS, 1967
47⅞ x 42⅙ INCHES

Born in St. Louis, Missouri, James Brooks began his formal art training while living in Dallas, Texas, from 1916 to 1926. In the early twenties, he studied painting with a former student of William Merritt Chase and majored in art at Southern Methodist University. He then took courses in drawing at the Dallas Art Institute until his departure for New York in 1926. From 1927 to 1930, Brooks studied with Boardman Robinson and Kimon Nicolaides at the Art Students League. For many years, he supported himself as a freelance commercial artist.

During the early 1930s, Brooks began to exhibit in New York. He was included in the first biennial organized by the Whitney Museum of American Art in 1934. While working for the Federal Art Project toward the end of the decade, he met Philip Guston and Jackson Pollock. Brooks' first one-man exhibition was held in 1949 at Peridot Gallery, New York, and in 1963, the Whitney Museum of American Art organized and circulated his first retrospective. Brooks lives and works in East Hampton, New York.

Brooks first received recognition during the 1930s and early 1940s for lithographs, paintings, and murals executed in a social realist style. His move to complete abstraction in 1948 was the result of several factors. Immediately after the war, he began exploring the principles of synthetic cubism with the encouragement of Wallace Harrison. After renewing his friendship with Pollock in 1946, and under his influence, Brooks experimented with automatism and freer paint handling. His shift to abstraction was finalized by his appreciation of ghost images discovered on the backs of some of his recently completed paintings.

Brooks has described his painting process: "I start a canvas with a mindless complication of several colors which I then accept as a separate entity, and on equal terms." During the 1950s, Brooks painted complex compositions in which bold, overlapping, broken forms and sharp contrasts of light and dark were rendered in either primary colors or monochromes. He particularly favored white, black, and red. Throughout the 1960s, Brooks maintained his spontaneous approach, well-ordered structure, and concern with contrasts of light and dark. His forms and colors changed, however, in part due to his use of acrylic paint after 1966. Compositions became broader with a few large areas of color activated by powerful linear elements and sometimes by small areas of contrasting color. Less reliant upon monochromes, Brooks emphasized brighter, lusher colors in canvases which combined aspects of abstract expressionism with 1960s color field painting.

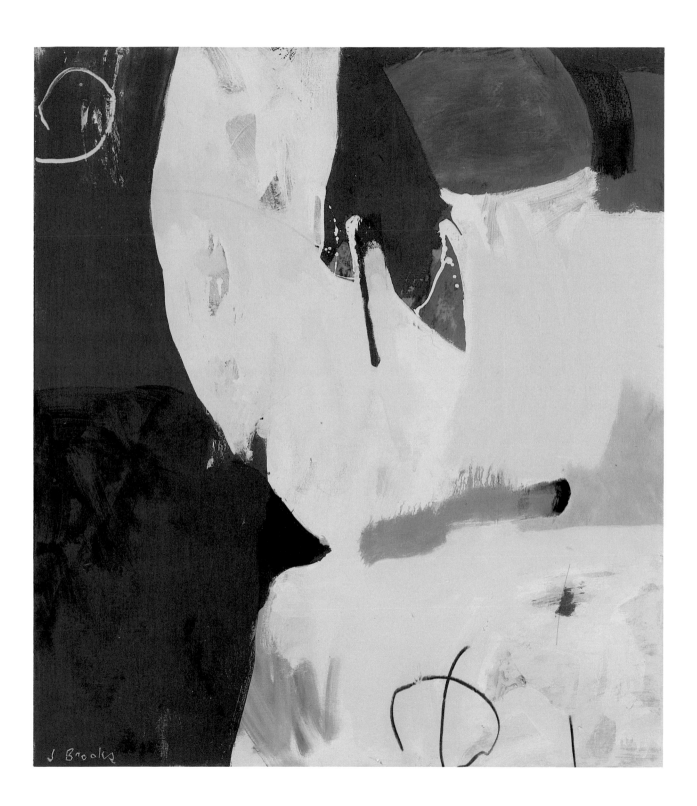

JOHN HELIKER
BORN 1909

MAINE LANDSCAPE
OIL ON CANVAS, 1963
49¾ x 51¾ INCHES

With few exceptions, John Heliker's paintings are all landscapes. Born in 1909 in Yonkers, New York, Heliker studied at the Art Students League. He won the Prix de Rome in 1948, and the resulting trip to Italy, as well as a subsequent visit to Greece, greatly influenced his work. However, it is the New England landscape which interests Heliker most. He makes annual excursions to Maine from his home in New York City in order to revitalize his commitment to the interpretation of nature. In 1958, Heliker was included in an exhibition at the Whitney Museum of American Art, *Nature in Abstraction*. The Whitney also mounted a retrospective of his work in 1968. Heliker has received an honorary doctorate from Colby College.

Heliker's early works are particularly influenced by Cézanne's concern with expressing the formal unity in nature. His works of the 1930s are indebted to Marsden Hartley as well. Heliker aimed to discern the underlying structure of natural forms – the Maine seacoast or the New England countryside – through direct aesthetic experience rather than through the imposition of his own order. This early phase of his work is relatively structured and geometric. After a second trip to Italy in 1951, Heliker developed his mature style. Using loosely arranged planes of chalky broken colors, evenly spaced and softly outlined, he achieved a delicate realism. During the 1960s, certain of his paintings became almost totally abstract. Heliker's evocative landscapes are devoid of any extremes or harsh contrasts and imply a mystical affinity with nature. In this, Heliker continues the tradition of New England landscape painting and is linked with nineteenth century figures such as Albert Pinkham Ryder and George Inness.

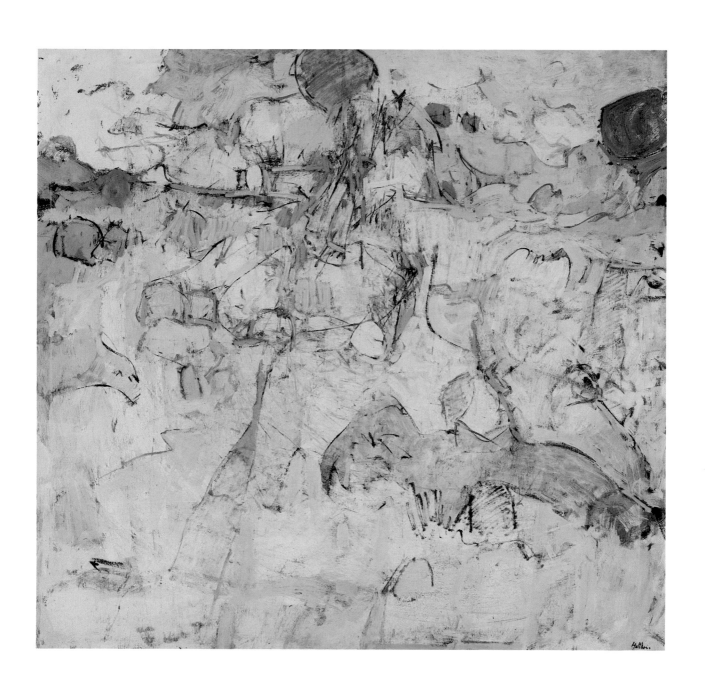

CIBA-GEIGY CORPORATION

CIBA-GEIGY Corporation is a diversified chemical company engaged principally in the discovery, development, manufacture, and marketing of a wide variety of special-purpose chemicals and chemical products. Headquartered in Ardsley, New York, a suburb of New York City, the corporation has approximately ten thousand employees and maintains regional sales offices, distribution centers, and warehouses in thirty-nine states across the country. CIBA-GEIGY Corporation is the result of a 1970 merger between CIBA Corporation of Summit, New Jersey, and Geigy Chemical Corporation of Ardsley. It is the American subsidiary of CIBA-GEIGY Limited, a publicly owned Swiss company located in Basel, Switzerland.

Both CIBA and Geigy had their origins in Basel many years ago. Geigy was founded in 1758 by Johann Rudolph Geigy, a trader in "colonial" goods—spices, dyewoods, and drugs of various kinds. CIBA was originally a dye house, founded in 1856 by Alexander Clavel to manufacture synthetic dyes for silk. It acquired the name CIBA, an acronym for Chemical Industry in Basel, in 1884. For many years, both companies sold products in the United States through agents. The Geigy agency in the United States was transformed into a company in 1903; CIBA began operations here in 1920. Over the years, both corporations expanded and diversified with research into the chemistry of dyes and drugs. CIBA-GEIGY now provides hundreds of products—pharmaceuticals, dyestuffs, pigments, epoxy resins, agricultural chemicals.

The art collection was begun in 1959 by Geigy Chemical Corporation, largely to enrich its newly constructed facility in Ardsley. Works by Swiss and American artists, primarily paintings, drawings, and graphics, were originally selected. By 1965, the collection had so diversified that it encompassed the works of artists from around the world in many different media. To add greater unity and historical significance to its collection, the corporation began to concentrate on works of the New York School. Included are figurative and nonrepresentational works by such artists as James Brooks, Elaine de Kooning, Adolph Gottlieb, Alex Katz, Joan Mitchell, Pat Steir, and Jack Tworkov. In recent years, the collection has received growing exposure through several impressive loan exhibitions. Some have highlighted special aspects of the collection, including exhibitions of watercolors and drawings and of works exclusively by women.

Sponsorship of the arts reflects the corporation's commitment to support the cultural life of the communities in which its facilities are located. Summing up this policy, Otto Sturzenegger, CIBA-GEIGY's President and Chief Executive Officer, has stated: "I am more and more convinced that industry and the communities in which it exists depend on one another so completely and in such complex ways that neither can be creative and healthy over the long run if the needs of the other are ignored—the creative arts hold an important place among the community activities to which we at CIBA-GEIGY lend our support. Our policy is in no small measure attributable to the similarities we see between the prerequisites for creativity in the world of art and the creativity on which we rely so heavily in our research laboratories."

THEODOROS STAMOS
BORN 1922

TEAHOUSE VII
OIL ON CANVAS, 1952
55⅞ x 41⅝ INCHES

Theodoros Stamos was among the youngest of the first generation abstract expressionists and one of the few who was a native New Yorker. He left high school in 1936 to attend the American Artists School, New York. In 1943, at the age of twenty-one, he had his first one-man show at the Wakefield Gallery. Stamos taught briefly at Black Mountain College, North Carolina, and later at the Art Students League, New York, from 1958 to 1975. The Corcoran Gallery of Art, Washington, D.C., held a retrospective of his work in 1959.

Through his Greek-born parents, Stamos shared the immigrant experience, a factor crucial to many abstract expressionists. Stamos' art reflects a wide variety of influences, both artistic and philosophical; his interests range from American painters James McNeill Whistler, Arthur Dove, and Milton Avery to the Eastern philosophies of Zen Buddhism and Taoism. In discussing the difference between the Eastern approach to art and the immediacy of the psychic automatism practiced by the surrealists and very important to the abstract expressionists, Stamos stated: "To achieve the inner vision, the Eastern artist tried to become the object itself. . . . He draws bamboo for ten years, eventually becomes bamboo, and then forgets all about the bamboo he is drawing."

Stamos' early paintings reveal a deep interest in marine life and other natural phenomena relating to his Mediterranean heritage or to childhood memories. In the early forties, he was drawn to mythology and mysticism as sources for his imagery; this interest was shared by William Baziotes, Adolph Gottlieb, and others who were using the biomorphic forms of surrealism and exploring the symbolic content of ancient art forms, including those of the American Indian.

By the early 1950s, Stamos abandoned his explicit symbolic imagery for a greater degree of abstraction. The biomorphic shapes evolved into loosely geometric forms structured into tight compositions by unifying slashed lines of paint. Gradually the images dissolved into compositions of highly textured brushwork producing ragged-edged shapes perceived against atmospheric backgrounds as in *Teahouse VII*. The allusions were to nature, to hazy landscapes with fluctuations of light and color reflecting over the highly textured surface of the painted canvas. During the sixties, Stamos gradually developed more simplified images and a reduction of contrasts. Through a minimum of form, color, and texture, his art has continued to convey an intense emotional and spiritual experience.

174

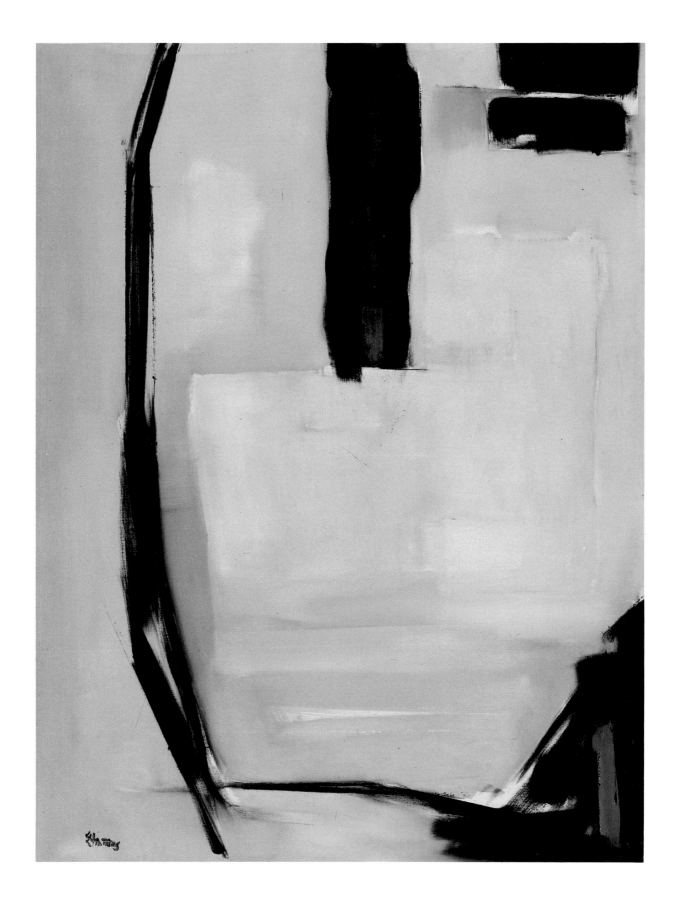

175

PHILIP GUSTON

BORN 1913

THE ACTORS III

OIL ON BOARD, 1961

30 x 40 INCHES

Philip Guston is in the third major phase of a career which many critics erroneously thought had reached its maturity in the 1950s. Born in Montreal in 1913, Guston was raised in Los Angeles. He attended Manual Arts High School, from which he and his friend Jackson Pollock were together expelled as cultural dissidents. Guston lived in the Midwest during the 1940s, teaching at several universities. From 1951 to to 1958, he taught painting at New York University. His first retrospective was at the V São Paulo Bienal in 1959. He has had many subsequent exhibitions, including a 1962 retrospective at The Solomon R. Guggenheim Museum and a 1966 one-man show at the Jewish Museum, New York. He now lives in Woodstock, New York.

In the early thirties, Guston became interested in de Chirico's enigmatic city scenes and Picasso's classical figures from the 1920s. As a result, he turned to the study of Masaccio, Mantegna, Piero della Francesca, and Paolo Ucello. This interest in the Renaissance characterized the first phase of his work, which lasted until 1948. His representational works tended to be stage-like settings of figures, often children, placed in a ghostly urban environment. Guston also produced several large murals. An early one, at the City of Hope (a medical center in Duarte, California), was executed with Reuben Kadish and is among the finest American murals of the thirties. Another, for the Queensbridge housing project (1938-1940), was especially well-received.

In 1948, Guston went to Italy. Soon, his figures and objects became dematerialized in a shimmering light-filled atmosphere. By 1951, after prolonged deliberation and self-criticism, Guston was firmly established in a second phase — abstract expressionism. For him, it meant acknowledging the sensual and spontaneous side of his personality. His painting became an intuitive activity rather than a premeditated effort. The pastel-colored works from the early fifties are light and airy. Composed of hatched strokes crossing one another, they seem like vaporous counterparts to Piet Mondrian's "plus and minus" paintings. By the end of the decade, Guston's palette had shifted to much darker tonalities of gray, red, and black. The brooding and somber canvases of the late fifties and early sixties seem laden with Guston's solemn and personal musings on such things as memory, fear, and nostalgia. *The Actors III* exemplifies this change. Its intensity suggests the struggle of an object to form itself from an abstract tangle of brushstrokes.

Guston's current work might be seen as a synthesis of his two earlier approaches. He has returned to representational painting in a highly eccentric way, schematically rendering his images in a manner that verges on caricature. There is a suggestion of both comic strip humor and political cartoon in these enigmatic canvases. Their oblique philosophical and social content is accompanied by the use of sensual color and painterly brushstrokes. Guston's fertile imagination and intensive self-scrutiny have impelled him to confront changing times and views. Now in his late sixties, Guston is producing works with the freshness and zeal of those he produced almost fifty years ago.

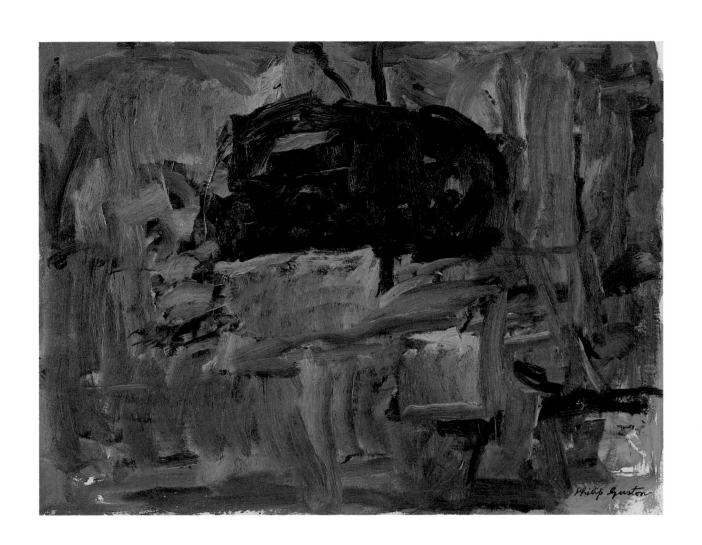

ADOLPH GOTTLIEB
1903–1974

ASTERISK ON RED
OIL ON CANVAS, 1967
40 x 30⅛ INCHES

Adolph Gottlieb was a largely self-taught artist. Born in New York City, he studied briefly under John Sloan at the Art Students League in 1919 and then in Europe for two years. His first one-man show in New York was in 1930. Gottlieb has since been included in many group exhibitions and has had numerous one-man shows and retrospectives.

Gottlieb painted representational works on the WPA Federal Art Project during the 1930s. In 1937, he left the WPA for Arizona, where he was deeply impressed by the art of the Southwest Indians. In cacti and other desert phenomena he found biomorphic forms which were soon to affect his abstract painted images. "When my paintings are finished," Gottlieb explained, "I can usually find some connection with nature in the painting. The connection is always tenuous, obscure, and ex post facto."

Back in New York in 1939, Gottlieb was among a number of painters looking for a way out of figurative painting by using abstracted images based on mythological and archaeological subjects. He was deeply involved in the abstract expressionist community from the start, participating in their exhibitions and their forums. Later, Gottlieb divided his time between studios in New York City and East Hampton, Long Island, the country retreat of many of the abstract expressionists.

Gottlieb's paintings reveal three distinct stages of development: the Pictographs of 1941-1951; the Imaginary Landscapes, begun in 1951; and the Bursts, be-

gun in 1957. The Pictographs included abstracted but recognizable symbols and mythological references within a compartmentalized, grid-like framework. In the Imaginary Landscapes, Gottlieb concentrated more on pictorial structure, in particular the relationship between floating forms in the upper portion of the canvas and a dense mass below. The Burst paintings, such as Asterisk on Red, are characterized by the juxtaposition of two or more forms on a monochrome ground. In these paintings, the disc became the dominant form. Gottlieb explored its expressive potential in combination with a variety of other forms. The repetition of the burst motif in different media — an endeavor that occupied the artist until his death in 1974 — took on various means of expression, from the almost hard-edge, geometric precision of Asterisk on Red to loose, amorphous interpretations. In the Bursts, Gottlieb explored a symbolic format in which he could communicate his feelings about the individual's relationship to a vast, constantly changing universe, using color as an important vehicle to communicate emotion.

Despite his interest in myth and his attraction to nature, Gottlieb's primary concern was always with the communication of feelings; he said of painting: "I frequently hear the question 'What do these images mean?' This is simply the wrong question. Visual images do not have to conform to either verbal thinking or optical facts. A better question would be 'Do these images convey any emotional truth?'"

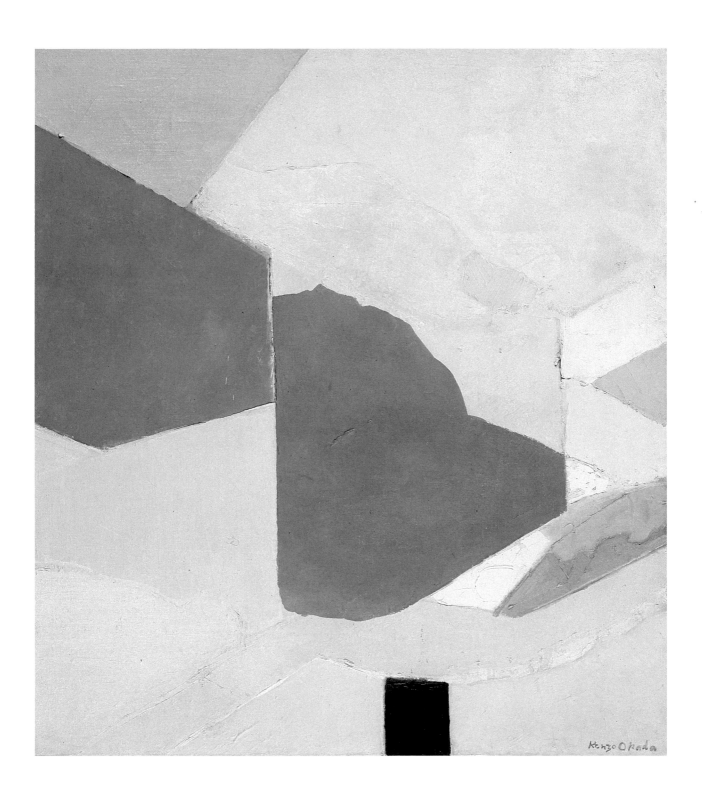

SAUL STEINBERG

BORN 1914

LANDSCAPE THEORY I

WATERCOLOR ON PAPER, 1967

22⅞ x 29 INCHES

Saul Steinberg combines art, caricature, and illustration to demonstrate that adherence to traditional categories in the visual arts is unimportant. Steinberg enjoys his ambiguous status of perhaps being an artist, perhaps not. Born in a small town in southeast Rumania, Steinberg was raised in Bucharest where his father was a printer and bookbinder. In 1932, Steinberg graduated from high school and entered the University of Budapest. A year later, he enrolled in a school of architecture in Milan. Steinberg says of this experience, "The study of architecture is a marvelous training for anything but architecture. The frightening thought that what you draw may become a building makes for reasoned lines."

Later that same year, Steinberg began drawing from life for the first time. This process, he felt, demanded the elimination of a ready-made vocabulary and resulted in genuine clumsiness. The best "clumsy" painters in Steinberg's opinion were Cézanne and Matisse. Steinberg started publishing cartoons in *Bertaldo*, a Milan biweekly, in 1936. Then under the rule of fascism, Italy and its press were carefully controlled. To avoid this oppression and possible reprisal, Steinberg decided to venture to the United States to be an artist. He forged a passport by using rubber stamps. In 1940, Steinberg's drawings were published in *Life* and *Harper's Bazaar*, and in 1941, he began regularly publishing in *The New Yorker*. He was married to the artist Hedda Sterne in 1944. Steinberg has traveled extensively throughout the world, characterizing and caricaturing in his drawings the memorable places he has visited.

Rubber stamps and passports became prominent motifs in Steinberg's drawings and paintings on paper. Steinberg is also recognized for his figures with mask-like faces and his witty fingerprint images. In many of his passport pictures, a cluster of fingerprints in the shape of a head and shoulders indicates both a specific identity and, since the face has no features, a lack of identity. Steinberg's images are often characterized by architectonic organization. Frequently, cubist, constructivist, art deco, Greek, and Oriental styles are evident. His strange worlds are often inhabited by animals with human heads or vice versa.

Landscape Theory I displays many of the qualities unique to Steinberg. The compositional elements are diagrammatic, but the wash background is cloudlike and painterly. The viewer senses a horizon across the lower half of the watercolor and a sunrise in the circle. The handwritten script across the bottom, found in many of Steinberg's works, is illegible although it appears elegant. Emblematic of the futility of communication, it seems pretty but discloses nothing. Fingerprints across the middle of the work perhaps indicate the artist's own self or suggest a mysterious, even criminal, presence. In the upper left hand corner appears the famous Steinberg trademark, the rubber stamp—the mark of officialdom, of bureaucracy, of the immigrant and of the perpetual traveler.

185

JACK YOUNGERMAN

BORN 1926

BLUE-WHITE-GREEN

ACRYLIC ON CANVAS, 1967

72 x 72 INCHES

Jack Youngerman was born in Louisville, Kentucky. He studied at the University of North Carolina from 1944 to 1946 and received a Bachelor of Arts degree from the University of Missouri in 1947. For the next nine years, Youngerman lived in Europe, traveling extensively and studying briefly at the Ecole des Beaux Arts in Paris. In 1951, the Galerie Arnaud, Paris, presented his first one-man exhibition. He designed the stage sets for George Schehade's *Histoire de Vasco* in 1956 and for Jean Genêt's *Death Watch* in 1958. Youngerman has lived and worked in New York since 1956.

Associated with a group of hard-edge painters, Youngerman paints colorful flat abstractions. The austere refinement of his silhouetted forms and generally primary colors suggest roots, in part, in the works of Matisse, Arp, and Mondrian. Youngerman has described his paintings as depicting reciprocal relationships between shape and space: "The active shape transfers its dynamism to the previously passive space that it seizes. The surrounding space is animated and it seizes the shape in its turn." In his flat, two dimensional canvases, the emphasis is on the surface. Interlocking forms take on positive and negative identities according to their outline, position, and color. This is particularly true of those works in which white or black appears, white being a painted color rather than blank canvas. The flowing line, the organic shapes, and the interaction of two or three colors all create an illusion of movement and subtle shifts in spatial depth. Simultaneously, the sharpness and precision in Youngerman's works produce a sense of balance and suspended action.

In *Blue-White-Green*, the shapes are both jagged and curvilinear. Youngerman has favored a diagonal orientation since he shifted from compositions of many small geometric shapes to fewer large nongeometric ones. In *Blue-White-Green*, the downward thrust from the upper left is countered by the opening movement spreading upward from the lower right. Youngerman's later paintings are more biomorphic; they recall petals, blossoms, and other organic phenomena.

Youngerman has always drawn prolifically. Although his often tiny drawings call upon a collection of shapes similar to those in his paintings, they are usually independent works and not preparatory sketches intended for enlargement. In the late 1960s, Youngerman executed painted stainless steel sculptures which suggested large motifs indirectly translated from the paintings. More recently, he has introduced circular and oval canvases as well as rectangular paintings in which large central forms are echoed in thin gray outlines on lighter gray grounds. This development has signaled an important shift in Youngerman's work away from the sharp contrasts of shapes interacting in space.

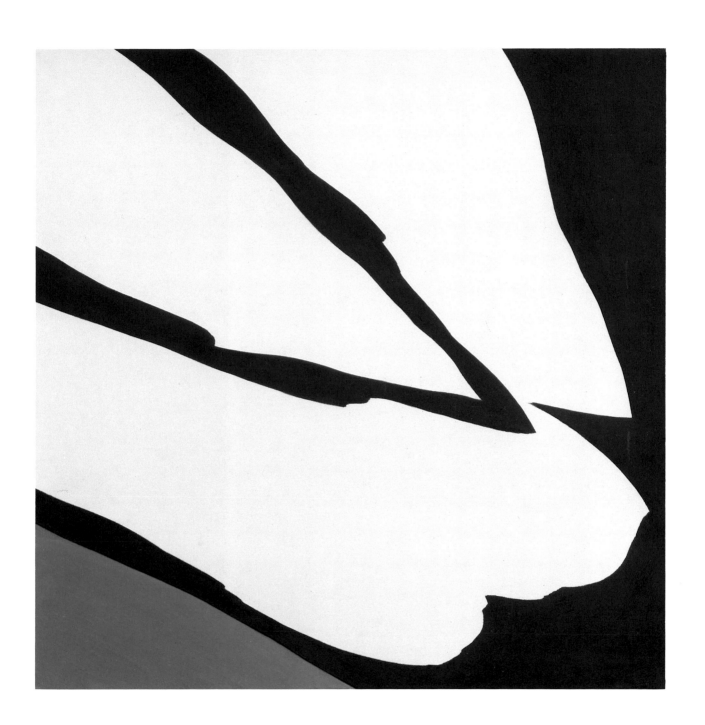

THE
PRUDENTIAL INSURANCE COMPANY
OF AMERICA

Prudential Insurance Company, the world's largest insurer, began in 1875 as the Prudential Friendly Society. From a small basement office in Newark, New Jersey, company founder John F. Dryden aimed to provide insurance protection for the working man. Today, Prudential offers a variety of insurance products for people of all economic levels. It has twenty-five thousand sales representatives in one thousand seven hundred offices throughout the United States and Canada, serving over fifty million policyholders. The company began decentralizing its operations in 1947 and now has eight regional home offices throughout the United States and a headquarters in Toronto for its Canadian operations. The main corporate office is located in Newark. In recent years, Prudential has been expanding its overseas business operations, and it now has a European agency in Wiesbaden, Germany, and a Far East agency in Agana, Guam.

Prudential began assembling art for its offices in 1970 under Donald S. MacNaughton, Board Chairman and Chief Executive Officer. From the outset, designer Lois Dickson has been in charge of selecting the work. The focus of the collection is on contemporary American art, with the greatest concentration on works from the past ten to fifteen years. There are many examples of the most stimulating and provocative recent art. Consisting of approximately three thousand pieces, the collection includes paintings, works on paper, graphics, and to a lesser extent, sculpture and tapestries. Represented are such distinguished artists as William Baziotes, Robert Motherwell, and Adolph Gottlieb.

Occasionally, the company has commissioned artists to create works for specific places in the building. Those having received such commissions include many increasingly important contemporary artists: Richard Smith, Guy Dill, Loren Madsen, Jake Berthot, Al Held, and Chryssa. The extensive collection is now being professionally catalogued.

The art program at Prudential is an extension of an overall design program. Not assembled specifically as a "collection" but as a vibrant part of the everyday environment, the art holdings complement the company's modern interiors and project a contemporary image which mirrors Prudential's progressive outlook in the business world. The presence of art enriches the working environment by adding color, warmth, and interest. In addition to serving a decorative function, the art program exposes employees to the art of our times. The works are periodically rotated between different facilities in a successful and innovative attempt to introduce employees to a broad sampling of contemporary creative achievement. The art program is also intended to benefit the art community by encouraging and supporting living artists and by preserving their work for the future.

Robert A. Beck, Prudential's present Chairman and Chief Executive Officer, views support of the arts as an important element in Prudential's overall commitment to corporate social responsibility. He has observed, "The arts provide an important dimension to our lives and to the social structure of our society." At Prudential, this dimension is conscientiously explored.

WILLIAM BAZIOTES

1912–1963

UNTITLED

OIL ON CANVAS, CIRCA 1957

60 x 72 INCHES

William Baziotes belonged to the generation of painters which pioneered abstract expressionism in the years following World War II. Baziotes was born in Pittsburgh in 1912. He arrived in New York in 1933 and studied for three years under the painter Leon Kroll at the National Academy of Design. From 1936 to 1941, Baziotes worked on the WPA Federal Art Project. His first one-man show was held in 1944 at Peggy Guggenheim's Art of this Century Gallery, at that time one of the few showplaces for avant-garde art in New York. From 1952 until his death in 1963, Baziotes taught at Hunter College, New York. In 1965, the Guggenheim Museum held an important retrospective of his paintings.

During the early forties, like many future abstract expressionists, Baziotes was drawn to the surrealist technique of psychic automatism, which was related to the Freudian method of free association. Its objective was to free images buried in the unconscious for the purpose of artistic inspiration; the process of creation was to take place without preconception. The surrealists sometimes employed accidents, random occurrences, and chance effects in an effort to preserve spontaneity and prevent the conscious mind from taking over. Although Baziotes drew upon his unconscious and worked without preconceived plans, he approached the canvas slowly and worked intuitively.

Psychic automatism was not the only important influence on Baziotes and the abstract expressionists. Along with Theodoros Stamos, Adolph Gottlieb, and others, Baziotes was drawn to the amoeboid forms of Arp, Miró, and Picasso. These forms seemed to suggest living things that were neither plant nor animal. Often they were combined with images having ancestral and mythological associations thought to be part of a shared racial past.

Untitled reflects certain changes that occurred in Baziotes' work in the fifties. In that decade, he moved away from biomorphic shapes and began to employ more personal forms which symbolized emotions or moods; they were psychologically inspired rather than abstracted from the visible world. Baziotes reduced the elements in these large compositions to two or three shapes, leaving more empty space than previously. He never developed the gestural lines of his abstract expressionist colleagues nor the raw power of their emotions. Instead, he became a subtle colorist of great sensitivity. Abstract forms, both supple and angular, quietly float through the colorful atmospheric effects rendered from his palette. Denizens of some primordial undersea world, they are simultaneously strange living creatures and metaphors for growth and change.

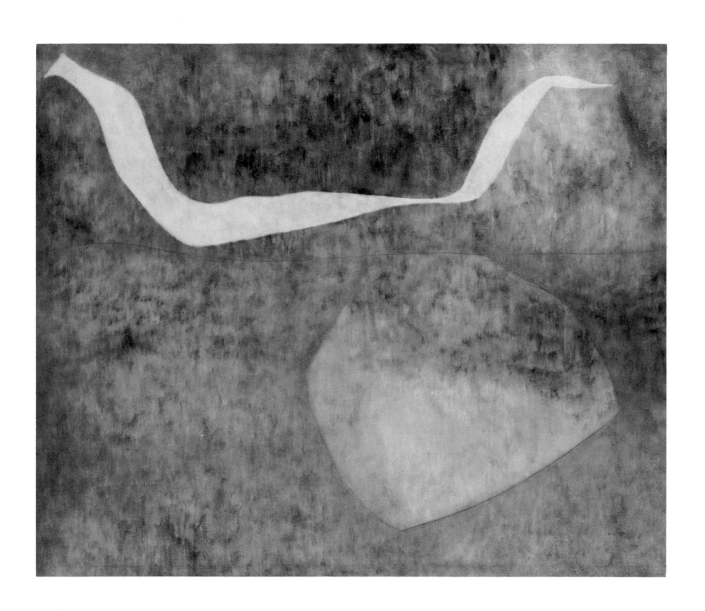

RICHARD DIEBENKORN

BORN 1922

OCEAN PARK #31

OIL ON CANVAS, 1970

93 x 81 INCHES

Richard Diebenkorn is one of California's most influential and well-known artists, having led parallel careers as a prominent representative of the northern California figurative style of painting and as an important teacher in Los Angeles and the San Francisco Bay area.

Born in Portland, Oregon, Diebenkorn studied at various universities in northern California from 1940 to 1949. In the early fifties, while studying at the University of New Mexico in Albuquerque, he painted a series of abstract landscapes depicting the colors and the sparse, arid surfaces of the high desert. In 1953, after brief periods of teaching in Illinois and living in New York, Diebenkorn found his way back to California. Settling in Berkeley, he renewed his friendships with David Park and Elmer Bischoff, two of his former teachers from the California School of Fine Arts (now the San Francisco Art Institute). Diebenkorn continued to paint abstract landscapes for a short time, inspired by his new West Coast environment, but in 1955, dissatisfied with his progress, he turned to figurative painting. Together with Park and Bischoff, Diebenkorn became a proponent of that style of painting which combined the spontaneous brushstroke of abstract expressionism with an organized, representational composition. Un-

like the abstract expressionists, Diebenkorn retained in his paintings a strong sense of location, sometimes referring to the landscape, sometimes to architectural space. He was still working in this figurative style when, in 1966, he moved to Los Angeles to take a position at the University of California.

In 1967, Diebenkorn began the *Ocean Park* paintings, generally considered his most important achievement. Named for the Santa Monica neighborhood where Diebenkorn's studio is located, these abstractions are devoid of any figuration or representational imagery and retain only vestiges of their relationship to the landscape. The paintings synthesize several stylistic elements: the luminous color of Matisse, the interlocking space of late cubism, the rigorous compositions of Mondrian, and the gestural brushwork of abstract expressionism.

Diebenkorn was slow to gain national recognition, owing partly to the lack of an adequate patronage and support system in California and partly to his avoidance of the mainstream styles of art during recent decades. The major retrospective of his work which toured the country in 1977, however, has raised him from an important regional artist to a figure of national and even international stature.

192

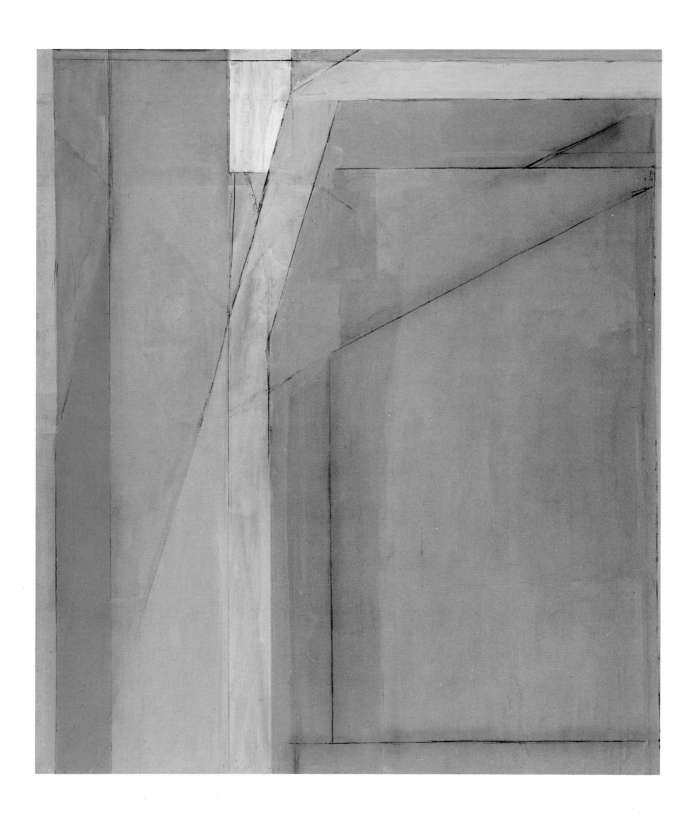

TOM HOLLAND

BORN 1936

UNTITLED from BERKELEY SERIES

EPOXY PAINT ON FIBERGLASS AND RESIN, 1970

48 x 71⅜ INCHES

Tom Holland was born in Seattle, Washington, in 1936. His mother was a portraitist, his father an amateur photographer. Holland studied in Oregon, at Willamette University, and at the University of California's campuses in Santa Barbara and Berkeley. At Berkeley, he worked under the important California figurative painter, David Park, from whom he learned an expressionist style of painting. In 1960, Holland received a Fulbright fellowship to study painting in Chile; the country's influence on his art was evidenced in his new attention to symmetry and use of motifs resembling tribal patterns. Holland's first one-man show was at the Universidad Catolica de Chile, Santiago, in 1969. After returning to the Bay area, he spent the next several years, during the height of Bay area "funk" art, producing audacious works in which papier-mâché palm trees and waterfalls protruded from expressionistically painted oil canvases.

The year 1967 was decisive for Holland; he moved to Los Angeles to teach at the University of California, along with fellow Bay area artist Richard Diebenkorn. Holland now abandoned representational imagery completely, becoming interested in the non-traditional materials with which many Los Angeles artists were experimenting. Southern California painters were substituting everything from metal to plexiglass for canvas, and stretcher bars were often given up in favor of unstretched surfaces secured to the wall by pushpins.

Holland himself began to use sheets of industrial fiberglass, constructing three dimensional supports by cutting through the material with shears and then fastening together the overlapping and sometimes woven forms. To this support, he applied layer upon layer of epoxy paint in a gestural manner, building up a heavily colored surface. Holland shunned the high polish which most Los Angeles artists coveted, choosing instead rough, textured surfaces more often associated with Bay area art.

In a reversal of traditional painting, where the supporting surface is flat and the painted surface creates the illusion of solid space, Holland made the supporting surface of his paintings three dimensional while applying the paint in a non-illusionistic abstract manner.

In 1969, Holland returned from Los Angeles to the Bay area. He currently resides in Berkeley, where he continues to experiment with materials and techniques. In recent work, he has begun to use sheet aluminum in place of fiberglass and to create sculpture as well as painting. Holland continues to explore the paradox between literal and illusory space and to investigate the expressive possibilities of color.

ATL

Atlantic Richfield Cor
resources company, pro
leum, mineral, and c
growing manufacturer
icals. Its other busines
aluminum, uranium o
products. The diverse
and its subsidiaries are
United States, with
cated in Los Angele
Plaza. There are also

The corporate art
ten years ago and cor
sand works; these in
sculpture, photograp
collection emphasize
works of art on pap
ples of primitive art
century engravings,
and Eskimos.

Many of Atlantic
arts have been the
Robert O. Anderso
merly Chairman of

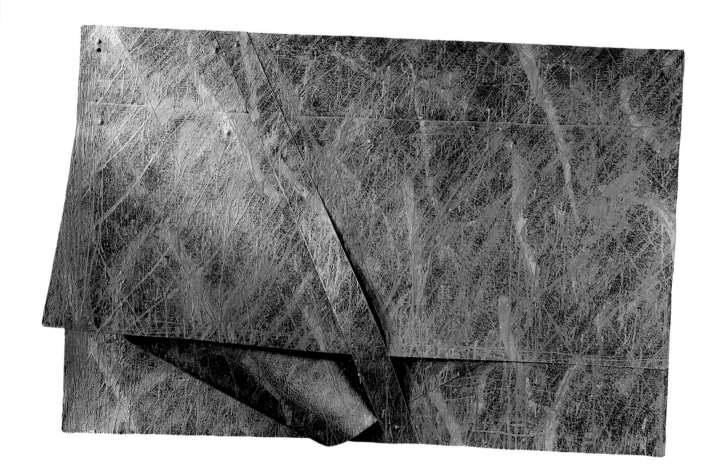

LEE KRASNER
BORN 1908

BLUE SPOT
OIL AND COLLAGE ON BOARD, 1954
40 x 48 INCHES

Lee Krasner is now recognized as a seminal figure in the evolution of abstract expressionism. Born in Brooklyn, New York, she attended the Women's Art School of Cooper Union and the Art Students League from 1926 to 1929. Shortly after, while studying at the National Academy of Design, Krasner encountered the works of Matisse and Picasso at the Museum of Modern Art. From 1934 to 1943, she worked for the New Deal art projects, including the mural division of the WPA Federal Art Project. She also took classes at Hans Hofmann's art school during the late thirties. At that time, Krasner began to associate with David Smith, Arshile Gorky, and Willem de Kooning, artists who were soon to transform American art. She also received encouragement from Piet Mondrian, then living in New York. In 1940, Krasner exhibited with the American Abstract Artists, and in 1942 she was included in the important exhibition *French and American Painting,* organized by painter and theoretician John Graham at McMillen Gallery, New York. Krasner married Jackson Pollock in 1945. In 1951, she held her first one-woman exhibition at Betty Parsons Gallery, New York. The Whitechapel Art Gallery, London, organized her first retrospective in 1965. She lives and works in East Hampton, Long Island and in New York City.

As a student, Krasner's growing awareness of Matisse, Picasso, and Mondrian effected her move toward abstract compositions based on organic forms.

Influential also was her reading of John Graham's 1937 treatise, *System and Dialectics of Art.* She was responsive to Graham's emphasis on art as emotional and subjective expression and on drawing as the principal gesture of this expression.

The 1940s was a decade of exploration for Krasner. Her *Little Image* paintings of 1946-1949 emerged from the reworking of several early imageless gray paintings. In the thickly textured, calligraphic revisions she came convincingly to grips with scale, gesture, and space. Krasner began painting on a large scale in 1951. In 1953, she cut up both raw canvas and many of her earlier paintings. Utilizing these fragments, she made a series of collage paintings like *Blue Spot.* A limited range of brilliant colors, a vertical thrust, rough painterly edges, curving forms, and dense flat space created the rhythmic arabesques characteristic of the series.

After 1955, Krasner's paintings became increasingly freer in gesture and larger in size. Her works fluctuated in emphasis between linear elements and organic shapes, between vivid colors and muted tones. The sense of growth and change and the importance of gesture in her works have remained consistent. During the 1970s, Krasner has resumed making collage paintings in which cut segments of her early charcoal drawings and oil sketches are combined with areas of sober color and unpainted canvas to create dynamic, gestural patterns.

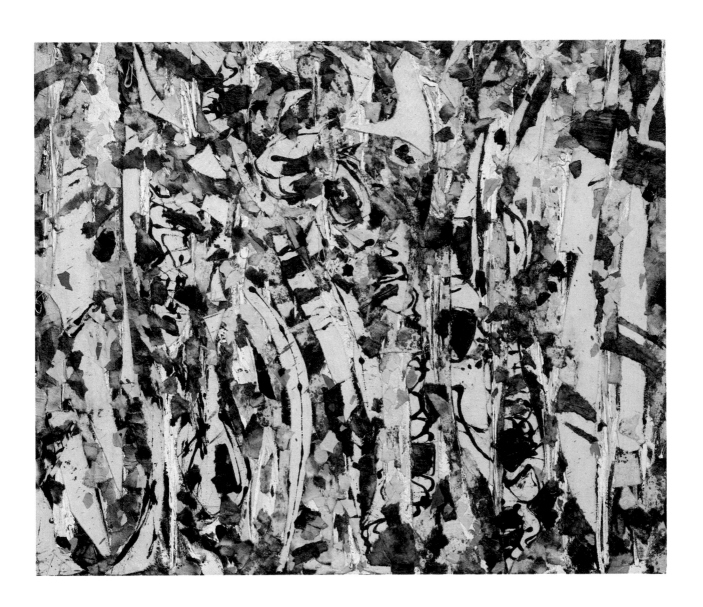

199

LORSER FEITELSON

1898–1978

COBALT WITH RED

ACRYLIC ON CANVAS, 1967

60 x 60 INCHES

Lorser Feitelson was a pioneer in the development of modernism in California from the time of his arrival there in 1927 to his death in 1978. Widely exhibited, he was also an articulate writer, important gallery director, influential teacher, and, during the mid-fifties, host of a Los Angeles television program called "Feitelson on Art."

Born in Savannah, Georgia, in 1898, Feitelson was raised in New York City. There, he was exposed at an early age to both American and European avant-garde art, most notably at the Armory Show of 1913. His early artistic training in New York and Paris was rigidly grounded in classical and Renaissance art, particularly drawing and composition; Michelangelo and Piero della Francesca were the standards by which he measured himself. In the late teens, Feitelson explored cubist and futurist aesthetics but returned to classically inspired figurative art by the early twenties. Tiring of the high-pressure New York and Paris art scenes, Feitelson moved to California in 1927 and joined the nascent Los Angeles art community. His cosmopolitan point of view was to be a strong influence on the local artists.

During the Depression, Feitelson worked actively on the WPA Federal Art Project, both as administrator and artist. During the same period, he joined with Helen Lundeberg and several other painters to found a movement variously called post surrealism or subjective classicism. They explored a conscious symbolism which expressed psychological states of mind.

In the mid-forties, Feitelson abandoned the representational and symbolic imagery of post surrealism for an abstract style manifested in a series of paintings called *Magical Forms*, whose curvilinear shapes sometimes related to the human figure. During the fifties, his work evolved into nonrepresentational hard-edge painting. The term "hard-edge" was coined by the critic Jules Langsner in the catalogue essay for a 1959 exhibition at the Los Angeles County Museum of Art. Entitled *Four Abstract Classicists*, it included Feitelson and California painters John McLaughlin, Karl Benjamin, and Frederick Hammersley. These artists all painted crisply defined geometric forms, carefully marked out and painted in smooth, unmodulated colors.

Of his works, Feitelson said: "Space, with its expressive possibilities of monumental magnificence and mystery, and linear rhythm, with its limitless potentialities for harmonic and emotional experience, are the two principal elements in my hard-edge paintings. Color functions solely in the role of intensifying the activity of these elements." Feitelson's paintings of the 1960s were the culmination of a long and fruitful career. On a bright monochromatic ground, he manipulated either a twisting ribbon of contrasting color, as in *Cobalt with Red*, or several thin lines in graceful arcs and curves. With this simple repertoire of forms, Feitelson achieved a remarkable range of emotions, combining order and freedom, gentleness and severity, stability and flux.

200

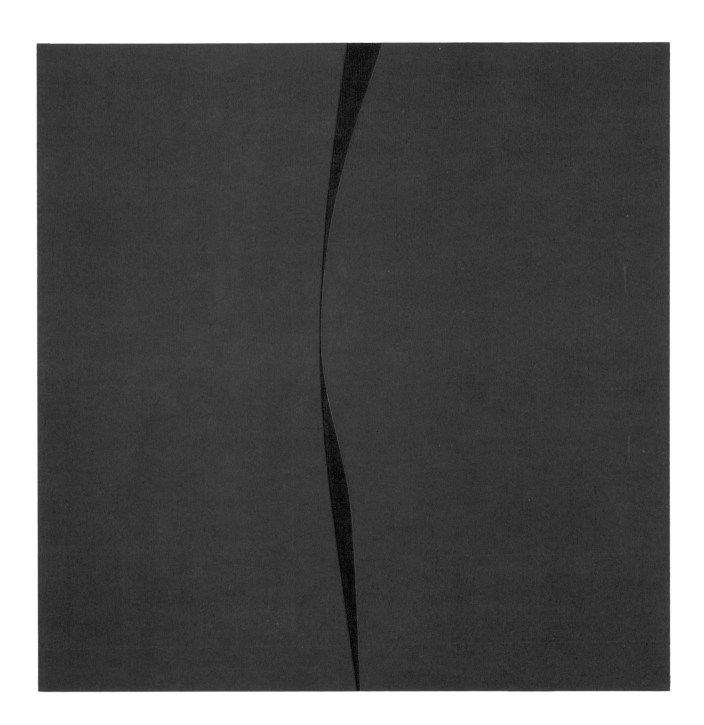

ROY DE FOREST
BORN 1930

BROTHERS BENEATH THE SKIN
OIL ON CANVAS, 1968
67⅛ x 67⅛ INCHES

Roy De Forest is one of the many California artists whose work evolved in the creative environment of San Francisco during the 1950s. Born in North Platte, Nebraska, De Forest grew up in Yakima, Washington, where he attended Yakima Junior College from 1948 to 1950. Awarded a scholarship, he moved to San Francisco and studied until 1952 at the California School of Fine Arts (now the San Francisco Institute of Art). Among his teachers were Edward Corbett, Elmer Bischoff, James Budd Dixon, and David Park.

Even as a student, De Forest was active in the San Francisco art community, exhibiting his work and participating in artists' discussion groups, particularly Hassel Smith's seminars from 1951 to 1952. In 1953, De Forest received his Bachelor of Arts degree from San Francisco State College, where he also earned a Master of Arts degree and his teaching accreditation in 1958. Shortly thereafter, he returned to Yakima Junior College as an art instructor. In 1961, De Forest settled once again in the Bay Area, where he has exhibited regularly. Since 1965, he has taught at the University of California at Davis. The San Francisco Museum of Modern Art organized his first retrospective in 1974.

De Forest's highly personal narrative style springs from his love of adventure and fantasy. His whimsical autobiographical approach aligns him with artists such as William T. Wiley, Robert Arneson, and Robert Hudson who, in different media, developed a significant alternative to the figurative and abstract trends which flourished in the Bay Area during the 1950s and 1960s.

Like many of De Forest's paintings, *Brothers Beneath the Skin* suggests an aerial map view of imaginary lands and peoples. Distinct areas of brilliantly colored, elaborately detailed scenes invite close examination and at the same time direct attention to the center of the painting. Such organization is characteristic of De Forest's works of the mid-sixties.

A prolific artist, De Forest works in several media. He has executed bas relief sculptures and constructions from a variety of readymade objects and discarded materials. Independent of the paintings, though unmistakably related in imagery and theme, De Forest has also produced a significant body of drawings. The undefined space of his early work has given way to an increasingly organized, frontal focus, while his busy calligraphic imagery has become broader and more formalized in its symbolism.

FIRST CITY NATIONAL BANK
OF HOUSTON

First City National Bank is the leading member bank of the holding company, First City Bancorporation of Texas, Inc., which includes a total of twenty-seven banks throughout the state. Founded in 1866 as the First National Bank of Houston, it later became First City National Bank after a series of mergers. It is now the largest bank in Houston and, based on domestic deposits, the largest bank in Texas.

The corporate art collection includes painting, sculpture, prints, and drawings. It was initiated five years ago due to the personal commitment of James A. Elkins, Jr., Chairman of the Executive Committee, and other members of the bank's senior management. The collection is modest in size and ambitious in the quality of the art it contains. Featured are works by contemporary American artists Cy Twombly, Ed Ruscha, Al Held, Billy Al Bengston, and Christopher Wilmarth. The bank has also purchased monumental works by such important artists as Helen Frankenthaler, Ellsworth Kelly, Morris Louis, Kenneth Noland, and Frank Stella. This outstanding collection, built in consultation with Houston art dealer Janie C. Lee, is located in the bank's three downtown buildings. Ms. Lee oversees the maintenance, restoration, and placement of the works and has produced an illustrated catalogue in which all but the two most recent acquisitions — works by Jules Olitski and Robert Motherwell — are reproduced. Elkins has explained that the purpose of the art collection is both to create a beautiful environment and to provide cultural enrichment for customers and employees. Although most of the pieces of art have appreciated in value, Elkins, like other committed corporate collectors, stresses that the bank does not look upon the collection as an investment and has no intention of ever selling the artworks.

The First City National Bank believes strongly in supporting both the arts and charitable organizations in Houston. Its ideological commitment is backed up by a substantial annual contribution budget. In addition to the acquisition of works of art — which is funded separately from the budget for charitable contributions — the bank supports the Combined Arts Corporate Campaign in Houston. Through this organization, First City National funds museums and performing arts groups in the area: the Houston Jazz-Ballet Company; the Houston Grand Opera Spring Festival in Miller Outdoor Theater; and numerous educational, medical, welfare, civic, and charity organizations. Such generosity has greatly contributed to Houston's continuing physical growth and its expanding cultural resources.

ROBERT MOTHERWELL

BORN 1914

ELEGY TO THE SPANISH REPUBLIC #134

OIL ON CANVAS, 1975

72 x 84 INCHES

Robert Motherwell, one of the most articulate spokesmen for abstract expressionism, was also one of its most important painters. Born in Aberdeen, Washington, he grew up in San Francisco. After majoring in philosophy at Stanford and Harvard Universities, Motherwell moved to New York in 1939. Influenced by art history professor Meyer Schapiro at Columbia University and by the European surrealists in exile in America, he decided in 1941 to become a painter. Owing to his association with both the European and American avant-garde in New York, Motherwell became what was at the time a rarity—an abstract painter from the outset of his professional career.

Motherwell exemplified the new interrelationship between art and criticism that developed around the avant-garde in the 1940s. He was not only a painter; he wrote, taught, and edited, all with particular concern for what artists said about their own work. In 1944, Motherwell was included in an important series of one-man exhibitions by new American painters held in New York at Peggy Guggenheim's Art of this Century Gallery. Also included were Jackson Pollock, William Baziotes, and Adolph Gottlieb. With Baziotes, Gottlieb, and others, Motherwell founded an informal loft school called "Subjects of the Artist." Motherwell has had numerous one-man shows around the world, including a 1965 retrospective at the Museum of Modern Art, New York. He has also been included in the major group exhibitions of American abstraction. Motherwell has taught at Black Mountain College, Hunter College, Yale, and Harvard. He lives and works in Greenwich, Connecticut.

In his paintings, Motherwell seeks to balance several conflicting themes: the conscious and the unconscious, emotion and reason, life and death. Always a prolific artist, he has experimented simultaneously with a variety of styles, techniques, and subjects. He integrates elements derived from such disparate sources as the private fantasy worlds of dada and surrealism; the rigorous pictorial structure of Piet Mondrian; the fragmented space of cubism; the abstracted windows and walls of Matisse; and the free brushwork, dripping, and spattering of abstract expressionism.

Unlike other abstract expressionists in the 1940s, Motherwell concerned himself not with mythological themes, but with what he saw as the destructive elements of civilization. In 1948-1949, he established the theme that became the basis for the major paintings of his career, the *Elegies to the Spanish Republic*. The *Elegies* are generally monumental in scale but also include some small sketches and drawings done in oil and gouache. Employing two archetypal forms—large ovoid shapes and thick phallic columns—painted mainly in black on a light-colored ground, these haunting paintings unite Motherwell's painterly and philosophical concerns. His major works since the 1950s, the *Elegies* have been augmented by other explorations of nonrepresentational painting, hundreds of smaller drawings, collages, prints, and typographical experiments.

206

AL HELD

BORN 1928

NORTH-NORTHWEST

OIL ON CANVAS, 1973

72 x 96 INCHES

Originally known as a second generation abstract expressionist, Al Held was among the first to react against that style in the late 1950s. In the sixties, he became recognized for huge canvases characterized by bold colors applied in thick layers to depict flat, geometric forms often cut off at the framing edge.

Held was born in Brooklyn in 1928 on the eve of the Great Depression. He began painting in 1948, enrolling in the Art Students League where he studied under Kimon Nicolaides, Robert Beverly Hale, and Harry Sternberg. Held's early paintings were figurative and painted in a social realist style. After his plan to study with muralist David Alfaro Siqueiros was unexpectedly upset, Held traveled to Paris, but not before seeing the paintings of Jackson Pollock for the first time. This experience profoundly influenced his art.

In Paris from 1950 to 1952, Held studied sculpture under Ossip Zadkine and took courses at the Académie de la Grande Chaumière. He also associated with the large community of American artists then living in Paris, including Ellsworth Kelly and Jack Youngerman. Held abandoned figurative painting and began to paint dark, thickly pigmented canvases in which he tried to synthesize Pollock's "subjectivity" with Mondrian's "objectivity." He returned to the United States in 1953, continuing to paint in a style strongly influenced by abstract expressionism. In 1959, Held had his first one-man show in New York at the Poindexter Gallery. During the sixties, he became associated with artists who were using hard-edge or geometric forms of abstraction. He was included in several major exhibitions which examined this new direction in nonrepresentational art. In 1974, Held was given a major retrospective at the Whitney Museum of American Art, New York.

North-Northwest exemplifies the phase in Held's work, begun in 1967, during which he painted black and white linear variations of three dimensional, geometric forms in space. In 1973, Held exhibited a series of prismatic forms seen in perspective, half painted in black outlines on a white ground and half painted in white outlines on a black ground. Since he had always shown an interest in spatial illusion, it was logical for Held to extend this interest into an exploration of perspective, even though nothing could have been further from the concerns of abstract art in the 1960s. Unlike traditional painters who used perspective to create a logical, ordered illusion of three dimensional space, Held aimed to subvert the very possibility of such illusion, using the interaction of overlapping forms to create tension and, above all, ambiguity.

In *North-Northwest*, the overlapping outlines of geometric forms are painted in what appears to be a multiple vanishing point perspective so that the objects do not fit together into a coherent structure. The manner in which the forms overlap leads to visual contradictions. At times, one surface appears in the foreground; then another takes its place. The depth implied by the perspective is negated by the large circles which emphasize the flatness of the canvas.

BILLY AL BENGSTON

BORN 1934

BIG JIM McLAIN

LACQUER POLYESTER RESIN ON ALUMINUM, 1966

58 x 60 INCHES

Billy Al Bengston was a leading participant in the development of a California aesthetic during the 1960s. During these years, many Californians overcame their subordination to New York art and began to work in an independent, recognizable style. Through association with Los Angeles artists surrounding the Ferus Gallery, including Craig Kauffman, Robert Irwin, and Larry Bell, Bengston gained an interest in using non-traditional materials to achieve various effects. The methods of these artists emphasized surface, color, and light; hard-edge, "cool," geometric forms; and a focus on visual perception as the subject of their work.

Although there were local artistic precedents for the development of this "California style" in the work of hard-edge painters Lorser Feitelson and John McLaughlin, the Southern California lifestyle and environment themselves were possibly more influential. The interest in cars and surfboards, the beauty of sunlight reflecting off the Pacific Ocean or the light-drenched land, and the ready availability of industrial techniques and materials all contributed to the evolving California aesthetic.

Bengston was born in Dodge City, Kansas, in 1934 and moved to Los Angeles at the age of thirteen. His art education began there at Manual Arts High School. It continued at various colleges including the California College of Arts and Crafts, Oakland, where he studied under Richard Diebenkorn and Sabio Hasegawa, and ended at the Los Angeles Art Institute (now Otis Art Institute) in 1957, where he studied

under Peter Voulkos.

Together with Voulkos, John Mason, and Kenneth Price, Bengston revived ceramics as an art form on the West Coast in the mid-fifties. Although he abandoned ceramics for painting in 1957, it did have a profound influence on his art.

Big Jim McLain from the *Canto Indento* series exhibits the characteristics for which Bengston is best known. Symmetrical, centered imagery dominates Bengston's work of the sixties. His personal repertoire of emblems includes the heart, the iris, and, as in this painting, the chevron. *Big Jim McLain* is a study in opposites: the marred aluminum support contrasts with the technical perfection of the painted surface; the hard-edge militaristic insignia is superimposed on a soft, feminine flower or erotic form painted in delicately shaded pastel colors.

Perhaps the work's most significant feature is the painting technique. A motorcycle enthusiast, Bengston admired the way light reflected off the machines' painted surfaces. He began to learn the techniques of motorcycle painting, working in seclusion to perfect his skills. In the *Canto Indento* series, begun in 1966, Bengston applied these techniques to an aluminum support which he prepared by hammering, puncturing, folding, crumpling and denting because he liked the way that the marred surface reflected and diffused the light. Since the late 1960s, Bengston has become increasingly involved with the more sybaritic aspects of painting: lush color, soft light, and vibrant pattern.

211

GREAT WESTERN SAVINGS AND LOAN ASSOCIATION

Great Western Savings and Loan Association was founded in 1877 to provide a repository for the savings of the public and to make mortgage loans for homes. The company is located throughout California in one hundred seven branch offices. It serves more areas than any other savings and loan institution in the state and is presently continuing its expansion in California.

The art collection became part of the company when Great Western Savings acquired Lytton Savings and Loan Association in 1970. Bart Lytton, the founder of that company, was involved in contemporary art early in his life and was a friend of Pablo Picasso in the 1930s. Becoming successful in the savings and loan business, Lytton began a personal collection, at first concentrating on European classics of the early twentieth century such as Georges Braque, Joan Miró, and Marc Chagall. He began the corporate collection after an interesting observation: in mort-gage loans, after the initial transaction with both a husband and wife, subsequent dealings were usually only with the wives. Lytton decided to make his offices more attractive and selected an interior decorator to assist him. Pursuing this new interest in the visual quality of the working environment, Lytton reached a logical conclusion. To complement the more comfortable interior space and to encourage artists in the state where his business was located, Lytton began to assemble a corporate art collection that focused exclusively on California artists.

Included in the extensive collection are such artists as Ed Ruscha, Peter Voulkos, Karl Benjamin, Helen Lundeberg, and Stanton Macdonald-Wright. At present, the collection numbers more than four hundred fifty works and is located in the branch offices throughout California. In a state presently rich in corporate collections, Lytton's collection was one of the earliest.

213

HELEN LUNDEBERG
BORN 1908

THE STUDIO—NIGHT
OIL ON CANVAS, 1958
30 x 24 INCHES

Helen Lundeberg's paintings are both classic and romantic; a sense of calm and order coexists with the mysterious and the puzzling. Born in Chicago in 1908, Lundeberg was raised in California from the age of four. In 1930, she enrolled in the Stickney Memorial School of Art in Pasadena where a new instructor, Lorser Feitelson, had an immediate and profound influence on her. In 1931, her painting *Apple Harvest* was accepted into the 6th *Annual Exhibition of Southern California Art*. The following year, Lundeberg's *Landscape with Figure* received an honorable mention at the Los Angeles County Museum's *13th Annual Painting and Sculpture Exhibition*. Lundeberg had by this time established herself as an important and innovative artist and had begun to work in the mode for which she would become nationally known.

With several other California artists, including Feitelson, Lundeberg belonged to a group which called itself post surrealist. The artists were interested in the symbolic aspects of European surrealism but rejected its pathological and incomprehensible aspects, even though they shared some common symbols. Lundeberg and Feitelson produced meticulously ordered canvases, manipulating images consciously rather than unconsciously. They explored the normal functions of the mind, rather than the Freudian influenced dream subjects found in European surrealism. In 1935, Lundeberg painted her well-known *Double Portrait in Time* (National Collection of Fine Arts,

Smithsonian Institution), a meditation upon birth, growth, change, and self-awareness, essential themes of her work.

The introspective nature of Lundeberg's personality became the basis for her art. She maintained that she was a classicist "by conviction and nature" and that her aim in a painting was to calculate every element with regard to its function in the entire composition. She did not work from nature but did use natural elements, such as seashells, flowers, stars, planets, or mountains, as symbols. Her compositions are always rhythmical and balanced, stressing form over emotion.

During the 1950s, flat, abstract planes became the settings for Lundeberg's poetic objects and symbols. In the latter part of the decade she responded to California's hard-edge movement by painting backgrounds with sharply outlined geometric areas. *The Studio—Night* of 1958 exemplifies her work of this period. The composition is sharply divided by the architectural elements of the table and room. The apple on the table lies in a flat plane; the foreground of the work contains an easel with a portrait on it, an element often seen in Lundeberg's work. The colors are muted and closely related. Since the early 1960s, nonrepresentational forms have characterized Lundeberg's paintings. Largely replacing the imagery and symbols of her earlier work, these lyrical compositions may suggest undefined natural processes or forms but are not, in fact, abstracted from nature.

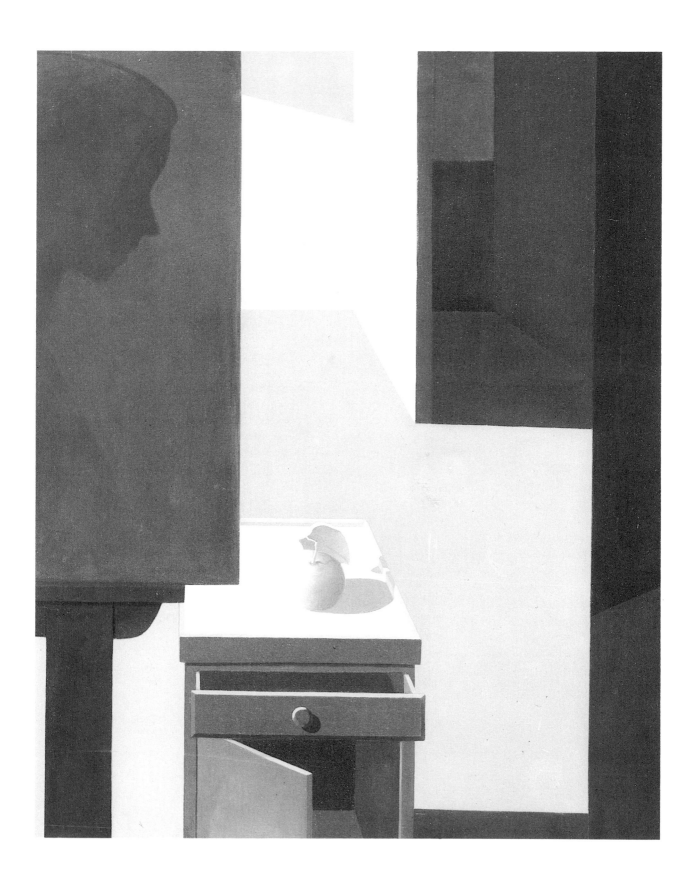

STANTON MACDONALD-WRIGHT

1890–1973

DU NORD

OIL ON CANVAS, 1958

40 x 32 INCHES

Stanton Macdonald-Wright was born in Charlottesville, Virginia, and began art lessons under private tutors at age five. In 1900, his family moved to Santa Monica, California, where he enrolled in 1905 at the Art Students League of Los Angeles. At seventeen, he married and then traveled to Europe to study art. He attended the Sorbonne and studied briefly at the Académie Colarossi, the Académie Julian, and the Ecole des Beaux Arts. During this period, Macdonald-Wright painted in an impressionist manner and was influenced by both Cézanne and the old masters. He was, however, aware of the newest currents in art espoused by Picasso and Matisse.

In 1910, at the *Salon d'Automne*, Macdonald-Wright exhibited a portrait which he considered coloristically daring. The following year, he met Morgan Russell, and together they began formulating a theory of color. Both artists studied under Percyval Tudor-Hart and read the color theories of Eugène Chevreul.

By 1912, Macdonald-Wright and Russell had founded an aesthetic they called synchromism, the word "synchromy" suggesting harmonized color. Macdonald-Wright's first synchromy was an abstraction based on Michelangelo's *Slave*. Later, the figure was abandoned totally to leave only broad patches of large geometric patterns; the result was an overall effect of voluminous color. In 1913, Russell exhibited at the *Salon des Indépendants*, and later that year he and Macdonald-Wright exhibited together. Macdonald-Wright's work was characterized by fan-like elements and colorful discs which moved diagonally across the canvas.

In 1914, Macdonald-Wright brought his work to New York and exhibited at several places. He stayed for only a few months and left for Paris with his brother, the critic Willard Huntington Wright. They collaborated on several books and published *Modern Art: Its Tendency and Meaning* and *The Future of Painting*. Macdonald-Wright returned to New York in 1916 and exhibited at Alfred Steiglitz' "291" gallery. He then moved to California in 1919 and became involved with motion pictures. Discouraged by "the personal academicism of his own synchromism," Macdonald-Wright retired from exhibiting in 1920 to begin a period of study and experimentation. He pursued an interest in Asian art and philosophy and became an active teacher and designer. From 1922 to 1930, he directed the Art Students League of Los Angeles; during the 1930s, he painted a mural for the Santa Monica library and directed the WPA Federal Art Project in Southern California.

In the 1940s, Macdonald-Wright taught art history, iconography of art, and Oriental aesthetics at the University of California, Los Angeles, exhibiting only rarely. He began actively to exhibit again in 1954, and in 1956 the Los Angeles County Museum presented a major retrospective of his work. He also returned to painting in a synchromist style.

Du Nord of 1958 exemplifies synchromist principles reworked in decorative colors and rhythmical forms. In the 1960s, Macdonald-Wright refined his ideas on synchromy, replacing the impulsive quality of his early work with a careful attention to the lyrical harmony of color.

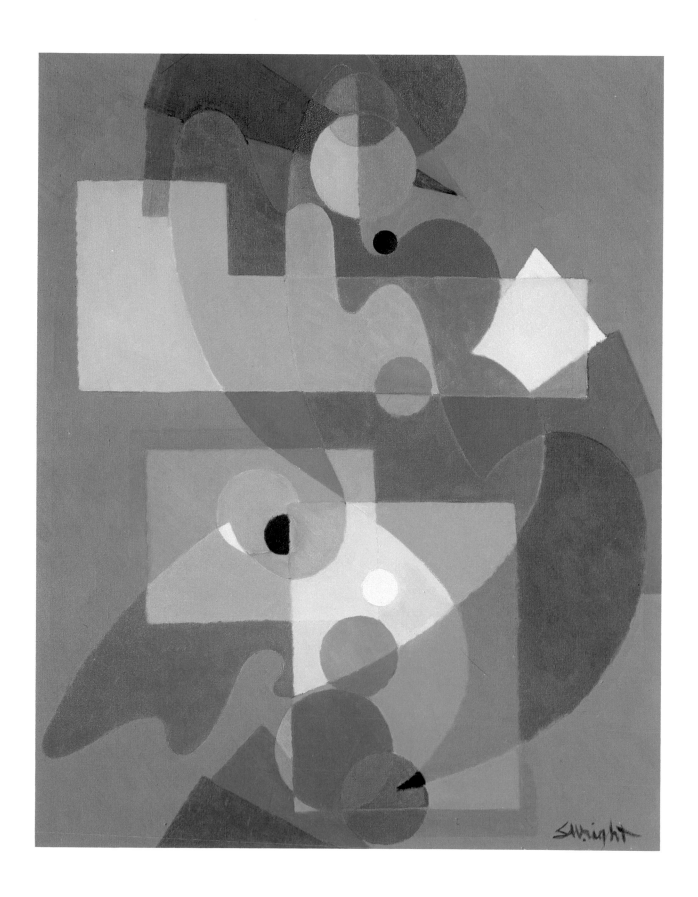

217

KARL BENJAMIN
BORN 1925

TG #23
OIL ON CANVAS, 1961
18 x 14 INCHES

Born in Chicago, Karl Benjamin studied at Northwestern University, the University of Redlands, and the Claremont Graduate School. He had his first one-man show at the University of Redlands in 1953 and was included in the Los Angeles County Museum of Art's 1959 exhibition *Four Abstract Classicists* and the Museum of Modern Art's 1965 show *The Responsive Eye*. He currently lives and teaches in Claremont, California.

Benjamin's representational works from the late forties were largely inspired by cubism. By 1951, his images had become flat, ordered, and crisp, although references to objects still remained. These references were eventually eliminated, and beginning in the mid-fifties, Benjamin's paintings were purely abstract and entirely preconceived. Although influenced by Mondrian and constructivism, Benjamin's primary concern is with color. His hard-edge style, free of any visible brushmarks, is intended to heighten the impression of the colors as pure unmodulated expanses.

With Lorser Feitelson, John McLaughlin, and Fred Hammersley, Benjamin was included in *Four Abstract Classicists*. The artists shared a goal of rendering color and form as one unit and an interest in ordering seperate shapes into a unified whole. Before 1959, Benjamin's abstract canvases were covered with jagged shapes and planes which conveyed a sense of being cut like a piece of fabric from a larger design. These zigzag forms seemed also to retain a remote suggestion of the human figure. After 1959, his compositional complexity was reduced in favor of simple bands or grids which allowed color to dominate even more than previously. He has continued to use oil paint in an age of acrylic because "it's beautiful and sensuous and has 'feel' to it."

Benjamin employs mathematics to a certain degree in ordering his structures, but it is his own intuition and visual satisfaction which determine the final composition. He has been influenced by both Josef Albers and Ad Reinhardt in terms of his unusual color juxtapositions and simplified structural designs. In Benjamin's paintings, the chromatic saturation of geometric shapes imparts an expressive power; it is the evidence of an individual artistic personality and gainsays the impersonality one would expect from such hard-edge forms.

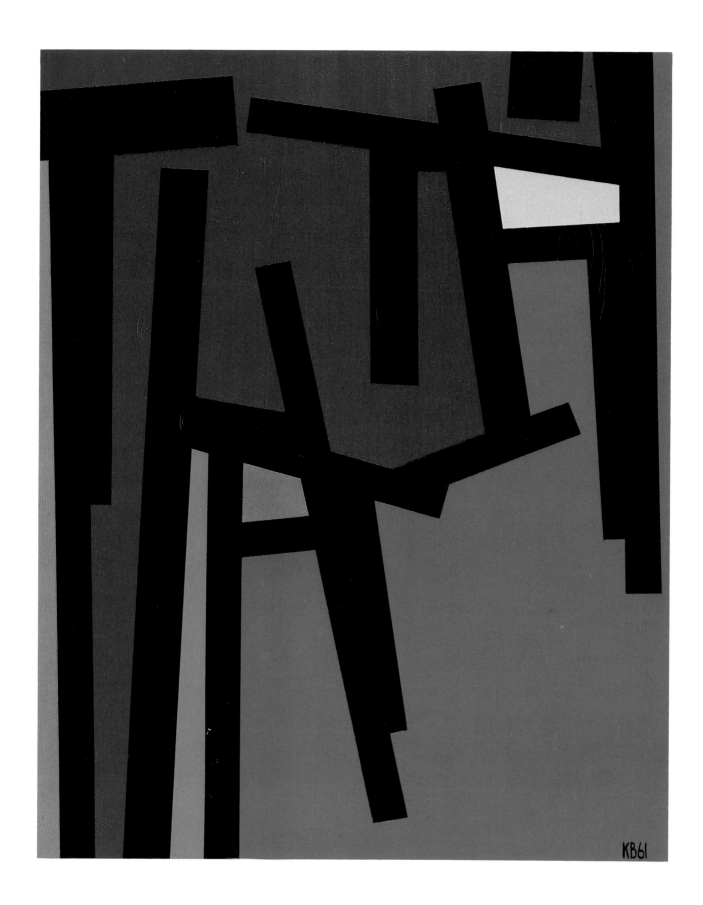

219

CUMMINS ENGINE COMPANY, INC.

Cummins Engine Company was incorporated in 1919 as a manufacturer of diesel engines and their components. The company was founded by C.L. Cummins who, at the age of nineteen, had been hired as a chauffeur by T.W. Irwin, a banker and businessman in Columbus, Indiana. While working for Irwin, Cummins soon converted the family garage into a small machine shop. At that time, the "oil engine" was bulky, oversized and suitable only for stationary power. Since it was too big to be installed inside vehicles — like the gasoline engine — the oil engine was most frequently found on farms where it supplied power for large thrashing and pulping rigs sturdy enough for the engine to be attached to them. This oil-powered engine is now called a "diesel" after its inventor, Dr. Rudolf Diesel. It was Cummins, however, who was responsible for devising many of the applications of the diesel to mechanical vehicles like trucks, boats, buses, and earth movers.

Today, Cummins Engine Company, Inc. employs twenty thousand workers worldwide; its main assembly plant is still located in Columbus. Facilities are also situated in New York, South Carolina, Ohio, Tennessee, California, Brazil, Mexico, and the United Kingdom. Distributorships and working agreements abroad extend the company's interests throughout the world.

The corporate art collection was begun in the 1960s by J. Irwin Miller, Chairman of the Board at that time, and his wife. Rather than focusing on the decoration of executive offices, the Millers purchased pieces of art selected especially for certain public spaces within the company. They wished to expose as many company employees as possible to fine works of art. The collection is composed of approximately one hundred works — prints, drawings, paintings, and sculpture — emphasizing contemporary American art from 1950 to the present; some European art is represented as well. Included are works by important artists such as Josef Albers, Victor Vasarely, and Ellsworth Kelly as well as younger artists like Paul Staiger.

Even greater than its commitment to visual art is Cummins' support of twentieth century architecture. The three company buildings in Columbus were designed by the distinguished architects Bruce Adams, Kevin Roche, and Harry Weese. Through the generosity of the Cummins Foundation, architects' fees have been paid so that outstanding figures could be commissioned to design public buildings such as churches, schools, and libraries throughout the city. The roster of those who have thus been able to build in Columbus encompasses almost every important contemporary architectural firm and includes Edward Larrabee Barnes; Gunnar Birkerts; Gruen and Associates; Hardy, Holzman and Pfeiffer; Mitchell and Giurgola; I.M. Pei; Paul Rudolph; Eero Saarinen; Eliel Saarinen; Skidmore, Owings and Merrill; Venturi and Rauch; John Carol Warnecke; and Harry Weese. Daily guided tours of the architecture in the community begin at the Visitors' Center, fittingly located in an 1864 building that was renovated in 1973 under the direction of Mrs. J. Irwin Miller.

The successful and inspiring efforts of Cummins Engine Company and Cummins Foundation to enrich the cultural life of Columbus, both through the corporate art collection and by underwriting architectural commissions, have given this small city an aesthetic prominence usually accorded only the great metropolises of the world.

JOSEF ALBERS
1888–1976

HOMAGE TO THE SQUARE: RESOUND
OIL ON COMPOSITION BOARD, 1964
48 x 48 INCHES

Born in Bottrop, Germany, Josef Albers was trained as an elementary school teacher. He then studied during the second decade of this century at the Royal Art Academy, Munich, the Kunstgewerbeschule, Essen, and the Art Academy, Munich. After attending the Bauhaus in Weimar from 1920 to 1923, Albers became a professor there. He taught a variety of design and craft courses at the school's successive locations until its closing by the Nazis in 1933. That year, he was invited to the United States to take a post at Black Mountain College, North Carolina, where he taught until 1949. Internationally sought as a teacher, Albers directed the Yale University Art School throughout the 1950s. The first of his several retrospectives was organized by Yale University Art Gallery in 1956. Albers published his major treatise, *Interaction of Color,* in 1963. The International Council of the Museum of Modern Art circulated an exhibition of his *Homage to the Square* paintings in 1963 and 1964 and again three years later. In 1976, Albers died in New Haven, Connecticut.

An articulate spokesman on the practice and theory of his art, Albers has stated, "In my work I am content…to search with simple palette and with simple color for manifold instrumentation." During his Bauhaus years, Albers introduced his concern for economy in form and material and experimented in nonrepresentational works with perceptual ambiguity caused by overlapping lines and planes. In the 1930s, to create suggestive shifts in form and space, he experimented with variations on basic abstract configurations in different color combinations. In 1947, Albers began a series of paintings called *Variants,* in which flat areas of color were organized around two rectangular focal points of different size.

Albers brought two decades of preparation to bear on the widely known *Homage to the Square* paintings, begun in 1949. In each variation of *Homage to the Square,* two or three squares are organized around a central one. The interaction of size and color among the squares creates different impressions in each painting — movement forward or backward in space, afterimages, warmth, or coolness. The subtitle of a work in the series, such as *Resound,* often refers to its particular evocation. A survey of the subtitles would reveal a sensitive range of effects achieved by a seemingly cold, stringent scientific system. In the early homages, color contrasts tend to be dramatic and active; in later variations like *Resound,* color values are more subtle.

Albers' highly developed color theories, manifested in an impressive body of painted and printed works and disseminated during a highly successful teaching career, have earned him premier rank among artists concerned with geometric abstraction and visual perception.

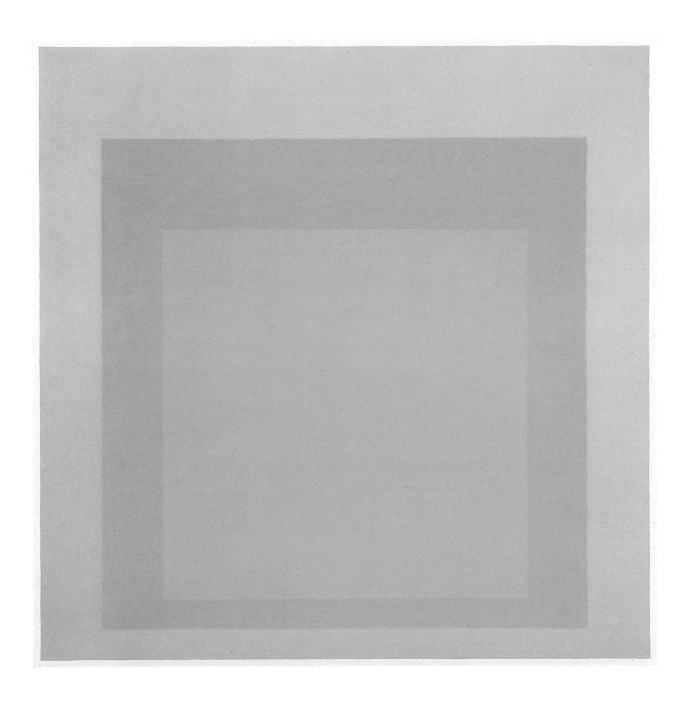

223

ELLSWORTH KELLY
BORN 1923

CITY ISLAND
OIL ON CANVAS, 1958
78 x 57 INCHES

Ellsworth Kelly was born in Newburgh, New York. After studying at the Pratt Institute, Brooklyn, in 1941-1942 and at the School of the Museum of Fine Arts, Boston, from 1946 to 1948, he attended the Ecole des Beaux Arts, Paris, for two years. Kelly remained in France to travel and paint, returning to New York in 1954. The Betty Parsons Gallery there gave him his first one-man show in 1957. Two years later, Kelly was among the *Sixteen Americans* exhibited at the Museum of Modern Art, and in 1966 he was one of four Americans included in the Venice Biennial. The Museum of Modern Art organized Kelly's first retrospective in 1973. He lives and works in Chatham, New York.

Kelly's crisp nonrepresentational works, intensely colored and radically simplified, have been cited as pioneering examples of hard-edge painting. While he acknowledges the presence of the edge in his work, Kelly repudiates the classification, saying, "I'm not interested in edges. I'm interested in the mass and the color, the black and the white. The edges happen because the forms get as quiet as they can be. I want the masses to perform."

Kelly's involvement with abstraction began while he was in Paris. There, he encountered the work of Matisse, Arp, and members of the group Réalités Nouvelles. His figurative work gave way to paintings in which curvilinear and rectilinear elements suggested fragments of visual phenomena such as shadows or architectural elements. In 1950, he explored random determination of form and color in paintings based on collages that were composed from details of drawings. Kelly worked with serial and modular systems in grid paintings, and by 1952 these concerns were translated into large panel paintings in which each panel was a single unit of color.

After his return to the United States, Kelly focused on single large biomorphic shapes painted in black and white. He reintroduced primary colors into his work after 1957, usually in paired variations or in contrast with white, as in *City Island*. During the late 1950s, Kelly produced a group of works to which he assigned titles with urban references, particularly to Paris and New York. Included in this series was *City Island*, first shown in his one-man exhibition at Galerie Maeght, Paris. Its insistent figure-ground relationship, two-color system, broad yet sharply defined form, and edge to edge tautness exemplify the emblematic character of his work during this period. Since 1963, Kelly has produced modular and serial works in his effort to merge pure color with geometric form. He has also produced an impressive body of sculpture with forms that relate to those in the paintings.

PAUL STAIGER

BORN 1941

FIVE TRUCKS AT THE BIG RIG RESTAURANT

ACRYLIC ON COMPOSITION BOARD, 1968

33 x 48 INCHES

Paul Staiger was born in 1941 in Portland, Oregon. Between 1962 and 1967, he studied at Northwestern University, the University of Chicago, and the California College of Arts and Crafts, where he later taught. Since 1967, Staiger has taught at San Jose State College. His first one-man show was held in 1969 at Michael Walls Gallery, San Francisco. He has exhibited frequently in photorealist group shows, most notably *22 Realists* at the Whitney Museum of American Art, New York, 1970, and *Sharp Focus Realism* at Sidney Janis Gallery, New York, 1972. He lives and works in Boulder Creek, California.

Staiger has summarized his early paintings in the following manner: "My work deals with a kind of post-modernist figurative painting, which is based on the literal translation of a photographic image to canvas. The dependence on the photo-subject leads to a dismissal of formal considerations, and the primary interest becomes the facticity of the painted image on the one hand, and the fact that its content documents a gesture which is ultimately more important than the object."

Although he paints from photographs, Staiger's translations of reality cannot be mistaken for actual photos as can works by other photorealists. Like Ed Ruscha and Robert Bechtle, whose influence he acknowledges, Staiger paints factually accurate renderings in which the color, light, and flat stylized refinements signal the mediating influence of a photograph.

Staiger tends to work in series. Among his early series were trucks and truck stops in California. *Five Trucks at the Big Rig Restaurant*, a scene from San Jose, California, was included in *22 Realists* at the Whitney Museum. By identifying the circumstances and locale of the subject, Staiger introduces a tongue-in-cheek element of narrative documentary, seldom found in most photorealist painting. Later series of the 1970s included California beaches and homes of Hollywood stars.

Most recently, Staiger has begun a series of paintings based on the violent deaths of literary figures. After photographing reenactments of a writer's demise, such as the automobile accident that killed Albert Camus, the scene is blown up onto Kodak mural paper. Staiger then paints over the greatly enlarged image. The result is a painting of a photograph of an event that mimicked a grisly reality; the poignancy belies the fact that the painting is thrice-removed from actuality.

AMERICAN REPUBLIC INSURANCE COMPANY

American Republic Insurance Company was founded in 1929 in Des Moines, Iowa, by Watson Powell, Sr. Specializing in life and health insurance, the company concentrates on individual hospital and surgical medical insurance and is the only major life insurance company to concentrate on low-cost term insurance for individuals and families. Having begun operations just prior to the Great Depression, American Republic grew slowly at first. Today, it is licensed in every state except New York, where it operates through a subsidiary. It is one of few insurance organizations to be so widely licensed.

The corporate collection was initiated by Watson Powell, Jr., Chairman of the Board, Chief Executive Officer, and President. At the time the present national headquarters was being designed, Powell conceived of forming a collection which would be an integral part of the new building. Designed by Gordon Bunshaft of Skidmore, Owings and Merrill, New York, the building received an award from the American Institute of Architects in 1968. The warm, white walls and sandblasted concrete seemed to call for a contemporary collection. In addition, American Republic Insurance views itself as a modern business that confronts contemporary problems and utilizes contemporary technology.

Powell assembled a collection that focuses on American art of the 1960s and 1970s including sculpture, tapestries, several hundred paintings and works on paper, and a commissioned stabile by Alexander Calder which graces the courtyard of the company headquarters. Among the art represented in the collection are paintings by Alfred Jensen, Jack Tworkov, Ron Davis, and David Hockney. In addition, there are several commissioned works: a Warhol portrait of Watson Powell, Sr., a large-scale painting by John Clem Clarke, and a wall mural by graphic designer Ivan Chermayeff who is responsible for the company's graphics. The corporation frequently lends its works to traveling exhibitions, and some of the pieces have even been shown in communist countries. Most of the collection is located in the headquarters building in Des Moines, with some pieces placed in the National Sales Headquarters in Scottsdale, Arizona. An extensive collection of prints is dispersed throughout the fifty-seven branch offices.

American Republic has published an impressive catalogue of its collection with numerous color illustrations. In its art, architecture, and graphic design, the company has successfully pursued a threefold program to enhance the quality of the visual environment. In the foreword to the catalogue of the art collection, Powell has written, "We knew, and we have seen proven, that the 'taste' for contemporary art must be developed and conditioned. Its forms and abstractions are often broad departures from traditionally accustomed expressions of esthetic creation.... That which we hoped would happen, however, has happened, indeed! Living with the art, our people have become interested in it.... Those who work with us now accept that which may not formerly have been acceptable.... The lesson we learned from the art—to criticize from knowledge rather than from ignorance—we can carry into our personal and business lives.... The new and the unfamiliar no longer need frighten us. We can accept, yes, even welcome the changes that will make us better people and a better business endeavor."

FRITZ GLARNER

1899–1972

RELATIONAL PAINTING, TONDO #56

OIL ON COMPOSITION BOARD, 1961

49 INCHES IN DIAMETER

Born in Zurich, Fritz Glarner became an important link between European and American abstraction. Between 1904 and 1923, he lived primarily in Naples, where he attended the Academy of Fine Arts from 1914 to 1920. In 1923, Glarner moved to Paris, attending the Académie Colarossi. While living in Zurich in 1935, he joined the Association of Modern Swiss Painters and was included in the exhibition *Contemporary Problems in Swiss Paintings and Sculpture*. In 1936, Glarner immigrated to the United States, where he soon joined in the activities and exhibitions of the American Abstract Artists. During World War II, Glarner and Piet Mondrian renewed their earlier acquaintance and developed a close friendship which was to influence Glarner's art. In 1968, although an American citizen, Glarner represented Switzerland in the XXXIV Venice Biennale. The San Francisco Museum of Modern Art organized and circulated his first American retrospective in 1970. Glarner died in 1972 in Locarno, Switzerland.

Glarner's still lifes and architectural subjects of the 1920s and 1930s, painted in Paris and Switzerland, reflect his assimilation of the structural methods of cubism as well as neo-impressionism's systemized application of color. He was also attentive to Mondrian's theory of neoplasticism, the principles of Russian constructivism and suprematism, Theo Van Doesburg's 1930 treatise on concrete art, and the revisions of Van Doesburg's theories by Swiss artist Max Bill.

During the early 1940s, Glarner committed himself to pursuit of a system of geometric abstraction which he termed "relational painting." Characteristic of this work are the primacy of the canvas surface as a flat pictorial space; the elimination of perspective in favor of varied color harmonies which create spatial tensions; the use of diagonals as foils to verticals and horizontals; and a structure composed of interlocking rectangular or wedge-shaped forms. Glarner often added a range of grays to his predominant colors of red, yellow, blue, black, and white.

The basic structural form in relational painting is the rectangle. Logical but nongeometric permutations of rectangles—wide bands, narrow lattices, small and large blocks—coupled with changes in color sparked the variations in surface arrangements. Around 1943, Glarner introduced the circular format, or tondo, as an alternative shape in which to balance his networks of form and color. Continuing to employ both rectangular and circular canvases until his death, Glarner developed a personal approach to geometric abstraction. Like fellow painters Burgoyne Diller and Ilya Bolotowsky, however, he should also be considered in the larger context of postwar abstract efforts in Europe and the United States which developed variations on Mondrian's theory of neoplastic painting. In the 1960s, with the advent of hard-edge painting in this country, Glarner's efforts received renewed attention.

ALFRED JENSEN
BORN 1903

MAYAN TEMPLE, PER. 1: TIKAL
OIL ON CANVAS, 1962
76⅛ x 50 INCHES

Alfred Jensen was born on December 11, 1903, in Guatemala City. In 1925, after studying at the School of Fine Arts, San Diego, he traveled to Europe to enroll in Hans Hofmann's school in Munich. He left there in 1927, dissatisfied with Hofmann's approach. With the patronage of the American collector Saidie May, Jensen continued his studies at the Académie Scandinave, Paris, with Charles Despiau, Orthon Friesz, and Charles Dufresne. During the 1930s and 1940s, Mrs. May and Jensen traveled extensively throughout Europe and the United States studying the old masters, visiting artists, and acquiring works for Mrs. May's modern art collection. After her death in 1951, Jensen settled in New York and devoted himself to his own painting.

During the 1950s, Jensen began exhibiting in New York and developed important friendships with Mark Rothko and Sam Francis. In 1961, the Solomon R. Guggenheim Museum presented Jensen's first major one-man show. A twenty-year retrospective of his work was organized by the Albright-Knox Gallery in 1977. This exhibition represented the United States in the XIV International Biennial in São Paulo, Brazil. Jensen lives and works in Glen Ridge, New Jersey.

In 1957, Jensen reached a turning point in his art. Abandoning figurative and abstract expressionist efforts, he adopted the diagrammatic approach which he had used since 1944 in his sketched notations on visual phenomena. Jensen has stated that the post-1957 paintings were "done by conceptions being placed side by side in patterns, and of magic things that influence one another, not by acts of mechanical causation." Certain parallels may be drawn between his work and such disparate historical styles as orphism, minimalism, or even the current trend toward decorative pattern painting. However, the philosophical and theoretical roots of Jensen's geometric abstractions ultimately set him apart from any single movement.

Believing that art should express a universal order, Jensen has focused on color and number as his guiding principles. Intensive study of Goethe's and Chevreul's color theories, of physics, and of ancient number systems, philosophies, and myths (especially the Chinese and Mayan) has shaped his art. Jensen has repeatedly eschewed alignment with any art movements or schools. His brilliant colors, hard-edge geometric patterns, and arcane symbols are determined by a constant reinterpretation and synthesis of these sources. In 1960, he read *Maya Hieroglyphic Writing* by J. Eric S. Thompson. The associations triggered by this book influenced multi-panel works like the *Mayan Temple* paintings. *Per. 1: Tikal* represents one panel of the large group of related paintings. Within a flat rectangular field divided by two major diagonal bands and the cardinal points, Jensen has applied a heavy impasto to build a grid of diamonds and triangles. The grid balances mirrored opposites: black and white, light and dark, up and down, left and right, sun and moon. It is this resolution of polarities which satisfied Jensen's search for order, meaning, and structure.

ANDY WARHOL
BORN 1928

THE AMERICAN MAN (PORTRAIT OF WATSON POWELL)
SILKSCREEN INK AND ACRYLIC ON CANVAS, 1964
128⅞ x 64⅜ INCHES

Andy Warhol is rightly regarded as the quintessential pop artist. Born in Pittsburgh, Pennsylvania, he received a Bachelor of Arts degree in pictorial design from the Carnegie Institute of Technology, Pittsburgh, in 1949. He then moved to New York, where he became a successful advertising designer and commercial illustrator. In 1952, Warhol exhibited drawings based on the writings of Truman Capote at Hugo Gallery, New York. From 1956 to 1959, he exhibited regularly at the Bodley Gallery. Warhol's stature in the pop art movement was immediately established in 1962 — by one-man shows at the Ferus Gallery, Los Angeles, and New York's Stable Gallery, and by his inclusion in *New Realists* at Sidney Janis Gallery, New York, and in *New Paintings of Common Objects* at the Pasadena Art Museum. After making his first film in 1963, Warhol became deeply involved in producing films, such as *Chelsea Girls, Lonesome Cowboys,* and *Trash.* In 1970, the Pasadena Art Museum organized and circulated a large one-man exhibition of his work. Warhol lives and works in New York.

Perhaps more than any other figure, Warhol has been identified with pop art, a movement which appropriated for art the images of popular culture and the methods of popular media. He has said, "I feel I'm very much a part of my times, of my culture, as much a part of it as rockets and television." Warhol's first paintings were sketchy copies of sections selected from newspaper advertisements and comic strips. Stylized enlargements of newspaper front pages fol-

lowed. His last group of painted images included dance diagrams and the famous series of Campbell soup cans. In August, 1962, Warhol produced his first silkscreened painting — a serial portrait of Troy Donahue.

Untrained as a painter and schooled in commercial design, Warhol effected a radical change in painting and in the criteria for artistic originality. In monotyped drawings, experiments with stencils and stamps in the 1950s, and the silkscreened paintings of the 1960s, he developed painting as a depersonalized picture-making process based on mechanical reproduction. Warhol has consistently worked from photographs, often using popular imagery extracted from printed matter. Appearing as large single images or in serial form, his likenesses of money, Brillo boxes, or electric chairs assume an ironic and iconic stature. Serial presentation, employed since 1962, underscores the commodity status and mass availability of Warhol's subjects. Cropped around the edges, the repeated frames suggest the continuity of film strips. Warhol's portraits from the 1960s of movie stars and other celebrities were almost always based on documentary photographs rather than candid shots. Printed on a flat unarticulated background, each unit in a serial portrait is distinguished by irregularities in the silk-screening process or by added splashes of earthy or high-keyed colors. *The American Man (Portrait of Watson Powell)* is the first known portrait by a pop artist to be commissioned by an American businessman.

234

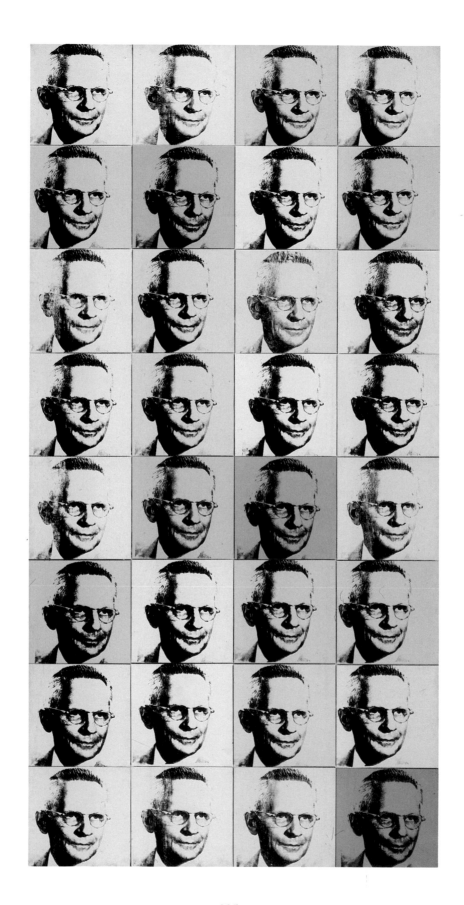

235

CONTAINER CORPORATION
OF AMERICA

The nation's leading manufacturer of paperboard packaging, Container Corporation of America was organized June 18, 1926. In 1968, the company merged with Montgomery Ward to form Marcor, Inc. Six years later, Mobil Oil Corporation completed a tender offer for shares of Marcor, resulting in voting control by Mobil with an aggregate fifty-four percent of the outstanding shares. In 1976, the remaining shares of Marcor were acquired by a new entity, Mobil Corporation, which presently owns and controls the three companies: Mobil Oil, Montgomery Ward, and Container Corporation of America.

Container Corporation operates one hundred forty-five facilities at home and abroad and is one of the nation's leading recyclers of paper. Nearly one half of the packaging produced by the company is made from recycled paper material. The two major paperboard products are corrugated shipping containers and folding cartons. A major part of the corporation's role in the paperboard industry, and one that distinguishes it from other companies, is the role it plays in packaging services. Market research, graphic and structural design, and mechanical packaging development are a few of the areas in which Container Corporation excels, producing innovative and convenient packaging for its customers.

Great Ideas of Man, the series of public service messages Container Corporation has sponsored since 1950, uses art and historically important concepts as a principal vehicle for corporate communication. Since the series' inception, close to two hundred paintings, graphics, and sculptures have been commissioned by the company. The touring collection of one hundred one works has been exhibited since 1957 in more than one hundred galleries and museums throughout the world. Today, funding is provided for educational projects related to *Great Ideas*.

The art collection originated in the decade prior to the introduction of the *Great Ideas* program. Walter P. Paepcke, founder of the Container Corporation of America, set up a unique series of advertisements. Noted graphic artists were commissioned to interpret and illustrate brief statements about the company. As the advertisements became popular, others were developed. Themes gradually evolved from interpretive statements about the corporation to provocative concepts about government and history. Stuart Davis, Willem de Kooning, Henry Moore, and others were represented in the early series.

Paepcke continued to explore novel possibilities in communications and arrived at the idea for *Great Ideas* in 1949 as a result of his participation in a discussion group conducted by Robert M. Hutchins and philosopher Mortimer Adler at the University of Chicago. With assistance from Adler, moral, philosophical, and political statements were selected from the writings of important thinkers. Artists were then chosen by a committee and given the task of interpreting each statement. Ben Shahn, Herbert Bayer, and Leonard Baskin were among the first to participate. A wide spectrum of works executed by contemporary artists like William Baziotes, Man Ray, René Magritte, James Rosenquist and Joseph Cornell is included in the series.

The *Great Ideas* program distinguishes Container Corporation by expressing its commitment to both the graphic arts and to intellectual history. Serving as a vehicle for corporate support of the arts and humanities, the series has brought to a wide audience a greater understanding of the relationships among art, history, philosophy, and business.

JAMES ROSENQUIST
BORN 1933

LOUIS DEMBITZ BRANDEIS
ACRYLIC ON CANVAS, 1966
48⅛ x 44⅛ INCHES

James Rosenquist was born in Grand Forks, North Dakota. Between 1952 and 1954, he painted gasoline tanks, service stations, and large outdoor advertisements for Minneapolis-based industrial firms. Rosenquist earned an Associate of Arts degree in 1954 from the University of Minnesota, where he studied classical painting techniques with Cameron Booth. In 1955, he completed a one-year scholarship at the Art Students League. A member of the Amalgamated Sign and Pictorial Painters Union of America, Rosenquist executed large interior and exterior displays during the late fifties, including billboards in New York's Times Square. In 1962, he held his first one-man exhibition at the Green Gallery, New York, and was included in the landmark pop art exhibition, *New Realists*, at the Sidney Janis Gallery. The Wallraf-Richartz Museum, Cologne, and the Whitney Museum of American Art presented independent surveys of his work in 1972. Rosenquist lives and works in Easthampton, New York.

Prior to 1960, Rosenquist experimented with several styles, including abstract expressionism. Eventually, he developed an approach which earned him recognition as a major figure in the pop art movement of the sixties. The importance of his years spent as a sign painter is unmistakable. The grand scale, object-oriented imagery, high-keyed color, and mechanical execution of his paintings all derive directly from the billboard idiom. In his fragmented compositions, Rosenquist consciously suggests the lack of perspective experienced by a sign painter as he lays out a large picture at close range. Enriching the insights derived from commercial experiences is his appreciation of murals by José Clemente Orozco and Diego Rivera, large field paintings by Jackson Pollock, Sam Francis, and Ellsworth Kelly, and cubist and surrealist methods of distorting space.

Removed from their familiar contexts, Rosenquist's ordinary images are enlarged, combined, and juxtaposed in provocative visual patterns. A disquietingly oblique meaning, often social or political, is implied by the selection and arrangement of the images. In his interpretation of Louis D. Brandeis' view of democracy, Rosenquist chose the automobile as a double-edged symbol of material status and waste. He has described the painting as the merger of two colliding cars, which creates rather than eliminates waste. The juxtaposition of curling, sauce-laden spaghetti and static, harshly metallic surfaces is dramatically jarring.

Since the late 1960s, Rosenquist's paintings have become increasingly abstract and at times monumental in size, involving extended series of panels. He has also experimented with videotape and printmaking.

238

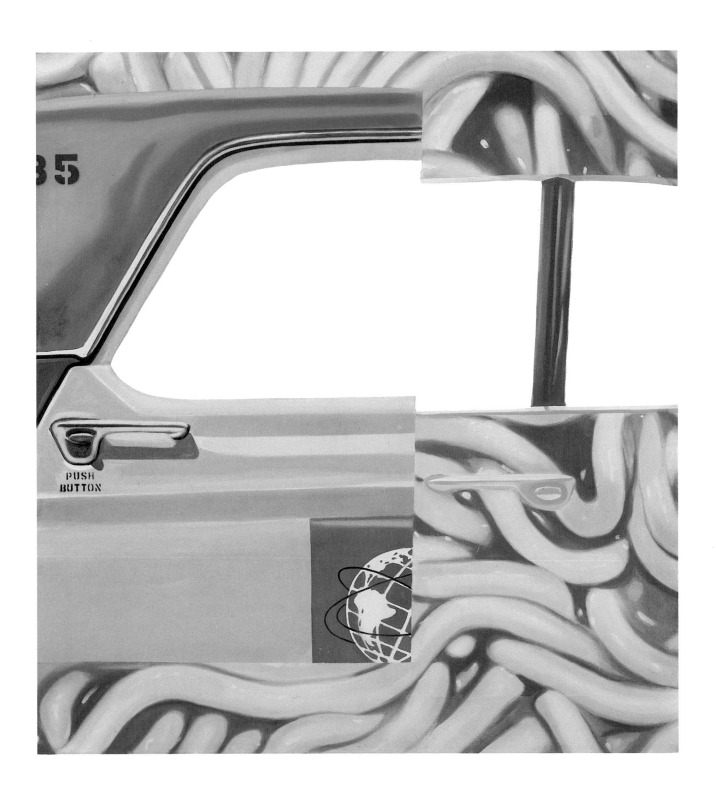

239

BEN SHAHN
1898–1969

THE VOTING BOOTHS
GOUACHE ON BOARD, 1951
16 x 12 INCHES

Ben Shahn was born in Lithuania in 1898 to a family of craftsmen. His father was sent to Siberia for revolutionary activities but escaped and immigrated to the United States with his family when Shahn was only eight years old. Shahn grew up in New York City, where he began work as a lithographer's apprentice. He attended college in New York and studied art there at the National Academy of Design. Later, he continued his art studies in Paris.

Shahn's paintings of the 1930s reacted against the provincial focus of the regionalists. Although he favored American themes as his subjects, Shahn's vision of his adopted homeland was markedly different from that of such native sons as Thomas Hart Benton and Grant Wood. In contrast to their often romanticized tributes to rural American values, Shahn created images that glorified the struggle of the urban poor and the immigrant working class. During the Depression, Shahn, like many other artists, used his art to express a leftist political viewpoint. A particularly influential experience for Shahn was his work in 1933 as an assistant to the Mexican muralist Diego Rivera.

The political artists of the thirties are often referred to as social realists; their realism relates not to the tradition of representational painting but to the depiction of the day to day lives of common people. It was in this spirit of realism that Shahn painted a series of paintings based on the Sacco-Vanzetti murder case; these have become some of the most poignant and familiar images of American art from the 1930s. Shahn also worked on the various art projects sponsored by the New Deal, producing easel paintings, murals, and photographs.

During the war, Shahn remained devoted to an art of social content, believing that an artist's personal experience and vision could be communicated to a large group of people without losing its immediacy. The focal point of his imagery changed from the misery and tragedy of the Depression to the devastation and suffering caused by war. After the war, his outlook brightened and the solemn social realism of his earlier years gave way to themes that were more personal and psychological than social or political. Jewish images, especially Hebrew calligraphy, became favorite subjects for Shahn after 1948.

In *The Voting Booths*, Shahn celebrates the right to vote. The colorful, patterned image gives evidence of his new optimistic attitude. Shahn has said of this work: "I think of the voting booth as the most succinct pictorial statement about democracy—where the voting booth is present, government cannot for long pursue ends other than those of the public good. As to the question of treatment, I feel that too literal handling might tend to banalize the entire concept. For this reason I've made the painting as gay as possible, and as exciting and unresolved as the voting process always is. The suggestion of war and destruction behind the booth at the left is intended to indicate how serious a responsibility the vote is. The uninformed vote, the emotionally partisan vote, the intimidated vote may lead to disaster."

240

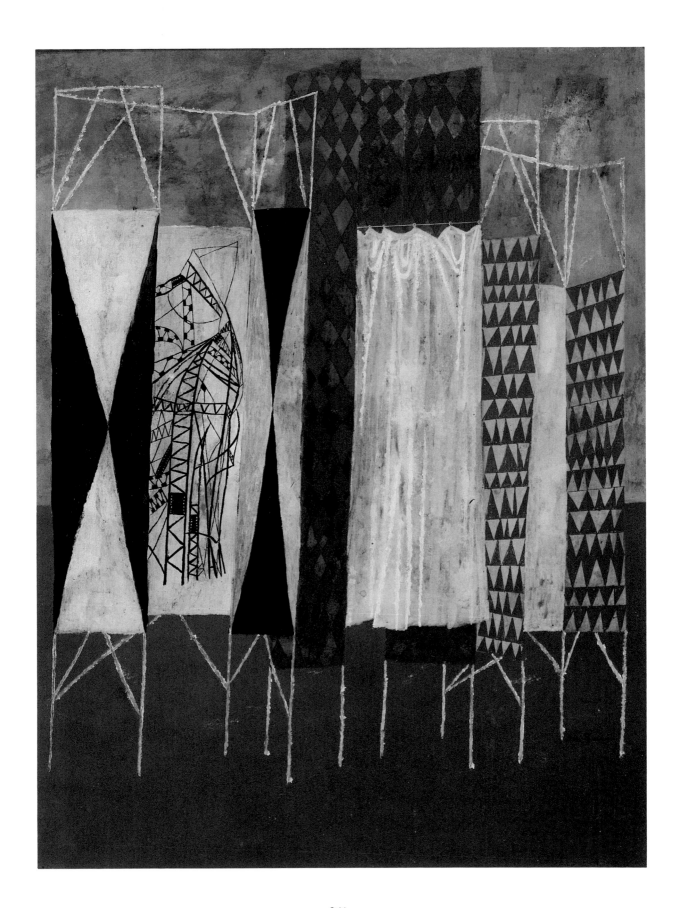

RICHARD LINDNER
1901–1978

BENEDICT (BARUCH) SPINOZA
OIL ON CANVAS, 1956
25⅝ x 18 INCHES

The melding of his European roots and experiences with his reactions to New York life profoundly influenced Richard Lindner's development as an artist. He was born on November 11, 1901 in Hamburg, Germany, and studied at the Kunstgewerbeschule (School of Applied Arts) in Nuremberg from 1922-1924 and then at the Kunstgewerbeschule and the Academy of Fine Arts in Munich. Lindner was the art director for a prominent Munich publishing firm from 1929 until 1933, when he fled to Paris after the Nazis came to power. In 1941, he immigrated to New York where he became a successful illustrator and graphic designer for fashion magazines. When Lindner decided to concentrate on painting in 1950, he supported himself by teaching at the Pratt Institute in New York. Betty Parsons Gallery, New York, presented his first one-man exhibition in 1954. In 1968, the Leverkusen City Museum, West Germany, organized and circulated his first restropective. The retrospective was expanded and presented in 1969 at the University Art Museum, Berkeley, and the Walker Art Center, Minneapolis. In 1978, Lindner died in New York.

Lindner first received critical attention as an artist when he was included in the 1963 *Americans* exhibition at the Museum of Modern Art. Although his urban iconography, high-keyed color, and cool polish suggest certain affinities with pop art, the autobiographical and philosophical dimensions of his paintings set him apart. Significant also was his respect for the intellectual premises of dada and for the paintings of Fernand Léger, Oscar Schlemmer, and the early twentieth century Russian suprematists.

Lindner consistently painted erotic fantasies and social comedies with a theatrical flair. Truncated, massive figures placed against flatly colored spaces with strange perspectives, electrifyingly clashing colors, and precise handling became the hallmarks of Lindner's style. His archetypal figures—the all-powerful woman, the impotent man, the menacing child, and the omniscient stranger—are grossly exaggerated caricatures. Oversized, sculptural, almost architectonic, they are the denizens of both pre-World War II Europe and post-1950 New York.

Lindner's paintings of the 1950s are generally smaller and more subdued than his later works. Often, the subjects of this decade were drawn from European theatre, music, and literature. Between 1954 and 1958, he painted a group of portraits in which incomplete figures are set off by cryptic abstract forms.

Benedict (Baruch) Spinoza is one of two paintings commissioned from Lindner for Container Corporation's *Great Ideas of Western Man*. The artist was interested in the Euclidian nature of Spinoza's philosophy and his reference to eternity in the pursuit of human freedom. According to Lindner, the geometric diagram at the right of the painting alludes to Euclid, the composite abstract shape at the left to eternity, and the incomplete column to wisdom.

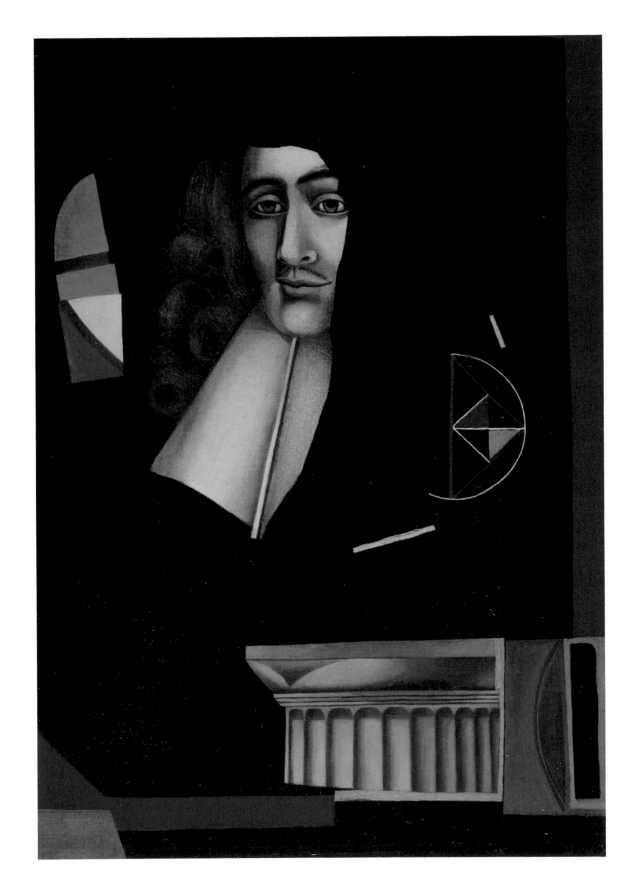

243

PLAYBOY ENTERPRISES, INC.

Twenty-five years after its founding in 1954 as a men's magazine, Playboy Enterprises, Inc. has grown to include a variety of publications. In addition to *Oui* magazine and the international editions of *Playboy,* the corporation distributes books under three publishing companies. Playboy Enterprises also has clubs, hotels, and casinos throughout the United States as well as in England and the Bahamas. It has created an important program resource for the motion picture and television industries, Playboy Productions, which has developed essential software for new video technologies. A licensing and merchandising division has been initiated to take advantage of the world-wide recognition of the Playboy name and its trademark, the rabbit head.

The Playboy Foundation is the activist arm of *Playboy* magazine's philosophy. As a catalyst for positive social change, it initiates and funds projects that are innovative, experimental, and frequently controversial. Since its inception in 1965, the foundation has provided extensive support for groups and individuals striving to advance human rights and freedoms, including issues of women's rights, drug-law reform, capital punishment, sex-law reform, government surveillance and police spying. It has especially fought impingements on First Amendment freedoms.

The art collection was begun twenty-five years ago with the founding of the company itself. Arthur Paul, Art Director of *Playboy,* began commissioning works of art to accompany the articles and fiction included in the magazine. He felt that figurative works by well-known artists and outstanding illustrators would provide additional insight into stories which warranted a personal interpretation. The corporation then bought the works to display in its headquarters. The collection now contains several thousand executed in many different media. Several important pop artists, such as James Rosenquist, Andy Warhol, and Tom Wesselmann, are represented. A special feature of the collection is a group of works by Chicago artists Roger Brown, Ed Paschke, Christina Ramberg, and Karl Wirsum. Included also is sculpture by George Segal and Frank Gallo.

Two traveling exhibitions of the collection, *Beyond Illustration* and *The Art of Playboy: From the First 25 Years,* have been circulated, each accompanied by illustrated catalogues. The philosophy that inspired the collection intended to interrelate quality fiction and journalism with significant works of art and to provide that art with the wide exposure possible through a magazine format. The successful implementation of this program has acquainted a generation of *Playboy* readers with a vibrant and diverse body of fine art.

TOM WESSELMANN

BORN 1931

MOUTH #8

ACRYLIC ON CANVAS, 1967

77 x 94 INCHES

One of the prominent figures of American pop art, Tom Wesselmann has consistently drawn inspiration from popular art sources, especially the mass media and consumer advertising. In New York during the early 1960s, a varied group identified as pop artists, including Wesselmann, Andy Warhol, James Rosenquist, and Roy Lichtenstein, turned away from abstract art toward the familiar emblems of the everyday world.

Wesselmann was born in Cincinnati, the son of a paper company executive. He attended Hiram College and the University of Cincinnati but showed no interest in art at that time. While in the Army, he started drawing cartoons, and following his discharge, enrolled at the Cincinnati Art Academy. Studies under Nicholas Marsicano at the Cooper Union, New York, followed. From cartooning, Wesselmann soon developed an urge to paint. He turned briefly to abstract expressionism but gave it up in despair, saying that de Kooning, whom he idolized, "had already painted all my paintings." Other artists whose work he greatly admired included Jackson Pollock, Henri Matisse, and the fifteenth century Dutch painter Hans Memling.

By late 1959, Wesselmann was experimenting with collage elements which injected specific subject matter into his art. Combining collage with painting, he also began introducing figures, often taken from magazines and newspapers. The small format of the early collages gradually gave way to larger works, occasionally utilizing real objects in conjunction with flat painted surfaces. Denying any interest in the social commentary and satire attributed to many pop artists, Wesselmann stressed instead the formal and visual aspects of his images.

In 1961, he had his first one-man show at the Tanager Gallery in New York. He has since participated in many major group shows, often organized around themes dealing with figurative, realist, or pop art. The *Great American Nude* series for which Wesselman is probably best known was started in 1961. The subject of the series is a flatly painted nude female figure placed in a setting such as a bedroom or bathroom. Often focusing on highly stylized nipples or open mouths with protruding tongues and cigarettes, the nudes, in the words of critic Hilton Kramer, "took on the appearance of a mass-produced fantasy commodity."

Wesselmann's *Mouth* and *Smoker* series isolate one motif and emphasize its fetishistic qualities. *Mouth No. 8* displays the scale, directness, and slick color of a billboard advertisement. It strongly projects the bawdy sensuality so often associated with pop art female imagery. In a similar manner, Wesselmann has focused on other images of anatomical fragments—legs, breasts, feet—disembodied and often overtly sexual. He has observed that "a big foot against the sky retains its identity as surely as a figure." However recognizable the image may be, there is also in Wesselmann's work an emphasis on abstract qualities—sharp outlines, curvilinear shapes, simplified forms, and bold colors.

KARL WIRSUM
BORN 1939

CROSS THE BORDER, CLOSE THE GAP
ACRYLIC ON PAPER, 1969
30 x 30 INCHES

Born in Chicago in 1939, Karl Wirsum attended the School of the Art Institute of Chicago where he earned his Bachelor of Fine Arts degree in 1961. As a member of an exhibition group called the Hairy Who, Wirsum participated in its first show at Chicago's Hyde Park Art Center and in several shows which followed. The Hairy Who was the first and best known of several groups of Chicago artists formed during the 1960s. Other groups, such as the False Image and the Nonplussed Some, soon followed the Hairy Who with exhibitions of their own. Wirsum's work has been shown in a number of museum exhibitions on Chicago art and was included in the United States representation at the XII São Paulo Bienal.

The activities of the various Chicago groups in the late sixties and early seventies revealed a distinctive though diversified style. Since the postwar years, Chicago art had shown a strong tendency toward fantasy and a highly personalized choice of imagery. In many ways, Wirsum and his generation may be considered a continuation of this trend. He shares with many younger Chicago artists a pronounced indifference to the aesthetics of traditional art and a preference for commonplace yet fantastic imagery. Their ideas and images are often taken from popular and commercial art, the mass media, and aspects of the urban environment, but they are remarkably transformed. Wirsum and other members of the Hairy Who were especially influenced by comic strips, even to the point of producing a comic book to accompany their boisterously colorful exhibitions.

Cross the Border, Close the Gap was commissioned as an illustration for *Playboy* magazine. The poster-like format and use of gaudy colors and flat decorative motifs are typical features of Wirsum's work. The stomping cowgirls with their smoking guns and flaring whips provide a certain narrative context but remain a part of the overall pattern created by the flamboyant linear designs which charge the entire surface of the painting. The stylized figures and essentially absurd theme derive from the comic strip. Verbal and visual clichés surround the primitive central figure; characteristically, Wirsum draws on the vernacular for much of his humor.

In his recent paintings, Wirsum has continued to develop his bizarre comic creatures as well as more abstract iconic figures and masks which relate to the decorative designs of primitive and naive art forms.

249

ROGER BROWN

BORN 1941

XONG OF XUXAN

OIL ON CANVAS, 1970

34½ x 25¼ INCHES

Roger Brown first exhibited in 1968 as a member of the False Image, one of several short-lived groups of young Chicago artists which formed during the 1960s. Born and raised in Alabama, Brown attended the School of the Art Institute of Chicago, from which he received his Master of Fine Arts degree. His studies of perspective and space under Ray Yoshida and Betsy Rupprecht have exercised a vital influence on Brown's painting. In his use of repeated images, decorative patterns, and strange perspectives, Brown has drawn on many sources to create a highly personal view of the world. An interest in Chinese and medieval painting has contributed further to his exploration of shallow spatial effects. He has shared with other Chicago artists a strong respect for naive art and particularly admires the French painter, Henri Rousseau, and the self-taught Chicago artist, Joseph Yoakum.

Brown's earliest exhibited works of theater interiors were based on childhood memories and personal experiences at movie houses and theaters. As in many of his later works, he used stylized forms and non-specific indirect lighting to suggest a mysterious narrative content. In 1969, Brown started painting exterior views, often street scenes. *Xong of Xuxan* belongs to this period and was commissioned to appear in *Play-*

boy. The painting depicts an eerie and threatening night scene of the city, reminiscent perhaps of Giorgio de Chirico's ominous cityscapes from the early twentieth century. The streets and architectural setting in Brown's painting are reduced to unfriendly, stark geometric shapes; the isolated running female becomes a cut-out silhouette. These disturbing images are heightened by the strange light on the horizon and the dark forms of the sky and trees. The blowing curtain and the clear suggestion of violence in the shattered window glass also add to the disquieting atmosphere.

By the early 1970s, Brown was painting urban and suburban landscapes, and in 1972 he produced a "Disaster Series" which depicted burning buildings and other castastrophes. The people in the landscapes are small, silhouetted figures. Experimenting with materials other than the traditional canvas, Brown also made painted constructions, works he considers three-dimensional paintings rather than sculpture.

Whether recording the more ominous aspects of an urban scene or the lyrical rhythms of a stylized landscape, Brown's art imparts a sense of the bizarre beauty and the mystery to be found in the commonplace environment.

250

PAINE WEBBER / MITCHELL, HUTCHINS GROUP

Paine Webber was founded in 1879 as a brokerage firm in Boston. Today it is one of the largest investment houses in the world, with branch offices located throughout the United States, England, Switzerland, France, Japan, and Hong Kong. In 1977, Paine Webber merged with Mitchell, Hutchins, another brokerage house specializing in servicing the research and trading needs of institutional investors.

Donald B. Marron, President, Paine Webber Inc., had been President and Chief Executive Officer of Mitchell, Hutchins, and, while associated with that firm, had assembled an impressive art collection numbering approximately five hundred works. The collection encompasses several areas of specialization: prints by American artists who worked between 1830 and 1930, including Edward Hopper, Charles Sheeler, Winslow Homer, and Grant Wood; turn-of-the-century French color prints by artists such as Pierre Bonnard; contemporary prints and drawings by younger artists as well as established ones like Frank Stella and Robert Rauschenberg; postwar American paintings by such well-known artists as Mark Rothko, Ad Reinhardt, Andy Warhol, and Jasper Johns.

The corporation's interest in collecting began about eight years ago when Marron began to bring works from his personal collection into Mitchell, Hutchins. The works were hung only in public areas because Marron did not want to impose unfamiliar art on the employees in their private offices. Instead, he let it be known that if an employee saw a work he liked, he could hang it in his office. If an employee wanted to, moreover, he could purchase any of the works. Within a short while, all the employees had selected works for their offices. Interestingly, the most popular were those by artists generally considered the most important.

An avid and knowledgeable collector, Marron personally buys art for the corporation as well as for himself. In the company's collection of postwar art, the best known artists are represented by superior works: a "combine painting" by Robert Rauschenberg, a 1949 canvas by Clyfford Still, and an early 1963 shaped canvas by Frank Stella. Recently, newer works by younger artists have also been acquired.

Marron, who is a Trustee of the Museum of Modern Art, derives enormous pleasure from the employees' enjoyment of the art: "Art is clearly something everyone should live with but not have imposed on them," he has stated. "Contemporary art is a reflection of what is going on in society, and the best contemporary art often anticipates these events. Given the breadth of art today, the corporation aims to expose its employees, clients, and guests to the best examples of major artists working today."

ROY LICHTENSTEIN
BORN 1923

CUBIST STILL LIFE
OIL AND MAGNA ON CANVAS, 1974
90 x 68 INCHES

In the early 1960s, Roy Lichtenstein was one of the artists who incorporated into paintings images of popular culture drawn from magazine advertisements, billboards, film, television, and comic books.

Lichtenstein was born in New York City in 1923. In the 1940s, he studied at Ohio State University and later at the Art Students League under Reginald Marsh. The early 1950s found Lichtenstein painting in an abstract expressionist style, but in 1957 he began to produce representational paintings of such commonplace objects as machine parts, dollar bills, and cartoon characters. By 1961, Lichtenstein had abandoned his expressionist style and adopted a new method, borrowing commercial art techniques and using stenciling and Ben Day dots. These were to become his trademark in the world of fine art.

Pop art, as the works of Lichtenstein and others came to be known, was created by a generation of artists reacting against abstract expressionism in favor of a more impersonal, disciplined, and objective method of making art. Like the paintings plotted out on graph paper by Frank Stella and the geometric abstractions of Al Held, pop art provided an alternative; it differed, however, by introducing representational elements drawn from the most banal aspects of mass culture. Lichtenstein and the other pop artists sometimes appeared to embrace this banality wholeheartedly. They were, in fact, ambivalent, and their message was often double-edged.

The mass media were not the sole source of imagery for the pop artists; they turned as well to the past — to the history of art. Lichtenstein created numerous takeoffs of works by Mondrian, Monet, and Picasso. These he translated into his own language by simplifying forms and colors and substituting for them his stylistic idiom derived from comic books and commercial art. The result was a serious examination of various art styles, an activity which also contained a humurous, even satirical, element.

Lichtenstein regards his use of cubism as simply another instance, in a tradition as old as painting itself, of one artist borrowing from the work of another. Picasso himself produced a large body of work based on the masterpieces of others, but his borrowing was an act of homage to his predecessors; for Lichtenstein, it was an act of social and artistic criticism. From the vantage point of the pop artist, a masterpiece became another item of popular culture, an item known and appreciated primarily through photographic reproduction, as is suggested by Andy Warhol's multiple silkscreen of the *Mona Lisa* entitled *Thirty Are Better Than One.* Pop art implies that mass culture inevitably trivializes images by churning them out in great numbers. *Cubist Still Life* notes that even art does not escape this process.

EDWARD RUSCHA

BORN 1937

JINX

OIL ON CANVAS, 1973–1974
54 x 60 INCHES

A central figure in the development of pop art in general and California art in particular during the 1960s, Ed Ruscha was born in Omaha, Nebraska, in 1937. In 1956, he enrolled in the Chouinard Art Institute of Los Angeles to study commercial art. After graduating in 1960, Ruscha worked for two years as a commercial artist before becoming disenchanted. He turned to the genre later to become known as pop art and was included in its first major exhibition, *The New Painting of Common Objects*, at the Pasadena Art Museum in 1962. During the next three years, he had several one-man shows at the Ferus Gallery in Los Angeles, a showplace for avant-garde art in Southern California at the time. As the pop art phenomenon grew, Ruscha was included in many important exhibitions; his considerable local reputation thus grew into one of national significance.

Although his use of commercial art techniques as well as his choice of subjects—a can of Spam, a gas station, the famous Hollywood sign—makes Ruscha's art easily identifiable as pop, it is in fact descended from dada and surrealism. Despite these discernible roots and influences, however, much of his work extends beyond the limits of easy categorization. Ruscha combines technical virtuosity as a draftsman with sophisticated wit to create works, often of the same image or "vision," in a variety of media: painting, drawing, and printmaking. Often these traditional forms are altered by non-traditional materials, such as gunpowder or even food on satin.

Ruscha has made two short films and published a number of books. His first book, *Twenty-six Gasoline Stations*, 1962, documents the gas stations Ruscha passed on an automobile trip from Los Angeles to Oklahoma City; others include *Various Small Fires (and Milk)*, 1964, and *Every Small Building on the Sunset Strip*, 1966. Ruscha has resisted the fine art prejudices against such "amateur" techniques as snapshot photography, and each of his books employs snapshots in a similar format to record the subject or event suggested by the title. Ostensibly narrative and sometimes depicting his Los Angeles environment, the images intentionally frustrate any attempt at divining a logical sequence. In these works, which rely on the photography to document information rather than to express mood, Ruscha has paved the way for the development of "artists' books" as a contemporary art medium.

Ruscha's paintings of the 1970s usually present a single word or phrase surprisingly rendered. On one canvas, globs of syrup form the word "Annie"; in another, strips of paper spell out "city." In *Jinx*, the letters are formed by delicate shafts of wheat. Direct, simple, and bordering on the surrealistic, these paintings require little decision-making as to their composition. Usually viewed frontally and placed in the center of the canvas, the words float in empty space. The relationship between the medium and the meaning of Ruscha's words is suggestive of the ambiguity and arbitrariness of language. As mysterious as they are amusing, his paintings decontextualize language and transform words into images.

256

ROBERT RYMAN

BORN 1930

UNTITLED

*PASTEL AND PENCIL ON PLEXIGLASS
WITH BLACK OXIDE PLATED STEEL PLATES AND BOLTS, 1976
49⅝ x 49⅝ INCHES*

Robert Ryman was born in Nashville, Tennessee. In the late 1940s, he attended the Tennessee Polytechnic Institute and the George Peabody College for Teachers. His works have been shown frequently, especially in Europe, during the last decade. Ryman's first one-man show was held at the Solomon R. Guggenheim Museum, New York, in 1972. In 1974, the Stedelijk Museum, Amsterdam, held an important retrospective of his work.

In 1952, Ryman saw a painting by Mark Rothko and was impressed by the fact that Rothko had painted around the edge of the canvas, thereby abolishing the need for a frame and establishing the entire painting as an object to be seen in relationship to the surrounding space. These observations were brought to bear on Ryman's own paintings. In 1957, he painted on paper a small untitled work which was almost square. A thick but uneven layer of white paint covered the surface while two spots of dark pigment marked the top and left sides of the square. The utter simplicity of the work is startling; it makes one ponder the intensity of a single mark, its color against the white paint, and the difference between the white of the paint and the white of the paper. Ryman has continued to use white pigment almost exclusively, although sometimes other colors are hidden beneath a white surface. His subtle color modulates according to the color of the supporting surface of the pigment, the color of the wall, and the color and space of the room in which each work is displayed.

Ryman continually experiments with different materials and media. He has used oil, enamel, acrylic, ink, pencil, and various kinds of tape and metal clips on supports as diverse as linen, coffee filter paper, rolled steel, plexiglass, cardboard, burnished aluminum or copper, wax paper, tracing paper, and the wall itself. Ryman explores such perceptual qualities as transparency, translucency, reflection, and opacity. Choosing his materials specifically because of their visual properties, Ryman heightens their peculiar characteristics in his work: a matte enamel painting on shiny aluminum contrasts reflectivity and dullness; oil on linen bordered by wax paper may suggest extremes of translucency and texture. Essentially physical, works like *Untitled* may at first glance appear to be concerned only with form and structure; a second look, however, should result in an appreciation of Ryman's sensitivity for perceptual qualities. More than just a divided square, the work exhibits different degrees of transparency, a range of solidity, and a certain ambiguity as to the depth of its markings. There is an intellectual clarity to Ryman's work; it seems the result of an ordered and logical but always creative mind.

Ryman invites the viewer to participate, like a connoisseur, in an investigation of visual and tactile information where virtually every other sense is cancelled out. As in the late works of Turner, Monet and Rothko, the meaning in a work by Ryman is discerned through a direct visual encounter, a sustained act of looking.

259

AVCO FINANCIAL SERVICES

Avco Financial Services, a consumer finance lending operation, resulted from the merger of Seaboard Finance Company and Avco Delta Corporation, two sister divisions of Avco Corporation, in February, 1971. By the end of the year, the new Avco Financial Services had approximately fourteen hundred branch offices situated throughout Australia, Canada, and the United States. Since that time, Avco has experienced a very steady growth, adding three hundred branch offices and expanding to Japan and the United Kingdom.

Headquartered in Cleveland, Ohio, Avco Delta Corporation began its first art collection in 1965. Architect Walter Gropius, founder of the Bauhaus and its director from 1919 to 1928, was instrumental in stimulating Avco's interest in the fine arts. Assisting Avco in building its first collection, Gropius concentrated on the area that interested him most—contemporary art. After the merger, Avco Financial Services moved its corporate headquarters to Newport Beach, California. Although it was felt the new headquarters should feature contemporary art, the decision was made to specialize in American contemporary art with an emphasis on West Coast artists. As a result, a second collection was initiated; the first, begun in Cleveland, was generously donated to the Newport Harbor Art Museum. The museum director, Tom Garver, and T. J. Broderick have been consultants for the acquisition of several contemporary pieces pre-sently located in the headquarters. Local galleries, art dealers, and artists serve as the primary sources for acquisitions. The collection contains more than two hundred fifty works including painting, sculpture, prints, and drawings by contemporary American artists, half of whom are from the West Coast. Displayed throughout the headquarters and rotated on a regular basis, the works in Avco's collection are easily visible and accessible to all employees.

In addition to its continuing interest in the Newport Harbor Art Museum, Avco's other cultural concerns include the Orange County Philharmonic Society, the South Coast Repertory, and the Orange County Choral Association. Besides supporting these organizations through active participation on boards or through donations, Avco heightens public awareness of them through a public service advertisement campaign, now in its fourth year. This endeavor not only contributes to cultural enrichment, but also helps charitable organizations including the American Cancer Society, the Mental Health Association, and the American Diabetes Association.

H. Wallace Merryman, Chairman of the Board, and Ross M. Hett, President, are responsible for Avco's outstanding support of the arts. Merryman has expressed the belief that a collection of contemporary art benefits a corporation because it can "simultaneously beautify our corporate headquarters, educate our employees, and encourage the artists of today."

JOHN McLAUGHLIN

1898–1976

NUMBER 14, 1970

OIL ON CANVAS, 1970

48 x 59⅞ INCHES

Born in Sharon, Massachusetts, in 1898, John Mc-
Laughlin was a self-taught artist who did not begin
painting until the age of forty. In 1946, he settled in
Dana Point, California, a small beach community
about halfway between Los Angeles and San Diego,
devoting himself full time to painting until his death
in 1976.

In Dana Point, McLaughlin lived a modest life of
isolation, both geographic and intellectual, from the
mainstream of art activity. In spite of this seclusion,
his numerous exhibitions in the Los Angeles area
were crucial to the development of a younger genera-
tion of California artists during the 1960s. Until
recently, however, his work was virtually unknown
outside of California.

Deeply influenced by the earlier reductivist ideas
of Piet Mondrian and Kasimir Malevich, McLaughlin
also shared certain formal qualities with abstract ex-
pressionists Barnett Newman, Mark Rothko, and Ad
Reinhardt. Ultimately, he differed from all of them by
rejecting any reference to personal expression. By
1948, McLaughlin's style had crystallized into several
elements that would occupy him for the rest of his life:
large, hard-edge, geometric forms; non-visible brush-
strokes; and a minimum of basic colors. Through the
careful balancing of these elements, McLaughlin
sought to avoid the illusion of space and volume and to
prevent the possibility of finding any realistic images

or associations in the forms.

McLaughlin was included in the exhibition *Four
Abstract Classicists*, organized by the Los Angeles
County Museum of Art in 1959. The show also in-
cluded California abstractionists Lorser Feitelson,
Karl Benjamin, and Frederick Hammersley. The term
"hard-edge" was coined to describe the crisp, geo-
metric forms with which these four artists were working.

Beyond technical similarity, McLaughlin shared little
with the other three artists. "My purpose is to achieve
the totally abstract," he explained. "I want to communi-
cate only to the extent that the painting will serve to
induce or intensify the viewer's natural desire for con-
templation, without benefit of guiding principle. I
must, therefore, free the viewer from the demands or
special qualities imposed by the particular by omitting
the image (object). This I manage by the use of neutral
forms." *No. 14, 1970* is from a series of paintings in
which color is reduced to black, white, and gray, so
that, like the rectangular forms, the color would "drain
the composition of self-assertive elements that might
be construed as content."

Paintings by McLaughlin from the last twenty years
of his life have been the subject of several recent ex-
hibitions and publications. He is beginning to be
recognized as one of the major nonrepresentational
painters of recent decades.

262

RON DAVIS
BORN 1937

CUBE III
POLYESTER RESIN AND FIBERGLASS, 1966
29⅝ x 41½ INCHES

In his early works, Ron Davis expressed the cool, sophisticated attitude of the younger generation of Los Angeles artists who specialized in hard-edge geometric shapes, strong coloration, reflective surfaces, and experimentation with new materials.

Born in California in 1937, Davis spent part of his youth in Cheyenne, Wyoming. After studying engineering at the University of Wyoming in 1955-1956, he worked at a variety of odd jobs and began painting in 1959. He returned to California in 1960 to study at the San Francisco Art Institute. Five years later, Davis moved from San Francisco to Los Angeles, where he had his first one-man show at the Nicolas Wilder Gallery. Since that time, he has received widespread recognition.

Davis uses perspective to create the illusion that the canvas is a solid geometric object. The effect is quite different from that created by traditional Renaissance perspective which aims to produce a realistic scene. In Davis' work, the goal is to depict the object not in relation to its surroundings but abstracted from them and viewed in isolation on the white ground of a blank wall. Even the painting's relationship to the wall is minimized as much as possible; rather than hanging on it, the painting juts out from it. The viewer feels somehow unrelated to Davis' works, for their perspective creates the sensation of leaning forward or standing upside down. Disorientation on the part of the viewer also arises from the contrast between the illu-

sion of depth supplied by the perspective and the painting's actual flatness. Other ambiguities arise from the non-rectangular canvases and from the use of color to suggest transparency of the actually solid objects. Davis sometimes embeds areas of gestural painting in an abstract expressionist style under layers of transparent resin.

The polyester resin paintings, such as *Cube III*, were begun in 1966. Davis started by taking a flat formica mold on which the illusionary planes were demarcated with tape. The polyester resin was then mixed with a variety of pigments, dyes, mirror flake, aluminum or bronze powder, pearl essence, and glitter, and applied in successive layers beginning with the one nearest the viewer. Fiberglass impregnated with resin was then laminated to the back to provide support, and a wooden stretcher bar in the shape of the object was added; only then was the painting peeled off the mold and polished and the image viewed by the artist for the first time. This basic technique was varied and refined over several years as Davis progressed from early, simple forms like *Cube III* to more complex geometric configurations. He abandoned this medium in 1972 for reasons of aesthetics and also due to health risks associated with the resins. Davis has returned to using traditional paint on canvas and continues to explore problems of spatial illusion and color through the use of complex geometric forms.

LADDIE JOHN DILL
BORN 1943

UNTITLED
CEMENT AND MIXED RESINS ON PLYWOOD, 1973
30 x 40 INCHES

Born in Long Beach in 1943, Laddie John Dill now lives in the nearby artists' community of Venice, California. Dill graduated with a Bachelor of Fine Arts degree in 1968 from the Chouinard Art Institute, Los Angeles. He received almost immediate recognition as an artist for his environmental installations — temporary three dimensional constructions of materials like sand, glass, plywood, and neon lighting. In 1971, for his first one-man show in New York, Dill created a floor piece in which a pile of sand concealed a support for vertical panels of glass rising mysteriously out of the sand. Also concealed were tubes of colored neon lights which set the edges of the glass aglow.

In 1972, Dill began to create concrete sculptures embedded with bits of glass. By 1973, this work evolved into a form of painting; it had become two dimensional and was intended to be hung on the wall. The basic materials remained concrete mixed with natural pigments; these were often used in combination with glass and then applied over a wooden support.

During the sixties, many artists had experimented with industrial materials to achieve the highly finished appearance of manufactured surfaces such as metal and plastic. In recent years, the trend towards more personal, autobiographical content in art has led artists involved with industrial materials to become increasingly interested in the process of creation itself and in the interaction between artist and raw material. The result has often been a rough product which seems to record or embody the manufacturing process.

Dill's development in the 1970s follows a similar pattern. His early installation works are transitional, moving from an involvement with "cool" manufactured materials, like neon, to an interest in warmer natural materials. In his recent concrete paintings, Dill has made works that are contemporary in their emphasis on the materials and the process of creation, but are also traditional in their romantic evocation of landscape. Unlike traditional landscape painting, there is no illusionistic representation in these topographical abstractions. The process of artistic creation is evident in the texture of the cement; no longer fluid, it records the changes it has undergone. The emphasis on process also serves as a metaphor for change in nature, particularly the erosion of land by wind and water. Dill employs both chance effects and conscious decisions in making his works, as seen in the natural pitting of the surface and the straight diagonal lines he has intentionally marked.

266

PONDEROSA SYSTEM, INC.

Ponderosa System, Inc. owns approximately six hundred fifty steakhouses in the United States and Canada. ESI Meats, Inc., a meat processor and supplier, is a subsidiary of the company. A self-service family restaurant, the Ponderosa Steakhouse aims to provide good food at moderate prices. By the end of 1979, Ponderosa expects to have about twenty thousand employees.

The Ponderosa Collection was assembled in 1974 for permanent installation in the new corporate headquarters in Dayton, Ohio. Selections for the collection were made by Gerald S. Office, Jr., Chairman of the Board and President and an active and long-time contributor to the visual and performing arts in his community. He wanted the collection to reflect the progressive and youthful attitude of the company while maintaining the high quality reflected in the handsome design of the new headquarters.

Initially, the collection contained approximately fifty works in a variety of media by artists of the late 1960s and early 1970s. It includes works by such important contemporary artists as John Chamberlain, Christo, Jim Dine, Robert Morris, Jasper Johns, Robert Rauschenberg, James Rosenquist, Ed Ruscha, and William T. Wiley. During the almost five years since the construction of the new building, the collection has grown to include nearly eighty works of art. Because the more recent acquisitions have focused on less well-known or younger artists like Rafael Ferrer, Alan Shields, Terry Allen, and Joan Snyder, the collection displays the wide variety of aesthetic concerns held by American artists over the past ten years. Representing a variety of media, it includes commissioned works such as Hannah Wilke's latex sculpture, *Ponde-R-Rosa*, in which nine cabbage roses project from the wall in a diamond-like structure.

Selections from the decade covered by the works in the Ponderosa Collection are exciting because of their high quality and their audacious experimental nature. Through a generous loan policy to traveling exhibitions and by conducting public tours of the collection, Ponderosa System, Inc. strives to make its impressive and stimulating collection accessible to the general public.

BEN SCHONZEIT

BORN 1942

TOOLS

ACRYLIC ON CANVAS, 1974

60 x 48 INCHES

Ben Schonzeit began his painting career as an abstract artist but evolved into a realist painter producing images of photographic exactness. Born in Brooklyn, New York, Schonzeit graduated in 1964 from the Cooper Union School of Art. Since 1972, he has been included in numerous group exhibitions organized around the theme of contemporary realism.

While devoted to minute and realistic precision in his paintings, Schonzeit does not regard himself as having left abstraction. He explains this paradox by asserting that his primary interest as a painter has always been color, and that the objects he now paints —mostly common things like food, clothing, and found objects—are interesting purely for the opportunity they provide to apply color in challenging ways.

Like most other photorealists, a varied group that developed in the 1960s, Schonzeit works by projecting a slide onto a canvas. He then applies acrylic paint in successive layers over various masks and uses an airbrush. Despite an apparent fidelity to photographic reality, Schonzeit delights in the manipulation of the image. In his early works, he would superimpose images from two different and unrelated slides, creating incongruities of scale and odd spatial relationships. Often, he would suggest an ambiguous middle ground between the two planes. In more recent work, such as *Tools*, Schonzeit has moved to a single projected image. Two planes are still discernible: the objects and their shadows. However, now the planes are not interrelated but rest one before the other. The images are further manipulated by painting some in crisp detail and others out of focus. This approach accentuates the camera's manner of recording objects.

Schonzeit's most recent works have represented objects in a single plane, pressed close to the surface of the painting, seemingly about to burst forth into the viewer's space. Unlike the cool and aloof mood sought by many other photorealists, Schonzeit's delight in the images he paints often results in luscious renderings and invitingly tactile objects.

PAT STEIR

BORN 1938

BORDER LORD

OIL ON CANVAS, 1972

69½ x 94¾ INCHES

Born in Newark, New Jersey, Pat Steir has developed a unique style outside the mainstream of American art since her graduation from the Pratt Institute in 1962. She has nonetheless managed to attain some of the recognition to which she is due. Her first one-woman show took place in 1964, and she has since exhibited in major museums and galleries throughout the United States and abroad. The Corcoran Gallery of Art gave Steir a one-woman show in 1973. In 1977, she was included in the Whitney Biennial, and a year later, her paintings were represented in two important traveling exhibitions on new American painting of the 1970s.

Steir's paintings seem, at first glance, to have a narrative content. *Border Lord*, for instance, suggests a landscape, containing recurrent images of Steir's pictorial vocabulary—sky, water, mountains, birds, and flowers—arranged in a linear, grid-like fashion so as to take on the appearance of hieroglyphs or ideograms. Reinforcing this effect are words and phrases juxtaposed with the images. Any attempt to discover the exact story and the meaning of the images leads only to tentative conclusions. All the images seem to have been chosen and assembled in such a way as to make it clear to the viewer that they are not mere representations of objects but symbols; furthermore, they are symbols open to multiple interpretation. The flower, for instance, is a form appearing in numerous mythological, literary, psychological, and art historical sources; its appearance in *Border Lord* offers little to specify which of those sources is relevant. Despite this ambiguity, Steir does intend her work to be acces-

sible and meaningful to each viewer.

Steir insists that intention—especially in art—is insignificant to meaning. What is relevant is that which each individual observer brings with him to the work. Steir constructs her paintings, then, to encourage viewers to supply the levels of association by means of which the painting can be understood.

Steir's paintings are based on personal experiences. The identity, form, and arrangement of the various images and letters reflect some remembered event. Layered over those associations are formal elements that belong to the specific act of painting, such as the grid lines and the cross or "x" marks. The total image that emerges thus stands as a record of the past and present, the remembered and the real. The viewer reproduces this process in the act of interpreting, putting together his own associations while looking at the painting.

In *Border Lord*, one is naturally led by the title to reflect on two meanings of the word "border": geographic borders and the painted borders within and around the canvas. When combined with the abstracted landscape images of the work, this dual connotation leads to the idea of geographical maps as metaphors for maps of the mind. The painting's depiction of external realities becomes a means for the visual expression of internal realities, so that the border lines between the outer world and the inner world are dissolved. Steir's paintings lead the viewer into an exploration of his own mind as a consequence of searching for the meaning of their cryptic symbols.

272

273

TOM WUDL
BORN 1948

UNTITLED
LIQUITEX AND METALLIC PAINT ON PERFORATED RICE PAPER, 1973
80⅝ x 63 INCHES

Tom Wudl, born in Bolivia in 1948, immigrated to Los Angeles when he was ten years old. He received a Bachelor of Fine Arts degree from the California Institute of the Arts in 1970 and had his first one-man exhibition in Los Angeles the following year. Wudl has gained national exposure in one-man and group exhibitions. He resides in Venice, California, a beach community which is home to many artists.

While certain elements of Wudl's paintings find their origins in the common concerns of Los Angeles artists of the sixties, other aspects of his work would have been unthinkable at that time. In the late 1960s, Wudl was among many artists who abandoned the traditional canvas and stretcher bar support for their paintings, preferring to tack an unstretched surface directly to the wall. Wudl wanted to create a surface that was tactile and sensuous; his fragile, handcrafted works differ markedly from the polished, often industrial looking surfaces of other Los Angeles artists. Interested in technical virtuosity and experimentation with new materials, Wudl was also concerned about the beauty of the objects that he created.

Wudl's paintings comprise layers of laminated paper and other materials which are then perforated with a paper punch. The holes extend the layering effect to the wall behind the painting, and it shows through to become part of the overall image. The wall energizes the colorful paper surface with stark, usually white, accents.

Both the structure and the images in Wudl's paintings are part of a personal symbolism derived from such diverse sources as mathematics, Indian mysticism, and the theories of Buckminster Fuller. In *Untitled*, the complex geometric patterning provides structural coherence upon which Wudl superimposes such organic forms as spirals. The underlying structure of regular hexagons and diamonds suggests molecular configurations, a beehive, mosaic tile, a patchwork quilt, or even some fantastic architecture. In the spirals might be seen microscopic life forms or meaningful ancient symbols. Wudl's combination of the geometric and the curvilinear is common in Oriental art; it is perhaps this shared trait, and the use of delicate materials, which lends his work an air of exoticism.

275

EDWARD W. DUFFY & CO.

Founded in 1924, Edward W. Duffy & Co. is an industrial steam supply company that distributes valves, pipe, and fittings. Named for its founder, this family-owned business, located in Detroit, is now run by a grandnephew James Duffy, Jr. The company employs only sixteen persons but houses in its ten thousand square foot warehouse one of the most extensive collections anywhere in the country of work by artists from a single city.

The collection began in 1972 with Duffy's interest in the Willis Gallery, a cooperative art gallery in Detroit. He felt that the young Detroit artists represented there needed a patron and commissioned them to make works of art for installation in the warehouse. In addition to free standing or hanging sculptures, there are also paintings, some of which are executed directly on the enormous walls of the building. Duffy's belief that any space could be used for a work of art resulted in some artists even making works for the doors. Gordon Newton, Michael Luchs, Robert Sestock, and others have created works for specific spaces either in the warehouse or in the offices. Some of the pieces are monumental in scale. The collection is enormously popular with the public, and the company offers frequent tours of the warehouse.

In addition to his collection, Duffy is an active supporter of the arts through the Detroit Institute of Art and the Visiting Artists Program at Wayne State University. The company's approach to art in a corporate setting is perhaps unique in this country; the work is not only commissioned for specific locations, but these locations are most frequently of an industrial character.

The company's encouragement of artists from its own city points to a common trend in much contemporary corporate collecting — the support of artists from locales in which the company headquarters are located. However, rarely has a corporation so intensively collected artists from one city. The Duffy & Co. collection also points to another important factor — that significant support of the visual arts through monetary contributions and art collecting is in no way restricted to large corporations. Through creative initiative, businesses such as Duffy & Co. have made important contributions to the visual arts far out of proportion to their moderate size.

JAMES CHATELAIN
BORN 1947

UNTITLED
OIL ON CANVAS, 1976
16⅝ x 15½ INCHES

James Chatelain depicts the raw energy of street people engaged in violent interaction. Neither symbolic nor abstruse, his images are obvious in meaning; they are Chatelain's response to the brutality around him in the Cass Corridor of Detroit.

Chatelain was born in Ohio in 1947. He graduated from Wayne State University, Detroit, in 1971 and began exhibiting the same year. He was one of the original members of the Willis Gallery, a cooperative which brought together new Detroit artists and exhibited their work. After showing many times there, Chatelain was included in the Detroit Institute of Art's 1975 group exhibition *Focus* and in *Bad Painting* at the New Museum, New York, in 1978. He was also one of two artists in a 1978 exhibition at the Willard Gallery in New York.

Untitled is typical of Chatelain's painting. It not only depicts urban violence; it also brings it close to home. The painting was inspired by muggings occurring in Chatelain's own neighborhood, the Cass Corridor. This area is a midwestern Bohemia where violent crime, drug trafficking, and prostitution are commonplace. So are the large, cheap working and living spaces needed by artists. Chatelain's paintings are not cynical, but factual. They are tightly organized; no extraneous details divert the viewer's attention. One is forced to address the violent encounter of the two figures, shorthand renditions which are abstract yet recognizable. They are pictorial signs the artist uses as universal symbols for people. The background indicates no particular place or time; it is not only the artist's personal experience that is seen but an occurrence familiar to all city dwellers. The expressionist quality of the work, reminiscent in its rawness of abstract expressionism, is a reaction to much art in the 1970s, especially against highly illusionistic realism and the intellectual orientation of conceptual art. The unruliness of the painted surface often extends beyond the canvas onto the frame, where paint is found dripped or splattered.

The confrontation in Chatelain's work is always between two males. This suggests that the paintings do not possess sexual overtones but refer directly to violence. Chatelain's work also includes three dimensional pieces and wall paintings. When asked about the impetus behind small paintings such as *Untitled*, the artist has simply and evasively replied that he likes them, they work for him, and that other people like them.

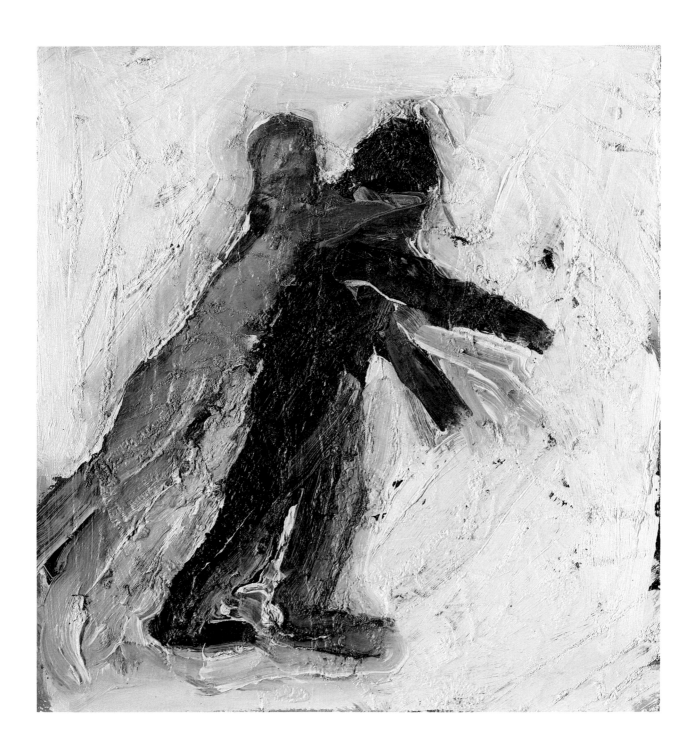

MICHAEL LUCHS

BORN 1938

RABBIT

CARDBOARD AND FABRIC ON WOOD, 1976

43⅛ x 55¼ INCHES

Luchs was born in Portsmouth, Ohio, in 1938 and attended the University of Michigan and Wayne State University, Detroit. He began exhibiting his work in 1970, when he was included in the *58th Exhibition for Michigan Artists* at the Detroit Institute of Arts. In 1972, he was represented in *Twelve Statements Beyond the 60s* at the Detroit Institute, and in 1975 he received a commission from the Detroit Department of Parks and Recreation. After being included in several other exhibitions, he had his first one-man show at the Feigenson-Rosenstein Gallery, Detroit, in 1977. A year later, he was one of two artists shown at the Willard Gallery in New York City.

Luchs has maintained an expressionist idiom in his work. His idiosyncratic gestures and imperfect surfaces recall abstract expressionism as well as the mood of current post-minimal art. Luchs almost always makes images of rabbits, although he has worked with other subjects. The works are not reliant on traditional materials and forms. Starting with weathered plywood, he gouges, chisels, and punctures it. He then adds jagged wire, torn clothing, paper, and staples to create an image of a gentle rabbit. Without painting a stroke, Luchs produces works to hang on the wall and be experienced as paintings; his creations defy traditional categorization.

The piece owned by Edward Duffy & Co. has the image of a rabbit etched into its surface and is typical of Luchs' work. Since his days as a student at Wayne State, Luchs has made rabbits, creating them in various media. Electric rabbits, leather jacket rabbits, and paint-sprayed rabbits have all emerged as the products of Luchs' creative expression. An eccentric symbol, the rabbit has been regarded by some as a surrogate personality for an artist "trapped in his own vulnerability yet sustained by some inner strength."

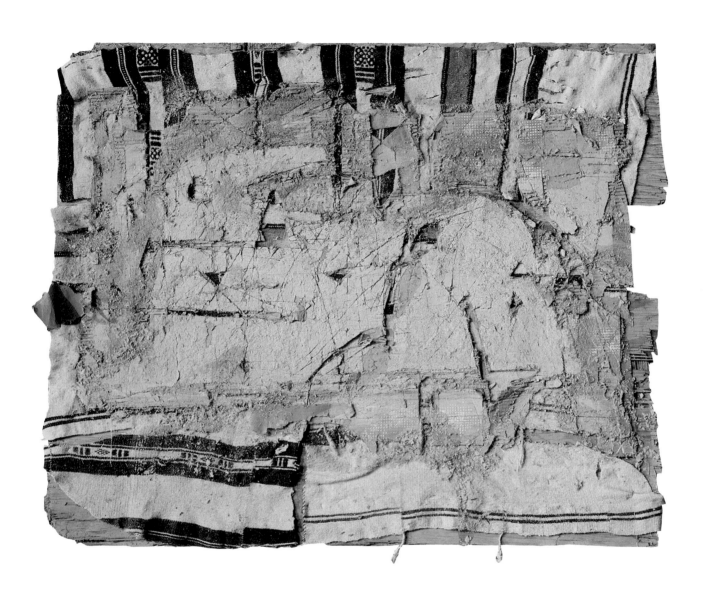

281

GORDON NEWTON

BORN 1948

UNTITLED

PAINT AND MIXED MEDIA ON PAPER MOUNTED ON PAPERBOARD, 1974
25¾ x 22 INCHES

Gordon Newton was born and raised in Detroit. He attended the Port Huron Community College but returned to Detroit to become a member of the Society of Arts and Crafts and to attend Wayne State University. At twenty-three, he began exhibiting. In the *58th Exhibition for Michigan Artists* at the Detroit Institute of Arts, 1970, he won the Mr. and Mrs. Lester B. Arwin Purchase Prize and the Detroit Artists Market Prize. During the next year, Newton exhibited in five shows including one at M. Knoedler & Co., New York, and in the Detroit Institute's *Twelve Statements Beyond the 60s.*

It was probably the New York showing which led to Newton's inclusion in *American Drawings* at the Whitney Museum of American Art in 1973. Having exhibited for only three years, he was shown in a major American museum. Several more exhibitions followed, and in 1978 Newton was one of thirteen artists in The Guggenheim Museum's *Young American Artists: 1978; Exxon National Exhibition.* A work by each artist was purchased for the Guggenheim's permanent collection.

For Newton, the atmosphere of the 1960s provided an important foundation. He feels that the social and political revolution of that era allowed forms of art other than painting and sculpture to be taken seriously. The strong feeling of independence which characterized the sixties encouraged artists to work outside established aesthetic traditions. Newton took advantage of this atmosphere and has flourished—not as part of any movement or school but guided by personal objectives.

Newton begins each "project," as he prefers his works to be called, with geometric shapes. Some of his work is constructed from existing objects which are not significantly altered. Other pieces, like his polychromed chain saw or routed epoxy sculpture, undergo drastic metamorphosis. Newton feels that the alterations an artist performs are analagous to those in nature. He attempts to convey a physical sensation to the viewer; in *Untitled*, one is able actually to feel movement because the piece extends in many directions. Newton is fascinated by games and gadgets. Perhaps it is this attraction to the ways in which parts fit together, rather than the conscious influence of historical precedents in art, that gives rise to his constructed works.

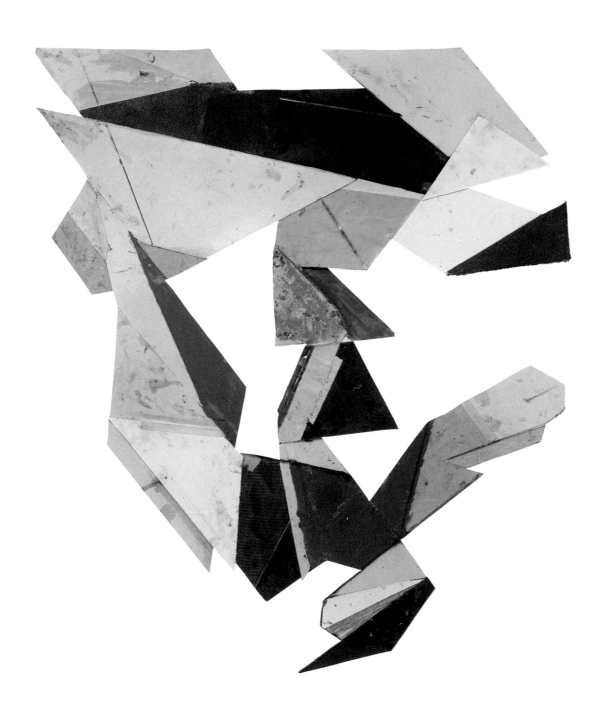

283

NATIONAL COMMITTEE

ACKNOWLEDGMENTS

An exhibition of this scope and complexity could not have been possible without the support of many individuals. My sincerest appreciation is extended to the following board chairmen, presidents, and special personnel who have aided the organization of this show: American Republic Insurance Company: Watson Powell, Jr., Chairman of the Board, Ronald P. Morden, C.P.A., Vice President and Comptroller; The Anschutz Corporation: Philip Anschutz, President, Irene Rawlings, Curator; Atlantic Richfield Company: T.F. Bradshaw, President, Leila L. Mehle, Curator; Avco Financial Services: H. Wallace Merryman, Chairman of the Board, James Straw, Assistant Director of Public Relations; Blount, Inc.: Winton M. Blount, Chairman of the Board, President, and Chief Executive Officer, Holman Head, Vice President — Administration; The Chase Manhattan Bank: David Rockefeller, Chairman of the Board of Directors, Merrie S. Good, Director, Art Program; CIBA-GEIGY Corporation: Otto Sturzenegger, Chairman, President, and Chief Executive Officer, Markus J. Low, Manager, Corporate Art Services; Citibank, N.A.: Walter B. Wriston, Chairman of the Board, Laura Miner, Specialist, Facilities Planning; Cleveland Trust Company: M. Brock Weir, Chairman and Chief Executive Officer, Donald D. Rolla, Operations Officer; Commerce Bank of Kansas City, N.A.: James Kemper, Chairman of the Board, Laura Kemper, Assistant Vice President; Container Corporation of America: Henry G. Van der Eb, Chairman, John V. Massey, Director of Communication; Cummins Engine Company, Inc.: J. Irwin Miller, Chairman, Executive and Finance Committee, Peg Charipar, Public Relations Manager; Deere & Company: William A. Hewitt, Chairman of the Board, George Neiley, Director of Public Relations; Edward W. Duffy & Co.: James F. Duffy, Jr., President; First City National Bank of Houston: Nat S. Rogers, Chairman of the Board, J.A. Elkins, Jr., Chairman of the Executive Committee, James E. Day, Manager of Public Relations; The First National Bank of Chicago: Richard L. Thomas, President, Robert G. Donnelley, Vice President, Robert B. Middaugh, Curator of the Collection; Great Western Savings and Loan Association: Stuart Davis, Chairman of the Board, Ralph Rivet, Director, Office of Public Information; Gulf States Paper Corporation: Jack W. Warner, President and Chairman of the Board, Doris Fletcher, Communications and Publications; Hallmark Cards, Inc.: J.C. Hall, Chairman of the Board, Donald J. Hall, President, William S. Johnson, Director of Public Relations; International Business Machines Corporation: Frank T. Cary, Chairman of the Board, Nicholas Costantino, Manager of Graphic Design; Paine Webber/Mitchell, Hutchins Group: Donald B. Marron, President, Jean De Poer, Secretary to the President; PepsiCo, Inc.: Donald M. Kendall, Chairman and Chief Executive Officer, Katherine Niles, Program Coordinator; Playboy Enterprises, Inc.: Hugh Hefner, Chairman, Arthur Paul, Art Director of *Playboy* and Vice President/Corporate Art and Graphics Director of Playboy Enterprises, Barbara Hoffman, Executive Assistant to Mr. Paul; Ponderosa System, Inc.: Gerald S. Office, Jr., Chairman of the Board and President, Kenneth Palmer, Vice President, Corporate Affairs; The Prudential Insurance Company of America: Robert A. Beck, Chairman of the Board and Chief Executive Officer, Connie Rogers, Art Program Administrator; Seattle-First National Bank: William M. Jenkins, Chairman, Lawney L. Reyes, Art Design Officer; Steinway & Sons: Henry Z. Steinway, Chairman of the Board, John H. Steinway, Vice President; United States Steel Corporation: Edgar B. Speer,

Chairman, Board of Directors, Andrew E. Reilly, Office Manager-Office of Chairman; Weil Brothers-Cotton, Inc.: Adolph Weil, Jr., Chairman of the Board, Robert S. Weil, President; and Westinghouse Electric Corporation: Robert E. Kirby, Chairman, J.P. Andrews, Director of Corporate Design.

We are also indebted to our National Business Advisory Committee which, under the Chairmanship of Winton M. Blount, supported the project. Those serving on the Committee are: T.F. Bradshaw, William A. Hewitt, Donald M. Kendall, Robert E. Kirby, J. Irwin Miller, David Rockefeller, and William Ruder, President, Ruder & Finn, Inc.

Art Inc.: American Paintngs from Corporate Collections was made possible by a generous grant from The Blount Foundation, Inc. Special thanks must be given to Winton M. Blount; his enthusiastic leadership contributed greatly to the show's reception in Montgomery and throughout the country.

During the organization of the show, we have been very fortunate to have had the support of many colleagues, committees, and individuals whose assistance has been invaluable. Walter Hopps, our Curatorial Advisor, deserves special praise for the excellent advice and assistance he gave to the project. Jay Belloli, Anne Livet, Diane Gingold, and I composed a visitation team which traveled to approximately one hundred corporations to survey collections. Final choice of the paintings represented in *Art Inc.* was made by our selection committee under the guidance of Walter Hopps; also included were Jay Belloli, Mitchell Kahan, and myself. We met several times in Montgomery to make refinements and to review and discuss works to be included in the exhibition.

Special assistance was given to the visitation team in numerous cities, and collectively we would like to thank Shirley Phillips Hall in Los Angeles, Aleen Moulds in San Jose, Adrienne Horn in San Francisco, James E. and Sandra K. Johnson in Minneapolis, and Stephen Reichard in New York. Mabel H. Brandon has given us her assistance for the exhibition's presentation in Washington, D.C.

This publication reflects contributions from numerous individuals. We are very appreciative of the research assistance given by Miriam Roberts who compiled our extensive bibliography, the most definitive to date on the subject of corporate collecting. Also, the following dedicated librarians gave important assistance contributing to our research archive on corporate collections: Eugenie Canbau and Grace Baker, San Francisco Museum of Modern Art; Susan Craig, University of California at Berkeley; Odette Mayers, The Oakland Museum; Katherine M. Ratzenberger and William B. Walker, National Collection of Fine Arts, Smithsonian Institution.

For the many insightful catalogue entries, I wish to thank Gilbert T. Vincent, Lynda Roscoe Hartigan, Miriam Roberts, H. Nichols B. Clark, John H. Hofer, Grace Baker, and Katherine Campbell on our own staff. Anne Livet provided the research on each of the corporations selected for this exhibition; her work was accomplished with tenacity and vigor. Mei Su Teng was our editorial consultant and expeditiously guided the text to final press copy. William R. Anderson assisted in the final proofreading of this publication.

The physical appearance of the book is due to the talents and special concern of several people. The Montgomery Museum's graphic designer, Julie Toffaletti, designed the book and undertook the task of coordinating all of the various components necessary for such a publication. The advice of Clarkson Potter of The Brandywine Press, our co-publisher, and the efforts of Elsevier-Dutton Distribution Services are greatly appreciated. W.M. Brown & Son, Inc. of Richmond, Virginia, printed this publication and we are especially grateful to the staff for their quality control and assistance. We are also indebted to James H. Witt, Vice President of W.M. Brown, who contributed his expertise in art publications. Malcolm Varon, with two exceptions, took all the photographs for the publication on location throughout the country and also advised us on the color accuracy for the book. James Milmoe photographed the Georgia O'Keeffe painting and Robert Wallace, the Ellsworth Kelly.

The successful tour of this exhibition is to be credited to the outstanding cooperation of the other museum staffs: Dr. Peter Marzio, Director, and Jane Livingston, Associate Director, Corcoran Gallery of Art, Washington, D.C.; Robert A. Yassin, Director, and Hilary Basset, Registrar, Indianapolis Museum of Art, Indiana; and Henry G. Gardiner, Director, The San Diego Museum of Art, California.

Karen Hughes and Susan Bloom from Ruder & Finn, Inc. were responsible for our United States publicity and we are very appreciative of their excellent services. We were assisted in several areas by John Scott, who provided photographic services.

Within the City of Montgomery, enthusiasm has been considerable. Mayor Emory Folmar has given his support to the project and we are most grateful for his making this exhibition a city-wide activity. The Museum's President, Mr. J.L. Sabel, has admirably directed our Trustees throughout the show's organization. The leadership of the Museum City Board and the Board of Trustees of the Montgomery Museum of Fine Arts Association during the organization of this show was essential to its success. The Art Inc. Council, established to contribute to the show's current organization and the future growth of the Art Inc. Division, must be commended. Members of the Council include Winton M. Blount, Mrs. Robert P. Gallagher, Philip T. Murkett, Jr., J.L. Sabel, Adolph Weil, Jr. and Robert S. Weil.

Credit must also go to the staff of the Museum for maintaining the momentum and dealing with the many details and arrangements that were necessary. Mitchell D. Kahan, Curator, has written an illuminating essay on the history of corporate collecting and served as our general editor for the publication. Katherine Campbell, Assistant Curator, handled curatorial logistics and helped keep us on schedule. Edward R. Quick, Registrar, undertook the responsibility of organizing all our special shipping, crating, and insurance requirements in addition to supervising the photography and handling the exhibition in San Francisco, Chicago, and New York. Theodore W. James, Assistant Director, with the help of Patrick Kirkland, Preparator, supervised the design of the installation planned by Walter Hopps and Mitchell Kahan. Special mention must go to members of our administrative staff: Audrey Gryder, Administrative Assistant, expertly handled key organizational problems; secretaries Patti Mastin and Shirley Woods typed the manuscript. Elizabeth Brown, Publications Librarian, secured resource materials for the project and assisted with state-wide publicity. Grace M. Hanchrow, Membership Coordinator, developed special activities in conjunction with the exhibition.

The organization of this exhibition for me has been very rewarding, and I am immensely indebted to all those who contributed to the task. My warmest thanks and congratulations to each of you who became involved.

Henry Flood Robert, Jr.
Director

SELECTED BIBLIOGRAPHY

The bibliography is divided into three major sections: General Books and Articles;
Individual Corporate Collections; and Group Exhibitions of Corporate Collections.

GENERAL BOOKS AND ARTICLES
Arranged alphabetically by author.

Abell, Walter. "Industry and Painting." *Magazine of Art*. Vol. 39, No. 3 (Mar., 1946), pp. 82–93, 114–118.

_____. "Viewpoints: Can Industry Be Counted on as a Patron of the Arts?" *Magazine of Art*. Vol. 37, No. 4 (Apr., 1944), p. 135. Reply: Walter S. Mack, Jr. "Viewpoints: A New Step in Art Patronage." Vol. 37, No. 6 (Oct., 1944), p. 228.

Akston, Joseph James. "Editorial." *Arts*. Vol. 42, No. 7 (May, 1968), p. 5.

_____. "Editorial." *Arts*. Vol. 43, No. 3 (Dec., 1968–Jan., 1969), p. 5.

"Art and Industry." A special issue of *Art in America*. Vol. 44, No. 2 (Spring, 1956). Eloise and Otto Spaeth, guest eds. Contents: Eloise Spaeth, "Guest Editorial"; Russell Lynes, "Whose Business is Art?"; "New Styling By Yale and Towne"; Bernice Fitz-Gibbon, "DepARTment Stores"; John McAndrew, "General Motors Technical Center"; Daniel Wildenstein, "The Role of the Art Dealer"; Ben Barkin, "Art at Meta-Mold"; Hans van Weeren-Griek, "The Underwood Experiment"; Otto Spaeth, "A Proposal for Hotel Art."

"Art in a Supermarket." *Art Digest*. Vol. 24, No. 13 (Apr. 1, 1950), p. 13.

Benton, Thomas Hart. "Business and Art from the Artist's Angle." *Art Digest*. Vol. 20, No. 8 (Jan. 15, 1946), pp. 8, 31.

Blount, Winton M. "Art and Business...Natural Allies." Business Committee for the Arts, Inc. publication, 1978. Address delivered to the "Business in the Arts" Awards Luncheon, Los Angeles, June 15, 1978.

Boswell, Peyton. "Comments: Common Sense." *Art Digest*. Vol. 20, No. 6 (Dec. 15, 1945), p. 3.

Bothwell, Robert. "Reader's Response: Further Exploration of the Elusive World of Corporate Philanthropy." *Grantsmanship Center News*. Vol. 4, No. 2 (Mar.–Apr., 1978), pp. 57–61. Response to article by Jack Shakeley.

Business Committee for the Arts, Inc. *"Business in the Arts" Awards: A Ten Year History: 1966–1975*. Foreword by Goldwin A. McLellan. New York: Business Committee for the Arts, Inc. 1975.

_____. *Business Support of the Arts 1976*. Foreword by Goldwin A. McLellan. Brochure.

_____. *1426 Examples of How BCA Companies Supported the Arts in '74 and '75*. New York, 1975. Brochure.

_____. *1776 and More Examples of How BCA Companies Supported the Arts in 1975 and 1976*. New York, 1976. Brochure.

_____. *2507 Examples of How BCA Companies Supported the Arts in '76 and '77*. Preface by Goldwin A. McLellan. New York, 1977.

Calas, Nicolas. "ABC or LSD?" *Arts*. Vol. 40, No. 9 (Sep.–Oct., 1966), p. 15.

Caspers, Frank. "Patrons at a Profit–Business Discovers Art as a Selling Force." *Art Digest*. Vol. 17, No. 15 (May 1, 1943), pp. 5, 17.

Chagy, Gideon, ed. *Business in the Arts '70*. New York: Paul S. Eriksson, 1970.

_____. *The New Patrons of the Arts*. New York: Harry N. Abrams, 1973.

_____. ed. *The State of the Arts and Corporate Support*. New York: Paul S. Eriksson, 1971.

Cochran, Diane. "Looking Back—Three Corporations Evaluate Their Art Collections." *Interiors*. Vol. 136, No. 4 (Nov., 1976), pp. 114–116. Discusses Chase Manhattan Bank, Prudential Insurance Company, and Mitchell-Hutchins (Paine Webber).

Crane, Aimée, ed. *Portrait of America*. Preface by Bernard De Voto. New York: Hyperion Press, 1945. Includes artworks drawn almost exclusively from corporate collections.

Davis, Felice. "The Art Preferences of Two New York Banks." *Connoisseur*. Vol. 180, No. 723 (May, 1972), pp. 36–46. Article about the Bank of New York and the Seamen's Bank for Savings.

Dillon, C. Douglas. "Cross Cultural Communication Through the Arts." *Columbia Journal of World Business*. Vol. 6, No. 5 (Sep.–Oct., 1971), pp. 31–38.

_____. et al. *Tax Impacts on Philanthropy*. Princeton, Tax Institute of America, 1972. See especially "The Philosophy of Corporate Philanthropy" by Gavin K. McBain, pp. 13–20.

Eells, Richard Sedric Fox. *The Corporation and the Arts*. New York: Macmillan, 1967.

Elicker, Paul H. "Why Corporations Give Money to the Arts." *The Wall Street Journal*. Mar. 31, 1978, p. 51, col. 1. Reprinted in "Commentary." *Museum News*. Vol. 56, No. 6 (Jul.–Aug., 1978), pp. 5–6.

"Exhibitions Coast to Coast: Industrial Relations." *Art News*. Vol. 54, No. 8 (Dec., 1955), pp. 9–10.

Finley, George T. "Art at Work." *Industrial Design*. Vol. 18, No. 6 (Jul., 1971), pp. 60–61.

Finn, David. "Art for Business's Sake, Art for Art's Sake." *Across the Board*. Vol. 13, No. 12 (Dec., 1976). Article about Henry Moore sculptures at corporate headquarters.

Frost, Rosamund. "The Artist-Reporter in Industry." *Art News*. Vol. 44, No. 11 (Sep., 1945), pp. 14–19.

Gent, George. "The Growing Corporate Involvement in the Arts." *Art News*. Vol. 72, No. 1 (Jan., 1973), pp. 21–25. Article about the Business Committee for the Arts.

Georgi, Charlotte. *The Arts and the World of Business*. 2nd rev. ed. Metuchen, New Jersey: Scarecrow Press, in press. This edition will comprise a revised and expanded edition of the 1973 edition *The Arts and the World of Business: A Selected Bibliography* together with Supplements I and II, published by the Management-in-the-Arts Program, University of California, Los Angeles, 1974 and 1976.

Gibbs, Jo. "State Department Sends Business-Sponsored Art as U.S. Envoys." *Art Digest*. Vol. 21, No. 4 (Nov. 15, 1946), p. 8.

Gingrich, Arnold. "The Arts and the Corporation." *Conference Board Record*. Vol. 6, No. 3 (Mar., 1969), pp. 29–32.

_____. *Business & the Arts: An Answer to Tomorrow*. Foreword by David Rockefeller. New York: Paul S. Eriksson, 1969.

Grafly, Dorothy. "Industry—Art Angel." *American Artist*. Vol. 11, No. 9 (Nov., 1947), pp. 46–47.

_____. "Industry Turns to Art—And Vice Versa." *American Artist*. Vol. 17, No. 7 (Sep., 1953), pp. 53, 63–67.

_____. "The New Psychology in Collecting." *American Artist*. Vol. 19, No. 8 (Oct., 1955), pp. 37, 63–65.

"Great Day Coming—Maybe." *Art Digest*. Vol. 27, No. 8 (Jan. 15, 1953), p. 5.

Haacke, Hans. *Framing and Being Framed: 7 Works, 1970–75*. Halifax: The Press of the Nova Scotia College of Art and Design, and New York: New York University Press, 1975, pp. 113–121.

"Interface: Business and Beauty; An Interview With Armand G. Erpf." *Columbia Journal of World Business*. Vol. 2, No. 3 (May–Jun., 1967), pp. 85–90.

Kaiden, Nina and Hayes, Bartlett, eds. *Artist and Advocate: An Essay on Corporate Patronage*. New York: Renaissance Editions, Inc., 1967. Contains a catalogue of The Mead Collection.

Kingsley, Robert E. "Esso's Support of the Arts Ties-In With 'Positive Nationalism'." *Public Relations Journal*. Vol. 22, No. 8 (Aug., 1966), pp. 33–36.

Kuhn, Annette. "Post-War Collecting: The Emergence of Phase III." *Art in America*. Vol. 65, No. 5 (Sep.–Oct., 1977), pp. 110–113.

"Lobby Art and Plazas." A special issue of *Skyscraper Management*. Vol. 58, No. 9 (Sep., 1973). Contents: Charles M. Edwards, "Art Can Be Beautiful and Make Your Leasing Easier Too," article about Bell and Hefter, Inc., Chicago; "First National Bank of Oregon's Art Acquisition Program"; "The Bank of California/Portland"; "9200 Sunset Tower's Open First Floor"; "Art and Art Happenings."

Lowry, W. McNeil. "How Are the Arts Best Supported?" *Arts and Architecture*. Vol. 80, No. 5 (May, 1963), pp. 22–23, 32–33.

McLellan, Goldwin A. "The Business Committee for the Arts." *Historical Preservation*. Vol. 21, No. 1 (Jan.–Mar., 1969), pp. 22–24.

————. "Business Needs the Arts." *National Sculpture Review*. Vol. 18, No. 1 (Spring, 1969), p. 7.

————. "What's Good for the Arts is Good for General Motors." *Industrial Development*. Vol. 139, No. 1 (Jan.–Feb., 1970), pp. 3–5.

Miller, J. Irwin. Address to the "Business in the Arts" Awards Luncheon, Indianapolis Museum of Art, June 21, 1977. New York: Business Committee for the Arts, Inc., 1977. Brochure.

Millsaps, Daniel W., et al, eds. *National Directory of Arts Support by Business Corporations*. Washington, D.C.: Washington International Arts Letter, a subsidiary of Allied Business Consultants, Inc., 1979.

————. *Washington International Arts Letter: Private Foundations and Business Corporations Active in the Arts/Humanities/Education*. Vol. 2, Washington, D.C.: Allied Business Consultants, 1974. See especially "Corporate Support," pp. 219–60.

Morris, Hal. "Art Enhances the Image of Finance — Pays Other Returns." *Burroughs Clearing House*. Vol. 50, No. 9 (Jun., 1966), pp. 38–39, 84–86.

Morse, John D. "Americans Abroad." *Magazine of Art*. Vol. 40, No. 1 (Jan., 1947), pp. 21–25. Article on State Department traveling exhibition of American corporate-owned art.

Norman, Michael. "Office Art: Buyer, Beware." *New York Times*. Feb. 19, 1978, Sec. III, pp. 1, ff.

O'Connor, John. "Business: Getting Better?" *Cultural Affairs*. No. 2 (1968), pp. 43-44.

Osborne, Alan, ed. *Industry Supports the Arts*. London: The Connoisseur, 1966. See especially "Business and the Arts in the United States: A Hopeful Partnership," by August Hecksher, pp. 13–15.

Plaut, James A. "Art and American Industry." *Art Digest*. Vol. 27, No. 7 (Jan. 1, 1953), p. 5.

"Portrait of a Product." *Art in America*. Vol. 52, No. 2 (Apr., 1964), pp. 94–95.

Reiss, Alvin H. *Culture and Company: A Critical Study of an Improbable Alliance*. New York: Twayne, 1972.

————. "Visual Aid." *Cultural Affairs*. No. 7 (1969).

Rosenbaum, Lee. "Money and Culture." *Horizon*. Vol. 21, No. 5 (May, 1978), pp. 24–29.

————. "The Scramble for Museum Sponsors: Is Curatorial Independence for Sale?" *Art in America*. Vol. 65, No. 1 (Jan.–Feb., 1977).

Russell-Cobb, Trevor. *Paying the Piper: The Theory and Practice of Industrial Patronage*. London: Queen Anne Press, 1968.

Scotese, Peter G. "Business and Art: A Creative, Practical Partnership." *Management Review*. Vol. 67, No. 10 (Oct., 1978), pp. 20–24.

Seldis, Henry J. "Business Buys Art." *Art in America*. Vol. 52, No. 1 (Feb., 1964), pp. 131–134. Article about corporate art collecting in California.

Shakeley, Jack. "Exploring the Elusive World of Corporate Giving." *Grantsmanship Center News*. Vol. 3, No. 5 (Jul.–Sep., 1977), pp. 35–39. See reply by Robert Bothwell.

Sheeler, Charles. "Power: A Portfolio by Charles Sheeler." *Fortune*. Vol. 22, No. 6 (Dec., 1940), pp. 73–83.

Smith, George Alan. "Business Investment in the Arts." *Conference Board Record*. Vol. 3, No. 7 (Jul., 1966), pp. 23–26.

————. "Who Gives a Dollar for Art?" *Public Relations Journal*. Vol. 22, No. 3 (Mar., 1966), pp. 13–14.

Stanton, Frank. Untitled address to the Arts Council, Columbus, Ohio, Feb. 23, 1967.

————. Untitled address delivered at the dedication of the Brown Pavilion, Museum of Fine Arts, Houston, Texas, Jan. 15, 1974. New York: Business Committee for the Arts, Inc., n.d.

Tesar, Jenny. "The Banker as Patron of the Arts, 1974." *Banking*. Vol. 66, No. 18 (Dec., 1974), pp. 28–31, 40–44.

"Their Own Fault." *Art Digest*. Vol. 14, No. 20 (Sep. 1, 1940), p. 22.

"Through Industry, A Forward Movement Towards an American Art." *Art Digest*. Vol. 8, No. 10 (Feb. 15, 1934), p. 31.

Toffler, Alvin. *The Culture Consumers: A Study of Art and Affluence in America*. New York: St. Martin's Press, 1964. See especially Part 2, "Trends," Ch. 7, "Culture Incorporated," pp. 92–108.

Tuchman, Maurice. *A Report on the Art and Technology Program of the Los Angeles County Museum of Art: 1967–1971*. Los Angeles: Los Angeles County Museum of Art, 1971.

Weiss, Margaret R. "Big Business: Photography's Newest Patron." *Saturday Review*. Vol. 4, No. 21 (Jul. 23, 1977), pp. 44–45, 54.

Wenger, Lesley. "Art, Like Religion, Only Works if You Believe in It: Three Corporate Collections." *Currant*. Vol. 1, No. 6 (Feb.–Mar.–Apr., 1976), pp. 22–29, 46–51. Discusses Atlantic Richfield Co., Times-Mirror Corporation, and Security Pacific Bank.

Willard, Charlotte. "The Corporation as Art Collector." *Look*. Vol. 29, No. 6 (Mar. 23, 1965), pp. 67–72.

INDIVIDUAL CORPORATE COLLECTIONS
Arranged alphabetically by company. Includes catalogues, exhibitions, and articles on corporate collections.

Abbott Laboratories. *A Corporation Collects: A Selection of Paintings from the Abbott Laboratories Fine Art Collection*. Introduction by Emily Genauer. Exhibition organized and circulated by The American Federation of Arts, Sep., 1959–Oct., 1960.

American Republic Insurance Company. *Collection of American Republic Insurance Company*. Foreword by Watson Powell, Jr. Des Moines, 1970.

Anschutz Collection. *American Masters in the West: Selections from the Anschutz Collection*. Denver, 1976.

Atlantic Richfield Company. *Art and Architecture Tour*. Los Angeles County Museum of Art, 1976.
 See also, under General Books and Articles: Wenger, Lesley, *Currant*.

Bank of New York:
 See, under General Books and Articles: Davis, Felice, *Connoisseur*.

Blount, Inc. *Blount Collection*. Foreword by Winton M. Blount. Mongtomery, 1978.

Chase Manhattan Bank:
 "The Chase Manhattan Collects." *Arts*. Vol. 35, No. 10 (Sep., 1961), p. 59.
 Davis, Felice. "Art Collecting and New York's Chase Manhattan Bank." *Connoisseur*. Vol. 181, No. 73 (Dec., 1972), pp. 265–74.
 Kuh, Katharine. "First Look at the Chase Manhattan Bank Collection." *Art in America*. Vol. 48, No. 4 (Winter, 1960), pp. 68–75.
 Lansdale, Nelson. "The Chase Manhattan Bank: A Patron of Art and Artists." *American Artist*. Vol. 29, No. 1 (Jan., 1965), pp. 32–37, 72–75.
 See also, under General Books and Articles: Cochran, Diane, *Interiors*.

CIBA-GEIGY Corporation. *CIBA-GEIGY Art Collection*. Ardsley, New York, 1973.

_____. *Works by Women from the CIBA-GEIGY Collection*. Ardsley, New York, 1974. Exhibition at the Kresge Art Center Gallery, Michigan State University, East Lansing, Mar. 2–24, 1974; and at the Weatherspoon Art Gallery, University of North Carolina at Greensboro, Apr. 7–28, 1974.

_____. *Works on Paper from the CIBA-GEIGY Collection*. Ardsley, New York, 1976. Exhibition at the Wichita Falls Museum and Art Center, Wichita Falls, Texas, Sep. 30–Nov. 7, 1976; and at the Neuberger Museum, College at Purchase, State University of New York, Nov. 21, 1976–Jan. 2, 1977.

Commerce Trust Company. *Modern American Painting from the Commerce Trust Company Collection*. Exhibition at the Museum of Art, University of Kansas, Lawrence, Dec. 4, 1966–Jan. 1, 1967.

Container Corporation of America. *Modern Art in Advertising: An Exhibition of Designs for Container Corporation of America*. Chicago, 1945. Exhibition at the Art Institute of Chicago, Apr. 27–Jun. 23, 1945; and at the Massachusetts Institute of Technology, Mar. 30–Apr. 28, 1946.

_____. *Great Ideas of Western Man*. Chicago, 1967. Exhibition at the Herron Museum of Art (now the Indianapolis Museum of Art), Nov. 3–24, 1967.

_____. *Great Ideas of Western Man*. Chicago, 1974. A catalogue of the collection.

_____. *Great Ideas: Container Corporation of America*. John Massey, ed. Introductions by Rhodes Patterson, David Ogilvy, Herbert Bayer, Mortimer Adler, and Franz Schulze. Chicago, 1976. Expanded catalogue of the collection.

Deere & Company. *Selections from the John Deere Art Collection*. Introduction by Esther Sparks. Moline, n.d.

"Rural Mural for a Tractor Maker." *Fortune*. Vol. 70, No. 6 (Dec., 1964), pp. 144–47.

Encyclopaedia Britannica, Inc. *Contemporary American Painting: The Encyclopaedia Britannica Collection*. Written and edited by Grace Pagano. Introduction by Donald Bear. Preface by Daniel Catton Rich. New York: Duell, Sloan, and Pearce, 1945.

Esmark. *The Esmark Collection of Currier & Ives*. Anselmo Carini. Chicago, n.d.

First City National Bank of Houston. *The Art Collection of the First City National Bank of Houston*. Foreword by J.A. Elkins, Jr. Assembled by Janie C. Lee. Houston, n.d.

First National Bank of Chicago. *The Art Collection of the First National Bank of Chicago*. Introduction by Gaylord Freeman. Foreword by Katharine Kuh. Chicago, 1974.

McQuade, W. "First National of Chicago Banks on Art." *Fortune*. Vol. 90 (Jul., 1974), pp. 104–11.

Schulze, Franz. "The Collection of the First National Bank of Chicago." *Apollo*. Vol. 96 (Aug., 1972), pp. 96–105.

Gilman Paper Company:

Lynn, Letitia. "Corporate Collecting." *Art/World*. (Jun.–Jul., 1977), p. 8.

Gimbel Brothers:

Caspers, Frank. "Gimbel Collection Pictures Pennsylvania Life." *Art Digest*. Vol. 22, No. 3 (Nov. 1, 1947), p. 17.

"Painters Look At Pennsylvania." *Art News*. Vol. 46, No. 11 (Jan., 1948), p. 34.

See also, under General Books and Articles: Grafly, Dorothy, "Industry — Art Angel," *American Artist*.

Gulf States Paper Corporation. Tuscaloosa, n.d. A catalogue of paintings owned by the Gulf States Paper Corporation.

Hallmark Cards, Inc. *Alechinsky to Wyeth: An Exhibit of Representative Artwork from the Lounges and Offices of Hallmark Cards*. Foreword by Donald J. Hall. Kansas City, n.d.

_____. *The Hallmark Art Award*. Forewords by Daniel Wildenstein, Joyce C. Hall and Vladimir Visson. Kansas City, 1949.

_____. *The Second International Hallmark Art Award*. Kansas City, 1952.

_____. *The Third International Hallmark Art Award*. Foreword by Vladimir Visson. Kansas City, 1955.

_____. *The Fourth International Hallmark Art Award*. Kansas City, 1957.

_____. *The Question of the Future: The Fifth International Hallmark Art Award*. Foreword by Joyce C. Hall. Introduction by Alfred Frankfurter. Kansas City, 1960.

Home Savings and Loan Association. *Winners, 1953–1974: Purchase-Award Winning Works by Los Angeles Artists from the All City Outdoor Art Festivals: Selections from the Collection of Home Savings and Loan Association.* Exhibition at the Los Angeles Municipal Art Gallery, Barnsdall Park, May 7–Jun. 1, 1975.

International Business Machines Corporation. *Cross Currents in American Art.* n.d. Exhibition brochure.

_____. *Contemporary Art of 79 Countries: The International Business Machines Corporation Collection.* Introduction by Thomas J. Watson. 1939. Exhibitions at IBM Gallery of Science and Art, Business Systems and Insurance Building, New York World's Fair, 1939; and at IBM Gallery of Science and Art, Palace of Electricity and Communication, Golden Gate International Exposition, San Francisco, 1939.

_____. *Contemporary Art of the United States: Collection of the International Business Machines Corporation.* Foreword by Thomas J. Watson. 1940. Exhibitions at the Gallery of Science and Art, IBM Building, New York World's Fair, 1940; and at the IBM Gallery of Science and Art, Palace of Electricity and Communication, Golden Gate International Exposition, San Francisco, 1940.

_____. *Contemporary Art of the United States: A Special Loan Exhibition of Paintings from the International Business Machines Corporation.* Foreword by C. Powell Minnigerode. Exhibition at the Corcoran Gallery of Art, Washington, D.C., 1940.

_____. *Contemporary Art of the Western Hemisphere.* 1941. Catalogue of traveling exhibition.

_____. *Sixty Americans Since 1800.* 1946. Brochure for traveling exhibition arranged by the U.S. State Department. (Published also in French and Arabic versions.)

_____. *Water Colors of the United States.* 1946. Exhibition brochure.

_____. *Small Paintings by Americans 1850–1950.* 1950. Exhibition brochure.

_____. *Twenty American Paintings.* 1958. Exhibition brochure.

_____. *Art at Santa Teresa Laboratory.* 1978.

S.C. Johnson and Son. *Art: USA: Now.* Text by Allen S. Weller. Edited by Lee Nordness. 2 vols. New York: Viking Press, 1963.
 "Art: USA: Now — Thanks to a Wax Company." *Fortune.* Vol. 66, No. 3 (Sep., 1962), pp. 132–39.
 Hess, Thomas B. "Big Business Taste: The Johnson Collection." *Art News.* Vol. 61, No. 6 (Oct., 1962), pp. 32–33, 55–56.

Mead Corporation. *The Mead Painting of the Year: 45 Paintings by Artists from the Southeastern States Selected from the 7 Annual Painting of the Year Competitions, 1955–1961.* Brochure of exhibition organized and circulated by The American Federation of Arts, n.d.

_____. *Art Across America: An Exhibition of 50 Contemporary American Paintings and Wall-hung Constructions Sponsored by the Mead Corporation, 1965.* Foreword by George H. Pringle. Traveling exhibition, 1965–1967.
 Ahlfeld, William J. "Art Program Relates to Community-At-Large." *Public Relations Journal.* Vol. 23, No. 3 (Mar., 1967), pp. 16–17.
 "Art for the Corporation's Sake." *Business Week.* No. 2041 (Oct. 12, 1968), pp. 82–84.

McCrory Corporation. *Constructive Concepts: A History of Constructive Art from Cubism to the Present.* Text by Willy Rotzler. Introduction by Celia Ascher. Zurich: ABC Edition, 1977.

Meta-Mold Aluminum Company:
 Barkin, Ben. "Art at Meta-Mold." *Art in America.* Vol. 44, No. 2 (Spring, 1956), pp. 36–39.

Miller Company. *Painting Towards Architecture: The Miller Company Collection of Abstract Art.* Text by Henry-Russell Hitchcock. Foreword by Alfred H. Barr, Jr. New York: Duell, Sloan, and Pearce, 1948.
 Lansford, Alonzo M. "Miller Collection Presents Art as Step-Mother of Architecture." *Art Digest.* Vol. 22, No. 9 (Feb. 1, 1948), pp. 12, 34.
 Louchheim, Aline B. "Abstraction on the Assembly Line." *Art News.* Vol. 46, No. 10 (Dec., 1947), pp. 25–27, 51–53.

National Bank of Tulsa and The Williams Companies. *Art from the Collections of National Bank of Tulsa and The Williams Companies.* Tulsa, n.d.

Owens-Corning Fiberglas Corporation. *The Owens-Corning Collection*. Foreword by John H. Thomas. Introduction by Otto Wittmann. Exhibition at Toledo Museum of Art, Jun. 21–Jul. 20, 1969.

Paine Webber/Mitchell, Hutchins Group:
See, under General Books and Articles: Cochran, Diane, *Interiors*.

PepsiCo, Inc.:
Conrad, Barnaby, III. "PepsiCo's Art Generation." *Art/World*. Vol. 1, No. 10 (Jun.–Jul., 1977), p. 3.
Mack, Walter S., Jr. "Viewpoints: A New Step in Art Patronage." *Magazine of Art*. Vol. 37, No. 6 (Oct., 1977), p. 228.
Pearson, Ralph M. "A Modern Viewpoint: The Pepsi-Cola Prize Contest." *Art Digest*. Vol. 20, No. 6 (Dec. 15, 1945), pp. 28–31.

Philip Morris, Inc.:
Weissman, George. "Good Art is Good Business." *Public Relations Journal*. Vol. 25, No. 6 (Jun., 1969), pp. 8–10.

Playboy Enterprises, Inc. *Beyond Illustration: The Art of Playboy*. Foreword by Arthur Paul. Chicago, 1971.

————. *Beyond Illustration: The Art of Playboy*. Foreword by Sam Yates. Preface by Arthur Paul. Exhibition at the Priebe Gallery, University of Wisconsin, Oshkosh, Mar. 2–26, 1978.

Ponderosa System, Inc. *Ponderosa Collection*. Exhibition at The Contemporary Arts Center, Cincinnati, May 3–Jun. 24, 1974. Checklist.

PPG Industries Inc., Coatings and Resins Division. *Catalogue of the Art Collection*. Pittsburgh, n.d.

Prudential Insurance Company of America:
See, under General Books and Articles: Cochran, Diane, *Interiors*.

Rainier National Bank. *The Rainier Collection*. Foreword by G. Robert Truex, Jr. Seattle: Rainier Bancorporation, 1977.

RCA. *Selections from the RCA Collection of Art*. Researched and documented by Grant Jacks, Inc. New York, 1977.

Santa Fe Industries, Inc. *Indians and the American West*. Exhibition at the National Archives of the United States, Washington, D.C., Oct. 26, 1973–Jan. 21, 1974. Paintings from the collection of the Santa Fe Industries, Inc. with selected subjects from Robert E. and Evelyn McKee Foundation and The Anschutz Collection.

————. *The Santa Fe Collection of Southwestern Art*. Chicago, 1974. Checklist.

————. *Art of Arizona and the Southwest*. Exhibition at the Phoenix Art Museum, Mar. 20–May 4, 1975. From the collection of the Santa Fe Industries, Inc. with selected subjects from Robert E. and Evelyn McKee Foundation.

————. *A Special Exhibition of Paintings Featuring the Grand Canyon from the Santa Fe Collection of Art*. Exhibition at Visitors Center, Grand Canyon National Park, Winter 1975–1976. A second exhibition on the same theme was also held in Jul.–Oct., 1976.
"Artists of the Santa Fe." *American Heritage: The Magazine of History*. Vol. 27, No. 2 (Feb., 1976), pp. 57–72.

Seamen's Bank for Savings:
See, under General Books and Articles: Davis, Felice, *Connoisseur*.

Seattle-First National Bank. *Art of the Seattle-First National Bank Collection*. Foreword by William M. Jenkins. Exhibition at the Seattle Art Museum, Dec. 7–29, 1968.

Security Pacific Bank. *Large Scale Paintings from the Collection of Security Pacific Bank*. Introduction by Mary Hunt Kahlenberg. Exhibition at Security Pacific Plaza, Los Angeles, May 17–Jul. 31, 1977.
Isenberg, Barbara. "Art Goes to the Bank, Earns Interest." *Los Angeles Times*. Jul. 21, 1978, Part 4, pp. 1, 26.
See also, under General Books and Articles: Wenger, Lesley, *Currânt*.

Standard Oil Company of New Jersey:
Gibbs, Josephine. "Artists Recount the Story of Oil." *Art Digest*. Vol. 20, No. 8 (Jan. 15, 1946), pp. 5–7.
McCausland, Elizabeth. "The Lamp." *Art in America*. Vol. 45, No. 2 (Spring–Summer, 1957), pp. 40–43.
"Oil at War." *Art News*. Vol. 44, No. 19 (Jan. 15–31, 1946), pp. 15–18.
"Oil: 1940–45." *Carnegie Magazine*. Vol. 20, No. 2 (Jun., 1946), pp. 38–41.

Steinway & Sons. *The Steinway Collection.* New York, 1919. Subtitled "The Steinway Collection of Paintings by American Artists together with Prose Portraits of the Great Composers by James Huneker."

Levi Strauss & Company. *The Levi Strauss Collection.* Foreword by Walter A. Haas, Jr. Introduction by Henry T. Hopkins. Exhibition at the San Francisco Museum of Art, Mar. 15–Apr. 14, 1974.

Times Mirror Corporation:
See, under General Books and Articles: Wenger, Lesley, *Currant.*

Underwood Corporation:
van Weeren-Griek, Hans. "The Underwood Experiment." *Art in America.* Vol. 44, No. 2 (Spring, 1956), pp. 40–41, 66–68.

United Missouri Bank. *The United Missouri Bank's Collection of American Art.* Foreword by R. Crosby Kemper. Kansas City: United Missouri Bancshares, Inc., n.d.

_____. *The United Missouri Bank's Collection of American Portrait Artists.* Kansas City: United Missouri Bancshares, Inc., n.d.

Upjohn Company:
"Upjohn Collection." A special issue of *Art Digest.* Vol. 20, No. 4 (Nov. 15, 1945).

GROUP EXHIBITIONS OF CORPORATE COLLECTIONS
Arranged alphabetically by organizing institution.

Heinz Galleries, Museum of Art, Carnegie Institute. *Pittsburgh Corporations Collect.* Foreword by Leon A. Arkus. Oct. 25, 1975–Jan. 4, 1976. Inaugural Exhibition of the Heinz Galleries.

Indianapolis Museum of Art. *Art from Business and Corporate Collections.* May 25–Jun. 26, 1977. Foreword by Robert A: Yassin. Indiana corporate collections.

Loch Haven Art Center, Inc., Orlando. *Art in Florida Corporate Collections.* Foreword by David M. Reese. Feb. 14–Mar. 14, 1976.

Montgomery Museum of Fine Arts. *Corporate Collections in Montgomery.* Introduction by Henry Flood Robert, Jr. May 15–Jun. 20, 1976.

Otis Art Institute Gallery, Los Angeles. *Corporate Art Collections.* Mar. 10–Apr. 17, 1977. California corporate collections (no catalogue).
Wilson, William. "Patronage and the Corporate Patriarchy." *Los Angeles Times.* Mar. 20, 1977, "Calendar," p. 70. Review of the exhibition.

San Francisco Museum of Art. *American Business and the Arts.* Foreword by J.E. Wallace Sterling. Introduction by George D. Culler. Sep. 14–Oct. 15, 1961.

Whitney Museum of American Art, New York. *Business Buys American Art.* Forewords by David A. Praeger and David M. Solinger. Mar. 17–Apr. 24, 1960. Third loan exhibition by the Friends of the Whitney Museum of American Art.
"The Corporate Splurge in Abstract Art." *Fortune.* Vol. 61, No. 4 (Apr., 1960), pp. 138–47. Article about the Whitney Museum exhibition.
Gordon, John. "Exhibition Preview: Business Buys American Art." *Art in America.* Vol. 48, No. 1 (Spring, 1960), pp. 88–93.

Whitney Museum of American Art, Downtown Branch. *Art at Work: Recent Works from Corporate Collections.* Mar. 9–Apr. 11, 1978.

INDEX OF ARTISTS AND CORPORATIONS

This catalogue was designed by Julie Toffaletti, Toffaletti Design, Montgomery, Alabama.

Color separations and lithography are by W.M. Brown & Son, Inc., Richmond, Virginia. Two thousand casebound and four thousand five hundred softcover copies were produced for the Montgomery Museum of Fine Arts in May of 1979.

The text typeface is Goudy Old Style, set by Typography Shop, Atlanta, Georgia. Headline faces are Goudy Hand-tooled and Goudy Old Style, set by Type Direction, Atlanta, Georgia.

Softbound cover stock is Champion Kromekote C1S 12 pt. cover. The inside stock is 100 lb. Champion Wedge-wood Gloss.

All transparencies for the publication were taken by Malcolm Varon, New York, New York, with two exceptions: James Milmoe photographed the Georgia O'Keeffe; Robert Wallace, the Ellsworth Kelly.